P9-DUT-014

ALSO BY FRANCESCA FIORANI

The Marvel of Maps: Art, Cartography, and Politics in the Renaissance

THE SHADOW DRAWING

specchio

concauo

THE SHADOW DRAWING

How Science Taught

LEONARDO

How to Paint

FRANCESCA FIORANI

Farrar, Straus and Giroux
New York

Farrar, Straus and Giroux
120 Broadway, New York 10271

Copyright © 2020 by Francesca Fiorani
All rights reserved
Printed in the United States of America
First edition, 2020

Owing to limitations of space, illustration credits can be found on pages 371–74.

Library of Congress Cataloging-in-Publication Data
Names: Fiorani, Francesca, author.
Title: The shadow drawing : how science taught Leonardo how to paint /
 Francesca Fiorani.
Description: First edition. | New York : Farrar, Straus and Giroux, 2020. |
 Includes bibliographical references and index.
Identifiers: LCCN 2020027807 | ISBN 9780374261962 (hardcover)
Subjects: LCSH: Leonardo, da Vinci, 1452–1519—Knowledge—Optics. |
 Leonardo, da Vinci, 1452–1519. Codice C. | Optics and art—History. |
 Painting—Technique—History.
Classification: LCC QC352 .F56 2020 | DDC 759.5—dc23
LC record available at https://lccn.loc.gov/2020027807

Our books may be purchased in bulk for promotional, educational, or business
use. Please contact your local bookseller or the Macmillan Corporate and
Premium Sales Department at 1-800-221-7945, extension 5442, or by e-mail
at MacmillanSpecialMarkets@macmillan.com.

www.fsgbooks.com
www.twitter.com/fsgbooks • www.facebook.com/fsgbooks

10 9 8 7 6 5 4 3 2 1

To Paolo and Davidi

Contents

THE SHADOW DRAWING

Prologue

We know why the candle was on Leonardo's desk—to bring light into the darkness. But why a ball and a small screen, perhaps made of thick paper, or of simple wood?

The "shadow drawings" suggest an answer.

When darkness fell and there was no other source of light in the room, Leonardo lit the candle and lined up the three—candle, ball, and screen. The small portion of the ball's surface that directly faced the candle was brightly lit. But, moving outward in any direction, he could see that the remainder of the ball was left in varying degrees of shadow, as if the light never quite came its way. Where, then, did that light go instead?

Depicting the light *not* as we see it—as one solid beam—but rather as a set of discrete rays, he charted the individual destination of each and every one, line by line. Clearly, he knew something about the science of optics—or at least how light behaves when it hits an opaque object—because with exquisite precision he identified which rays would hit the ball in a straight line and be reflected straight back to the viewer (providing that brightness) and which, because of a more acute angle of incident (or impact), would hit it diagonally, leaving the edges of the ball in deeper and deeper shadow.

Again and again, he repeated the experiment, moving the ball

closer to the light and then farther away, sometimes to the left and then to the right. He added a second source of light and examined the effect as the light from one source intersected with the light from the other. And he looked at the color of the ball and saw that it changed just as the shadows and light changed. And then there came the day he moved outside, ready to tackle the most difficult question of all—how the rays of the sun behave when they, too, meet an opaque object, such as a ball. Or, one must imagine, a human form.

For "nothing was more important to him than the rules of optics," as one of his contemporaries noted. But in fact this obsession appears to have been very narrowly focused on just one aspect of optics: when and where light produces shadow. Every one of his notes beneath these sketches makes this point:

> Every shadow made by an opaque body smaller than the source of light casts derivative shadows tinged by the color of their original shadow.

> An opaque body will make two derivative shadows of equal darkness.

> Just as the thing touched by a greater mass of luminous rays becomes brighter, so that will become darker which is struck by a greater mass of shadow rays.

Why this obsession with shadows? Because of some new invention or experiment he was considering? No. His goal was a different one: to learn how to paint.

As a young boy, when he was taken by his father to apprentice at the most important *bottega* (or workshop) of the early Renaissance, Leonardo had learned how to draw. Given a piece of charcoal or a quill pen dipped in ink, he could sketch a complex set of figures striking poses that were simultaneously true to life and emotionally evocative. Not surprisingly, while other new apprentices were sent to wash brushes

or work on the mass-produced objects meant for the middle class, Leonardo quickly joined his master, Andrea del Verrocchio, at the easel, where the most important work of the bottega was done—the paintings meant for the Church or other important patrons.

But that same young man who could draw almost anything had yet to learn how to paint. And by "how to paint," I am not referring to how to mix colors or apply them to the panel. I am referring to the sensibility of an artist who instinctively reaches for what makes a painting a great painting.

At the time, a quiet revolution was just starting to take hold in the world of Renaissance art, especially in the bottega of Verrocchio, one that would be based upon a new kind of *revelation*. This revolution was not the sort achieved through faith, which is what the Church wanted its paintings to convey. Nor would it be based upon the fixed truths rulers expected artists to use their talents to reinforce—that each of us must know our place in the larger scheme of things, deferring to the supposedly inherent nobility of those above us. Rather, this revolution in art was founded on the notion that a new and different kind of truth was waiting to be identified by our senses and made sense of by our minds—the truth that came from careful observation.

Just how this revolution would lead Leonardo to a new kind of art—one that would move viewers much more deeply, and one that speaks to us today in a way that most Renaissance painting does not— is the story this book tells. Crucial to that story, however, is the unraveling of a myth—a myth propagated, as my book will explain, by a renowned authority in the decades after his death. I am referring to the notion of Leonardo as the iconic representative of two very different forms of genius.

Leonardo, it is commonly believed, is the artist who painted masterpieces such as the *Ginevra de' Benci*, the *Mona Lisa*, and the *Last Supper* and drew the iconic *Vitruvian Man* and then underwent a metamorphosis of sorts. Somewhere in his late thirties and early forties, there is the emergence of a second Leonardo, the one who imagined

inventions that would not come to exist until centuries later, from the parachute to the flying machine—the one who became fascinated by science and philosophy.

The artist and the scientist. Each exceptional in his own way, but representing different parts of the same man. The traditional characterization of this "dual Leonardo" is that the natural philosopher in him decided to work out scientifically what the artist had somehow vaguely intuited decades earlier.

Many of us who inadvertently helped perpetuate this dual-genius thesis had good reason to do so: scholars relied, after all, on documents Leonardo himself left us, in particular his "folios," or notebooks. Many of the folios are dated, and based on those dates (with the exception of a few outliers, which were somehow ignored), it seemed that the vast majority of his shadow drawings, for instance, were done when Leonardo was well into his late thirties or early forties—in other words, long after he knew how to paint, and contemporaneous with his shift toward his philosophical investigation of nature. Science was called natural philosophy back then.

But do the dates written on the folios indicate what we have long assumed they indicate?

Let me explain.

It always surprises my students when I tell them that Leonardo was one of the least prolific painters of his time. Over a period of about four decades, he left us only between twelve and fifteen paintings (the number changes depending on the attribution of a handful of controversial works), and a number of these he never fully completed, including, it might surprise many to learn, the *Mona Lisa*. If he was not busy painting, then how did Leonardo spend most of his time?

He spent it writing.

Leonardo was an inveterate notetaker. He got into the habit of never going out without a little notebook, just in case something caught his eye. When it did, it could be how a flock of birds seemed to hang in midair, or how water moved through a canal, or something as simple as a cat playing in the street. He would take out his notebook and write

about or sketch what he had seen, or he would make a note to himself to pursue a question he could not resolve on the spot.

A staggering 4,100 or so pages of sketches and notes, many supplemented with technical drawings in the style of the shadow drawings, have come down to us. But most scholars believe that what has survived represents no more than half of what Leonardo likely produced, which would mean he wrote around 8,000 pages. A more liberal estimate would place the number at 16,000. No other artist from the Renaissance left a written record of this size behind.

And here is the important point: there eventually came a time—when, exactly, we do not know, but certainly by 1490—when Leonardo believed that by organizing and expanding the notes and drawings he had made over the years, he could eventually produce a book, a book with the aim of teaching artists that "painting is philosophy." He was aware that "few painters make a profession of writing since their life is too short for its cultivation" and that, in general, they "have not described and codified their art as science." Determined to do something about this, he started to take notes on what we would now call "scrap paper," and in Leonardo's time, scrap paper would quickly succumb to the elements.

To preserve the most important of his writings and drawings, he copied each into a new folio and assembled these reorganized sheets of paper into sets of "folios" (which we now refer to as Leonardo's "notebooks"). The shadow drawings he transferred to the largest folio set, suggesting that they were among his most important sketches.

These writings, both the reorganized folio sets and the scrap-paper writings that survived, could more accurately be described as a mass of rambling, fragmented, repetitive, and mostly undated notes that needed (and to this day need) thorough editing. For example, Leonardo thought nothing of writing about one topic one day on one sheet of paper and then continuing the discussion, months later, on another piece of paper. Or he would add notes on a new topic to a piece of paper that already contained notes on a different topic altogether. And everything he wrote, he wrote backward, so you need a mirror to read it. It

is neither surprising nor unrealistic that some scholars threw up their hands when it came to these folios, describing Leonardo's writings as nothing more than a "vast accumulation of words" and an unfortunate distraction from his paintings.

But other scholars, starting as far back as two centuries ago, began what can only be described as the painstaking detective work of putting these notes in chronological order. Over time, they learned to date even the flimsiest scrap of paper, sometimes by examining the spelling conventions Leonardo used—were they Florentine or Milanese? They studied the quality and size of the paper itself: Was it cheap or high quality? Large or small? Did it have a watermark? And did Leonardo prepare the paper with colors before writing or sketching on it? They also studied the tools he used—metal point or silverpoint? Chalk or pencil? Gall ink or just dark, diluted pigment?—and even the look of his handwriting: Was it firm or trembling? Above all, they looked to the layout of each of his folios for clues, paying particularly close attention to how he arranged drawings and words on the page.

Two conclusions emerged from this detective work—conclusions that have shaped our understanding of the life and work of Leonardo. First, based largely on the only reliably dated folios, scholars concluded that Leonardo started to write in earnest only around 1490, when he was in his late thirties. (There are a few folios from earlier—between 1478 and 1480, when he was in his late twenties—but these were seen as exceptional.) Second, since everything he preserved in these folios was of a philosophical or scientific nature—even when they discussed painting, which a great deal of the material did—scholars concluded that these writings document Leonardo's increasing distance from the world of art and his turn toward science and philosophy.

As this scholarly consensus formed, no one explicitly intended to dismiss the possibility that science played a role in shaping young Leonardo as an artist. It was just that Leonardo's writings about the science of art from his mature years were so numerous in comparison to the surviving writings from his youth—and so few scholars consid-

ered the possibility that the stunning paintings produced by a young Leonardo might be the result of early exposure to science and philosophy. Nor did anyone challenge the notion that much of the material in the folios was likely a carefully copied version of discarded scrap-paper notes that could have been made years, if not decades, earlier. Rather, the details of young Leonardo's possible engagement with science were neglected as attention was focused on his later writings and scientific pursuits.

This focus, however, has obscured as much as it has revealed. I am part of a group of art scholars who believe that the stress on answering the question of when and how Leonardo became a scientist has inadvertently prevented us from understanding something much more interesting: the possibility that Leonardo did not suddenly "become" a scientist at all. At the heart of the scientific mindset is curiosity—the need to understand and explain the seemingly inexplicable—and Leonardo showed a great deal of curiosity in his early work.

If science meant so much to the young Leonardo, why, you might ask, did he not, like Galileo Galilei, devote himself to science from the start? Why, of all things, painting? That question is easy to answer. It was the only outlet available to him. As an illegitimate son, he was denied the right to a higher education by the laws of the time. He was lucky to have learned how to read and write and to do elementary math. Had he not shown such a strong desire at an early age to observe and record nature in drawings, suggesting he might succeed as an artist's apprentice, he would likely have been turned over by his father to the Church, to spend the rest of his days contemplating the divine.

Fortunately, while the law may have constrained the options available to illegitimate children, the arts themselves did not. To the contrary, an artist's studio was the ideal setting for a child like Leonardo, who would be not only exposed to philosophical and scientific ideas but encouraged to seek them out—and to use them in the service of the

arts. Of course, it is not just Leonardo who has come down to us as an example of "dual genius." The Renaissance is still most often described as a time when art and science both thrived—but separately.

That is how I, too, saw the Renaissance until my undergraduate days at the University of Rome, when I attended a lecture by Professor Corrado Maltese. That day, he pointed out that we have lost sight of the true Renaissance. It was, he argued, a time when artists were deeply interested in science *not apart from their art but because of it*. Renaissance artists, the professor insisted, had enormous respect for what science could teach them, because Renaissance artists were taught that artists could make visible for society "what we know" only *after* science explained "how we know it," an inversion of the artist-to-scientist hypothesis often applied to Leonardo. Artists and artisans followed science closely. From science, they learned how to be better painters, better sculptors, better metallurgists, better architects—better everything—and watched their art and that of others deepen as science explained more and more. Maltese taught us how to decode Renaissance art and to look for evidence of the scientific principles artists used to create their works.

Indeed, as my book will show, shortly after his arrival at the workshop of Andrea del Verrocchio, Leonardo would be given a fascinating opportunity. He would witness (and perhaps assist with) the painstaking experiments that his master conducted in order to design the golden orb that sits atop Brunelleschi's dome of the Cathedral of Santa Maria del Fiore in Florence. He learned early on that there were philosophical and scientific truths that could help him make art, and that those truths could teach him what he desperately wanted to know—how to paint.

Most often, those truths were the truths of optics. Long before the Renaissance, artists understood that how a person holds his face and body unconsciously reveals a great deal about how that person sees himself—or wishes to be seen by others. The smirking smile needs no

further explanation. Nor do drooping shoulders. But artists also understood that much of what we really feel is revealed by almost imperceptible details.

Here is where the science of optics enters the picture. A figure striking a pose creates countless shadows—in the folds of a garment as well as in the lines and creases of a forehead or around the lips. Every tilt of the body or head casts its own subtle pattern of shadows against a floor or wall. By paying attention to these shadows, an artist with some knowledge of optics could work backward from the interplay of light and dark to more accurately render the human form—and to better convey the emotions it expressed.

But if optics informed Leonardo's art almost from the start, how might he have acquired this knowledge?

There were books in Latin, a language Leonardo never mastered, that taught the science of optics. And there was an eleventh-century manuscript titled *Book of Optics* by the Arab philosopher known in the Renaissance as Alhacen—his real name was Abu Ali al-Hasan Ibn al-Haytham—that Renaissance artists knew about, because it had been translated into the vernacular. A copy of this Italian translation was in the hands of an artist Leonardo knew.

We know that Leonardo would take notes whenever he read a book. Not surprisingly, written on scraps of paper and in his notebooks are thoughts that are so deeply aligned with Alhacen's book that they seem, at times, nearly direct quotes from it—such as Alhacen's belief in the truthfulness of sensory experience, which Leonardo rephrased as "experience does not err, but rather your judgements err when they hope to exact effects that are not within her power." Even the way Leonardo described painting—as an activity that "embraces all the ten functions of the eye; that is to say darkness, light, body and color, shape and location, distance and closeness, motion and rest"—is a rephrasing of Alhacen's description of the eight conditions that make proper human vision possible: "distance between eye and object, a facing orientation, light, size, opacity, transparency in the air, time, and a healthy eye."

Leonardo also declared that his "little work [*piccola opera*]"—the

book on painting he planned to assemble from his notes—"will comprise an interweaving of these functions," stressing the connection between optics and art. Even his description of painting as being "grounded in optics [*prospettiva*]," which was nothing else than "a rational demonstration [*ragione dimostrativa*] by which experience confirms that all things send their semblance to the eye by pyramidal lines," reads like a sentence from an optical text. When Leonardo wrote that experience was "the mother of every certainty," and that "true sciences are those which have penetrated through the senses as a result of experience," he seemed to be echoing scientific studies of optics in general, and Alhacen's in particular.

But why are these thoughts and quotations so important to the argument I am trying to make?

When I began to think about writing this book, I made myself a promise. Instead of standing at a remove, I would try to imagine myself standing behind Leonardo in an attempt to see the world through his eyes—as he stopped to sketch something that caught his attention, or as he sat struggling to write his unfinished book, which would affirm that "painting is philosophy." And here is what this practice has made clear to me: Earlier, I suggested that as a child, Leonardo had an insatiable need to make sense of the world. To do so, he employed the only tools then available to him—his senses, in particular his eyes. And then he recorded that sensory data in the only way he knew how: by making little drawings. Recalling what my professor Corrado Maltese told me many years ago—how Renaissance artists saw art as expression of what science revealed—I began to ask myself a question I had never asked before. *Did Leonardo see each of his paintings as an experiment that would give him a novel opportunity to refine his understanding of optics and its ability to help him capture human emotions in paint?*

The recent emergence of a new shadow drawing lends support to this hypothesis. Carmen Bambach, an expert on Leonardo who is the curator of Italian and Spanish Drawings at the Metropolitan Museum

of Art in New York, has dated it convincingly to Leonardo's twenties. What this means is that Leonardo was starting to consider scientific questions—especially those posed by the science of optics—from his earliest days as a painter.

My own readings of Leonardo's work offer further evidence in support of this argument. Consider his first solo painting, *Annunciation*. Leonardo placed Mary outside rather than indoors; at the heart of this painting is the "divine shadow" that will come over her and make her pregnant. That shadow is like no other shadow I have ever seen in Renaissance art. Optics can explain why.

I have also tried to understand what must have gone through Leonardo's mind when he chose to abandon the *Adoration of the Magi* and the *Mona Lisa*. Was the reason, in the case of the former, that he failed to achieve the optical rigor he had come to expect of himself? And could the latter no longer hold his attention once he had accomplished (or failed to accomplish) a demonstration of the scientific principles he had set out to understand?

And then there was the book on painting that Leonardo spent much of his life planning but that he never completed. He intended for it to explain why "painting is grounded in optics" and why the illusion of depth created by light and shadow is "the soul of painting." But why was it so difficult, for so many scholars, to make sense of what Leonardo was trying to accomplish? Because everyone who tried to do so approached it as a book about painting, when in fact it was to be a book about science for painters. It is really a chronicle of scientific discoveries—a subject typically written about in a language that Leonardo himself did not speak.

Leonardo's use of art to investigate science also goes against conventions of patronage during the Renaissance. The church still largely maintained a stranglehold on art: yes, paintings could generate emotional responses, but only certain ones—most often a sense of rapture with the aim of inspiring devotion. Alternatively, for the Medici and other families in the upper echelons of society, the desired message was one of strength, dignity, and power. In a preliterate society, where even

sermons were still delivered in Latin, the best way the church could tell its stories and leaders could address the public was through art. There is a reason many paintings from this era seem to have no center, no main focus, but rather a thread that needs to be followed from character to character. In this respect, Leonardo was being asked to play a role for which he was never quite suited. There was no space for his art to find its own grammar and its own voice, or to express its own sensibility. When forced to choose between his own comfort and security and using painting for his own ends, Leonardo invariably chose the latter.

Who was the man who gave us this legacy? By all accounts, Leonardo was fun to be around, a great talker and a fabulous dinner companion. He knew how to tell jokes and "sang beautifully to his own accompaniment on the lyre to the delight of the entire court." He even knew how to entertain a crowd with witty debates on lofty topics—in one

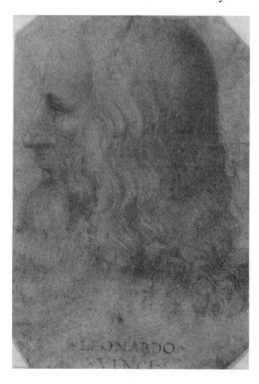

famous debate, he defended the superiority of painting over mathematics. His taste was impeccable, and he won fame as an "arbiter and inventor of all matters pertaining to beauty and elegance, especially spectacles and performances."

In old age, he stood out for his long beard that "came to the middle of his breast and was well combed and curled." He resembled an ancient philosopher, which is how his longtime assistant and

companion Francesco Melzi portrayed him in a drawing that has since become Leonardo's "official" image.

But when working he went into a kind of trance, forgetting food, time, friends, and everything else. He was volatile, alternating between sociability and social withdrawal. He was a compulsive draftsman and sketched constantly, scribbling on any piece of paper that crossed his desk, sometimes even on the panels of his paintings. Always, he carried "a little notebook" in his pocket to draw whatever attracted his attention.

He did not build close relationships, he did not have children, and he never married. But he was close to his apprentices, even though none of his disciples was "of great fame." Two of them, who joined his workshop in their teens, remained with him until his death.

He was well aware of his talent. "Read me, reader, if in my words you find delight, for rarely in the world will one such as I be born again," he jotted down in one of his notebooks when he was in his early forties, at the pinnacle of his fame at the court of Milan.

He had great difficulty finishing the things he set out to do, however. His soul "was never quieted." He would delve into a specific topic and write frantically for months on end, and then abruptly abandon it. He never published a single page of the thousands he wrote. He was hypercritical of his own work, and urged other artists to be the same way, as perfect works "will bestow upon you more honor than money would do." An eyewitness reported how for days he stood in front of his *Last Supper* without touching "the work with his hand," staying "for one or two hours of the day only to contemplate, consider, and examine his figures in solitude, in order to judge them." He did finish that painting, but there were many others that he did not.

Some say that he left his projects incomplete because "he knew so much and this did not allow him to work," or because he was always in search of "new means and refined artistic techniques." One of Leonardo's acquaintances who was a physician thought the reason was "his volubility of character and his natural impatience," a trait that caused him "always to discard his early ideas." The fact is that there was no way

to get Leonardo to do something he did not want to do. Kings and princes, even a pope, begged him for work and promised wonderful rewards, but he would do nothing if he did not have the right motivation. Money did not move him to action, even though he needed plenty to afford the lavish lifestyle he became accustomed to; nor did fame, and he acquired much during his lifetime.

For Leonardo, the focus was on the inner emotional lives of the people he portrayed, including how they reacted in the face of the divine. It is his emphasis on the human, on how human beings instinctually react to others and to the world, that gives his paintings such a modern feel, that allows them to continue to speak to us even after five hundred years.

PART I

How Science Taught

LEONARDO

How to Paint

1

///

The Right Place at the Right Time

The teenage boy who showed up for an apprenticeship at the bottega of Andrea del Verrocchio was, it seemed, a work of art in his own right. He was possessed of such extraordinary beauty, it was said, that "nature seemed to have produced a miracle in him." The boy's name was Leonardo. He was at most thirteen or fourteen years old. His father, a well-connected notary, had sought out the apprenticeship for his son, for there was no finer or more dedicated teacher than Andrea del Verrocchio, and no artist who knew more about "the sciences, particularly geometry," as an early biographer of Andrea noted.

The workshop of Leonardo's new master was on the southeast side of Florence, about half a mile from the city's magnificent cathedral, in the neighborhood of Sant'Ambrogio. It was there that painters, goldsmiths, sculptors, dyers, woodworkers, and stonemasons kept shop. The neighborhood buzzed with activity, and it remains as lively today as it was when Leonardo lived there five hundred years ago. Farmers from the countryside came every day to erect their stalls in the market, and visitors from other cities flocked there to buy the luxury goods for which Florentine craftsmen were famous. The small parish church lay at the heart of the neighborhood, and the craftsmen who lived nearby cared deeply for it even though it could hardly compare to Florence's cathedral and its towering dome. It was in one of the small houses

lining the neighborhood's narrow streets, amidst the shouts of workers and shoppers, the clanging of tools from the workshops, and the scent of spices from the market, that Leonardo learned how to paint—and where he also sketched his first shadow drawings.

During the Renaissance, sons typically followed their fathers' professions. The sons of doctors studied medicine at the university, those of craftsmen trained in their fathers' workshops, and the offspring of merchants went to abacus school to learn essential skills of their trade. Had Leonardo been a legitimate son, he would have followed a similar path. He would have studied law at the university and become a notary like his father and his great-grandfather. But Ser Piero had conceived him out of wedlock with a household servant named Caterina. Leonardo's grandfather proudly recorded the arrival of the boy, his first grandson, in the family memory book: "There was born to me a grandson, the son of Ser Piero my son, on the 15th day of April, a Saturday, at the 3rd hour of the night. He bears the name Lionardo [*sic*]." But in other, more fundamental ways, the boy was not part of the family. According to the laws of the time, illegitimate children were deprived of inheritance rights. They did not even have the right to attend university, let alone enroll in the guild of magistrates and notaries. Because of the circumstances of his birth, the boy was destined for a different career.

We know nothing about Leonardo's childhood, but based on what we know about the upbringing of children in this period we can surmise that he spent at least a couple of years with his mother outside the village of Vinci, where she lived on a farm with the husband Ser Piero had arranged for her. After being weaned, which would have occurred anywhere between the ages of two and six, he would have moved in with his father's family, taking up residence in either his grandfather's house in Vinci or in his father's house in Florence, where Ser Piero lived with his wife, whom he married after Leonardo's birth. (Ser Piero would marry three more times and would father at least twelve legitimate children and numerous illegitimate offspring, meaning that Leonardo had many step-siblings.) In 1457, Leonardo's grandfather,

who was the head of the family, claimed the five-year-old Leonardo and Ser Piero as dependents on his tax return, a fact that has often been taken as an indication that the boy spent his childhood in Vinci. However, if we consider that Ser Piero, who lived in Florence, was listed as a dependent as well and that Leonardo developed close, lifelong relationships with the family of Ser Piero's first wife, it seems possible, even likely, that the boy grew up in his father's Florentine household.

At age six or seven, Leonardo began attending an independent grammar school, which was probably near his father's house, to learn how to read and write in the Italian vernacular.

After a year or two, he began to attend an abacus school that offered lessons in Italian. Had he been a legitimate son, he would have gone to a Latin abacus school, which prepared students for higher education. For instance, Filippo Brunelleschi, the architect of the Florence cathedral's famous dome and the son of another notary, had attended such a school a few decades earlier. But Leonardo was sent to an abacus school where teaching was conducted in the vernacular and the focus was on commercial mathematics: double-entry bookkeeping, the use of numerals of Indian and Middle Eastern origin, and algebra, all skills that merchants needed for their profession. At these schools, pupils read popular vernacular books such as *The Flowers of Virtue*, which argued for the rewards of virtue with tales about animals (Leonardo owned a copy of this book), and *The Golden Legend*, which contained fanciful stories about saints' lives that made these holy figures seem fully human. Students might also read some of the modern classics in the vernacular, such as Dante's *Comedy*, or some classical authors in handwritten translation, such as Ovid's *Letters* or Pliny's *Natural History*, a book Florentines read avidly as it recounted the stories of classical artists. Students also learned some basic Latin so that they could read contracts.

One wonders, though, how much authority Leonardo's abacus teacher—whoever he was—held over the young man.

Leonardo was left-handed, and like many left-handed people he found it easier to write from right to left, instead of left to right. This way of writing allowed him to avoid smearing the fresh ink he had just

applied to the page. He also wrote in reverse—that is to say, the words he set down were mirror images of the words one would expect to see, and could be read by others only if they were reflected in a mirror. The norm at the time was to force left-handed pupils to write with their right hand. Leonardo did learn how to write in normal script with his right hand, but throughout his life he disregarded his master's teachings and followed his natural inclinations instead: he wrote with his left hand, from right to left, and in reverse.

When Leonardo was between the ages of twelve and fifteen, he was not sent to a monastery or directed toward a religious career, which was the path often chosen for illegitimate children. For instance, Leon Battista Alberti, who was also illegitimate, was sent to a seminary, learned Latin and the classics, and eventually became one of the most elegant writers of the Renaissance. Instead, Leonardo was assigned an occupation that many would have regarded as disgraceful for the son of a family of notaries.

He was sent to train in an artist's studio.

Ser Piero had come to know the Florentine art scene well, as he routinely helped artists negotiate agreements with their patrons. In 1465, he had assisted Andrea del Verrocchio, an artist who stood out for his innovative work. Verrocchio loved music and good literature. He wrote verse, some of which is still preserved among his sketches. He was a superb draftsman and was also the first artist to smudge black chalk drawings with his fingers in order to create a smoky effect, a technique known as sfumato, which his most talented pupil would perfect in both drawing and painting. By the time Leonardo joined Verrocchio's bottega and lived with his master, as was the custom for apprentices at the time, Verrocchio was a brilliant artist on a distinctly upward trajectory.

What was so special about Andrea? What did Leonardo learn in his bottega that he could not have learned elsewhere?

On the face of it, Andrea was a typical craftsman of the neighborhood of Sant'Ambrogio. He lived in the family home together with his

sisters and their children, having never married. His workshop was nearby, possibly in the same building. He was deeply attached to his local parish, and included in his will a provision to be buried there (when he died in Venice, his body was transferred to Florence in accordance with his wishes). Near his house was the Osteria dei Pentolini, a favorite tavern of locals and foreigners alike that advertised itself with the resounding of empty pots hanging above the door (*pentolini* means "pots" in Italian). He mingled with fellow artists and kept his shop running with skill.

His bottega could easily have been mistaken for just another shop on a busy street filled with enterprises meeting the middle-class demand for luxury goods, portraits, and religious art. Most of these shops had a *mostra*, a short wall on the street to display the ready-made objects that were kept in stock for walk-in buyers. If Verrocchio's bottega had one, it would have displayed candlesticks in marble or bronze, armor, bells, banners for festivities, small devotional images, and glass frames, as these were among the many items that were made in his workshop. He offered art objects in every price range and worked in expensive marble, in cheaper terra-cotta, in bronze, in wax, and in paint, which was the cheapest medium of all. He even made illustrated, handwritten books based on popular novellas and other stories.

But in Andrea's bottega, any storefront activity would have belied the real excitement of what was going on deeper inside, where he taught the skills of the trade to a group of apprentices, many of whom went on to become some of the most important names in Renaissance art. In his workshop, he created custom works for specific patrons. These lucrative commissions came in every so often, mostly for paintings, less often for sculpture in bronze or marble. His customers included the Church, the powerful families of Florence, and the leaders of various towns and republics wanting to honor their heroes.

For the most part, Andrea trained his assistants just as any other Renaissance master trained his pupils. He took them in as boys, usually around the age of twelve. Although the modern view of Renaissance apprenticeships is that they were an opportunity to work closely with

the best of the best, the reality was that most apprenticeships were one step up from servitude, for the system was little more than a means of obtaining inexpensive labor. The norm was for a master to contract with the apprentice's family for a term of two or three years. The family paid the master a fee to train, feed, and lodge the apprentice.

No contract between Verrocchio and his assistants' families has survived, but a contract that the Florentine painter Neri di Bicci drafted with an apprentice's family in 1456 is typical of the time. The boy had to "come to the shop at all times and hours that I [the master] wish, day or night, and on holidays when necessary, to apply himself to working without any time off, and if he takes any time off, he is required to make it up." We can presume Ser Piero signed a similar contract with Andrea and paid him a fee to train his son. We can also presume that Andrea trained his pupils in a similar fashion, even though most did not rise above the tedious labor of making copies of his works, filling in elements of landscapes or coloring buildings, and chiseling details.

Verrocchio's apprentices did whatever menial work they were told to do. One day it could be helping out in the rooms where paintings were made, grinding pigments on porphyry slabs, mixing colors, or cleaning brushes. Large spatulas were used to lay base colors, medium brushes for figures and buildings, thin brushes for the finest details of faces and landscapes. Another day they might be called to work in the rooms dedicated to sculpture, a dirtier and nosier affair than painting; they became familiar with hammering tables, powdered gesso, wet terra-cotta, chisels, and hammers of various kinds—and, because Andrea was also a goldsmith and a bronze caster, they learned how to handle tools to solder sculptures, or feed small furnaces to bake terra-cotta and weld metals.

Andrea was what we would call today a "multimedia" artist. His range meant he had to pay dues to two confraternities, the Compagnia di San Luca for his work as a "painter and engraver [*pittore e intagliatore*]," and the guild of stonecutters and carpenters for his work as sculptor (*scultore*). But it also meant that Andrea could receive the highest praise to which a Renaissance artist could aspire. According to the

poet Ugolino Verino, who knew many Florentine artists well, Andrea is "no less than Phidias" and "surpasses the Greeks" because "he both casts and paints." In the Renaissance, artists from ancient Greece and Rome were considered superior to contemporary artists. There was simply no higher praise for a Renaissance artist than to be regarded as "no less than Phidias," one of the greatest of ancient sculptors.

But for Andrea—and for the pupils who trained with him—to work as a multimedia artist was not only a way to win acclaim or to meet the demands of buyers of different means. In the words of Giorgio Vasari, the sixteenth-century artist and author who wrote the first biography of Verrocchio, it was a way "to avoid growing weary of working always at the same thing." It was a way to keep one's art fresh.

Indeed, if there was a dominant trait of Andrea's artistic personality, it was his constant quest to make his works more expressive. He always looked for technical innovations that would allow him to achieve the best results. This was a lesson Leonardo would take to heart.

Andrea made something exceptional out of even the most common ready-made devotional images of the Virgin and Child, rendering the tender interactions between mother and son in exquisite detail. In some, the Child reached out for his mother's face like any toddler would. In others, he tried to touch her nose, or played with her veil, or stood precariously on her lap. Often, Andrea allowed a small detail—a foot, a drapery fold, a hand—to escape the space of the painted image, intrude on the frame, and invade, so to speak, the real space occupied by the viewers of his works. This was an effective way to give viewers the illusion that they were so close to these sacred figures that they could touch their hands and garments. Soft light enhanced their simple gestures and revealed on their faces some of the most delicate and nuanced smiles and expressions that could be found in a Renaissance work. Florentine women of means felt close to these models of motherly love and flocked to Andrea's bottega to buy them for their houses. These female figures with their indefinable soft smiles were among the distinctive features of his workshop, and became an important model for Leonardo.

Another hugely successful product of Andrea's bottega was death masks. Though it may seem odd to us today, these were coveted artifacts, and Andrea's were more coveted than others. One could find his death masks "in every house in Florence, over chimney-pieces, doors, windows and cornices," according to Vasari. For the Medici family alone, Andrea made twenty of these "masks made after nature [*maschere ritratte al naturale*]."

The practice of creating death masks was ancient, dating back to the Egyptians, who used it to preserve the features of their pharaohs. It spread to ancient Rome, where it was used to keep alive the memory of family members, as Pliny wrote in his *Natural History*, and it became increasingly common in medieval and Renaissance Europe, first for kings, popes, and emperors, and later for famous poets and philosophers. The Florentine artist and writer Cennino Cennini left detailed instructions for making them in wax in his *The Craftsman's Handbook*, the most popular art handbook of the period, and artists began using death masks as an aid in the making of portraits. The most famous portrait made after a death mask that any Florentine would have known was Brunelleschi's; it was a prominent part of his tomb inside the cathedral whose magnificent dome he had built to universal acclaim.

The secret of Andrea's death masks was a soft stone he had found in quarries near Siena and Volterra. It was ground into the finest powder, which, once it was mixed with water, proved even more malleable than wax; it adhered to the minutest crinkles of the human face so perfectly that the death masks that resulted looked "so natural that they appear alive," as Andrea's first biographer, Vasari, commented. And when it solidified, the mask was so lifelike that it could be reused as a model for portraits. A small tempera painting on paper representing Saint Jerome that is now in the Gallery of Palazzo Pitti in Florence was perhaps a portrait of a Florentine man made from one such mask: the wrinkles testify to the man's austere life, just as they testify to the saint's in the wilderness.

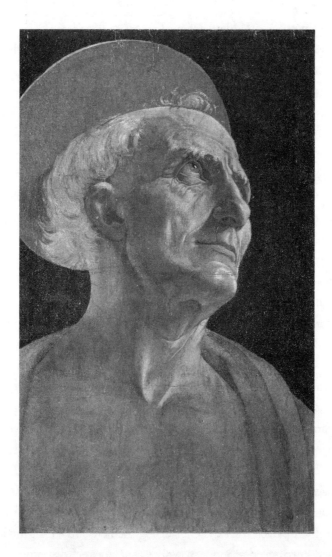

Early on, Leonardo came to learn the power of wrinkles to convey a sense of life's experiences.

Andrea's technical curiosity was not unusual in the Renaissance. The period is usually recalled for its rediscovery of ancient art and literature, but there was also a fascination with the revival of lost techniques of sculpting, building, and painting. Some artists rediscovered the use of linear perspective, a mathematically sophisticated way to

represent space on a flat surface. Others rediscovered the Roman way of laying bricks for buildings. Still others rediscovered the ancient method of casting large bronze statues. Andrea, for his part, developed new techniques based on old ones to capture the delicacies of facial expressions, resulting in death masks that were even more realistic in their inwardness than those made by the ancients.

Leonardo learned from his master's physiognomic investigations, but in due time he would turn those techniques inside out. Instead of using molds to capture the external appearance of faces, he looked at them from within. By way of dissections and drawings, he studied the bones, nerves, and muscles underneath the skin.

When Leonardo arrived at the workshop, Andrea was working on major commissions that had come his way thanks to the family that controlled the city. Florence was a republic, and the Signoria, the executive branch of the Florentine government, ruled the city from its palace. But the reality was that the Medici family had taken over the city—not just its politics and commerce, but also its cultural life, its art, and its symbols. Although they rarely held official positions, they stacked every elective office with their allies. The Medici palace—a square, three-story building constructed around a colonnaded courtyard—was the real seat of politics.

Unusually aware of the power of art to convey authority, the Medici filled their palace with ancient statues, medals, and coins, and commissioned cutting-edge modern works that masterfully supported their political agenda. For the most-public areas of the palace—the courtyard, the garden, the audience hall—they chose subjects with conspicuous political underpinnings. In the 1440s, they had commissioned the great Donatello, their favorite sculptor, to create a bronze statue of the most politically charged figure in Renaissance Florence: David, the king of Israel, who as a young boy slayed the giant Goliath with a sling in defense of his country. Donatello delivered a masterpiece, the first life-sized nude sculpture since ancient times. Now the Medici wanted

another *David*, and they turned to Andrea, who had become their favorite sculptor after Donatello's death.

A persistent rumor says that Andrea's *David* is a portrait of the young Leonardo, but this is just a myth. What is true is that Leonardo was employed in Andrea's workshop when his master created this statue, with its exceptional psychological charge.

It is hard to imagine that Andrea did not see this commission as *his* chance to assert his vision of art, contrasting it with Donatello's. Unfortunately, Andrea—and Donatello before him—did not write about their art, and we can only speculate about what they wanted to achieve by looking closely at their works. At first glance, Andrea's *David* looks a lot like Donatello's. Both artists represented the biblical hero as a slender boy of about thirteen years of age with an anatomically accurate body. Donatello's *David* is nude and has defined chest muscles. Andrea's wears a leather tunic that reveals the boy's bone structure and musculature underneath. Andrea rendered the body even more precisely than Donatello. An anatomically perfect leg emerges from a sturdy fold of the leather garment at the groin, while arm muscles and neck bones are expertly done.

What seems to set the two statues apart is how they handle David's gaze. A gaze is not as conspicuous a feature as muscles and bones, but sculptors had learned how to turn their figures' heads subtly to suggest the direction of their stare and, by extension, indicate something about their state of mind. Donatello's *David* looks toward the head of Goliath at his feet, the contour of his sturdy metal helmet pointing down and reinforcing the downward direction of his intent look. He is immersed in his thoughts, introspective and closed off, pondering the consequences of his actions, his body fixed frontally.

In stark contrast, Andrea's *David* stares straight ahead, his head turned to the side, his body slightly turned. He is eager to share with others news of his deed, engaging viewers with a subtle, triumphant smile that animates his beardless face. Verrocchio understood that a slight turn of the head meant also a slight torsion of limbs and muscles, and that those minimal changes in the positioning of the body make a

big difference in how people perceive a work of art. His *David* addresses viewers directly and draws them into his mood and thoughts, but viewers need to move around the statue if they want to "see" all the gestures and torsions of the boy's body.

Was this direct engagement with viewers something Andrea intended? Certainly, it was something Leonardo became obsessed with later on, when he wrote that painted figures "ought to move those who behold and admire them in the same way as the protagonist of the narrative is moved."

It seems that Andrea understood instinctively that the future of art lay not with those who simply learned how to draw the face and body in ways that would generate a strong emotional response, which Donatello knew how to do. What Andrea seemed to be striving for was a kind of emotionally charged art that would draw viewers more deeply into the inner world of his subjects or, as we would say today, into their psychology.

But, of course, he was not alone.

From the early fifteenth century, artists and scholars aspired to an art that elicited strong emotional responses, just as that of the ancients had done. They read about ancient artists in Pliny's *Natural History* and learned from Cicero what words could do to move people. But it was far from clear how to capture emotions and convey feelings with sculpture and painting. How do you identify and represent the emotional core of familiar narratives, stretch traditional techniques, and create figures of unprecedented expressive intensity? How do you reveal incredulity and belief, pride and conceit, vanity and contempt, fear and despair, with nothing more than pigments, metal, marble, or clay?

Verrocchio supplied an answer based on his close observation of nature. If the artist knew what to look for, he would begin to see that even the subtlest change of heart or mind involuntary triggered a change in the positioning of a person's body and face; this change, in turn, created a new set of expressions, gestures, positions, even garment folds. These variations were made visible through the unexpected shad-

ows they generated, darkening a garment previously shining in the light, or shading a part of the face that was lit earlier. Best of all was to spot the areas where light met shadow, where penumbras ("pen" meaning "almost" and "umbra" meaning "shadow") occurred, where there was often some light but not enough for clarity, creating a fuzzy effect. It was such changes from light to dark—penumbras—that Verrocchio wanted his pupils to study and to depict in order to communicate the inner lives of their figures.

Drapery may seem to us a minor artistic subject, but Renaissance artists who were inspired by ancient artists regarded it as foundational for their art. Verrocchio seems to have been more aware than others that a fold that did not fall in the right direction or a crest that did not catch the light in the right way compromised how figures communicated their feelings to viewers.

It is no coincidence that Leonardo's earliest works were studies of drapery. Later, Leonardo advised artists to make sure that "folds with dark shadows are not placed in the illuminated portions, and folds of excessive brightness are not to be made in the shaded portions." The point was to make sure that folds do not "seem to be a pile of drapery cast off by man" or "completely cram a figure," but rather to wrap people's bodies so that the folds show "the posture and motion of such figures" and avoid "the confusion of many folds." His suggestion to his peers was unequivocal: "as much as you can, imitate the Greeks and the Latins in the way in which the limbs are revealed when the wind presses the draperies over them." Was he recounting in his own words his master's teachings?

Indeed, garments were the real novelty in Verrocchio's *Christ and Saint Thomas*, a sculptural group Andrea was commissioned to make in January 1467, when Leonardo was in his bottega.

The work was for an outdoor niche at Orsanmichele, the grain market located midway between the cathedral and the Signoria palace, next to some of the greatest Renaissance sculptures. There was *Saint George*, a marble work by the young Donatello that had stunned the

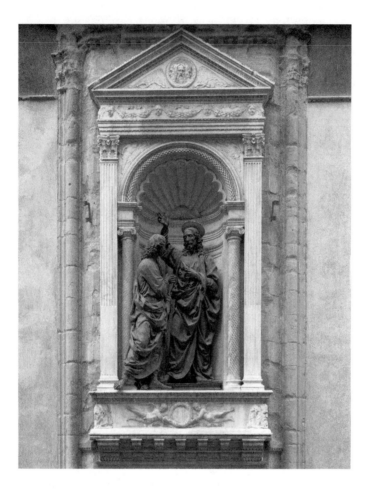

city for its boldness about fifty years earlier. Then there was the *Four Crowned Martyrs*, a large sculpture of four men whom the artist Nanni di Banco had arranged in a circle inside a niche as if they were orators debating with one another. And then there was the magnificent *Saint John the Evangelist*, the first life-sized sculpture in bronze to be made in the Renaissance; it was the work of Lorenzo Ghiberti, the artist who had "rediscovered" the bronze technique of the ancients. No place was more visible—and more intimidating—than Orsanmichele for a sculptor who wanted to measure up to the great.

It took Andrea 3,981 pounds of bronze and more than fifteen years

to complete his group sculpture, but considering what was at stake, it was not a lot of bronze, nor too long a period of time.

Young Leonardo was right there when his master transformed a traditional image into something completely original.

Instead of a lone statue of the saint, Verrocchio cast two statues, re-creating an encounter between Christ and Thomas that painters had represented often on flat panels but that sculptors had never rendered in the round. Although we do not know for sure, it is possible Andrea talked the patrons into accepting his conception, which required considerable technical inventiveness to stretch the amount of bronze that was allocated for one figure to fashion two, as well as a daring design in order to place two statues inside a niche that was meant for one. The result was "the most beautiful thing one could find and the finest head of the Savior that has ever been done," as a Florentine chronicler put it. Christ and Thomas are hollow statues with no back; they are "an immense relief in bronze," as Vincent Delieuvin, the chief curator of sixteenth-century Italian painting at the Musée du Louvre, aptly describes them. It was Andrea's ingenuity that created the illusion of full, rounded figures whereas in reality there is only a hollow relief. Christ is fully inside the niche, but Thomas actually stands entirely outside it, with his right foot suspended in midair. He does not touch Christ's wound. This was a departure from previous representations of the biblical story and from familiar accounts, including the very popular *The Golden Legend*, which reported that Thomas acknowledged Christ's resurrections "not only by sight, like the others, but by seeing and by touching." But the Bible made clear that seeing was enough: "because you have seen me, you have believed" were Christ's words to Thomas (John 20:29). Andrea understood the spiritual significance of the encounter more deeply than popular writers: the point was that Thomas did not need to touch in order to believe, for sight was superior to touch.

Their garments capture the mood of the encounter. Ample wavy folds around Christ's waist convey his serene calm, in contrast to the more jagged and fragmented folds of Thomas's tunic that suggest his

trembling. Andrea, it seems, was attracted not by the encounter per se but by Thomas's emotional turmoil—by the rapid change in his state of mind from doubting and incredulity to revelation and belief. It seems these more difficult-to-communicate aspects of art were precisely what drove Verrocchio, and what later fascinated Leonardo.

Andrea was apparently dissatisfied with the traditional method of copying drapery. When cloth was casually thrown on wood or wax mannequins, the fabric shifted position easily, the folds changed shape, and light created new penumbras. He could not focus on and observe each fold in depth, but instead had to start anew whenever anything changed. But if he impregnated the fabric with a concoction of clay or wax and arranged it over a terra-cotta or wax relief of a figure in the position he wished to represent—sitting, kneeling, or standing—the folds would set permanently. He could also place a large candle or a torch in such a way that the light would hit the fabric and create deep shadows in the folds and dramatically illuminate the crests. When the fabric was dry and the flame was lit, he could copy the drapery from different points of view with great attention to the minutest variations of light and shadow. His pupils could gather around him and do the same. Years later, Leonardo wrote that "to draw in company is much better than to do so on one's own" because an artist learns "from the drawings of those who do better than you" and because "a healthy envy will stimulate you to become one of those who are more praised than yourself."

Verrocchio taught his pupils to carefully observe each fold and to capture the effect of shifting light. He did not want them to worry whether the drapery was going to be for the figure of an angel, a saint, a Madonna, or a pagan goddess. He did not even care if there were heads, hands, or feet attached to these drapery studies. All he cared about was that they captured the right light at the right angle. Because he insisted that the folds look real—because he wanted to capture not just the light and the movement but also the texture of the fabric—he experimented with different materials. In some instances he even drew on linen instead of paper.

This is not to say that hands and feet were unimportant to Andrea—to the contrary. Like the face, they could also convey emotion. Andrea had his pupils study hands in the act of praying, blessing, pointing, and greeting, but he did not have them work from real hands. He used casts because he wanted to "have them before him and imitate them with greater convenience." One of those casts became the model for Christ's large hand, with its many vessels and wrinkles, in *Christ and Saint Thomas*. It was placed at the very center of the niche, directing the viewer's attention to Christ's chest wound.

Andrea instructed his pupils to use a unique stock of casts, drapery studies, death masks, and drawings. He was an extraordinary draftsman. The pupils learned to combine them freely to create male and female figures for biblical or pagan narratives in any medium. For an angel in a painting of the Annunciation, they would select the drapery for a kneeling figure and combine it with a head in profile and a hand in the act of giving. For the Virgin, they would choose the drapery for a sitting figure and combine it with a frontal face and with hands in the act of praying or even in the act of welcoming, depending on which aspect of the religious narrative they wished to stress. But if another commission came in—be it a painting or a sculpture—that required a sitting prophet or king, they would know how to adapt that same drapery study they had used for Mary to a male figure, and they would also know how to combine it with different hands, feet, and heads.

This is why the figures that came out of Andrea's bottega looked so expressive, intense, and emotionally charged. And this is also why the atmosphere of his bottega was so vibrant, so alive, that even established artists—among them Sandro Botticelli and Domenico Ghirlandaio, the future master of Michelangelo—often spent time there.

Andrea was a great master, and also a generous one. He shared his drawings and inventions even with his rivals. This is why figures striking identical poses or displaying the same drapery folds and even the same expressions appear in the works of so many different artists. As the poet Ugolino Verino put it around 1500, "Whatever painters have that is good, they drank from Verrocchio's spring."

In short, there was simply nowhere better for a teenage apprentice with talent and drive to be than the workshop of this Renaissance impresario. Leonardo saw his master at work, and would eventually become an impresario in his own right. Both master and pupil shared an affinity for technology and technical experimentation, and above all, they shared a deep interest in using art to communicate what people thought and felt.

Had young Leonardo not been so talented, he could easily have spent the rest of his days cleaning brushes, rising at best to the mind-numbing work of casting the religious figurines depicting the Mother and Child, or adding details to his master's paintings. But the boy could draw—could he ever draw.

In the Renaissance, drawing was regarded as *the* foundational artistic skill. No artist could advance if he was not skilled at it. Apprentices started by copying their master's drawings, then expanded their repertoire by copying other artists' works, and eventually began to produce original works, sketching simple inanimate objects like jars and vases before progressing to buildings and landscapes. Human figures came last. Years later, Leonardo himself advised young artists to work slowly and "not to pass on to the second stage until you already have the first committed to memory and well practised."

As an apprentice, Leonardo quickly learned to sharpen his already acute powers of observation. When he copied folds from a relief covered in wet cloth, the results were stunning; we can feel the effort young Leonardo put in, day in and day out, to capture the right light on a crest or the darkness in the recesses of a fold.

In some ways, though, Verrocchio was not the typical master. He did not train his apprentices as other masters did, in part due to his own surprising backstory. In 1452, Andrea killed a boy with a stone in the course of a fight outside the city walls. The death was an accident, and he was acquitted, but the incident set him back. He did not begin his own apprenticeship as a painter but rather as a metallurgist. He trained

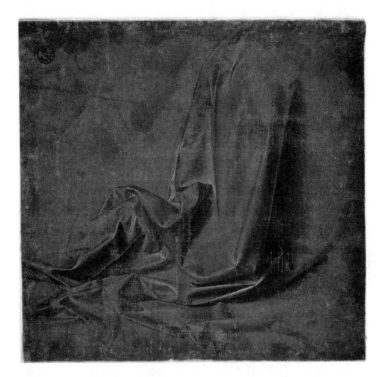

with a competent but minor goldsmith. We do not know exactly who his master was, but we know that Andrea was associated with masters who did not have what it took to make it in the ferociously competitive art market of Renaissance Florence. In 1457, just as Andrea, age seventeen, was expected to start to reap the rewards of his training and make a living with his art, one of the masters he was associated with went bankrupt. Andrea found himself out of work as a goldsmith. To make matters worse, around the same time, his father died, leaving him responsible for his stepmother, a younger brother, and two nieces.

In the middle of these hardships, Andrea retrained himself. He learned how to carve in marble, mold in terra-cotta, and cast in bronze. It is possible he learned sculpture from Donatello, who had returned to Florence from Padua in 1457. Or he might have trained with Vittorio Ghiberti, the son of Lorenzo Ghiberti and one of the finest bronze casters in Florence. He also learned how to paint, and his work displays

a deep affinity with that of Filippo Lippi, a friar who left his order to marry a nun and to paint (his son, Filippino Lippi, would become one of Leonardo's dearest friends). By the early 1460s, Andrea had opened his own shop and had turned his career around. He even started to take on apprentices, Leonardo among them.

There was one thing from his early training as a goldsmith that Andrea valued above all: the knowledge of how to produce the heat needed to melt and cast metal. He began to apply himself more and more to the sciences, and eventually turned his attention to light: how it disperses when it hits an object like the human face or body, how it refracts and reflects. The science of optics was becoming increasingly critical to his art, not just for what it could teach him about how to capture light, but also for how it could be harnessed as a tool. The importance of optics would be made dramatically evident in one of his most important commissions to date.

In the late summer of 1468, Verrocchio was asked to create a golden ball, or *palla*, that could be mounted above Brunelleschi's dome, atop Florence's cathedral. The ball was so large and heavy that it would need to be welded in situ, high above the city. In order to make these welds, Verrocchio would need to create a set of "burning mirrors"—concave mirrors that reflected the light of the sun and concentrated it at a single point. Leonardo, who witnessed the making of the palla while an apprentice and who saw a burning mirror at work, called this instrument "a concave sphere that makes fire."

Strangely, these burning mirrors are rarely mentioned in accounts of the cathedral's dome. Equally curious is the fact that they are largely absent from accounts of Leonardo's youth, though his own writings indicate the powerful influence they had on his thinking. If we are to connect Leonardo's revolutionary art to the science of light and shadow, we must start with his dramatic introduction to the science of optics at the pinnacle of Brunelleschi's dome.

///

Brunelleschi's Dome, Verrocchio's *Palla*, and Leonardo's Eye

The palla commission would keep Verrocchio's bottega busy for almost three years. It came from none other than the Operai dell'Opera del Duomo, the citizens in charge of the construction and adornment of the Florence cathedral. On the face of it, the commission was not too demanding. It did not involve creating statues displaying subtle body motions, expressive faces, or bold drapery folds, nor did it entail the creation of extravagant designs for luxury objects. All Andrea was asked to make was a large metal ball.

But the commission was not routine metallurgic work, either. The palla marked the end of a centuries-long construction process: the new cathedral had been designed around 1296 to replace a crumbling, undersized church that no longer met the needs of a growing population. After approximately one hundred years, the main body of the church was complete. In 1418, the architect Filippo Brunelleschi had won the competition to build a dome covering the area above the altar: it would be a majestic octagonal structure of redbrick and white marble ribs. He also designed efficient lifting machines to convey materials to where they were needed; as a result, the dome was completed in less than three decades, record speed for the time. Leon Battista Alberti, who observed the dome in 1435, right around the time it was finished, marveled at this "enormous construction towering above the skies, vast

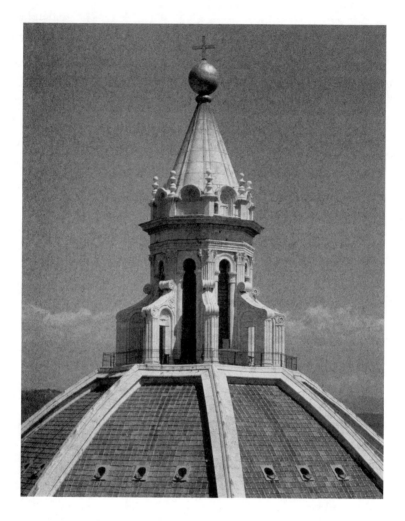

enough to cover the entire Tuscan population with its shadow." To this very day the dome defines the city's skyline.

Brunelleschi's design called for the dome's white ribs to converge on an elegant marble "lantern" at the top, which would be crowned by a golden globe surmounted by a cross. By 1461 the lantern had been completed: it was a slender structure with eight tall windows, each about thirty feet high, and massive buttresses with door-like openings that allowed for a continuous passageway around the base of the enormous lantern. This is the walk around the dome visitors still enjoy to-

day. All that remained to complete the cathedral was the golden ball. The Operai left in place the scaffolding and the lifting machine, the *castello*, so that it could be reused to lift the palla. They expected to make quick work of the job.

But six years passed and nothing happened. The situation was becoming increasingly absurd. The cathedral had been built, but it could not be declared finished because the palla was not installed. To add insult to injury, the beautiful lantern was still invisible, as it remained encased in the massive scaffolding of beams, stairways, and platforms that supported Brunelleschi's castello, the lifting machine the architect designed to build the lantern.

The failure to install the palla stemmed from the challenge of its size. The ball had to be seen from the street, at a height of over 350 feet, and against an open sky. It was known that the high elevation and the open backdrop would make the orb look smaller than it actually was; to counter this illusion, the palla would have to be enormous. The problem was that such a large ball was too big to pass through the lantern's narrow windows, which offered the only available passageway to reach the final location. This meant that either the palla had to be too small for proper viewing from below, or it had to be lifted in pieces and assembled on the lantern's terrace, where some sort of soldering device would have to be built. And since soldering with fire, at a height of 350 feet, on a terrace surrounded by wood scaffolding, was quite dangerous, the building of the palla would be no trivial affair.

Making matters more complex, the Operai wanted a golden palla that would mesmerize viewers as it glittered under the Tuscan sun. They knew it would be too costly to make it of actual gold, and settled for a ball manufactured from a different metal—which metal exactly was up for debate—that would be gilded using melted gold florins. The most effective gilding technique available at the time was mercury gilding, which was done by applying an amalgam of gold and mercury to a metal surface and heating it so that the mercury evaporated and left a thin coating of gold behind. The process involved the use of highly toxic substances (this is the reason it is hardly used today), and

often artists had to repeat it several times to achieve the desired coating. It also had to be applied to a finished object, and so the palla would have to be gilded atop the dome as well.

By 1468, all that the patrons had accomplished was to commission two craftsmen to make a bronze base on which the palla would rest. Unable to decide what to do next, they did what Florentines did whenever they faced challenging public works: they called for a public competition. Out of such competitions had emerged great works such as Brunelleschi's dome itself, as well as Lorenzo Ghiberti's set of doors for the Baptistery, the octagonal building facing the cathedral where Florentine children were baptized.

The Operai received two proposals. One came from the two craftsmen who had made the base. They proposed to cast the palla in bronze in a single piece, gild it, and attach it directly to the base. The other proposal came from Andrea del Verrocchio. Andrea planned to build a hollow palla to reduce its overall weight, supporting it with a sturdy internal armature that could be firmly anchored to the dome. He proposed to form the exterior of the palla from metal strips hammered into shape on a rock; the strips would then be soldered to one another with burning mirrors.

Andrea was probably the most talented bronze caster in Florence—possibly in all of Italy. More important, as Vasari reported, he excelled in "the sciences, particularly geometry." In fact, he came up with his design for the palla thanks to such expertise. One needed to know spherical geometry in order to cut the outer metal strips in triangles that would perfectly match one another and form a sphere. And one needed knowledge of optics to solder these metal parts with burning mirrors.

Andrea, however, was not awarded the contract for the palla.

The Operai ordered that "it should be made by casting [. . .] in a single piece" and that "under no circumstances should it be made by hammering." Their deliberation was an explicit rebuttal of Andrea's proposal. Instead, they contracted the craftsmen who had cast the base to fashion a palla out of a single piece.

These craftsmen set to work. By early August they had cast the ball

in an area near the cathedral that the Operai had reserved for them (we must remember that the streets around the cathedral were not paved at that time). They were ready to extract it from its mold. A group of dignitaries gathered to witness the moment. To this day, we do not know what happened, but we do know that something went so terribly wrong that the Operai went back to Verrocchio. A month later, Andrea was at work on his original plan, a hollow ball that would be four Florentine *braccia* (or about eight feet) in diameter, made of metal strips hammered into shape on a rock and soldered to one another. The plan required the full array of Verrocchio's inventiveness and technical expertise.

The first step was to find the right material.

Since the Middle Ages, artists had known that if you wanted to beat a metal to a fine edge without it cracking, the best option was unalloyed copper—copper that was not mixed with other metals. They also knew that this unalloyed copper was perfect for gilding, and that the gilding would be more durable if higher-quality copper was used. Cyprus and Germany produced the best copper, and Venice was the major commercial center for its distribution. Years earlier, Lorenzo Ghiberti had taken a trip to the city in search of proper copper for his *Gates of Paradise*. In June 1469, Andrea made the same trip for the very same reason. When he found copper of the quality he desired, he sent instructions to the Medici bank in Florence to transfer cash to their Venice branch to pay for eight sheets of this fine metal. He returned to Florence and waited for the copper shipments, which arrived in installments between July and October. In the meantime, he designed the specific tools he needed for the palla.

The first tool was rather simple, but it nonetheless required knowledge of spherical geometry if the palla was to be executed to perfection. It was an exact, one-to-one copy of the palla made of stone, which Verrocchio cut into two exact halves: one half was for the Operai, the other for him. He needed these two exact halves for two reasons. One reason was diplomatic. The construction of the Florence cathedral had been marred by bitter disputes between artists and patrons about un-

delivered work, unsuitable materials, poor building techniques, and even fraud. The best way to ensure that no issue arose with the palla was to provide each party with an identical "model" to assess the work. The Operai kept their half in their offices for centuries, and Andrea saved his own as well: twenty years later, when his workshop was inventoried after his death, it was still there. The other reason for dividing the sphere was of a technical nature. His design required hammering copper sheets into shape, and it was much easier to accomplish this by using a half sphere placed on its flat side than a sphere rolling around.

But what really required Andrea's technical virtuosity was another aspect of the palla. The eight copper sheets that he had so keenly purchased in Venice had to be cut into triangles and transformed into curved shapes by hammering. The difficulty was to calculate how exactly to cut these flat triangles so that they could eventually be joined together to form a perfect sphere. We do not know how Andrea proceeded, but spherical geometry would have allowed him to create a precise diagram.

Invented by the Greeks, transmitted to the Islamic world, and from there to the Latin West, spherical geometry was concerned with non-Euclidean spaces—that is, spaces that do not have straight and parallel lines but only curved ones. Traditionally, it was the domain of natural philosophers and astronomers, but in the Renaissance, merchants and sailors had become interested in it because it could help them calculate the routes of long-distance voyages around the globe and estimate the time required. Abacus schools had registered this new interest and added spherical geometry to their curricula. Andrea might have picked up some spherical geometry in such a school. But perhaps he also had the chance to discuss spherical geometry with an expert who was one of the most prominent figures of Renaissance Florence and whose name appears in Leonardo's notes: Paolo dal Pozzo Toscanelli (1397–1482). While Andrea was working on the palla, Toscanelli was building an astronomical instrument inside the Florence cathedral.

Toscanelli was a doctor, an astronomer, and a member of a mer-

chant family. His reputation in spherical geometry was such that he was called on to mediate disputes between the two most famous astronomers of the Renaissance, Johannes Regiomontanus and Nicolas of Cusa, who quarreled bitterly over whether it was possible to transform a circle into a square with the same area, using only simple geometry. (Years later, Leonardo himself became interested in this topic and claimed that he had found a way to solve it; he was wrong, however, and we know today that a circle cannot be squared—indeed, "to square a circle" has become an idiomatic expression for something that is impossible.) Today, Toscanelli is most famous for a map, now lost, that he made in order to demonstrate that the ocean that supposedly lay between Europe and Asia (what would later be called the Atlantic) was considerably smaller than previously believed. Ships, he argued, could sail across this smaller ocean to reach the Indies. In 1474, he wrote a letter to a Portuguese cardinal explaining his hypothesis. Eighteen years later, Christopher Columbus studied the letter and the map before his trip to China, a land he never reached as another continent stood in between.

In the early 1470s, however, Toscanelli was best known for his study of optics and for the astronomical instrument he was designing. The instrument used the Florence cathedral itself as one of its components: when sunlight passed through a hole pierced in the lantern, a beam of light was projected onto the cathedral's floor, where a mosaic, now lost, could be used to track its movement. The instrument was a "meridian line," and it was intended to measure how much time it takes the sun to return to the same position in the sky—for instance, the time it takes to move from vernal equinox to vernal equinox, or from summer solstice to summer solstice.

Did Verrocchio and Toscanelli talk about spherical geometry when they met on the lantern's terrace, or when they shared Brunelleschi's castello to lift objects they made? We do not know. What we know is that Leonardo recorded Toscanelli's name in one of his early folios connected to the palla and even owned some of Toscanelli's notes in Toscanelli's own hand. Those notes, interestingly enough, dealt with burning mirrors, the tools that were used to assemble the palla.

However Andrea learned spherical geometry, he was a quick study. In less than a year—eleven months to be precise—he built the palla. He cut the copper sheets into triangles. His assistants hammered the copper triangles with wooden mallets over the stone ball and helped lift the pieces from the church's floor to the platform, where the soldering took place.

As a goldsmith, Andrea was familiar with the soldering tools that were commonly used to assemble sculptures in metal or to make mechanical parts—roundels, screws, pulleys. Considering his bottega's large output of metal works, he must have owned a few soldering tools, although none were recorded in the inventories of his workshop.

But we do know that Andrea soldered the palla with burning mirrors. And we know this because Leonardo, who was an apprentice in the workshop at the time of the palla construction, wrote about it forty years later.

By then, Leonardo was in his early sixties and a famous artist. He had lost the beauty of his youth but still had an impressive presence; he resembled an ancient philosopher. He was living in Rome, where he designed weapons for the papal army. Legend has it that the Greek mathematician and inventor Archimedes of Syracuse had used a burning mirror to set the Roman fleet on fire at Syracuse in 212 B.C.E. Leonardo filled a small notebook with calculations, mathematical formulas, and notes on the workings of this theoretical weapon. He planned to create a military-grade burning mirror of his own.

In the midst of this frantic work, he jotted a side note on the margin of the page sitting in front of him—folio eighty-four of the notebook he was compiling, which is known today as Manuscript G. He wrote:

> Remember the welds that were used to solder the palla of Santa Maria del Fiore. [Make them] of copper hammered over stone as for the triangles of that palla.

The note may seem like a casual recollection of technical details, one of those mental detours the artist took when his mind wandered

away from the matter at hand and toward original machines, old phil-
osophical problems, new paintings. But this was much more than
that—it was a memory from his youth, a rare peek into his formative
years, a glimpse of things that mattered to him when he was an appren-
tice in Andrea's workshop. Leonardo did not specify what role he
played in making the palla, nor how his master designed the burning
mirrors. But the event stuck with him.

In principle, burning mirrors function like any mirror: beams of
light that hit their surface are reflected back. But because the surface
of burning mirrors is concave, the basic optical rule of reflection ac-
quires an added level of complexity: many of the reflected rays that
bounce off the surface do not disperse in the air, as they do in a flat
mirror, but instead hit other points of the concave surface, generating
additional reflected rays that go off in different directions, which in
turn create more reflected rays. Burning mirrors are a special subset of
concave mirror: their curvature is designed in such a way that rays that
reflect off their surface do not disperse in random directions but rather
converge on a single point—the focal point—and so produce intense
heat when the source of light is the sun. To use a modern geometrical
term, burning mirrors are parabolic mirrors.

We do not know how, exactly, Andrea made his burning mirror for
the palla. We do not even know what material he used—metal or glass?
We can speculate that the burning mirror was larger than those he
used normally in his workshop because of the palla's size. It would also
have to be very accurate. Where, then, would Andrea have acquired the
knowledge needed to construct it?

This is not an easy question to answer. When optical manuals were
first composed in ancient times, burning mirrors were not discussed.
Because burning mirrors create heat, earlier authors placed them in a
separate category from the science of vision. This distinction held for
centuries until the professor Biagio Pelacani da Parma (1365–1416)
arrived on the scene. His book on optics, *Questions on Perspective* (*Ques-
tiones* [*sic*] *super perspectiva communi*), was based on his university lec-
tures and was written in Latin. It was also generously illustrated. But

the peculiarity of Pelacani's book was that it linked university teaching with the work of craftsmen and artists as the author discussed various topics, including burning mirrors and "apparitions," as he called them, or visual illusions, which he claimed to have experienced personally. Like burning mirrors, these apparitions were the result of the geometry of concave mirrors: they were images of earthly things reflected into the air by clouds that acted like gigantic reflectors. Pelacani's book and his ideas about applied optics enjoyed considerable success in the following decades, especially in Florence, where copies of his book from the years 1428, 1445, and 1469 survive. It is doubtful that people like Andrea del Verrocchio would have been able to master Pelacani's Latin. But they may have found certain vernacular books that had been modeled after Pelacani's book and that made its contents more approachable.

The most important of these vernacular books is now kept in Florence, its author unknown.

The text was a simplified version of Pelacani's *Questions*. It was beautifully illustrated. It was addressed to an artist in training and explained the science behind many objects produced in Florentine workshops: reading glasses, gigantic lanterns, fancy optical devices

meant as entertainment for dinner parties, and of course burning mirrors, which the author recommended be built in metal. The text also stressed the importance of the air as the medium within which vision occurs—and the medium responsible for many optical illusions. In fact, it offered the example of how towers, partly obscured behind a wall, appear to be farther away than they actually are because of the medium of air—an example Leonardo would later use himself.

We do not know whether Andrea saw this text, or one similar to it, but it is significant that advanced spherical geometry and the optics of burning mirrors could be studied in vernacular texts in Florence during the years of the palla operation. If any of these vernacular texts circulated in Andrea's workshop, chances are that Leonardo got a glimpse of them as well.

Leonardo, too, was fascinated by burning mirrors, and learned "how to make a concave sphere [*spera in cavo*] that makes fires."

Among his early folios are notes and sketches that refer to the workshops of glassmakers who manufactured burning mirrors from glass. These workshops were in the hills around Florence. Their furnaces could be dangerous, reaching temperatures of over one thousand degrees and emitting highly toxic fumes. Florentine law forbade such furnaces from being built within the city's walls.

One particular folio of about ten by eight inches leaves little doubt that Leonardo had direct knowledge of every stage in the manufacture of burning mirrors made of glass. This folio is carefully executed, each drawing beautifully spaced on the page and combined with carefully worded notes. It looks like a reworked draft of his field notes, and serves as a one-page manual on "how to make a concave sphere that makes fire." Leonardo may have written it either as a sort of personal *pro memoria* or as a means of teaching others.

This folio contains numerous sketches. There is a furnace, which he represented from different points of view to make visible its structural components. In a plan view, he visualized the large foundations required to feed a fire that would be intense enough to melt glass. In side views, he showed the cooling system made of buckets of water on a belt and of canals for the passage of air. In a small sketch, he illustrated the furnace in full operation with a burning mirror baking inside. In other sketches, he showed polishing machines used to smooth the mirror's surface. This is how he described the process of coating the supportive backing of a mirror with glass:

> This concave mirror should be made of earth-ware, then it should be baked and returned to the above machine [a polishing machine]; it should then be covered with a glass paste and put in the furnace upside down above ashes.

There is also a diagram with technical instructions for how to design the curvature of a polishing stone. The note reads like a primer on Euclidian geometry, except for a charming aside about Florentine bakeries and their breads:

If you wish to make a concave sphere that makes fires when it is turned toward sunrays [. . .] draw first a pyramid like the one represented here [. . .] And know that the pyramid should be round at its apex, like that of a sugar bread.

Such comparisons between high science and everyday life were also typical of abacus books, which often mixed references to daily routines into their calculations to make it easier for schoolchildren to retain mathematical rules for transactions and measurements. It became a lifelong habit of Leonardo's to make such comparisons in his own writing.

By the summer of 1470, Andrea and his assistants were done with the soldering.

They moved on to gilding, the final stage of creating the palla.

In August, Andrea received a large number of gold florins from the Operai, who also sent a representative to monitor the gold's proper use. Under close supervision, Andrea ground the gold, mixed it with mercury, made an amalgam of the two metals, and applied it to the globe. At least three goldsmiths helped him. We do not know how he evaporated the mercury high atop the dome or how he addressed the problem of toxicity. But the gilding was completed successfully and the coated surface rubbed to perfect smoothness.

The result was impressive.

In less than five months, Andrea had transformed a copper assemblage of soldered triangles into a majestic golden ball.

On Monday, May 27, 1471, Andrea oversaw the placement of the palla, with his assistants on hand to help with the maneuver. Some attached the ball to the castello, others pulled the rope, and another group guided the hoist's revolving arm as it moved the ball from the construction platform to the top of the lantern. Three days later, the same operation was repeated for the cross on top of the globe. On that day, Thursday, May 30, 1471, the cathedral was officially finished.

To mark this important event in the history of the city, "the canons [of the cathedral] and many other people went up [atop the dome], and sang the *Te Deum* there." Workers were treated to bread and wine. Grateful Florentines paraded through the city, and the palla came to be seen as one of Andrea's greatest accomplishments. It even became part of his name. In official documents from 1471 onward, he was no longer called Andrea di Michele di Cione or Andrea del Verrocchio.

He was Andrea della Palla.

Unlike his master, Leonardo did not become "Leonardo della Palla," but the experience was even more transformative for him than it was for his master. At the very least, he looked over his master's shoulder and possibly helped hoist the palla atop the dome. An early biographer noted that Leonardo "was most skillful in lifting weight," which is an odd remark to find in the biography of a genius.

But the notes the sixty-year-old Leonardo made for himself show that he was fascinated with burning mirrors, and perhaps he did start to sketch them around 1470, even though the first notes we have date from seven to nine years later. With each passing year he acquired a deeper and deeper respect for what he later called "the science of art." Twenty years later, when he began making plans for what he intended to be a major book on painting, he talked clearly about the difference between guessing at how to solve an artistic problem and following rules of science in order to reach the same result every time. "Those who are in love with practice without science [*scientia*]," he wrote toward the end of his life, "are like the sailor who boards a ship without rudder and compass, who is never certain where he is going."

Leonardo's sketches and notes from the years following the triumph of the palla testify to his interest in uniting science and art. While scholars have largely dismissed these notes as primitive relative to his later scientific writings, they are suggestive of the preoccupations of the fledgling artist, and his interest in educating himself.

In a folio on polishing machines for burning mirrors, for instance, he mentioned "chained books [*libri incatenati*]," which can only be a reference to the books in one of the few public libraries in Florence, which were chained to their desks to prevent theft. In another folio, he sketched Brunelleschi's castello.

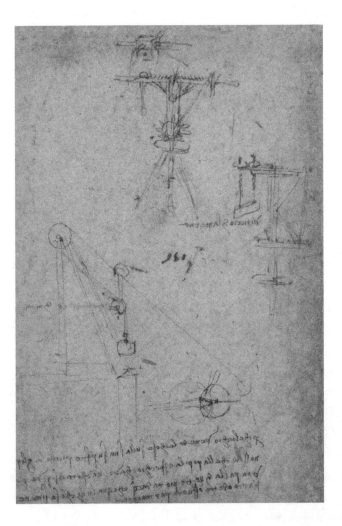

He made blown-up sketches of the mechanical parts Brunelleschi had designed in order to transform a hoist into a more efficient and versatile machine. He was especially interested in the *viticcio di lanterna*, as he called Brunelleschi's screw. This was another of Brunelles-

chi's fine inventions: a simple screw (*vite*) that made it possible to raise the castello as the construction of the lantern progressed upward. Leonardo understood clearly how Brunelleschi's staggering achievements often owed themselves to the design of small technical components.

This early folio is revelatory for another reason. Right below Brunelleschi's viticcio di lanterna, Leonardo attempted a crude picture of an eye, a first effort that has gone completely unnoticed until now. He drew the eye using black ink, and the ink has faded to a pale brown such that it is hard to see today. But the writing below it is still legible. It includes questions such as "Why does the eye perceive big things that reach its surface [*superfice*] as small?" And phrases such as "the pupil is a convex mirror [*popilla é specchio cavo*]," and what looks like "a glass ball filled of water [*palla di vetro piena d'acqua*]." The passage is short and convoluted, but those key phrases point directly to some of the most complex theories about the anatomy of the eye, which many authors discussed in the opening chapters of their books on optics.

In another folio about a polishing machine, he twice mentioned "Giovanni d'Amerigo Benci and company [*Giovanni d'Americho Benci et chompare*]." Giovanni d'Amerigo Benci was a member of a wealthy Florentine family, a patron of the arts, and the owner of a library of books on philosophy and science. His family palace was just a few blocks from Andrea's workshop. In the mid-1470s, Leonardo painted a portrait of his sister Ginevra. Did he also talk science with Giovanni?

In yet another folio, this one pertaining to water clocks, Leonardo jotted down a list of people who perhaps defined the contours of his intellectual world: a painter, an architect, an astronomer, a physician, a notary, an abacus teacher, and a humanist. On the list appears the name of Paolo dal Pozzo Toscanelli. Toscanelli was fifty-five years older than Leonardo, but the two had many interests in common. Among Leonardo's papers are notes in Toscanelli's handwriting on burning mirrors, which were copies of notes by the famous German astronomer Regiomontanus, who worked for the pope in Rome, and

who in turn had taken them from the eleventh-century Arab philosopher, Ibn al-Haytham.

On that same list appears the name of a Greek scholar, John Argyropoulos, who lectured on Aristotelian philosophy in Florence until 1471 and who translated, at the request of Cosimo de' Medici, Aristotle's *Physics* (*Physica*) and *On the Heavens* (*De coelo et mundo*), two fundamental texts on optics, reflectivity, and the atmosphere. Argyropoulos also translated Aristotle's *On the Soul* (*De anima*). It discussed how the immaterial soul exists only within a physical body, and was used as a university textbook in the Renaissance.

But the most revealing indication of Leonardo's early interest in optics can be found on the back of two beautiful drawings representing Saint Sebastian that have been dated to the years 1478–80: one has been in a German museum for decades, but the other has surfaced only recently. He sketched shadow drawings, the oldest that survive, and jotted down some notes.

Unfortunately, these notes are truncated. In one drawing he started to write "That part of the" but breaks off the sentence. He started again in the other drawing: "That part of the [. . .] will be more [. . .] that by larger luminous angle," and left the sentence incomplete again. Those are early drafts, but they are consequential ones. The aim of these shadow drawings is clear: to understand the science behind

penumbras. Carmen Bambach argues that these sketchy notes are "drafts for passages that the artist would later rewrite for cleaner redactions." When, about a decade later, Leonardo returned to these shadow drawings in another folio, he refined the notes and wrote in full sentences, although in convoluted prose (he never mastered the beauty of written language): "the wall will be darker or more luminous [depending on whether it] will be darkened or illuminated by light [rays] or shadow [rays] that have a larger [or smaller] angle [of reflection]."

He also added a full geometrical demonstration that was missing in the early sketch, although it is certainly possible that the intricacy of that geometrical demonstration was known to him from his early training and it simply did not survive among his papers.

All of these clues make it highly plausible that at some point in his early training Leonardo read books that were seminal works on the science of optics. We know copies of these books were in the city's public libraries as well as in the private libraries of wealthy Florentines whom Leonardo befriended. Among his many other talents, the young Leonardo was genuinely sociable. At this point he showed no trace of the mercurial temperament he later developed.

What Leonardo must have taken from these books would prove highly consequential for his art, and perhaps the most consequential of all was the *Book of Optics*, written by the Arab philosopher Ibn al-Haytham.

3

//

Body and Soul

Why is it important to establish that Leonardo read optical manuals early in his life? And why is it important that he read this specific tract written in Arabic by an eleventh-century philosopher? Because the author of this book, Abu Ali al-Hasan Ibn al-Haytham (about 965–1041), conceived of sensory experience differently from other optical writers—and that conception, it seems likely, was fundamental to Leonardo's art from the very beginning. This celebrated philosopher was known in Leonardo's time as "Alhacen" (or Alhazen), a Latinized form of his given name al-Hasan. In his *Book of Optics* (*Kitab al-Manazir*), he argued that sensory experience was the foundation of our knowledge of the world. More important, he provided experience-based examples of optical illusions related to the air that light must travel through to reach an observer. No other optical writer explored the subject in such detail.

But let's start from the beginning.

Why optics? And why Alhacen?

As odd as it may seem to us today, optics was a hot topic in the Renaissance. It was considered a science that stood between natural philosophy and physics and was taught in most European universities, together with astronomy, as part of the medical curriculum. In fact, thanks to optics, astronomers learned how to analyze the shadows

celestial bodies cast on one another and to use those shadows to better calculate their orbits and shapes; as Leonardo himself wrote, "the science of astronomy [. . .] is merely optics [prospettiva] since it consists of visual lines and intersected pyramids." Astronomy was also seen as essential to the practice of medicine: doctors consulted the stars to diagnose illnesses, and it was believed that cures were most effective when the stars were favorably aligned. This was the reason Renaissance doctors like Toscanelli and Marsilio Ficino were often authors of optical books.

For preachers, optics provided a way to talk about the divine. As Antoninus, archbishop of Florence from 1446 to 1459, wrote in one of his sermons, "The light of grace pervades the world according to optical principles." As we have seen, merchants were keen readers of optical manuals, as this science taught them how to measure distances indirectly through the position of stars and planets in the sky and to find new trade routes.

Craftsmen used optics to make eyeglasses and mirrors. Architects who followed the approach of the Roman architect Vitruvius, whose architectural manual was the only book on any art that survived from antiquity, found it helpful to solve "difficult questions involving symmetry" and to find "light in buildings," by which Vitruvius meant orienting buildings to maximize sunlight. Painters learned the basic rules of optics in order to represent three-dimensional objects on a flat surface—rules that by the second half of the fifteenth century had been codified into simple workshop procedures.

Like his fellow citizens, Leonardo learned about the most basic applications of optics by simply carrying on with his life. Whether by mingling with patrons and fellow artists, strolling past Florence's cathedral, or going to Mass, chances are he heard conversations about light, vision, mirrors, reflections, the length of the solar year, and the size of the ocean: these were all topics that were discussed in the Florence of his day.

He may have also read about optics in popular vernacular books that were taught in abacus schools. Cecco d'Ascoli's *The Bitter Age* in-

cluded cursory discussions on the propagation of light and its reflection in mirrors. Dante's *Comedy* offered a learned discussion on light. He might well have read *The Composition of the World*, a cosmology book written by a thirteenth-century scholar named Ristoro d'Arezzo, who, like Leonardo, was proficient in "drawing things of the world [*le cose del mondo*]"—although by Ristoro's own admission nothing delighted him more than "the science of the stars." Leonardo might have borrowed this rarer text from one of his acquaintances, perhaps from Toscanelli, or from Antonio Manetti, who was an influential "master of optics [*maestro di prospettiva*]" in Florence in the 1470s. He could even have potentially borrowed it from the Benci brothers, who were distant relatives of his friend Giovanni d'Amerigo Benci and active in Neoplatonic circles, the groups that defined elite culture in late fifteenth-century Florence. And, of course, he had been exposed to the optics of burning mirrors in Verrocchio's bottega.

But, since antiquity, optics had been much more than a set of rules by which to make eyeglasses, cure maladies, orient buildings, find new trade routes, and study astronomy. Optics, in its most refined formulation, was natural philosophy *tout court*.

When it was invented in antiquity, optics was the science that explained how vision works: the English word "optics" is derived from the Greek verb *opteuo*, which means "to see," and from the noun *ops*, which means "eye." But explaining how vision works entailed understanding how the soul—*psyche* in Greek and *anima* in Latin—processes information gathered by the eye. This, in turn, meant wrestling with one of the fundamental questions of natural philosophy: How do we know the world?

Aristotle had discussed sensory experience as the basis of our knowledge of the world in his book *On the Soul* (*De anima*), a text widely read in the Renaissance, and had regarded sight as "the most highly developed sense." He was unequivocal in stating that "sight can never be in error" but that our judgment "may be mistaken"—as, for

instance, when we perceive something white in front of us, but our judgment of what this white thing is "may be false." Optics, for Aristotle and later philosophers, was a philosophical investigation of the soul and, more specifically, the study of the role of visual experience in the acquisition of knowledge.

Michele Savonarola, a scholar from Padua and the father of the famous preacher Girolamo Savonarola, understood this: he wrote in 1445 that "the optics [*perspectiva*] of artist, which deals with the projection of rays," is in fact "part of philosophy." Decades later, Leonardo would share this view: "without optics [prospettiva] nothing can be done well in painting," he wrote in a note he meant to include in the book on painting he planned to write.

Gentlemen of the time—of which Leonardo was not one—read the canonical textbooks written by three clergymen in the thirteenth century: Roger Bacon's *Perspectiva* (c. 1265), Witelo's *Perspectiva* (c. 1275), and John Pecham's *Perspectiva communis* (c. 1280). These authors were priests—Bacon and Pecham were Franciscans—and they wrote their optical books while residing at the papal court, which was then in the small town of Viterbo, about fifty miles from Rome. The court had become a center for the study of human anatomy. Their books were written in Latin for university students, not artists, and they were modeled on Alhacen's *Book of Optics*, which had been written in Arabic, a language that was widely read and spoken around the Mediterranean in the Middle Ages. The *Book of Optics* was nonetheless translated into Latin sometime in the first half of the thirteenth century—most likely in Andalusia, where Arab and Latin scholars routinely worked side by side. The title of the Latin translation—*De aspectibus* (*On Visual Appearances*)—acknowledged the fundamental role optical illusions played in Alhacen's philosophical system.

Young Leonardo knew little Latin, although he was a sophisticated visual thinker and may have learned quite a bit from the illustrations and diagrams of these high-end optical books. He could have accessed them in Florence either through an acquaintance or a patron, or in the

library of San Marco, one of the very few public libraries in Europe at the time.

The library had been established by the Medici, and it contained over four hundred books ranging from various editions of and commentaries on the Holy Scriptures to an enviable corpus of volumes by ancient authors on philosophy, astronomy, mathematics, optics, geometry, history, poetry, literature, and even profane topics. Cosimo de' Medici had created this remarkable library from the books he had acquired wholesale from an inspired but financially inept Florentine bookseller, who had spent his life gathering texts by ancient authors and copying them for collectors across Europe, but who had also accumulated a staggering debt of over six thousand florins. Cosimo paid the debt and got the books in exchange, but instead of keeping them for himself he donated them to the Dominican monastery of San Marco, a religious institution near his palace that he supported. He even kept a personal cell there, as he liked to break his banking routine and move to the convent for a few days to meditate with the monks. The books themselves were kept in a church-like space commissioned from his favorite architect, Michelozzo.

Sixty-four wooden benches were lined up in a beautiful hall with a vaulted ceiling and slender columns. Tall windows maximized the availability of sunlight for reading. The books were stored flat on the benches' built-in shelves—religious books in the benches on the east side, philosophy and science books in the benches on the west side. A metal chain attached each book to its bench. The chain was long enough for readers to position the book comfortably on the desk, but the books could not be borrowed. Theft was a real issue.

These chained books (*libri incatenati*) made an impression on Leonardo, who mentioned them in his notes on burning mirrors. In the library of San Marco, in his twenties, he read an illustrated work on shadows and later jotted down a note to remind himself to copy some of the drawings: "reserve until the end of my book on shadows the figures which could be seen on the writing desk of Gherardo the illuminator at

San Marco in Florence." The "illuminator" was the painter Gherardo di Giovanni di Miniato, who lived as a lay brother in the convent, but the work on shadows that Leonardo saw on his desk cannot be identified, although the historian of science Dominique Raynaud has suggested recently that it was a "Latin optical source, apparently a scholastic disputation, contained in three books of numbered propositions, from the late fourteenth-century Paris school." We do not know if Leonardo read any of the optical books that were stored in a bench marked with the Roman numeral XIX on the west side of the library of San Marco. But we do know that he searched for the book by "Roger Bacon in print" and another by "Witelo in San Marco" in his early fifties and read Pecham's book in his forties. Those were the three canonical books on optics.

But these books were all written in Latin, and Alhacen's book was the only major optical book available in Italian.

It had been translated in the fourteenth century with the title *De li aspetti.*

One copy of this Italian translation—or at the very least a large portion of it—was in the hands of an artist who lived near Verrocchio's workshop and who was in contact with Leonardo. In addition to being

written in a language artists could read, Alhacen's book dealt extensively with visual illusions (Alhacen called them *deceptiones visus*) that were potentially of great interest to artists but that his medieval followers—Bacon, Witelo, and Pecham—had dealt with more cursorily in their books.

Alhacen was the philosopher who had redefined the field of optics, the *auctor perspectivae*, as Pecham called him reverentially. But he was just one of many Arab scholars whose work flourished in Spain, northern Africa, Iran, and Persia in the years between 800 and 1258. These scholars translated into Arabic works from ancient Greek and Roman authors as well as from authors who had lived in regions of the Islamic empire, which in its largest area extended from Spain and northern Africa to the Arabian peninsula, Iraq, and Persia. Books on astronomy, geography, medicine, physics, anatomy, philosophy, and mathematics that had originally been written in Greek, Latin, Sanskrit, Assyrian, and Persian were made available in Arabic and, through these translations, were preserved for posterity. In the course of the centuries, those Arabic translations made their way to the Latin West, where they were retranslated, first into Latin and later into vernacular languages, contributing to the advancement of modern philosophy and science.

A native of the city of Basra on the Persian Gulf, in modern-day Iraq, Alhacen moved to the al-Azhar Mosque in Cairo sometime after 1021 to devote his life to learning. He was one of the first philosophers to stress the importance of experiments and mathematical demonstrations to confirm hypotheses. Some regard him as the initiator of experimental science, and while this may be an exaggeration, there is no question that, as the historian of science and Alhacen expert A. Mark Smith puts it, "he took an overwhelmingly empirical, or inductive, tack in analyzing light and vision." Alhacen was an extraordinarily prolific author, and over 180 texts are credited to him, most of which are now lost. He made his name with the *Book of Optics*, the highly learned, seven-volume tract about direct, reflected, and refracted light that he wrote between the years 1028 and 1036.

The novelty of Alhacen's book was that it presented the mechanics

of vision—literally how the eye works—alongside a philosophical study of the soul and its ability to "process" visual data, while also offering a geometrical explanation of optical phenomena. It combined for the first time in one single philosophical system different strands of optical research that had been separated in previous centuries: anatomy, natural philosophy, and geometry. After Alhacen, one no longer needed to read what Aristotle, Euclid, Ptolemy, and Galen each had to say about optics. Alhacen brought their views into a single understanding of the visual world. One could go directly to Alhacen's *Book of Optics* and find there a philosophical system that combined Galen's anatomy of the eye, Aristotle's philosophical study of sensory experience and the soul, and Euclid's and Ptolemy's geometry, all illustrated by a plethora of examples and diagrams. The book was not "a mere agglomeration of past ideas" but rather "a synthesis" that, according to Smith's assessment, incorporated ideas of the past "into a seamless whole."

Alhacen began his book with the anatomy of the eye, which he based almost entirely on the work of Galen of Pergamum, the second-century c.e. Greek physician who had written the most important book on human anatomy. From Galen he lifted two fundamental notions: that the soul resides in the brain and not in the heart, as Aristotle had believed; and that the eyes and the soul are physically connected by optical nerves. His medieval followers adopted the same view, and centuries later Leonardo set for himself the task of fixing the exact location of the soul in the brain. For Alhacen and other philosophers, it was enough to simply talk about the soul, but for Leonardo such knowledge had to be visualized and mapped with cartographic precision—which is what he did by way of stunning drawings of the human skull.

Building on Galen's anatomy of the eye, Alhacen reasoned that visual data that travel along optical nerves are more reliable than sensory data coming from other senses—smell, touch, taste, and hearing—because they had to travel the shortest distance inside the body to get to the soul. This meant that sight was the prince of the senses—a notion Leonardo would adopt for the book on painting he planned to write.

The eye never errs: this was the central tenet of Alhacen's philosophical system—and one of Leonardo's foundational beliefs when he wrote that "experience does not err, but rather your judgements err when they hope to exact effects that are not within her power."

In truth, Aristotle had briefly mentioned the infallibility of the eye, and Galen had explained its anatomy, but legions of other philosophers, inspired by Plato, challenged this notion as they considered visual experience to be false, deceptive, and unreliable. No philosopher had previously built an entire philosophical system on the notion that the eye never errs.

It never errs, Alhacen reasoned, because it is the perfect organ to capture the only aspect of the physical world that we "see": color (Aristotle had made the same argument). In other words, we do not see the shape or motion of things, only their colors. From color and its variations due to light and shadow, we deduce everything else about the world: shapes, distances, textures, sizes, motion, etc. Color is inseparable from light: "The form of color is always mingled with the form of light and is not separable from it," Alhacen wrote, adding that "sight senses light only when it is mingled with color."

Today, thanks to Isaac Newton, we know that light is color, but Alhacen and his medieval followers thought they were different entities: color belonged to the object, whereas light was the condition that made sight possible. Leonardo repeated these views almost verbatim in many of his writings, but he was an artist writing for other artists, and so he transformed Alhacen's teachings into instructions for painters: "the quality of colors is revealed by means of light [. . .] Hence, painter, remember to display the true qualities of color in the illuminated parts."

All the eye sees are luminous colors, which Alhacen called "forms" (*sura* in Arabic, *forma* in Latin). Thousands of these forms radiate as rays from all the points of an object and scatter in all directions. These forms travel to the observer's eye through air and other transparent bodies, bringing information only about the particular points of the object from which they originate. This means that for Alhacen, forms were only radiations of color mixed with light from one of its points.

Later Leonardo illustrated these radiating forms in a beautiful drawing.

To study the trajectory of forms in a mathematically precise way, Alhacen adopted Euclid's geometry, which Euclid himself had applied to optics. He used Euclid's notion of visual rays to analyze the paths through which forms "travel" to reach the eye, but he did not share Euclid's and Ptolemy's view that these visual rays are mathematical abstractions and that forms are immaterial. For Alhacen, forms were physical objects: they radiated outward through a continuous, transparent medium and traveled along imaginary lines—visual rays—to the eye, upon which they made a physical impression.

He subscribed to what was known as "intromission theory," which argues that "vision cannot be due to some physical substance that comes out of the eye and travels to the visible object" but rather to forms of luminous colors that travel to the eye through air and other transparent bodies. In other words, from the infinite variations of forms that strike the eye we learn everything about the world.

Alhacen's philosophy of the soul was complex, his prose convoluted. It is difficult to summarize, but it is based on several guiding principles:

Contrary to Plato and other influential philosophers, but in agreement with Aristotle, Alhacen maintained that we do not have preexisting mental ideas of the world fixed in the soul that correspond with what we see in the world. Instead, we collect data through the senses, primarily the sense of sight, and transmit these sensory data to the soul via optical nerves for further elaboration. In other words, we form our judgments of the world from intuitive perceptions, not from preexisting ideas, a notion that had a lasting influence on Leonardo.

It is equally important to understand that for Alhacen, we do not form our judgments solely based on the eye, which is part of our physical body, or solely based on the soul, which is immaterial but nonetheless exists only within a material body. Instead, body and soul work together in a constant back-and-forth exchange, comparing new sen-

sory data with previous experiences stored in the memory, which is part of the soul. Aristotle had previously talked about the interaction of body and soul, but Alhacen expanded his understanding of such interactions; for him, the exchange of soul and body brings us knowledge of an object's characteristics, or its "visual intentions [*intentiones sensibiles*]," as Alhacen called them, such as an object's size and shape, its spatial relation to other objects, its distance from the observer, if it is in motion or at rest, if its surface is rough or smooth, if its body is transparent or opaque, if it is made of one continuous part or of separated parts, if it stands in darkness or in shadow, if it is beautiful or ugly. Some "visual intentions" we identify quickly, for instance shape or color. Others require a slower process of repeated visual scrutiny and judgment, such as an object's distance from us, or whether it is beautiful or ugly. The perceived characteristics of objects are continuously adjusted, modified, and perfected based on new intuitive perceptions. This means that knowledge is always temporary, and time is required to fine-tune our knowledge of the world—for instance, Alhacen argues that it takes longer to distinguish two identical twins than two unrelated men.

This was precisely the way Leonardo went about examining the world and painting it. The downside of his approach was that it made it very difficult to determine when a portrait of an object or person was "complete"—and in fact Leonardo was never done with anything, not a painting, not a book, not a building, not a machine.

While Alhacen believed the eye never errs, he was nonetheless fascinated by "visual illusions," as he called them.

Like modern neuroscientists who learn how the brain works by looking at its abnormal behavior, Alhacen focused on "why, when, and how, sight happens to be deceived." In his account, the never-erring eye will perceive "a visible object correctly" when the eight conditions of sight are met, which are, again, distance between the eye and the object, a facing orientation, light, size, opacity, transparency in the air, time, and a healthy eye. But "if an object lacks any of them it is still

perceived by sight, but it will not be perceived correctly." In addition, because he was a systematic and experience-based thinker, and also because he was so deeply concerned with a philosophical study of the soul, Alhacen established for each condition a "proper range of moderation" according to which "the visible object will appear as it actually exists," but "if one or more of these conditions falls very far outside that range, sight will not perceive the object as it actually exists."

He filled his tract with many examples, all based on firsthand observations, analyzing in excruciating detail and demonstrating with intricate geometrical diagrams how unfavorable conditions send contradictory sensory data to the soul. He went through this detailed analysis because he wanted to explain his main claim: "[the] only reason sight errs in perceiving forms is because one or more of the aforementioned conditions has fallen outside [the range of] moderation."

His observations on human flesh seen through transparent fabrics are exemplary of the attention to detail he displayed. "If a sheer cloth is placed in front of the eye and a body is seen behind that cloth, the color of the body will appear mixed [with that of the cloth]," he wrote. He then proceeded to differentiate "the color of the cloth [that] reaches the eye only from the threads" and "the colored spots on the body [that] only reach the eye through the interstices in the cloth." He reasoned that if there is no "perceptible separation" between the threads and the interstices through which the body is seen, cloth and flesh "appear to coalesce, so their colors appear as a perfect blend." The effect of blended color between body and fabric is even more evident if a body is seen through woolen cloth, which has "the threads [. . .] covered with hair" and its "interstices [. . .] made even narrower."

One could not ask for a more detailed explanation of the mingling of colors and complexion, effects that Leonardo was keenly aware of: "Do not make the boundaries around your figures of any color other than its adjoining background. That is, do not make dark outlines between the background and your figure," he told painters.

Because light affects the way we see, Alhacen analyzed every possible kind of light—candlelight, moonlight, sunlight, daylight, fire-

light, starlight, and even light coming from a window or through a pinhole inside "dark chambers" he created appositely to study the trajectories of light rays at different moments of the day. Later, Leonardo would study in great detail daylight coming into a dark room from a window.

But, as Aristotle had explained, color and light can be perceived only if they travel through a continuous substance with some level of opacity, such as air or water. This explains why Alhacen submitted the "transparency of the air" to close scrutiny: "an inordinate decrease in the transparency of the air is a cause of error," especially "when the air is hazy."

Interestingly, the example he used to describe the "transparency of the air" is the exact same example Leonardo would use to explain aerial perspective. "If the air is misty or dusky, as usually happens in the morning, and if there is a tower facing the eye at a moderate distance," Alhacen wrote, "it will be judged by sight to lie further away than it actually is" because the misty air hides the ground "according to which the distance of the tower is gauged." Centuries later, Leonardo wrote about aerial perspective in painting:

> There is another perspective which we call aerial, because through variations in the air we are made aware of the different distances of various buildings whose bases apparently arise from a single line, as might be seen with many buildings beyond a wall, all of which appear the same size over the top of the said wall. And if you wish in painting to make one appear more distant than the other, you should represent the air as rather dense.

Alhacen's goal was to show that regardless of their source and the medium through which they travel—air or water—color and light follow the same identical laws of reflection and refraction. But what he ended up most notably providing was an unprecedentedly exhaustive set of observations on reflected colors generated by different light sources.

Often, Alhacen illustrated "visual illusions" with examples taken

from the art of painting. For instance, the soul judges "the hair of somebody who is depicted in a painting" as having "texture because that texture is represented by the painting." But it arrives at this conclusion "by resemblance" as it knows that "real hair has texture" and it supposes that "there is texture in the painted hairs according to the way their form is represented." Similarly, the soul operates by resemblance in the case of "clothing with designs and with the hair of animals that are represented in paintings": it sees texture in a painting where "instead of actual texture there is utter smoothness." This was a philosophical explanation of trompe l'oeil: the soul operates "by resemblance" when it looks at a painting.

And then there were Alhacen's ideas on beauty—the hardest "visual intention" of an object to detect. Unlike color, shape, or size, which eye and soul apprehend quickly, beauty requires a slow, repeated process of back-and-forth between eye and soul. It resides in "the configuration [*compositio*] of different intentions," in their "proportionality or harmony," and in the way the parts relate to the whole.

The ultimate example of this composite idea of beauty is the human face, which is beautiful when facial features are "proportionate among each other as well as to the breadth of the face," not when individual features are beautiful. His Renaissance readers did not hesitate to apply his thoughts on proportion to art: "Proportions create beauty more than any other quality [*intenzione*]," the sculptor Lorenzo Ghiberti wrote in the early fifteenth century, quoting Alhacen almost literally.

To read Alhacen on visual illusions was to never again look at light and color the same way.

The only problem with Alhacen's catalog of "visual illusions" was that it was excruciating in details and, thus, an absolute bore to read.

Understandably, his medieval followers found it unpalatable and cut it to the bone. From their point of view, there was no need to have university students, astronomers, and doctors go through so many examples to make the simple point that light and color behave the same

way regardless of their generating source, or that the medium through which they travel affects the way we perceive things.

Even the writer and architect Leon Battista Alberti, who was deeply knowledgeable about optics and who in 1435 had written a seminal essay titled "On Painting" that was steeped in this field of study, thought that scientific discussions of color and light were of no interest to painters. Artists and patrons read Alberti's essay widely, as did Leonardo, who was highly influenced by it; scholars have detected many references to Alberti's essay in his writing, even though the artist did not list it among the books in his library or mention it explicitly in any of his surviving notes. Alberti writes that he had purposefully left out of his essay "all the functions of the eye [*officj degli occhi*] in relation to vision," as he thought they were not essential to painting, as well as a discussion of "whether sight rests at the juncture of the inner nerve of the eye, or whether images are represented on the surface of the eye, as it were in an animated mirror [*speculo animato*]." For Alberti, it was "enough in these books to describe briefly those things that are essential to the present purpose": that is, basic rules of linear perspective to diminish the size of objects mathematically. He omitted "the disputes of philosophers regarding the origins of colors" because artists did not need to know "how color is made from the mixture of rare and dense, or hot and dry and cold and wet."

At least two artists felt differently, and they went back to the medieval optical sources to write books that would teach artists precisely what Alberti had left out.

Leonardo was one, but before him there was the sculptor Lorenzo Ghiberti.

That Ghiberti read the Italian translation of Alhacen's *Book of Optics* is documented. He copied extensive passages from it for his own art book: "Note that Aristotle and Alhacen say that there is difference between light, lumen, and splendor [. . .]" and "The reason of this derives from Alhacen, as we said earlier [. . .]" are typical sentences

scattered throughout his book. When Leonardo trained in Verrocchio's bottega, Ghiberti's notes from Alhacen were in the hands of Lorenzo's grandson and heir, Bonaccorso Ghiberti, one of Leonardo's acquaintances.

Lorenzo Ghiberti is best known as Brunelleschi's rival and as the creator of the *Gates of Paradise*, a series of reliefs adorning the doors of the Florentine Baptistery. But he was also the promoter of a novel view on the arts. Before the Renaissance, artists were regarded as mere craftsmen since they worked in noisy workshops and dirtied themselves with dust and pigments, their manual labor deemed inferior to the intellectual work of writers. Lorenzo Ghiberti was among the first to revise this way of thinking.

He himself behaved like a man of letters.

He befriended the protagonists of Florentine intellectual life: the financially inept book dealer Niccolò Niccoli, whose stock formed the library of San Marco; Leon Battista Alberti; the historian and chancellor Leonardo Bruni; and the theologian and expert on Greek literature Ambrogio Traversari.

Ghiberti read widely.

Learning that Vitruvius recommended a liberal arts education for architects, Ghiberti advocated the same for artists: "painters and sculptors should be learned in all the liberal arts: Grammar, Geometry, Philosophy, Medicine, Astrology, Optics [Prospettiva], History, Anatomy, Theory of Drawing [*Teorica disegno*], Arithmetic."

Ghiberti also, of course, wrote a book of his own.

This book was meant to be about his own art, but it is not an art book—at least not as we understand it today. Ghiberti did not give it a title, so today the book is known simply as Ghiberti's *Commentaries*, which is a misnomer because it is not a commentary at all. It is an autobiography, but even as an autobiography it is odd. It does not start with Ghiberti's birth, childhood, and early training, but with Vitruvius's recommendation that architects be trained in the liberal arts. It continues with short biographies of ancient artists, which Ghiberti copied from Pliny's *Natural History*, and of medieval artists from Flor-

ence, Siena, and Rome, which he himself wrote. Only after about twenty pages of talking about others does he finally come around to his own biography. In so doing, Lorenzo created an illustrious genealogy for himself that connected him directly to the greatest artists of the past. The very idea of an artist writing about his own place in the history of art was a novelty, but one that was fitted to Ghiberti's conception of the artist.

But the oddest thing of all about Lorenzo's book is the third section, the so-called Third Commentary, which at over one hundred pages is by far the longest. He never finished this section, and it is hard to imagine how he would have, given that it was nothing else than a set of apparently disorganized notes on optics taken from Alhacen, Bacon, Witelo, and Pecham. But a more careful reading reveals that Ghiberti mastered medieval optics, which is in itself astonishing, as no other artist had ever read optical books of that complexity so thoroughly.

He wrote that since childhood, "I followed art with great study and discipline [*studio e disciplina*]" and always wished to understand "the basic concepts [*primi precetti*]" so as to "investigate how nature operates in art and how I can relate to it." He wished to know "how the species [*specie*] come to the eye, what is the role of visual acuity [*virtú visiva*], and how visual rays [*raggi visuali*] behave." "Species," "visual acuity," and "visual rays" are all technical terms Ghiberti lifted from optical books. Other terms he invented himself, such as light ray (*razzo luminoso*) and shadow ray (*razzo ombroso*); later, Leonardo himself used Ghiberti's terms—"razzo luminoso" and "razzo ombroso"—which is an indication that he was familiar with the sculptor's writings. Ghiberti's main goal was to understand "how the theory of the arts of sculpture and painting have to be carried out."

What is even more astonishing is that over half of Ghiberti's Third Commentary was based on Alhacen's *Book of Optics*. One may think that this was due to the fact that he could read Italian better than Latin, and Alhacen's work—unlike the later works based on it—was available in the vernacular. But there seems to have been another rea-

son as well: he copied from Alhacen mainly passages on "visual illusions" that were not present in the books written by his Latin followers.

Ghiberti never published his work, and at his death his grandson Bonaccorso inherited it together with the workshop's prized stock of sketches and drawings and the materials Ghiberti had consulted to compile his book: a complete copy of Vitruvius's *On Architecture*, various optical texts, and either a copy of the Italian translation of Alhacen's book or extensive excerpts from it (the Italian translation Ghiberti used was very similar to the only surviving Italian translation now kept in the Vatican Library).

Bonaccorso and Leonardo had much in common. Born only a year apart, they received similar artistic educations, though Leonardo trained in Verrocchio's workshop and Bonaccorso in his grandfather's foundry. Both developed similar interests in casting, metals, and furnaces. They were deeply fascinated by Brunelleschi's castello and made sketches of it that are so similar that it is conceivable they drew them while working near each other or, at the very least, showed each other their work.

Eventually, however, their interests diverged. Leonardo learned how to paint, and Bonaccorso became a talented gun maker, blacksmith, and military architect. But they shared a passion for writing, and although Bonaccorso never wrote as much as Leonardo—very few artists did— he kept a fat volume of 239 folios, each about twenty by fourteen centimeters, in which he gathered notes on subjects ranging from architecture and geometry to weaponry, metal casting, and the building of furnaces. Bonaccorso compiled his book between 1472 and 1483, when Leonardo was in Florence, and added notes to it in the 1490s.

Leonardo's own writings from this period testify to his preoccupation with optics, and later in life he himself quoted directly from Pecham and looked for Witelo's book in libraries in Florence and Pavia.

Some notes from later years seem to echo the words of Alhacen:

"Men wrongly complain of experience," Leonardo wrote, "which with great abuse they accuse of falsity [. . .] Experience does not err, but rather your judgements err when they hope to exact effects that are not within her power." He described painting as an art that "embraces all the ten functions [*offizi*] of the eye," adapting to art Alhacen's conditions of sight. Even more revealing is Leonardo's explanation that his "little work [the book on painting he planned to write] will comprise an interweaving of these functions." He revealed that in a way he thought of his book as a sort of simplified "Alhacen for Artists" to teach artists to imitate with their art "the works by which nature adorns the world," including the most distinguished of all the world's ornaments—"man and the intentions of his mind."

Even by his twenties, he had picked up fundamental notions of optics. As we have seen, he sketched the anatomy of the eye on a folio relating to the palla and wrote a note that strongly suggests he had fully grasped the most complex aspects of optical theory in his Florentine years: "surface" of the eye, "pupil as a convex mirror," and "eye as a glass ball" are all expressions that come from optical literature. His earliest shadow drawings, made to study penumbras cast by a round object, or projected onto it by various light sources, show just how important it was for him to grapple scientifically with forms of luminous colors that disperse in the air and to find a way to represent their true behavior in his works. It was not just a matter of learning how to draw from nature the lights and shadows on each muscle, which is what Verrocchio and his fellow artists did. Rather, it was a matter of learning how to capture the effect of particle-filled air on the luminous forms of people's faces and their bodies.

Considering that Alhacen's book was the only optical text translated into Italian, that it included long descriptions of "visual illusions," that Leonardo had painted such "visual illusions" since his youth, and that Alhacen's book was in the hands of an artist Leonardo knew, it is not inconceivable that Leonardo did actually read Alhacen's *Book of Optics* in the 1470s.

If Leonardo read Alhacen's *Book of Optics* in his Florentine years, he

would have found there detailed descriptions of "visual illusions" and exhaustive explanations of the science behind them. Buildings in a landscape filled with humid air, the texture of people's hair, the fur of animals, the brocaded decorations of precious textiles from Damascus, skin seen through a transparent fabric—these were among the excellent examples Alhacen had painstakingly described and that Leonardo had excelled in painting since his earliest works. As the art historian Martin Kemp remarked a long time ago, Leonardo "chased problematical perceptions at least as avidly as Alhazen, making his own telling observations, even if his exposition never achieves the orderly logic of book III of *De aspectibus*."

From optical literature, and Alhacen in particular, he would have learned that air is "in continuous contact" with faces and bodies, and that it was air that made visible the smallest and most imperceptible penumbras as people moved their limbs, faces, and expressions. Toward the end of his life, he wrote that "the boundary of a thing is a surface, which is not part of the body clothed in that surface, nor is it part of the air surrounding these bodies, but is the division interposed between the air and the body [. . .] Therefore, painter, do not surround your bodies with lines." But the depiction of air was the defining characteristic of his paintings from the very beginning.

Other artists had attempted to render the effect of air as well, but none with Leonardo's sustained focus, nor with his skills, let alone with his outcomes.

Brunelleschi designed two perspectival panels (now lost) in which the architect applied the medieval theory of vision to painting and in which—it is widely accepted—he invented linear perspective, a mathematically accurate procedure to represent three-dimensional objects on a flat surface. Less often considered is the fact that he was also deeply engaged in representing the effects of air. In the first panel representing the Florentine Baptistery, which he rendered with mathematical precision, he chose not to paint the sky above the building. Instead, he applied a layer of silver so that the background of the painting was actually a mirror. The scope of this odd arrangement was clear

to his first biographer, Antonio Manetti, who explained that "the air and natural heavens are seen reflected there, and also the clouds that are seen in that silver to be stirred by the wind when it blows." In other words, the painted image of the Baptistery was completed by the scattered reflections of natural light from the real sky on a layer of silver. In the second panel, representing the Signoria palace, which was also rendered with mathematical precision, Brunelleschi cut the panel along the palace's skyline so that when the painting was displayed outside, effectively like a cardboard cutout, real sky and real air completed the painted building. Not knowing how to represent in painting the effect of air, which Alhacen had shown was fundamental to perception, Brunelleschi in both panels had real sky and air do the work.

Donatello was also very attentive to optical matters. He created the illusion of great depth with carvings that were only millimeters deep, and with minimal variations of light and shadow between the carved figures and their background; but these shadows were so masterfully done that they gave the illusion of fully round objects situated in an enveloping atmosphere. It was known as flattened-out relief, or *rilievo schiacciato*, and it seemed like a realization of the "subtle engravings that are not of a different color but rather of the same color as the body" Alhacen mentioned to explain how light affects the perception of small details. These "subtle engravings" are visible when "moderate light shines upon that body" but are invisible if they "are illuminated by intense light" that faces the object. Ghiberti later described them as "*sculture sottili*," commenting similarly that the effect was visible in moderate light but that it was invisible "in feeble light or in the dark."

Optical literature and Alhacen offered Leonardo only a starting point, however. In his writings and drawings some fifteen years later, there remained some very basic unanswered questions.

What, for example, was the soul exactly? Where did it reside in the body? And how—by what mechanism—did it interact with the body to reveal its form to us? Young Leonardo had of course heard the "soul"

referenced in a religious context. And he had also encountered Aristotle's interpretation—that the soul and the body are inseparable. But such knowledge took him only so far. If he wanted to create a definitive book on painting, if he wanted to codify operational rules for art, then he would need to take a religious and philosophical statement about the interaction of body and soul and combine it with geometrical information about light and shadow.

Optical books, including Alhacen's, could not do that for him: For all his interest in painting, Alhacen knew far more about natural philosophy than about art. Only a painter could extract from his analysis a set of rules for painting.

Put more clearly, what Aristotle understood (the body-soul connection), what Alhacen explained scientifically (optical effects as markers of how we know the world), what Brunelleschi was unable to capture with pigments, what Alberti refused to discuss, and what Ghiberti attempted, and failed, to assemble into an art book—all this a young Leonardo took upon himself to synthesize into rules for a new type of painting that, like natural philosophy, aimed to reveal the truth about the world and, above all, the truth about people's soul.

The influence of optical literature and of Alhacen in particular on a young Leonardo becomes even more apparent in light of something equally remarkable: the particular way young Leonardo painted. In the first works he painted entirely by himself, he devoted great attention to atmospheric effects derived from "the air between the eye and the visible object," which were nowhere to be found in the art of his peers. Perhaps Leonardo developed this style simply through practice. But perhaps he painted differently than his peers because he had read and digested books they had not, including Alhacen's *Book of Optics*.

PART II

How

LEONARDO

Painted

4

//

Landscapes à la Leonardo and the First
Solo Painting

In the Renaissance, artists, eager for viewers to feel themselves present in their painted stories, used landscapes to enhance the illusion. If their works represented events that were distant in time and place—which was often the case, as the most popular subjects were biblical stories, historical events, and mythological fables—they tried to bring these distant events closer to their viewers' homes by setting them in familiar scenery. This intimate connection between viewers and paintings was especially important for religious stories.

A new form of devotion for the laity had emerged in the course of the fifteenth century and had spread rapidly from the Low Countries to Italy and other parts of Europe. It was called modern devotion, or *devotio moderna*, and it promoted an intense, personal relationship with God through frequent meditation on the divine. One of the best ways to experience the divine individually was to project oneself into a scene from Christ's life. Authors wrote books to instruct the faithful, not just the clergy, in how to achieve this deep, individual immersion, and artists achieved the same goal by setting biblical events in local landscapes rather than in the harsh desert of the Holy Land. This is the reason landscapes became more and more important in Renaissance art, although they remained backdrops to narrative stories and were never considered in themselves worthy of entire paintings, or even drawings.

Leonardo did not challenge this practice, at least not on the face of it. His landscapes were still part of religious stories. But the way he laid down mountains, rocks, rivers, and meadows on his panels, the way he transformed traditional stories by setting them outdoors, the way he immersed people and things in nature and the atmosphere, in effect gave landscapes a whole new dimension. No longer backdrops, they were fully integrated with the people in the foreground, essential to both the depiction of their states of mind and to the creation of a deep connection with the people who looked at his paintings.

Indeed, the first documented work by Leonardo is a small landscape that he sketched in ink. He drew it on a folio-sized sheet, about nineteen by twenty-nine centimeters, which he had previously washed with pale pink (Figure 1). He thought that "to paint objects in relief painters should stain the surface of their papers with a tint that is medium dark, and then put on the darkest shadows, and finally the principal lights in little spots, which are the first that are lost to the eye at a short distance."

From a high vista point that takes in a wide panorama of the valley below, he sketched the Arno River, which slowly winds its way to the Tyrrhenian Sea. A fortified medieval castle defiantly juts out from the edge of a high cliff that rises on the other side of the valley. The sun sets in the west, casting shadows on the right of the image. Treetops, rocks, and marshes all seem out of focus, as if they were screened by particles of dust in the air or blown by strong wind, or both. There are no people in this landscape, which Leonardo most likely imagined as the backdrop of a narrative painting.

It is a scene of uninterrupted beauty and majesty, not dissimilar to the magnificent panoramas that one can see from the town of Vinci, looking down to the valley, the Arno River, and the marshes of Fucecchio. Leonardo's drawing recalls landscapes that would have been familiar from his childhood. But, as the art historian Alessandro Nova has put it, this "landscape did not start as an autonomous and pure landscape; it has become one."

Leonardo began the drawing with a lead stylus that left faint marks.

Later, at his desk, he reworked these almost invisible signs with a light ink and then retouched the sketch with a darker ink, adding details to the rocks and trees.

About fifteen years later, he wrote a detailed note about teaching artists "how to portray a place accurately" using "a piece of glass as large as half sheet of royal folio paper," which they had to affix to a machine in such a way "that you cannot move it at all." He told artists to shut an eye or entirely cover it and then "with the brush or a piece of finely ground red chalk mark on the glass what you see beyond it. Then trace it onto paper from the glass, and pounce it onto paper of good quality, and paint it if it pleases you, making good use of aerial perspective." We do not know if he himself followed this procedure in sketching his first documented landscape.

But we do know that he took the highly unusual step of dating this drawing. On the top left corner, in reverse handwriting, using a notary script called *mercantesca* that was typical of lawyers, notaries, and merchants, he wrote:

> On the day of Our Lady of the Snow
> On the 5th of August 1473.

On the back he jotted, not in reverse, the name of a friend—Giovanni Morando d'Antonio—and added, "I am happy [*sono chontento*] [*sic*]." These are the oldest notes in Leonardo's handwriting that have come down to us. Leonardo was twenty-two years old. He was still a member of Verrocchio's workshop, but he was also an independent painter. About a year earlier, he had started paying dues to the Compagnia di San Luca, the Florentine confraternity that painters joined in order to practice as independent artists.

From an artistic point of view, this beautiful landscape was not exceptional. In fact, it was conventional.

The drawing replicated a successful scheme for vast panoramas in-

vented by Jan van Eyck, an artist from Bruges whose works were admired in Florence. Van Eyck had figured out a way to create the illusion of expansive views, even on panels as small as five or ten inches. His trick was to paint some natural features—usually rocks, sometimes trees—in the middle of the scene: these natural features worked as a kind of visual proscenium, giving the illusion of depth. Verrocchio had adapted a van Eyck landscape with rocks for use as a base for some of his paintings, although he had enlarged van Eyck's landscape scene from its original, diminutive size to a larger one that often filled half of the painted surface. The Pollaiuolo brothers had done something similar, most notably in an altarpiece representing the martyrdom of Saint Sebastian (although in their case the landscape took up about two-thirds of the entire panel).

To date a painting was exceptional, but the way Leonardo wrote the date on this drawing was common. In the Renaissance, most people did not keep track of the days of the month numerically, as calendars and clocks were not household items, and even many educated people, who may have owned luxury spring-driven clocks or had sundials installed on the walls of their palaces, did not know how to read them. What most people used to keep track of time were breviaries, books that listed prayers to be read every day, with each day dedicated to a saint or a sacred event. Days of the month were identified by the name of the saint or the event commemorated on that day. For instance, March 25 was the Day of the Annunciation because that was the day Gabriel appeared to the Virgin to announce her miraculous pregnancy. December 8 was the Day of the Virgin's Conception. August 5 was dedicated to Saint Mary of the Snow in commemoration of a miraculous summer snow that fell in Rome in the year 352.

One wonders, though, why Leonardo took such an unusual step of dating this small sketch. What did it mark for him? Was there something about it from his point of view as an artist that was worth celebrating?

We have established that the view was conventional, that the date was uncommon but also unremarkable—but what about Leonardo's marks on the page?

A few rapid, spiraling touches suggest fuzzy treetops seen through humid air.

Curved strokes form treetops, perhaps trembling in the wind.

Disciplined diagonal hatchings identify mountains in the distance.

Faint horizontal lines mark the damp valley and fumes coming from the marshes.

Tiny vertical touches mark trees and towers immersed in humidity, lost in the distance.

Thin lines hint at the crests of distant mountains.

Thinner lines suggest crests that were even more distant, more immersed in the atmosphere, less defined.

The faintest lines indicate the place farthest away, the coastline where the Arno River reaches the Tyrrhenian Sea, about fifty miles in the distance.

Why did Leonardo sketch this way?

Alhacen explained that air contains small particles—water vapor, smoke—and that these minuscule elements collide with "forms" coming from the objects in all directions, causing these forms to scatter even more and generating additional lights, colors, and reflections that are so dense that they create a veil of sorts over everything in view. The philosopher explained that air becomes thicker and thicker with distance, and that the thicker it becomes, the more it affects how things appear to the eye.

But in his catalog of "visual illusions," Alhacen also explained that it was not just that faraway things looked smaller than those nearby. More important, they looked different. Nearby trees displayed nuances of greens and browns, and flowers in close-up had distinct colors—yellows, pinks, reds, and violets. Each item of greenery had a distinct contour, and each leaf and plant could be identified. But those same

shapes and colors that were distinct and brilliant at close range blended into one another in the distance, with some becoming undifferentiated shapes of darkish green; those farthest away acquired blurred edges and a bluish veil. The lines separating lighted areas from shaded areas became fuzzy, especially in human faces and bodies.

Verrocchio had created stunning drawings of female heads that captured the effects of the atmosphere on their faces, which, Vasari reported, "Leonardo was ever imitating for their beauty." But no artist, not even van Eyck, not even the great Andrea or the Pollaiuolo brothers, had found a satisfactory way to replicate the effects of the atmosphere on nature—how it blurs contours, reduces faraway objects to a dot, makes detail indistinguishable, and blends colors and shadows. In their landscapes, things in the far distance—towers, trees, houses—were smaller in size and somewhat bluish, but their details were as distinct as those in the foreground. Even the artists of an earlier generation who were familiar with optical writings—Brunelleschi and Ghiberti—had struggled with rendering the atmosphere. No wonder. It was far from obvious how to make palpable what is ineffable and yet fundamental to how we perceive the world.

And so it was not majesty or beauty that drew Leonardo to that particular landscape. It was the humid atmosphere of the marshes that filled the entire valley on that hot summer day—a day bright enough to allow him to do what no artist had ever done before: capture, at least in black ink, the dense atmosphere that obfuscated the contours of treetops, rocks, marshes, rivers, coastlines, valleys, and mountains.

That is what that hot summer day in August of 1473 meant to Leonardo: it was the date he succeeded in rendering with black ink on washed paper what had eluded others—the effect of the atmosphere on how we perceive the world.

But could he accomplish the same with colors and brushes?

The bottega had recently received a commission for a new painting of Gabriel's visit to Mary, at which she was told that she would bear God's

child (Figure 2). To this day, we do not know who commissioned the painting, who led the patron to Verrocchio, or even where the finished painting was meant to hang. All we know is that Verrocchio, confident that Leonardo was ready, entrusted the commission to him.

Leonardo was indeed ready, ready to make this work a test case for his new way of painting. By the early 1470s he was unquestionably the most talented painter of the workshop.

The Annunciation was one of the most frequently represented stories from Mary's life. This was not surprising, since Renaissance theologians thought that, for the purposes of human salvation, the Incarnation—when God became flesh in Mary's womb—was even more important than the Crucifixion. In Florence, the story took on added civic significance since the New Year did not start on January 1 but on March 25, which was the Annunciation feast day. Florentine authors wrote plays about the meeting of Mary and Gabriel, bringing the story into the midst of Florentine everyday life, just as artists set the scene in typical Renaissance houses. One of the most famous theatrical representations was a play written by a Medici supporter, Feo Belcari (1410–1484), which was performed regularly in the Florentine church of San Felice during the years when Leonardo apprenticed in Verrocchio's workshop. Leonardo may well have been among the audience at one of those plays.

Belcari's play was based on the vivid description that the evangelist Luke had provided of Mary's shifting emotions during the event (Luke 1:34–35). Taken by surprise by Gabriel's sudden arrival, she was afraid. She was not reassured by the news Gabriel delivered—that she would bear a child who would be the son of God—as it defied all she knew about the laws of nature. Incredulous, she asked: "How will this be since I do not know a man?" Using an optical metaphor, Gabriel said that the Holy Spirit would pass through her body and make her pregnant without altering her virginal status, just as a shadow changes the way an object within its borders looks without actually altering the object itself. "The Holy Spirit shall come upon thee and the power of the Highest shall overshadow you" were his words. The comparison

was an apt one. The explanation made sense to Mary, who believed his words and submitted to divine will.

To an artist deeply interested in optics, the story offered the opportunity to paint a shadow that was divine *and* optically correct—not to mention the challenge of rendering Mary's shifting emotions.

Leonardo was determined to avoid what he had seen in the works of some of his contemporaries. He criticized a Mary who "looked as if she would, in desperation, throw herself from a window," and had equally harsh words for "an angel who looked, in his act of Annunciation, as if he would chase Our Lady from her room with movements which displayed as much offensiveness as you might show to your vilest enemy." His *Annunciation*, in other words, was not going to depict a veritable assault. To the contrary, it would capture Mary's emotions at the very moment when the immaterial divine spirit passed into her and miraculously made her pregnant.

Traditionally, the Annunciation was an indoor scene set in Mary's bedchamber or an area next to it. But this indoor setting created sharp shadows that, as Leonardo wrote years later, give a "wooden effect" to people's faces and make it hard to represent nuanced emotions. And so he placed his *Annunciation* outdoors, in the garden of Mary's villa, which he imagined on a hill, overlooking a magnificent view that telescopes out from the garden into a park and then seamlessly merges into a busy river, a harbor city, and a mountain range. Sun rays coming from the left cast shadows toward the right. Suffused light from the sky reflects and disperses those shadows in myriad directions, making visible the particles of the air, smoothing edges, softening shadows, and enveloping everything. These were perfect, realistic lighting conditions to create nuanced shadows that would make evident the smoothness of Mary's face.

In this setting, Gabriel casts on the grass his optically correct shadow, which points toward Mary, who casts her own shadow behind her, on the external wall of her own house, which is a fashionable Florentine villa with rusticated corners and square windows. Their cast shadows move in the same direction, along the same trajectory, and

suggestively make visible the moving of the divine shadow through Mary's body.

Having decided on the outdoor setting of his *Annunciation* and the kind of effects he was after, Leonardo set to work on the panel. A carpenter prepared it for him out of three planks of wood from local poplars. Usually, carpentry amounted to about 15 or 20 percent of the total cost of a painting, which may seem a high percentage to us today. But we have to remember that carpenters were better equipped than painters to select the right wood, cut planks without nodes and cracks, and frame the entire structure so that it would last for centuries, as it did. The cost was worth it.

Leonardo worked on the framed panel, which he layered with gesso to obtain a smooth, white surface to draw on. His first layer was the so-called gesso *grosso*, a thick mix of animal glue, chalk, and white pigment that adhered well to the panel, although it was hard to spread because of its rough texture. Leonardo spread it evenly with a large brush, but because of the frame he could not reach the edges: when the brush hit the frame, Leonardo raised it and moved it to another area, lifting also a small portion of gesso grosso, which created a barb, or *ricciolo*, as modern conservators call it. If we look carefully, we can see this ricciolo at the edges, which is proof that the panel remains its original size. (Had the panel been cut, the ricciolo would have disappeared.) Atop the gesso grosso and its ricciolo, Leonardo applied a layer of gesso *sottile*, which was more finely ground and made the surface perfectly smooth and ready to be drawn on.

His first decision concerned the location of the focal point of the narrative scene and what to represent in that important spot. He fixed this point according to the golden ratio, a measure Renaissance painters favored to define the proportions between a panel's height and its length because it added a subtle and pleasing balance to their works. The golden ratio is indicated by the Greek letter "phi"; it establishes how to divide a straight line in two different segments so that the proportion between

the entire line and the longest segment equals the proportion between the longer segment and the shorter segment. But this quite technical definition could be reduced to a simple geometrical procedure, which had become a basic practical skill used in the studios of Renaissance artists.

Later in life, Leonardo created beautifully shaded diagrams to demonstrate the relations between the height and the width of rectangles—revealing the golden ratio. They were illustrations for a book, *On Divine Proportions* (*De divina proportione*), written by his friend Luca Pacioli. But that was around 1498, about twenty-five years after he used the golden ratio to fix the geometrical focal point of his *Annunciation*. Now, on that crucial spot, he did not paint Mary or Gabriel, but a high mountain with faded colors and undefined outlines.

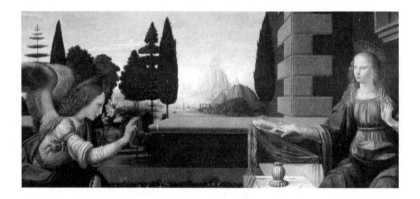

He made preparatory sketches for this panel, but apart from one beautiful drawing of Gabriel's arm wrapped in a soft, almost transparent gauze held by ribbons floating in the air, and another that served as a guide for the lily, they are all lost.

Lost are the geometrical drawings he made with compasses and straightedges to foreshorten Mary's villa, which is indeed a true showpiece of linear perspective. It demonstrates Leonardo's mastery of that hallmark of Renaissance art. We know he made a preparatory drawing because we can still see the indentation that the stylus left when he traced the drawing to transfer the palace's design from paper to panel.

Lost as well are the drapery studies that we know he made because we can see traces of how he transferred them to the panel. We cannot see these traces with our naked eye, but we can see them thanks to infrared photography, which, cutting through the paint layers, reveals little dots of *spolvero*, or "pouncing," a technique used to transfer drawings onto panels that was particularly effective for details such as folds, petals, stems, nostrils, eyelids, and chins. Here is what Leonardo did: he pricked tiny, closely spaced holes along the contours of his preparatory drawing. Then he positioned the drawing on the panel and sprinkled the holes with charcoal dust. The dust left minuscule dots on the panel. He then connected the so-called pounce marks using a brush dipped in black ink.

But when it came to shading the drapery, the long hours he had spent with his fellow apprentices copying folds from real fabric, wet with plaster, under mixed lighting conditions, paid off. He drew the shadows freehand, directly on the panel.

And lost, too, are the perspectival drawings for Mary's lectern—a wooden stand atop a richly decorated marble base, covered by a transparent veil, to support Mary's magnificent prayer book. Leonardo had modeled the marble base after the design his master had created for a Medici tomb, and constructed the foreshortened lectern on the panel carefully—his foreshortened lines are now visible from underneath the colors due to the aging of the pigments. He shaded lion legs, acanthus leaves, shells, volutes, garlands, rosettes, and festoons, all ancient motifs that his master had rendered in marble and bronze for the Medici tomb. Leonardo modeled them so masterfully that, with paint, he created the illusion of three-dimensional sculptural pieces. Twenty years later, Leonardo would write that painting is superior to sculpture because it creates with paint the illusion of depth that sculpture only achieves in three-dimensional space.

Drawings for the landscape are not lost because he never made them. He sketched a broad outline of the landscape in black ink directly on the panel, and did not even bother to fill in the details—he added them later, working directly and confidently with colors.

Drawing and modeling came easily thanks to his master's teaching. Coloring was an entirely different matter.

The painting technique Verrocchio used was tempera. It involved mixing pigments with a binder that dissolved in water—usually egg yolk. Over the centuries, Florentine artists had achieved unrivaled mastery of this technique, which offered considerable advantages. It was durable, which patrons appreciated, and it dried quickly, which permitted artists to speed up the application of one layer over another. Its drawback was that its brushstrokes never fully blended together, each stroke remaining visible even if applied with very thin brushes. Most artists saw no problem with this limitation. Not so Leonardo.

He had come to admire the paintings by northern artists that Florentine bankers and merchants had brought to Florence from Bruges, Antwerp, and Brussels. These northern works displayed brilliant colors and an array of optical effects, from shiny fabrics and brocades to transparent glasses and reflected shadows—in stark contrast to the effects achieved using tempera colors. Instead of mixing colors in egg yolk, northern artists diluted them in oil. The resulting mixture was more malleable than tempera, which allowed for greater nuance. It dried slowly, which was a drawback, but this long drying time also opened up possibilities for experimentation. Leonardo's master had never painted in oil and could not teach him. But he had taught him something much more valuable: never cease searching for the best materials and techniques to get your works to express what you want them to express. Leonardo made the continuous perfecting of his work one of the leading principles of his life as an artist, and years later wrote about it in notes intended for his book on painting:

> I remind you, O painter, that whenever you, in your own judgement, or in the opinion of another, discover some error in your works, you should correct it so that when you do show the work you do not also display the error. And do not make excuses to yourself persuading yourself that you will be able to

> rebuild your reputation with your next work, because painting
> does not die in the act of its creation as does music [. . .]

With oil, Leonardo could paint over a partially dried layer so that the two layers would blur into one. He could rework colors while they were still wet. He could retouch contours, adjust tones, and mingle outlines. He could even use his fingers to blend still-wet brushstrokes to create fuzzy outlines. More important, he could mix pigments with just a bit of oil to obtain opaque colors, known as body colors (*corpi*), which were perfect for drapery and buildings. But he could also dilute the same pigments further and apply them as semitransparent layers (*mezzi corpi*, literally "half bodies") in order to depict the shining texture of foliage. Experimenting further, he could mix the smallest quantities of pigment with oil to obtain a nearly transparent glaze, which he could apply in multiple layers. He could vary the tone and thickness of each layer to achieve an astounding variety of optical effects. These glazes were perfect for rendering transparent fabric, such as the veils that covered Mary's hair and her lectern—they could capture the "grada-tions" of light and shadow that "are infinite upon a continuous surface which is in itself infinitely divisible," that is, a surface that can be di-vided into smaller and smaller parts ad infinitum.

It took Leonardo a while to figure out that too much oil in the mixture makes colors wrinkle excessively once they dry, or slide off the panel instead of sticking to it. But oil became his technique. He might have learned by trial and error, or perhaps Verrocchio sent him to an-other workshop to perfect his art, a practice that was not uncommon. The Pollaiuolo brothers, for instance, had become masters of the oil technique, and although they were rivals they also participated in plenty of exchanges with Verrocchio's workshop.

Leonardo learned to apply *imprimitura*, an oil-based layer, over his preparatory drawings on the panel to insulate the wood from the pig-ments he would later apply. Painters typically did not retouch their designs once they had applied the imprimitura, but Leonardo often

made adjustments as he began to paint. Thanks to infrared photography, we can see what Leonardo changed between the making of his preparatory drawings and the application of his finishing touches, his *pentimenti.*

In the case of the *Annunciation*, Leonardo determined only later that Gabriel's profile was too low. He raised it a tad so that Gabriel looks at Mary straight on, reinforcing the intensity of their exchange.

The harbor in the background was too crowded with details that could not have been visible at such a distance. He chose not to paint half of them.

A bow window jutted out right above Mary's head in a manner that he must have later determined to be unsightly. So he flattened it.

And Mary's brooch was too large, its shimmering surface a distraction. He did not paint it, anticipating in practice what he wrote years later: "the resplendent beauty of youth lose[s] its excellence through excessive devotion to ornament." Painted figures should not be adorned "with costly gold and other expensive decorations."

Leonardo's *Annunciation* broke with tradition in other ways, too. He layered the color base over the imprimitura, but instead of applying a uniform brownish color across the panel, as was the norm, he used different base colors depending on the luminosity of each area. A bright pink was the base color for the gray architecture, which was a clever way to modulate the duller pigment used to render Mary's palace (today the pink peeks out, still in its full brightness, from the minuscule cracks in the aged gray paint). A brilliant green served as the base color for the vegetation. The sky has no base color at all: Leonardo painted it directly on the bright white gesso preparation. In fact, he left some areas of white gesso completely untouched, which was a great innovation: it made it look as if light came from within the painting. Later in life he wrote: "for those colors which you wish to be beautiful, always first prepare a pure white ground."

Otherwise, he used traditional colors. Carmine red for Gabriel's

drapery. Azurite blue for Mary's dress. Copper resin green for the vegetation. He added layer after layer, modulating the thickness of each, moving from a semitransparent body to a transparent glaze to reveal shadows in drapery folds and the tones of leaves, plants, and trees.

The red and blue colors are still quite strong, but the greens have lost their brightness due to oxidation, and today they are a rather undistinguished brown. Leonardo, however, was fully aware of the pitfalls of copper green, even in oil painting; later he wrote that copper green "loses its beauty like smoke if it is not quickly varnished" and, because it is made from a mixture of metallic salts, "it will disappear from the panel on which it has been painted if it is washed with a sponge, especially in humid weather." But even he could not do much to overcome the shortcomings of copper green.

Mary's face was harder to paint. Leonardo labored intensely on the delicate, almost imperceptible shadows that were intended to represent her alternating emotions. He painted her face once but was not satisfied. He erased it. He started again on the empty patch, but again he did not like the result. We do not know what displeased him; perhaps Mary's face came out too stiff, or perhaps her smile was not subtle enough to capture her emotional passage from hesitation to acceptance of divine will. Or perhaps Leonardo simply miscalculated the ratio of oil and pigment, as the excessive wrinkling of her face seems to suggest.

But Mary's face was not what defined his first painting. What made his first painting stand out so dramatically was what Leonardo did with the landscape. Here, he created thick yet translucent atmospheric effects, effects never before seen in a painting.

The scene was illuminated by direct sunlight, which is red, and by "universal light," which is "that of the atmosphere within our horizon," which is blue. Since, as he himself wrote thirty years later, "shadows generated by the redness of the sun close to the horizon will generally be blue," Leonardo modulated the red and blue colors of these two light sources on people and things depending on their positions. The most striking effect is visible on the architecture. In the palace, the bricks

facing the sun are more yellowish than those positioned parallel to the sun, which look more bluish. If we look carefully, a similar effect is discernible on the gray wall delimiting the garden, which appears more yellowish on the left side, closer to the sun, and more bluish near the palace, where it is more exposed to the sky. Similarly, the mountains look more yellowish on the left and more bluish on the right. The same goes for the marble base of Mary's lectern: the top side that holds the book appears yellowish, since it is directly exposed to the sun, but the vertical side looks bluish, since it is exposed only to the indirect blue of the sky.

No chemical analysis has ever confirmed that Leonardo did actually apply tiny yellow and blue touches to the panel to suggest the washing of sunlight and of blue sky over everything. But that is how we perceive the bricks, the walls, and the lectern. And "visual illusions" were what mattered.

Leonardo's peers would carefully position figures and objects based on their size—as that is what linear perspective taught—but Leonardo himself went a step further. He was the only one who understood that to enhance the connection between viewers and painted stories, an artist had to modulate colors and shadows with similar precision. It is not as if artists had never paid attention to colors and shadows before, but they had never figured out how to account for their variations due to exposure to different light sources. It was Leonardo who came up with rules for what is called "color perspective": "with a single color placed at various distances and heights, its brightness will be in proportion to the distances of each of these colors to the eye which sees them." These were matters Alhacen had discussed extensively in his book.

It would take Leonardo another forty years to come up with a simple diagram that explained the science behind the intricate optical effects in his *Annunciation*.

Between 1508 and 1510, he wrote a passage and drew a diagram that was intended to teach young artists how to paint objects in a countryside illuminated by red sunlight and by the blue light of the sky, which were the very lighting conditions he imagined for his first solo

painting. A ball is suspended outdoors in front of a white wall; it is illuminated by the sun and by the sky, which is represented as a hemisphere. Leonardo's explanation is worth quoting in full not because of its elegant prose—it is not elegant and it is not easy to follow—but because it shows how Alhacen influenced his thinking about the science of art. He wrote:

> The surface of every opaque object partakes of the color of its
> opposite object. Therefore, since the whiteness of the wall is
> deprived of any other colour, it is tinged with the colour of

objects opposite. The objects are in this instance the sun and the sky. Because the sun reddens towards the evening, and the sky shows its blueness [. . .] the cast shadow strikes the white wall with a blue color, and the area around the shadow, there is no view of the sun, according to the eighth proposition of the book on shadows, which states: No luminous body has a view of the shadow cast by it. Where there is no view of the sun on that wall, it is in view of the sky. Therefore, according to the eleventh proposition the derivative shadow strikes the wall with a blue color, and the background of that shadow, which faces the redness of the sun, takes on the red color.

One wonders if "the book on shadows" referenced by Leonardo in this passage is the same one he consulted in San Marco on the desk of the illuminator Gherardo di Giovanni di Miniato in his twenties. If so, this would be further indication that he was thinking deeply about the philosophical implications and physical properties of light at a very early stage in his artistic career.

Leonardo's originality lay in his distillation of optics into operational rules for artists that went far beyond linear perspective. Around 1490, he wrote about "aerial perspective," "color perspective," and the "perspective of disappearance," but he had no doubt been investigating these topics already when he painted his first solo panel.

The *Annunciation* was a painting to be proud of. Leonardo displayed mastery of the oil technique and employed the full range of possibilities it afforded. He mixed minute touches of pigments with brushes and with his fingers—traces of his fingerprints are visible on the lectern and elsewhere when viewed under a microscope. He superimposed layers of highly diluted colors to render transparent objects such as Mary's veil. He combined corpi, mezzi corpi, and transparent glazes to give depth and luminosity to every single element of the painting.

He also adapted the rules of optics to painting and showed that optically correct shadows could make invisible things appear visible, for

example the divine spirit of the Incarnation via shadows, or Mary's emotions via a smile. He was able to accomplish all this because he concentrated his attention on what he later called "the soul of painting"—the gradual blurring of edges, lights, and colors made by the atmosphere, which captured people's emotions in ways that had never been accomplished before. As his first oil painting, the *Annunciation* bears traces of sometimes frenzied experimentation, but Leonardo largely succeeded in capturing elusive things in paint: the atmosphere, the landscape, colored shadows, the transparent veil over Mary's book, Gabriel's shadow, Mary's smile. The painting epitomized his later dictum that "if you avoid shadows you avoid glory among the noblest minds."

And yet Leonardo was still very much a traditional Renaissance painter, dipping a toe only here and there into new waters. He did paint the faces of Gabriel and Mary against darker backgrounds in order to make their features more visible, as Alhacen had recommended. But Mary's face seems somewhat stiff—even after he painted it twice. And the angel is in full profile, a position that prevented viewers from looking into his eyes and that Leonardo rarely used in future works.

One thing is obvious, however: Leonardo already knew how to paint stunning landscapes. From that moment on, landscapes became one of Leonardo's signature settings. For everything, from small devotional images to grand altarpieces, he created landscapes with optically correct shadows and reflected colors generated by sunlight mixed with "the universal light of the sky."

Not all artists were keen on landscapes, however, and one was utterly indifferent to them. Later in life, Leonardo scorned this artist because he "makes very sorry landscapes." He was referring to Botticelli.

Leonardo and Botticelli knew each other well, but their art could not be more different. Botticelli was the master of idealized figures who possessed unsurpassed beauty and emotionless expressions, inhab-

itants of a pure world that was untouched by human feeling and by the particles of the earth's atmosphere. For him, the study of nature "was of no use." Leonardo, however, had an appreciation for landscapes that extended even to small devotional paintings.

In a diminutive *Madonna of the Carnation* he most likely painted for a member of the Medici family shortly after the *Annunciation* (and that was based on one of his master's popular models for devotional paintings), the Child plays on his mother's lap, trying to grasp a flower she holds in her hand (Figure 3). The flower is a carnation, which was considered a symbol of Christ's passion because of its deep red color, and also because legend has it that it bloomed from Mary's tears on the way to Calvary. The group is caught between two distinct light sources: one from the left that hits their faces directly, and another, more diffuse source that comes from outside and filters through large windows. Through the windows, behind the Virgin, there is a marvelous landscape with rocky peaks, but Mary's face is not seen against it. Her backdrop is a dark wall between the windows. As he recommended to artists in later notes, "Always ensure that you are able to arrange the bodies against backgrounds where the dark part of the bodies is offset against a light background and the illuminated part against a dark background." Leonardo made a compositional motif out of Alhacen's optical observation that an object has to be placed against a contrasting background in order to be seen best.

This setting—two light sources, natural light filtering from outside into a darker room, a dark backdrop for a face in full light—made it possible to achieve a masterful balance of optically correct colors and tones across the panel: the yellow folds of Mary's mantle are the brightest spots on her lap because they fall in the most well-lit location. But the same yellow diminishes in brightness in the folds around her shoulder, which are slightly more distant from the viewer—in accordance with what Alhacen said about how the eye perceives colors and what Leonardo would observe later. Similarly, the blue of her dress is more intense in the shadowed areas in the foreground and lighter on her well-lit chest. The yellow and blue of her dress connect visually with

the colors of the landscape, suggesting a close connection between Mary, who was seen as the rock of the church, and natural rocks. The flowers in the vase that are closer to the viewer are minutely defined, whereas bushes and trees in the background are undefined.

Above all, Leonardo seems intent on capturing transparency, reflections, and textures. Consider what we see:

A glass ball adorning a velvet cushion, which perhaps refers to the Medici coat of arms.

A vase, its form perhaps based on Verrocchio's models for bronze luxury objects, in which reflections seen in transparent glass rival the shimmering metal of Leonardo's master.

A transparent veil, which was a fashionable item for Florentine ladies.

Air that seems even thicker than that of the *Annunciation*.

Mountains peaks that dissolve into blue and white at the horizon and merge with brownish valleys and hills below.

Mary's brooch—he did paint a brooch this time—which reflects light like a mirror.

The goal of this carefully calibrated surface of color and light, depicting a Renaissance domestic interior (perhaps the Medici palace?), was to enhance the tender interaction between mother and son so that viewers could participate more fully in the love that connected the two—and also in the drama of the Child's death that this scene prefigures.

Verrocchio must have been the first to realize what his former pupil had achieved. For one, he had asked Leonardo to finish a panel that he had started in tempera years earlier, and that was lingering, unfinished, in the workshop. This was the *Baptism of Christ*, a large altarpiece that the monastery of San Salvi had commissioned from him thanks to the mediation of Verrocchio's brother, who was the prior there (and who, coincidentally, often hired Ser Piero as his notary).

Verrocchio had defined the entire composition, borrowing freely

from northern artists. He had brushed the figures with a color base—
a *verdaccio*, or dark green—and painted most of them. Only Christ's
body and the angel on the far left remained unfinished. When Leo-
nardo took over, he did not change his master's overall design, but he
did retouch a telling detail of the landscape (Figure 4). Verrocchio had
sketched some trees on the left of the panel. Leonardo erased them and
created instead an unobstructed view of mountains and valleys. Now
a dense, veiled atmosphere, freed from the trees, flows seamlessly into
the foreground and submerges everything: angels, Christ, John—and
perhaps even gives the impression of enveloping the worshippers stand-
ing in front of the painting.

Leonardo had become a landscape master—landscapes à la Leonardo.

But could these landscapes help Leonardo reveal the minds and souls not just of distant religious figures but also of ordinary people— of the men and women he met in the streets of Florence, those who shared his way of life, his beliefs, his passions?

5

The Painting of the Young Bride-to-Be

Starting in the mid-fifteenth century, artists, especially those in Germany and the Netherlands, understood that to take the viewer into the mind of a subject, you had to let him or her look into the subject's eyes. So they started to paint male subjects of all ages and origins gazing straight out at their viewers. But these supposedly "eye-to-eye" portraits were not truly "psychological" in a way we would recognize today. The portraitists were not trying to strip away pretense to reveal inner states of being. Their goal remained what it had always been: to acknowledge the subject's social standing, or convey some other aspect of his life that he wanted memorialized.

When it came to women, the very notion of an inner portrait had no meaning because, back then, women's identities came from the identities of their fathers or husbands. Women were certainly painted, but the rules called for them to look down to avoid the eyes of the viewer. This positioning focused the viewer on what the men in their lives wished to communicate—wealth (made evident by the expensive jewels a woman wore) and position (the family coat of arms embroidered on her wide-sleeved gown). In only one instance could a woman's gaze be directed upward—when her husband was posed next to her.

Marriage and betrothal were the main occasions for commissions of portraits of women. The portraits would usually hang either in the

woman's house of origin, so that her family could remember the daughter who had left home, or in the woman's new home, to show off the dowry she had brought to her husband. As odd as it may seem to us today, though, these portraits were visible only on special occasions—birthdays, weddings, funerals, or other exceptional family events. At all other times they were covered by curtains or hung with the reverse of the panel showing. In the Renaissance, people believed portraits had the special power of making an absent person present, and they found it disquieting to look at them too often, especially if they represented a beloved daughter who had moved far away or a dead family member. This is the reason a portrait's reverse was as important as its front—and why it made reference to the sitter through either her husband's coat of arms or symbols of chastity and marital fidelity.

It was with these customs in mind that Leonardo was approached to make the portrait of a member of the Benci family, sixteen-year-old Ginevra, who was about to get married (Figure 5).

The Benci family lived in the neighborhood of Santa Croce, not far from Sant'Ambrogio, and for years they had been clients of Ser Piero. They were also committed patrons of the arts. Ginevra's younger brother, Carlo (born in 1458), was interested in architecture. Her older brother, Giovanni (1456–1523), who was five years younger than Leonardo, was also a collector of science books. Leonardo jotted down his name in one of his early folios on the making of burning mirrors: "Giovanni d'Amerigo Benci and company." Perhaps Leonardo did not write Giovanni's name himself—scholars are unsure about the authorship of this note—but clearly Leonardo and Giovanni knew each other in the 1470s. They kept in touch throughout their lives, and in the early 1500s they were so close that they exchanged books, maps, and precious stones. Giovanni kept in his palace one of Leonardo's unfinished paintings, a large altarpiece representing the *Adoration of the Magi*. Unlike Leonardo, though, Giovanni d'Amerigo Benci was the scion of a wealthy family and had easy access to a large network of scholars, philosophers, and patrons.

Ginevra de' Benci herself (1457–1520) was a young woman of complexity and depth, qualities important to Leonardo because they meant

he would not paint a typical portrait of a bride, in which she would be represented indoors covered in jewels from her dowry, her dress embroidered with her husband's coat of arms. Still, no one—not her brother, not Ginevra herself, and not even Leonardo—was prepared for the reactions this portrait would elicit once complete. As an early biographer reported, the portrait was "painted with such perfection that it was none other than she." According to another, it was "a most beautiful thing." Many similar works appeared soon after Leonardo portrayed Ginevra this way, even though not every portrait showed Leonardo's level of skill. This portrait is often called the first modern psychological portrait, as Leonardo thought that "a picture or representation of human figures ought to be done in such a way that the viewer may easily recognize, by means of their attitudes, the purpose of their soul [*concetto dell'anima loro*]."

What made this portrait so special was Leonardo's ability to reveal Ginevra's unique personality and to capture the environment in which she had grown up. It was not just that Ginevra came from a wealthy and influential family, though she did. Her grandfather, Giovanni de' Benci (1394–1455), was Cosimo de' Medici's business partner, and by the time Ginevra was born his fortune of 26,338 florins made him the second-wealthiest man in Florence. Cosimo was the first.

It was also not just that the Benci were discerning patrons of art and architecture, though they were. They commissioned paintings and modeled their family palace after that of the Medici, although on a smaller scale (as was appropriate). Like the Medici, they supported a convent in their neighborhood (the Benedictine convent Le Murate, or the Walled In). This shielded the family from the accusation of usury, a Christian sin to which bankers were seen as susceptible. As Ginevra's grandfather, who gave lavishly to Le Murate, put it, "The Lord, in a short time, had miraculously paid him back with more than he had put in."

And it was not just that Ginevra was educated at Le Murate, though she was. The convent had become an elite boarding school for patrician girls from across Italy, who learned there how to embroider, play music, sing, copy manuscripts, and possibly also write poetry, until they came

of age to return to the world as wives or, alternatively, take their vows as nuns.

No, what ultimately elevated Leonardo's portrait was all of this—the cultural environment in which Ginevra grew up, an environment that mingled poetry, science, politics, and love. Her father, Amerigo de' Benci (1433–1469), was steeped in Florence's avant-garde cultural circles, and its atmosphere filtered down to the younger generation—not just to the boys, who routinely received a formal education, but also to the girls, who were exposed to much more than grammar and prayer books.

As firstborn and family heir, Ginevra's father, Amerigo, took over the family business and continued to support Le Murate, where he built a private cell for the Benci girls, *la cella* de' Benci (where Ginevra would live for a time). He worked for the Medici bank in Geneva, but oddly, in 1458, he joined a plot led by Luca Pitti to overthrow the Medici. The plot failed, and Amerigo went to prison. Two years later, he was released and went back to business, but he was no longer a Medici partner. Often, between 1458 and 1465, he hired Ser Piero, Leonardo's father, to draft legal documents. All the while, he mingled with the most exclusive literary group in Florence.

This was the Platonic Academy, a group of like-minded people who gathered to read the works of Plato. A Byzantine scholar named George Gemistus Plethon had brought these works from Byzantium to Florence in the early 1430s, when he came to the city for a gathering of church officials who attempted to reconcile the schism between the Roman Church and the Orthodox Church. The effort failed, and today these two churches still practice different rites. One positive outcome of the failed council, though, was that Cosimo de' Medici, who received a Greek copy of Plato's *Dialogues* as a gift, became an enthusiast of Plato's philosophy. Because few Florentines mastered Greek, he hired Marsilio Ficino, a doctor turned philosopher who was fluent in Greek, to translate Plato's *Dialogues* into Latin and supported public lectures on Platonism. He also sponsored another Greek scholar, John Argyropoulos, to give public lectures on Aristotle. As we have seen,

Leonardo was familiar with Argyropoulos, as he jotted his name down, alongside Toscanelli's, in one of his early folios.

Plato liked to teach philosophy around a dinner table, in private houses in Athens, conducting dialogues with guests who were usually prominent figures in politics and culture. The title of Plato's works—*Dialogues*—referred to these dinner conversations, each dinner devoted to a weighty topic: love, government, democracy, knowledge, ethics, beauty, the state. To kick off the Platonic Academy in 1462, Ficino hosted a banquet, a *banchetto platonico*, in his villa at Careggi, on the outskirts of Florence.

Ginevra's father was one of the diners at this inaugural banchetto platonico.

A few months after the inaugural banquet, in September 1462, Amerigo gave Ficino a special gift, a sumptuous codex of Plato's *Dialogues* made of *carta bambacina*, a high-end paper from Amalfi. Ficino valued this codex greatly and wrote in his will that, after his death, it had to be returned to Amerigo's heirs—that is, to Ginevra and her brothers Giovanni and Carlo.

Two other members of the Benci family were in Ficino's immediate circle, the brothers Tommaso and Giovanni Benci. Ficino called them "our co-philosophers": Ficino translated philosophical texts from Greek into Latin, and the brothers translated them into Italian, often working at record speed. They attended platonic banquets, which had become a staple of Ficino's academy. Although these brothers belonged to a different branch of the Benci family than Ginevra's father, to Ficino they were all from the same family. "Amerigo and Tommaso [. . .] both Benci" is how he described them to another friend.

Ginevra's father did not translate Ficino's works into the vernacular. He was not an author of original philosophical works. He did not write poetry. But he was close enough to many members of the Platonic Academy to be well informed of the conversations that animated the group, as well as of Ficino's own philosophical work, which reinterpreted Plato's philosophy in the context of Christianity.

Ficino's main work was a monumental book titled *Platonic Theology*. It was concerned with a metaphysical world of pure ideas and divine contemplation that was separated from the physical world of objects, passions, and people. He conceived the divine as an infinite eye, an *oculus infinitus*, that contained the entire universe in itself. Humans could access it only through the physical instrument of the human eye. If one understood how the eye worked, how light dispersed, how shadows were created, one could begin to contemplate the workings of the divine eye. In other words, optics was essential to Ficino's understanding of God.

Ficino was an expert in optics. One of his earliest works was a short essay, "Questions on Light" (*Quaestiones de lumine*), which dealt with light, sun rays, sound, touch, and smell, and which offered a comparison of the senses, especially sight and hearing—all topics that were discussed in optical manuals and that interested Leonardo. Early biographers reported that at age twenty-one, Ficino wrote "a work on optics [. . .] on vision and on concave and convex mirrors," but it has been lost.

If optics was the science that helped with the contemplation of the divine, love was the force that predisposed the soul to move from the physical world to the world of pure ideas.

This love was contemplative—platonic, as it were. It transcended physical and sexual love. It was, in Ficino's words, the "perpetual knot and [bond] of the world." Beautiful women, it was said, inspired platonic love: their beauty was a vehicle for personal religious uplift. The platonic lover was not just an ideal, but an actual social role. Leading figures, the Medici first among them, selected beautiful women as their platonic lovers. Their role overlapped almost seamlessly with the chivalric view of idealized lovers that the great vernacular poets of the previous century had held; Dante's Beatrice and Petrarch's Laura were the unsurpassed models of idealized feminine beauty who inspired the

creativity of their lovers. Often these modern platonic lovers were married to other men. Lorenzo de' Medici's was Lucrezia Donati, who was married to Niccolò Ardinghelli. His brother Giuliano's was Simonetta Vespucci, who was married to Marco Vespucci, one of Ginevra's first cousins (Marco was the son of Piero Vespucci and Ginevra's aunt Caterina).

These Renaissance men declared their ideal love publicly. They wrote love poems and often organized public events in honor of their beloved. The most lavish public events were chivalric tournaments or jousts: men fought with lances on horseback in public squares and ceremoniously offered their victory to the platonic beloved. Lorenzo de' Medici organized a joust for Lucrezia in 1469, and his brother Giuliano another for Simonetta. The latter took place in Piazza Santa Croce on January 29, 1475. The author Angelo Poliziano wrote a poem about it, and Verrocchio designed a banner, to which Leonardo contributed; art historian David Alan Brown notes that "the younger artist's characteristic left-handed hatchings are visible in the landscape." Among those who attended the tournament was the recently appointed Venetian ambassador to Florence, Bernardo Bembo, who was inspired to find his own platonic lover. Bembo settled on Ginevra de' Benci. Some think Bembo was the patron who commissioned Leonardo's portrait of Ginevra, but others think that Ginevra or members of her family were the patrons.

This is the environment in which Amerigo brought up his three children—Giovanni, Ginevra, and Carlo. Although Amerigo died unexpectedly at age thirty-six, his sophisticated artistic patronage, heartfelt religious beliefs, and intellectual curiosity continued to inform the lives of his children.

Ginevra's older brother and Leonardo's acquaintance, Giovanni, seemed the most attuned with his father's philosophical inclinations and developed a strong interest in science and medicine. Life had forced him to grow up quickly—he was only thirteen years old when

his father died. It is possible that, until he came of age, his uncle Francesco was in charge of the family inheritance, and that this uncle negotiated Ginevra's marriage and commissioned her portrait. But when Giovanni took over, he continued the family tradition. He supported Le Murate, and in 1462 he moved the family to the new Benci palace that his father had started to construct. He wrote orations and petitions to the Signoria and was well informed on civic matters. He also acquired beautifully illustrated manuscripts on scientific topics; one by Giordano Ruffo di Calabria is still kept in a Florentine library and bears Giovanni's hand: "This book belongs to Giovanni di Amerigo de' Benci, year 1485." Later, he chose to be buried at Le Murate, where his father and sister were buried, too.

Among Giovanni's duties was the care of his younger siblings, Ginevra and Carlo. Carlo, the youngest, was destined for the church, but like his siblings he was deeply interested in the arts. As a canon of the Florence's cathedral, a post he obtained in 1479, he contributed architectural designs for the cathedral's façade.

Ginevra was twelve years old and a student at Le Murate when her father died. Like other boarders, she learned embroidery but also how to write and read, and possibly also how to copy and illuminate manuscripts, as these were activities for which the nuns' scriptorium was renowned. Perhaps she also learned how to sing, as the nuns' chorus was so famous in the city that many Florentines came to the convent's church for Sunday Mass to hear it. If she did, she sat with her female companions behind the main altar, in a screened oratory, invisible to lay Florentines who sat on the screen's other side. Her family members may well have been in attendance, listening to her voice.

She herself was a poet, although only one of her verses has survived. It is an unusual verse, its meaning ambiguous, but it betrays an independent spirit: "I ask your forgiveness, and I am a mountain tiger," she wrote.

Perhaps unsurprisingly, Ginevra would leave Le Murate to marry. The husband her family had chosen for her was the widower Luigi di Bernardo di Lapo Niccolini (1442–1505), who belonged to a family

of Medici supporters that lived in the neighborhood (Luigi's uncle Otto had been Cosimo's trusted advisor). Not much is known about Luigi, apart from that he was a silk merchant, that his drapery shop and house were close to Verrocchio's, and that he served the republic during a trying moment of political unrest. He was the chief magistrate, or *gonfaloniere*, in May and June 1478, right after the Pazzi lead a conspiracy against the Medici. On Sunday, April 26, 1478, during Mass in the cathedral, Giuliano was killed and his brother Lorenzo wounded. Later, the conspirators were caught, and one of them, Bernardo Baroncelli, was hanged at the Bargello on December 29, 1479. Leonardo sketched Baroncelli's body and wrote a lengthy note about his attire— the third of his notes to have been firmly dated.

Luigi married Ginevra on January 14, 1474, only six months after his first wife's death, and received a sizable dowry of fourteen hundred florins. As was often the case in the Renaissance, their marriage sealed well-established relations between the two families. Both families sent their girls to board at Le Murate. Both had their family tombs a few feet away in the church of Santa Croce, in the north transept, just off the main chapel. Both often shared the services of the notary Ser Simone Grazzini di Staggia, who drafted the marriage agreement between Luigi and Ginevra as well as the wills of their respective fathers.

Though the wedding took place according to long-standing custom, the portrait Leonardo made of Ginevra can hardly be called a marriage portrait. The expectations of a wife at the time were that she would dedicate herself to giving birth, raising children, and being chaste outside marriage, all virtues a marriage portrait represented. Intellectual pursuits were not intended for married women. And yet those were precisely what Leonardo chose to represent when he was asked to portray his friend's sister. At a minimum, Leonardo was familiar with the environment in which Ginevra was brought up because of his friendship with her brother Giovanni. At a maximum, he was aware of the

specificity of her intellectual interests as well as her role in Florence's cultural sphere.

Giovanni, for one, interacted with intellectuals in the orbit of the Platonic Academy. Many among them were committed to promoting the use of the Italian language, especially the Tuscan dialect, in writing about literature, philosophy, and science. They hoped that Italian would replace Latin as the language of culture, and they took as their mission translating Ficino's writings as well as a myriad of other science books dealing with cosmology, astronomy, and cartography by famous authors such as Ptolemy, Pliny, Gerard of Cremona, and Isidore of Seville, as well as by obscure ones such as Sidrac and Alfagrano. Some of these literary men were Dante experts. Some wrote poems in the vernacular. All were versed in optics. Many had either direct or indirect relations to the Benci, or to people Leonardo knew. In other words, all were within Leonardo's orbit.

Leonardo read and owned Italian books translated by members of this group. Cristoforo Landino (1424–1498) was Giuliano and Lorenzo de' Medici's tutor but also the translator of Pliny's *Natural History*; he also wrote six poems extolling Bembo's love for Ginevra de' Benci. Francesco Berlinghieri translated Ptolemy's *Cosmography* from Latin into Italian.

Others were versed in topics that were of great interest to Leonardo. Antonio Manetti was regarded as an influential "master of optics" of his day, his library a trove of literary rarities and obscure scientific texts, including books Leonardo read and owned. Manetti had been Brunelleschi's good friend and the author of the architect's first biography, but he was known mainly for having used optics to explain confusing passages of Dante's *Comedy*. Dante had described the shadows that the mountains of Hell cast on one another, and Manetti applied the rules of optics to these shadows in order to map Dante's infernal rings, which nobody had been able to fully understand before. For Manetti, optics was an instrument of literary criticism.

Then there was the humanist Giorgio Antonio Vespucci (1453–1512), a legendary educator in Florence. One of his nephews, Piero Vespucci, was married to Ginevra's aunt Caterina; another nephew was the explorer Amerigo Vespucci, who had Giorgio as his teacher. The Vespucci and the Benci bought country properties from and sold them to one another. In general, the Vespucci were great patrons of the arts with an interest in innovative works, and while they did not employ Leonardo, they did commission frescoes for their family chapel from a young, innovative painter who knew Leonardo well, Domenico Ghirlandaio. Botticelli dedicated to Giorgio Antonio his drawings for Dante's *Comedy*. It is documented that years later Leonardo was in close contact with members of the Vespucci family, but it is not impossible that he knew some of them as early as the 1470s through the Benci family or his artist friends.

We know Leonardo was familiar with Toscanelli, who was at the center of this group of science-minded Florentines, and we know that the artist owned Toscanelli's handwritten notes on burning mirrors.

In addition, an early biographer reported that Lorenzo de' Medici invited Leonardo to the garden of San Marco, a property near the monastery of San Marco and the Medici palace, where the Medici displayed their collection of ancient works; visits to that garden would have provided Leonardo with additional opportunities for close knowledge of cultural and artistic matters in Medici circles. And, of course, Verrocchio was the Medici's favorite sculptor. Recently, the art historian Cecilia Frosinini has argued that "Leonardo's entry into the houses of the Florentine merchant aristocracy can be explained as an introduction warmly supported by [Lorenzo] the Magnificent."

It should be made clear that Leonardo never participated in a platonic banquet. But the circumstantial evidence above suggests he may well have known some of the people who did, especially those who had strong interests in optics (Manetti), or who were close to him in age (Giovanni de' Benci and Giorgio Antonio Vespucci), or who translated some of the books he read (Landino, Manetti, Berlinghieri). It is documented that later in life he did read the ancient and medieval

authors (Pliny, Plato, Ptolemy, Isidore of Seville, Gerard of Cremona) that members of this science-minded group translated in the years in which he was in Verrocchio's workshop. Perhaps he even flipped through some of these books as soon as they were translated in the 1470s.

At the very least, like any Florentine with a passing interest in cartography, astronomy, optics, vernacular poetry, and politics, he was familiar with the main ideas discussed in Platonic and literary circles and had heard, at least superficially, about platonic love and chivalric poetry. He was in Verrocchio's workshop when his master designed the banner for the joust Giuliano de' Medici dedicated to his platonic lover. This cultural milieu that blended poetry, love, religion, and optics informed Leonardo's portrait of Ginevra, whether or not Bembo was the patron who commissioned it.

Leonardo painted Ginevra wearing a simple woolen dress with a chaste, square neckline, called a *gamurra*, and beneath it a thin undergarment fastened with a button, called a *converciere*. This was not an unusual dress for women of her standing. Verrocchio had portrayed a woman in a marble bust who wore exactly the same attire as Ginevra. But unlike most women, Ginevra wore above her dress a dark scarf. This scarf seems to resemble the long scarves nuns wore over their tunics, a scapular, which some laywomen put over their dresses as a demonstration of piety. If indeed Ginevra wore a scapular, as it seems, this scarf revealed more about her than any coat of arms or jewels or broad-sleeved brocaded dresses. Just as her poem revealed a creative mind and independent spirit, the scarf revealed another aspect of her personality: that she lived in the world but followed the rules of the convent.

The scarf had to be perfect.

Carefully, Leonardo sketched the dress's neckline directly on the panel using a pencil. Then he outlined the scarf with large brushstrokes

of brown wash but did not finish it. Instead, he went back to the dress, which he worked up to the edges of the dark stole; only when he was done with it he did return to the scarf, which he painted in black.

Although most likely Ginevra owned jewels, Leonardo did not paint them. Whether he did so simply to defy tradition or to avoid the distraction caused by jewelry—as we have seen, he thought that "the resplendent beauty of youth loses its excellence through excessive devotion to ornament"—we will never know. But a young woman without jewels was a rarity in Renaissance portraiture.

Ginevra's face was a challenge. Leonardo had no trouble representing her in a three-quarter position, taking his inspiration from the work of Northern artists, but he did not paint her with the downward gaze that those same artists, especially Petrus Christus and Hans Memling, had selected for their sitters.

Ginevra gazed at the viewer frontally, or almost frontally.

He made a detailed, full-scale preparatory drawing of her face. Though the drawing is now lost, we can surmise that he made one because we can still see on the panel the tiny dots of carbon he used to transfer the drawing. He sought to capture on paper as precisely as possible each curl of her hair, each fold of the nostrils, the lips, the eye sockets, the tear ducts, the jawline, every single detail of her face and neck. When he thought he had gotten the pose right and captured the right details, he transferred the drawing from paper to panel with the spolvero technique

he had used for the *Annunciation*, as revealed by recent infrared photographs.

But he was not pleased with the result.

Infrared photography reveals that Ginevra's head and gaze were once oriented slightly more to the side. Her curls were closer to her cheeks and forehead, and her face was slightly narrower.

Leonardo retouched Ginevra's face over the imprimitura. He moved the part line of her hair a tad toward the center. The whole face now looked a bit more frontal. He pushed the curls slightly to the side. The face looked wider. Because of these minute adjustments, her gaze was no longer aimed downward, although it did not address the viewer directly, either. She looked off into the distance, as though she were thinking about something.

In the background, he sketched a hilly landscape with water, not dissimilar to the one he had created for the *Annunciation*—but soon he

realized that the landscape did not suit Ginevra's portrait. Such a backdrop would not allow enough natural light to wash over her face and create minute shadows on the moonlike color of her skin, on her eyebrows, lips, chin, cheeks, and neck. The landscape was too distant from Ginevra's head. It was also too light to serve as a backdrop for her face. It did not create the contrast that was required to render her pale flesh tones and the subtleties of her face.

What would be an appropriate backdrop?

A bush.

A bush placed midway between her and the landscape.

A bush with spiky foliage that would let natural light from the landscape percolate delicately through small openings between the needles.

A juniper bush, to be exact. It would be a pun on her name, since the word "juniper" (*ginepro* in Italian) shares the same root as her given name, Ginevra.

Leonardo sketched a juniper bush around Ginevra's head and neck and all the way down to her shoulders. He sketched it rapidly, with rough and imprecise brushstrokes, and the result was a dark, unrefined, almost unsightly mass of brown color that modern infrared photography has made visible beneath the pigments. Those wide brushstrokes are quite uncharacteristic of Leonardo, but we have to understand that he meant them only as a guide for shaping the bush, not as a final, visible layer.

It is a good thing that he did not paint the bush fully. He had miscalculated its size. It was too large. It blocked too much natural light.

And so Leonardo resized the juniper bush.

He covered the area between Ginevra's neck and left shoulder with a base pigment, and painted on top of this base a more expansive view of land and water. The bush shrank, and the landscape expanded. If we look carefully at the area between Ginevra's face and the landscape, we can detect a darker patch (made visible by aging) that is now covered with blue but that originally displayed the base color for the larger bush.

Once he settled on a bush of the right size, Leonardo painted individual needles with a copper resin pigment, creating delicate shades of bright green. The green has darkened considerably since Leonardo's time, but it was bright and intense when Leonardo applied it. To show clearly how natural light passed through the needles, he added a few branches at the top of the bush, against the sky. He painted these branches directly against the blue sky, and because their contours were

a little too stark in the bright sunlight he smeared them with his fingers, adding texture to the paint.

Everything looked much better. Sunlight reflected off water and land and scattered through the atmosphere, filtering through the juniper's foliage to Ginevra's face, which was bathed in soft light. Her head cast a dark but subtle shadow over her neck—a marvel in its own right, as were the edgeless shadows on her face. Skin was for Leonardo "a bit transparent." Pleased, he applied the final layers of varnish.

But the painting was not yet finished. He turned finally to the eyes. The eye was "the window to the soul" and "the primary means by which the common sense [*sensus communis*] of the brain may most fully and magnificently contemplate the infinite works of nature." Thin lines of brown and gray paint delicately portray eye sockets and tear ducts.

The portrait was finished.

But convention, as we have seen, dictated that the reverse of a woman's portrait include references to the sitter's chastity. Could he invent a sophisticated image and motto, an emblem, to celebrate a woman who was devout, pious, and virtuous, but who was also a poet?

Yes, he could.

Porphyry, a purple marble from Egypt, was the material reserved for emperors to single them out among their subjects. Only emperors were buried in porphyry sarcophagi. For the same reason, Verrocchio used porphyry for Medici tombs, to single them out among Florentines. But porphyry was also a common material in artists' workshops: as the hardest marble, it was the preferred material for the pestle on which artists ground pigments. Leonardo, who spent long hours grinding colors on a porphyry slab as part of his apprenticeship, and who possibly helped out with polishing porphyry for the Medici tombs, knew the texture of porphyry well. He painted a porphyry trompe l'oeil as the background of Ginevra's reverse to single her out among women of her time, just as emperors were unique among their subjects and the Medici among Florentines.

A laurel wreath had been the symbol of poetry since antiquity. An-

cient poets were crowned with laurel, and so were Dante and Petrarch, the great modern poets who wrote in Italian. Leonardo painted a laurel branch over the porphyry trompe l'oeil to signal that Ginevra was a poet.

A palm was the plant Christ held in his hand when he entered Jerusalem the Sunday before his Crucifixion. It had long been a revered Christian symbol. Leonardo painted a palm branch next to the laurel wreath to show that Ginevra was pious. He positioned the two branches so that they formed a perfect circle: one half stood for piety, the other half for poetry.

A thin juniper sprig painted between the symbols of piety and poetry made clear these qualities referred to Ginevra, the yin and yang of her personality.

A beautiful ribbon that almost resembled a roll of paper, a banderol, was entwined among the branches with a motto: "Virtue and Honor" (*Virtus et Honor*). Together with the plant symbols, the motto pointed to the fact that, contrary to expectations of the time, Ginevra's honor and virtue resided precisely in her piety and in her poetry, that a respectable woman like her could be pious and artistic, and that these aspects of her persona were not at odds.

It is odd that this emblem was associated with another poet: Bernardo Bembo, who had arrived in Florence as the Venetian ambassador shortly after Ginevra's marriage, and who sought out Ginevra as his platonic beloved.

Prominent members of the Platonic Academy wrote ten different poems about this love. Landino sang of "the chaste love of Bembo" for Ginevra and praised her for her unsurpassed "chastity, beauty, kindness, moderation, and pure morals." It has been suggested that Bembo, who was peerless at self-promotion, commissioned the poems himself.

The emblem on the reverse of Ginevra's portrait, which was associated with him, has led some to believe that Bembo commissioned this painting. Indeed, Bembo used the emblem to mark books from his

private library, and he had it displayed on Dante's funerary chapel in Ravenna, whose restoration Bembo had financed.

But whose emblem was it? Ginevra's? Or Bembo's?

According to Renaissance conventions, the reverse of portraits referred to the sitter, not to the patron. It extolled her qualities, not the patron's. The emblem was Ginevra's. It referred to her accomplishments and desires, and it referred to the sophisticated Florentine cultural milieu of which she was a part.

Whether Ginevra was pleased to be Bembo's platonic love we do not know. We do not even know how she settled into her role as Luigi's wife. She did not have children. In 1490, when she was thirty-three years old, an unidentifiable admirer who was a viola player and who signed himself as "G+H," suggested in a letter that she chose not to have "descendants": "Your Magnificence," he wrote to her, "from excessive haughtiness [you] refuse to present us mortals with descendants— well, you keep it and let it be yours [have it your way]."

What we know is that in 1480 her health was poor and she was "in the hands of doctors." We also know, from a sonnet he dedicated to her in the late 1470s, that Lorenzo de' Medici hinted that she "fled the city which is aflame with every vice" and that she "should never turn [her] gaze back to it." He did not specify where she fled. Nor did he say why she fled. He borrowed Saint Paul's words to remind her that "people imagine vain things" but that she should "let them talk, sit and listen to Jesus."

Ginevra may have chosen to move to one of the Benci properties in the countryside. Lorenzo addressed her as a devout spirit, a stray lamb rescued by the divine Shepherd who "finds you and takes you gladly in his arms." He praised her new circumstances, her "newly devoted ardor" in which "no suspicion, disdain, envy, or anger" have a place. "Follow where the voice of the Shepherd softly calls [. . .] and draws you," he wrote.

Later in life, Ginevra lived at Le Murate as a tertiary, or *commessa*, which means that she remained a *gentildonna*, a secular woman, and did not take the full vows but did choose to "join the college" and follow the nuns' routine of prayer, labor, and reading. Like her father, she chose to be buried in the nuns' church, "in a tomb set aside specifically for tertiaries so that at their death they can partake more fully of their religiosity," as a chronicle for Le Murate specified.

At some point, the motto Leonardo had chosen for her portrait's reverse—*Virtus et Honor*—was replaced with another inscription: *Virtutem Forma Decorat*, or "Form Adorns Virtue," which on its face seems even more attuned to the rhetoric of a platonic beloved. But the new motto was as much about Leonardo as it was about Ginevra. The painter was the one who was able to make visible Ginevra's virtues thanks to his skills as an artist at depicting her beauty, which was, in turn, a manifestation of her soul.

She was no bride, no platonic beloved, no idealized beauty. Just herself, lost in her own thoughts at a fundamental juncture of her life, when her inclination toward poetry and her pious disposition clashed with the expectations society and her family placed on her.

That's the inner portrait of Ginevra that Leonardo delivered with his new way of painting.

///

The Unfinished Painting

For centuries, ever since Christian theologians began to stress the need to teach religious stories to as wide a public as possible, painting was fulfilling a role it had never been suited for—storytelling. This approach continued to persist down to the Renaissance. Although by that time there were pocket-sized editions of the Bible translated into the vernacular, most people could not read even those, while religious services continued to be conducted in Latin. So it continued to fall to art to transmit Bible stories to the majority of Christians. That was why religious paintings always seemed so teeming with details. To understand them, viewers had to find the visual plot (the storyline) and follow it through both the time period and the space the work covered. People in the Renaissance knew how to look for the main thread of a picture, and they had no trouble "reading" these paintings and deciphering the stories they told. Put more simply, they did not see art the way we do. They read art in a way we no longer can.

Leonardo had no problem painting biblical scenes that told a *storia*. He continued to do so throughout his lifetime. But having had a new conception for art that would seem to stop time to reveal the soul, he found himself facing a dilemma: how could he reconcile storytelling with a focus on the inner lives of the people he painted so that those who looked at his figures would be moved to experience feelings like

theirs? As he put it later, he wanted his figures to "move those who behold and admire [his narrative paintings] in the same way as the protagonist of the narrative is moved." But he was also fully aware of another truth: "I have universally observed among all those who make a profession of portraying faces from life," he wrote, "that he who paints the best likeness is the worst of all composers of narrative painting."

His first painting, the *Annunciation*, revealed an artist still grappling with Renaissance rules for how paintings should be executed and with his own instinctive sense of what makes a painting great—and how to employ optical effects to reveal states of interiority. He made some mistakes, but he had become proficient in the oil technique and had learned how to combine corpi, mezzi corpi, and glazes, and to paint delicate objects such as Mary's veil. But apart from moving traditionally interior scenes outside, he was very much still locked into the conventions of traditional Renaissance painting.

With *Ginevra*, he had broken free, and the results were stunning.

Could he also break free with narrative paintings? Could he create not just a psychological portrait but a psychological narrative, one that served the needs of the church while also moving its viewers, telling them something profound about the world and their place within it?

This dilemma came to a head when Leonardo perhaps least expected it to—when he accepted a commission with the potential to fully confirm his skills as a painter. It was around the year 1480. Now he would interpret in his own way the biblical story of the three wise men from the East who came to Bethlehem to adore the Christ Child—the *Adoration of the Magi* (Figure 6).

The evidence suggests that Leonardo was eager to paint the *Adoration*, and that he worked on it incessantly for roughly two years, which is why what happened next is so mind-boggling. Until he had to actually *paint* what he had conceived and fully sketched out, he had been deeply involved in the work, employing to the fullest his remarkable talent for drawing. After completing his brilliant preparatory work for the *Adoration*, he did the unthinkable.

He walked away.

Today, just as he left it, the *Adoration* hangs in the Uffizi Gallery, alongside paintings he did finish. Until a recent restoration, which removed layers of yellowed varnishes that had been added over the centuries, most visitors to the Uffizi rarely did more than glance at it before moving on. But the artistic community—both scholarly and practicing—has made it one of Leonardo's most studied works. Most come to study it because they believe that in its unfinished state, this painting takes us as close as we are ever likely to get to the mind of a Renaissance genius.

But we can get much closer to that creative mind—much closer to understanding what made Leonardo Leonardo and how he changed Renaissance painting—if we turn our gaze away from what he accomplished in this would-be painting and focus instead on what he failed to do, and why he failed to do it. Why could he not finish a painting he was so eager to paint? What stood in his way?

The Augustinian canons of the monastery of San Donato a Scopeto commissioned the painting for their church, which was in a remote location called Bellosguardo, which literally means "beautiful view," on the southerly hills of Florence. To get to Bellosguardo, one had to exit the city walls from Porta Romana, the south gate that leads to Siena and Rome, and take a difficult walk along a steep and winding road to the top. The trip was taxing for both people and horses, but the setting was ideal for prayer and spiritual concentration and the view from on high was breathtaking: the city laid open with its red rooftops aligned along narrow streets, the cathedral's dome and the Signoria palace in full view.

The view has hardly changed over the centuries, but the church is long gone. In 1529, the Florentines themselves destroyed it, together with everything else that stood on those southerly hills, to keep the army of the Holy Roman Emperor Charles V from using it for shelter during a siege. All that remains today are stacks of dark building stones amassed in the place where the church once stood, and a few columns that were temporarily brought to safety—together with the Augustinians

themselves—inside the walls of the city before the siege. Leonardo's painting was to be for the main altar of this rural church.

When he got the commission for the *Adoration*, Leonardo was about thirty years old and had some presence in the city's artistic milieu. He had also had some contact with the law. In April 1476, he was arrested on charges of sodomy, together with three others, one a well-off young man related to the Medici. The group was acquitted. In the judiciary record it was reported that Leonardo "is with Verrocchio" (*sta con* Verrocchio), which meant that he had stayed in Verrocchio's workshop as an independent artist. Five years later, in April 1481, another judge forced him to compensate a tailor for an extravagant cut of green satin the artist had failed to pay for. But, as far as we know, his career did not suffer from these events. In fact, quite the contrary. At age twenty-four, Leonardo was regarded as one of the best artists in the city. In 1478, the Signoria, which hired only the best artists, commissioned from him a painting for a chapel in their palace. As far as we know, Leonardo did not even get started on this public work, which would have further enhanced his fame; years later, he had to return the advance of twenty-five florins he had received for it. He was not chasing fame and money, after all. He was more interested in testing the limits of his new way of painting.

The *Adoration* would become *the* new challenge for him.

He was so eager to paint it that he accepted unusually harsh terms. He agreed to deliver the painting within twenty-four months, or "[thirty] months at the most," which was an aggressive schedule for a large altarpiece, and to "forfeit all his work" if he failed, leaving to the Augustinians the option to "do with it whatever we wished." He would be paid a sum of 300 florins over a period of three years, which was a respectable amount (most altarpieces of similar size cost about 100 florins, although there were exceptions, and a handful of painters were paid as much as 400 or 500 florins). The oddity was that this sum came as expected revenue from one of the canons' properties. Even odder was that Leonardo could use only 150 florins of that revenue to cover the cost of the painting, including colors and materials, because

the Augustinians had previously allocated the remaining 150 florins for the dowry of a destitute girl; they wanted Leonardo to meet payments for the girl's dowry in their stead. In short, Leonardo received no cash in hand and had to pay up front for materials, including expensive colors such as lapis lazuli, ultramarine, and gold, and he had to pay installments of the dowry.

It is hard to imagine that his father, who served as the monastery's notary from 1479 onward, would have advised him to accept this contract. Most likely, Ser Piero intervened to convince the patrons to ease the terms when his son could not meet his contractual obligations; indeed, the patrons sent the artist "a barrel of red wine" and "a hopper of wheat" to help him make ends meet. They also agreed to pay a bill for pigments Leonardo had obtained on credit from the Gesuati, the monks who were apothecaries and made the highest-quality pigments in Florence. They also were willing to advance twenty-eight florins from their own reserve for the payment of the dowry because, as they themselves admitted, "time was passing by and such a late payment [from Leonardo for the dowry] was reflecting badly on us." The canons were as eager as Leonardo to see the *Adoration*.

The story of the Adoration celebrates the revelation of Christ's divinity to the gentiles. It is known as the Epiphany, which comes from the Greek word *epiphaneia* and literally means "manifestation" or "appearance." Florentines had (and have) a special attachment to this story, and every year on January 6, the day the Magi arrived in Bethlehem, they reenacted the kings' journey in the streets, transforming them into locations in Jerusalem and the Holy Land. The costume parade ended in front of the cathedral, where a hut was built for the Virgin, the Child, and Joseph. Local Florentines acted as holy figures, and animals and hay were brought in to complete the scene. A confraternity of the Magi had formed to prepare for this event, and over time it had become one of the city's most powerful institutions. The Medici were members, as were all the leading families. It is likely that as a city resident Leonardo attended these processions and that he was familiar with the confraternity of the Magi.

Certainly, he was familiar with the versions of the story Florentine artists had painted. His peers had lavished their attention on the mesmerizing details of the kings' journey—their luxury brocades, their travel companions who chanted and played music as they rode, and the exotic animals that accompanied them. But, unlike his peers, Leonardo did not represent the story as a happy cavalcade touring through gorgeous landscapes—this approach stressed the pageantry of the event, not its spiritual significance. Nor did he represent bystanders next to the Virgin and Child as if they were calmly attending a regular church function, which is what Botticelli had done for the funerary chapel of a banker a few years earlier. Judging by the many different gestures of the figures Leonardo would paint, it seems he was more interested in how people reacted to the manifestation of divine truth.

The evangelist Luke had quite an interesting take on people's reactions to the Epiphany. Instead of writing about the Magi, Luke wrote about a group of shepherds who kept watch over their flock in the hills around Bethlehem and were visited by a divine messenger at night. "An angel from the Lord appeared to them," Luke wrote, "and the glory of the Lord shone around them; and they were filled with great fear." The angel spoke to them: "Fear not," he said, announcing that the Messiah was born; they would recognize him because he was an infant "wrapped in swaddling clothes and lying in a manger." An angelic choir appeared in the sky and chanted God's praises. After the angel left, the shepherds talked to one another and decided to proceed to Bethlehem, where they found the Child with his parents. They stayed to adore him and then left to disperse the news to the world. "All who heard it," Luke continued, "wondered at what the shepherds said to them."

Florentine artists and patrons had showed little interest in Luke's shepherds, but artists from the northern cities of Bruges and Antwerp had favored them. The scene offered the possibility of showing how a large group of common people, not just kings and notables, reacted to divine revelation; it was also more in tune with modern devotion that stressed individual, nonhierarchical ways of experiencing the divine.

The Augustinian canons were fully aware of the importance of individual experience, for their monastic order was a fervent supporter of devotio moderna across Europe.

To combine the traditional Florentine adoration of the Magi with the northern adoration of the shepherds was a major departure from the narrative sequence of the sacred text, which reported that the Magi and the shepherds adored the Child at different moments. But it was an artistic license an artist could take because it was eminently attuned with the way people in the Renaissance understood revelation.

What counted in revelation was not the chronological succession of events, because what was told was not a *storia*, a narrative. What counted in revelation was that brief moment when all possible clues from the past, the present, and the future come together to reveal a divine truth. If in order to convey this feeling an artist had to assemble a group of figures who had never historically been together, so be it. This was far from an esoteric position. None other than Bonaventure, a famous Franciscan medieval theologian whom Pope Sixtus IV canonized in 1482, had written that "the story does not always follow chronological order" but is nonetheless organized according to a system. That system is not chronology but rather "typology"—an arrangement according to correspondences, presupposing a deep similarity among events that on the surface appear unrelated. According to this line of reasoning, it was perfectly acceptable to combine the different times—past, present, and future—of a religious story in one single image.

The point was to show how people from all walks of life reacted to the manifestation of the divine. As Leonardo himself wrote years later, a great artist should aspire to represent as many different emotions as possible: "terror, fear, or flight or, indeed, grief, weeping, and lamentation, or pleasure, joy and laughter, and similar states." In his *Adoration*, some figures would kneel, like the Magi. Other figures would be shocked, just like the shepherds were shocked by the angel's apparition and the sudden light that broke out of the night sky. Others would talk to one another, and others still would be shown in the act of talking to

others, sharing the news around the world. Each figure would be different, for Leonardo remarked that a painter should never repeat "the same pose [. . .] in one narrative" or "the same movements in a single figure, be it in its limbs, hands or fingers."

His earliest sketches for the painting were beautiful pen-and-ink drawings in which he explored compositions that were closer to northern versions of the *Adoration*. In these, the Virgin knelt beside a Child lying on the ground. But he discarded them and settled instead for a more traditionally Florentine composition with the Child on his mother's lap.

But that is all he conceded to tradition.

He made sketches of the figures, first in the nude and only later draped in heavy cloaks, because a painter should "attend first to the movements appropriate to the mental attitudes of the creatures in the narrative." He studied them frontally and in profile or from the back, their arms crossed in front of their bodies or hanging beside them, their hands pointing to the sky or placed on their foreheads to shade their view. He studied their hands and their gestures, their bent bodies, their straight legs, their arms stretched out in the act of offering or held close to the chest in the act of prayer. Later, he made this recommendation to artists in training: "do not draw the limbs of your figures with hard contours or it will happen to you as to many different painters who wish every little stroke of charcoal to be definite"; in so doing, those mediocre artists create figures that have "a beautiful and graceful and well-defined rendering of these limbs," but those limbs do not move in a manner that reflects "the intentions of their mind [*i concetti della mente loro*]." He called these body movements of figures "the beauty and quality of their limbs."

He focused on the buildings in the background. He sketched a perspective drawing, which is perhaps one of the most spectacular perspective drawings of the Renaissance. Its size was almost exactly eight times smaller than the painted surface, which made for an easy enlargement process (the drawing measures half a Florentine braccia, or about 11.5 inches, and the painted surface 4 braccia, or about

92 inches). It took hours of work to draw each line with geometric accuracy and to mark the areas of most intense light with minute brushstrokes of whitewash. He positioned buildings at the sides to create a vast landscape in the center and added figures and animals. He was supposed to transfer this preparatory drawing to the panel using one of the techniques he knew well from previous works.

He did not.

The panel that sat in front of him was a large square of about ninety-six by ninety-six inches (today it measures ninety-six by ninety-four inches because a section at the bottom was cut out at some point). It was made of ten irregular planks of poplar wood, which had been patched together with glue, nails, and crossbars. Leonardo covered it with a thick layer of gesso, glue, and other materials to minimize any irregularities in the wood and squared the area he would actually paint by incising four lines around the edges (this area measures exactly four Florentine braccia, or about ninety-two inches). He proceeded to transfer the architectural drawing, and the first step was to fix the focal point of the painting, which he did according to the golden ratio, just as he had done in the *Annunciation*. He divided the panel into three rectangles based on that ratio, and used the same ratio to fix the painting's focal point. There he stuck a nail. Recently, restorers found the exact spot where Leonardo started his *Adoration* over five hundred years ago: a small hole underneath the brown paint of the tree trunk, right behind the Virgin. This was not just a tree. It was a reference to her descent from the biblical Tree of Jesse, the genealogy of the Child Christ.

As he had done in the *Annunciation*, Leonardo did not transfer the perspectival drawing of the architecture but opted instead to sketch the buildings anew, directly on the panel. He tied a string to the nail, stretched it toward some additional points he had marked on the panel's edge, which are no longer visible, and traced a line that corresponded to the stretched string with the help of a rod. The operation was laborious, but the first line of his *Adoration* was drawn. More than one hundred additional lines had to be drawn, and those were just for the buildings, not for the figures. No wonder he cut corners. Some

geometrical lines he sketched freehand—no ruler, no rod, no string, just his eyes, which were good enough for making approximations. He had learned from Alhacen about "visual illusions" and about the limits of what the human eye can detect. No viewer would have been able to notice that the lines of his architectural background were not mathematically precise, but everybody would have been under the illusion that they were. As he proceeded, he repositioned things. The big building on the left he redrew to free up space for a broader landscape, and he got rid of the central hut altogether as it was too intrusive. In its place he sketched a big rock and two trees.

When he started work on the figures, he changed pace. He was a compulsive draftsman, and that immense surface, covered in white gesso, marked only with skeletal geometrical lines, had an irresistible pull for him.

Although no artist had ever drawn an entire composition directly on a panel, certainly not on a panel of that size, this is precisely what he did. Infrared photographs taken in preparation for the recent restoration are revelatory. They allow us to "see" how Leonardo sketched on

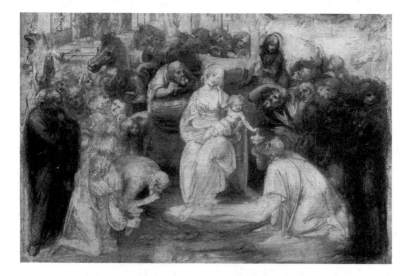

the panel without much of a fixed plan—freehand, no cartoons or other aids, just following his fancy as the figures emerged from his mind.

At first he sketched in soft chalk, since chalk marks can be erased easily with feathers, but soon he moved to metal point, which is unforgiving. Metal point is a black chalk with such a fine point that it looks like metal and leaves faint silvery traces. It requires a slightly rough surface, such as paper prepared with some wash of color, or a gesso panel, for the particles of metal point to leave a mark on the surface. Metal point also leaves indentations no feather can erase. But Leonardo loved metal point.

He loved its thin lines and subtle grooves. He loved to draw again and again over them without losing track of what was underneath. He loved to rework figures, sketching over a drawing he had just completed, the drawing underneath inspiring the one above, which would then inspire another that would replace it. He found this medium especially valuable for discovering the right movements and gestures, finding the best angles for his subjects' heads, which he preferred neither in full profile nor in full frontal view but rather in original, in-between positions. The selection of the best traits for each figure was mental before it was manual, as Leonardo scanned the web of lines he had drawn, the feeble traces of metal point that kept visible each successive stage of the drawing until one outline emerged out of the many he had traced—the right one to express what was on the figure's mind. For the *Adoration*, he repeated the same "scanning" operation for the more than thirty figures around the Child, plus many more in the background.

This was his method of working out figures, and years later he recommended that artists always draw with metal point on tinted paper: when you walk around, he wrote, "observe and contemplate the positions and actions of men in talking, quarreling, laughing and fighting together [. . .] in a little notebook [*piccolo libretto*] which you should always carry with you. It should be of tinted paper [*carte tinte*] so that you cannot make erasures." To draw this way was important because

"so great is the infinity of shapes and attitudes of things that the memory is incapable of retaining them all."

He sketched the central group of his *Adoration* with metal point freehand on the panel—the three kings, the Virgin, and the Child—and then traced their outlines with a thin brush dipped in black ink diluted with water. The ink strokes were quite rough, but in the finished painting they would look very different: they would be absorbed into the many layers of colors and varnishes he would apply over them, and their harsh outlines would be blurred with the background.

Around the central group, he sketched an adoring crowd composed of a number of dramatic figures (Figure 7). An old man covers his eyes as if to screen them from excessive light—for him, divine revelation is blinding (the recent restoration revealed a caption underneath this old man that identified him as "Giovanni," which may be a reference to

Giovanni Battista da Bologna, the prior of San Donato a Scopeto). Another man points his index finger up to the sky: revelation had come from there (Leonardo repeated this gesture in later works). Yet another raises his hand above his eyes to sharpen his view of the scene. A standing man at the left edge of the scene with his hand on his chin looks pensive; his reaction to revelation was introspective. A youth at the opposite edge seems to invite viewers into the crowd. Others ride horses; they lean to get a better glimpse of the scene to which they point. Others still talk to one another, their gesticulating hands and turned heads revealing the fervor of their conversation. Leonardo had studied this group in separate drawings and had originally sketched them debating around a dining table, subdividing them into smaller groups of three or four, their bodies turned toward one another, their hands in motion.

Eventually, he discarded these seated figures, but he did not forget them. He returned to them about ten years later, when he created his most dramatic psychological narrative, the *Last Supper.*

Who were all these figures in the adoring crowd? Shepherds? Members of the kings' retinues? Common people who received the news from the shepherds? Whoever they were, they were not the calm bystanders painted by Botticelli and other Renaissance artists.

Leonardo did not really know what to do in the case of many of these figures. Heads seem to be emerging everywhere—in the small space between the muzzle of a horse and the raised hand of another figure, for instance. Another head with beautiful curly hair appears as a faint image, almost a ghost, but its expression is one of rapture, and nearby figures turn to witness the ecstasy of divine revelation. Infrared photographs show even more heads, which Leonardo discarded.

Before he finished defining every figure, Leonardo moved on to the next step in his process.

He identified the areas of the panel that would be in full light and applied a splash of gray-white wash. These areas included Mary's head, bust, and arm; the Child's head; the faces of the figures around the Virgin; the backs of two kneeling kings; the head of a horse on the far

left; the rear of another horse in the background. But he did not paint highlights or reflections immediately. Instead, he began with the deepest shadows. Using a diluted greenish pigment, which has since oxidized and looks brownish today, he marked eye sockets, skeletal cavities, drapery folds, and mountains.

Leonardo thought about the *Adoration* in terms of extreme lights and extreme shadows, which—he knew—he would blend seamlessly into each other as the painting progressed.

One of the most revealing details in this regard is the hand of an old man (Figure 7). It is made of only two stripes of color, one very dark, the other very light. Leonardo's plan was to blur them into the layers of colors and varnishes he would apply over them. But he never reached this stage. We can get a sense of how he might have completed this hand if we look at Mary's outstretched hand in the *Virgin of the Rocks* (Figure 10), a painting Leonardo started right after he had abandoned the *Adoration*.

That Leonardo thought about the principles of optics while painting the *Adoration* is confirmed by recent X-ray analysis of his pigments. For the shadows, Leonardo used one single greenish color made of the same two pigments—copper green and an iron-based earth tone—which he diluted differently depending on the area he had to paint. He mixed the copper green with a greater proportion of earth tone to obtain a more brownish pigment, and with it he painted all the areas that were in deep shadow across the painting. He mixed the same green color with less earth-toned pigment to obtain a lighter brown, and painted with this all the areas that were a bit less in shadow. He used varying ratios of these pigments to capture different gradations of light and shade across the entire painting. Roberto Bellucci, who restored the *Adoration* in 2015–2017, explained that "Leonardo thought in terms of light and shadows since this initial phase." Leonardo saw the entire painting in his mind as a balance of light and shadow. For him, the *Adoration* was an optical problem.

About ten years after he abandoned the *Adoration*, he created a set of instructions for artists: "First give a general shadow [*ombra universale*] to the whole of that extended part which is away from the light. Then put in the half shadows and the strong shadows, comparing them with each other and, in the same way give the extended light in half tint, afterwards adding the half lights and the high lights, likewise comparing them together." But recent pigment analysis shows that he was thinking along those lines when he painted the *Adoration*. This new evidence raises a question: If Leonardo could envision the entire process he would use to paint the *Adoration*, why did he not finish it?

His problem was not a matter of *what* to do but of *how* to do it.

To be able to finish the painting, he had to know exactly what was going on around each figure and animal, which lights, shadows, and reflections would hit each of them.

The scene's main source of light was the universal light of the sky; he painted the sky with a thin layer of lead white mixed with a bit of lapis lazuli. Along the horizon he painted with more transparent colors, and while those colors were still wet he smeared them with his fingers, so that their shadows and variations appeared to be "fading into light, seeming to have no end [*che paia senza fine*]." It is impossible to determine exactly where one color ends and another begins, which is precisely how sky and land look from a distance, when they are affected by the atmosphere. He painted four trees, sketching them first with broad and imprecise strokes, just as he had sketched the juniper behind Ginevra's head, and then filled in the leaves one at a time. He nearly completed two of the big trees, but two small ones he only sketched.

Another source of light, most probably the sun, lay to the left, and Leonardo marked the shadows it cast from left to right on arches, stairways, and columns. He traced the shadows' edges with geometrical precision and then blurred them with his fingers to show that they were immersed in the atmosphere. He painted masterfully nuanced shadows on the undersides of arches. These shadowed arches would reappear decades later as illustrations for Leonardo's notes on "what part of a

body will be more illuminated by a light of even quality," which dealt specifically with outdoor illumination that combined direct sunlight and indirect light from the sky.

In his typically detailed prose, he explained, "The shadow made by

the sun, which is beneath the projections of the overhangs of buildings, gains in darkness with every degree of height."

The most perfect shadows are those on the backside of a rearing horse (Figure 8). He applied a light pigment made of lead white and just a bit of brown to mark the areas of the horse in full light, and added a broad stroke of darker brown for the shaded area. But unlike in other sections of the painting, he covered these pigments with thin layers of varnish to modulate the passage from light to shade. The horse's backside appears so beautiful and so regular that it looks like a perfect sphere. In fact, it is so masterly shaded that it recalls the highly nuanced spheres Leonardo sketched years later, around 1490, to illustrate his notes on shade and light, which he intended to include in his planned book on painting.

For some figures, such as the kings, the Virgin, and the Child, he painted the undermodeling—a substructure underneath colors and varnishes that gives volume to figures. Usually, artists created this undermodeling with a brownish wash, but Leonardo did things differently. He painted his undermodeling with a bluish wash, perhaps a

natural indigo dye. At times the wash was purplish; perhaps it contained a bit of red lac, the translucent, organic pigment that was exceptionally good for deep reds but that faded easily when exposed to sunlight. We do not know why he wanted his undermodeling to be bluish, but we know that he called it "the universal shadow" of a painting. He saw the undermodeling as the work's unifying structure, which raises an interesting question: did Leonardo think that a bluish wash was the best means he had to render pictorially the atmosphere that penetrates everything? We do know, at least, that Leonardo continued to paint the universal shadow of his works with a bluish wash.

This universal shadow is especially visible in another unfinished painting that was close in date and conception to the *Adoration*: Leonardo's *Saint Jerome*.

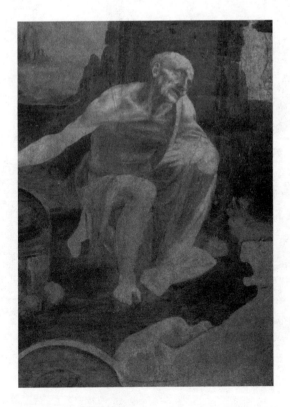

In this work, Leonardo conveys the saint's spirituality through his emaciated but anatomically correct body; Jerome's face displays the intensity of expression to which Leonardo must have aspired while painting the *Adoration*.

Another exquisite painting, a small devotional image of the Virgin and Child known as the *Benois Madonna* (after the name of a previous owner) that was likely painted around the same time, also displays the effects of light and color Leonardo must have had in mind for the *Adoration*.

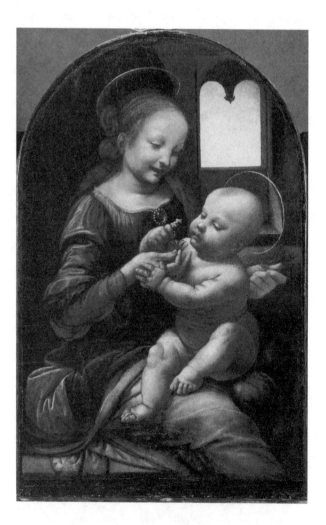

A universal shadow is also present in a beautiful sketch from those same years, the so-called *Study of the Madonna and Child with a Cat* (Figure 9). If he himself followed the recommendation he later made to artists, he based this drawing on rapid sketches made in metal point on the tinted pages of a small notebook he carried on his walks through the streets of Florence—perhaps he recorded the gestures and body motions of a toddler who played with a cat on his mother's lap. Back in the workshop, he reworked the composition and covered the figures' outlines with a brown wash to give a sense of the effect of the atmosphere. For Leonardo, outlines were not meant to define color fields or to separate figures—they were malleable boundaries meant to be penetrated by his universal shadow.

These three works, however, are all small panels and sketches with a limited number of figures; in one, the *Benois Madonna*, the scene is indoors; in another, *Saint Jerome*, rocks transform the outdoor space into a closed enclave. The *Adoration*, populated by many figures, set entirely outdoors, posed a much greater challenge.

Leonardo had conceived of his *Adoration* as containing over seventy figures. But this layout, as stunning and ambitious as it was, was still stuck in the storytelling traditions of Renaissance painting. Those traditions had not in any way impeded his ability to structure the painting or to draw the characters the way he wanted to. But they stopped him dead in his tracks when he tried to *paint* what was in front of him. For a new Leonardo was now emerging, the Leonardo who wanted to capture the unique response of each and every character as he or she experienced this joyous, momentous event.

Practically speaking, a modern computer would be needed to plot all the vectors of light and shadow and their precise effects, especially on people's faces. Furthermore, those lines of light and shadow could be captured only if time stood still. Yet the way Leonardo conceived of the painting was far from static. It was meant to capture the escalating

excitement as the characters edged closer and closer to the manger to observe for themselves the baby Jesus in his mother's arms.

So what did Leonardo do when faced with this nearly insurmountable challenge? Did he look at the *Adoration* the same way eyewitnesses reported he looked at the *Last Supper* about ten years later, without touching "the work with his hand," staying "for one or two hours of the day only to contemplate, consider, and examine his figures in solitude, in order to judge them"? Did he ponder the figures he sketched on the gesso and above the imprimitura, the others that emerged through the net of drawn lines, and the ghostly figures that he had erased but that were still visible through the transparent layers applied over them?

He tried to make a few adjustments, and thanks to infrared photography we have a sense of what he did. The hut on the right side of the background had already been drawn and cast in shadow, but suddenly it looked like an unneeded complication. He deleted it altogether and put in its place a wide landscape that opened up the scene and threw diffuse light into the foreground, which helped to unify the picture.

And then there was that dynamic group of armed horsemen fighting with one another. He had captured the force of the fight, which symbolized the Christian struggle in the years after Christ's birth. He left horses and fighters lingering on the panel, unresolved, thinking perhaps the solution would come to him one day, as indeed it did. Twenty years later, he lifted the fighting horses from the *Adoration* and put them at the center of his *Battle of Anghiari*, making what had started as a background scene into an entire composition. It was a great idea, although he did not finish that painting, either.

He also tried to fix the adoring crowd on the right side of the panel. He had sketched too many people there. He covered the entire area with a thick layer of dark pigment, basically erasing everything he had done. He started over, and these new figures look very different. They emerge from the dark background thanks only to highlights in lead white that define the twisting of their bodies, the crests of the folds in

their garments, their hair. Leonardo painted them so differently that many art historians think he painted them some twenty years later. I do agree that Leonardo painted them last. But I do not think Leonardo painted them twenty years later. He likely painted them right before he abandoned the painting. Their different style may be evidence of a last-ditch effort to salvage the panel—and indeed, the unresolvable problem consisted of figuring out how to use atmospheric effects to realistically render human figures. This time around, Leonardo was confronting not just a handful of figures—Gabriel, Mary, or the Christ Child—but over seventy people and eleven animals. It was an optical problem of epic proportions, and it demanded equally epic ingenuity.

Amidst his figure studies for the *Adoration*, he sketched an instrument to measure air pressure (or, as he put it, "to weight air and learn when it breaks the weather"). This instrument was far ahead of its time. It took another 170 years before Evangelista Torricelli invented the barometer to measure air and famously stated something Leonardo himself could have uttered: "we live submerged at the bottom of an ocean of air." Leonardo had only a rudimentary instrument, which consisted of a stick with a sponge at one of its extremities and a wax ball at the other. When the weather is wet or humid or hot, a sponge absorbs different quantities of water from the air, giving an indication, however imprecise, of the level of humidity and the "thickness" of the air. Why is this instrument sketched amidst figures for the *Adoration* if not as a testament to Leonardo's interest in atmospheric effects?

Once Leonardo put down his brush and walked away, however, he never looked back. As brilliant as the scheme was, the painting could not be salvaged. There was no way to paint that adoring crowd with the sophistication and optical rigor he had come to demand from himself. He had raised the bar impossibly high and come to realize that he could not accomplish a coherent treatment of both physical and spiritual light in a painting as complex as the *Adoration*.

He knew that portraiture and narrative painting were at odds—"he who paints the best likeness is the worst of all composers of narrative painting," he wrote. He had just learned this the hard way.

The Augustinians waited patiently for over ten years, hoping Leonardo would return to the work, but he never did. In 1496, they finally acquired an altarpiece from one of Leonardo's dear friends, the painter Filippino Lippi.

As for Leonardo, it took time for him to sort through the lessons from this frustrating experience. With the exception of the *Last Supper* and the *Battle of Anghiari*, where the demands of history had to be honored, Leonardo never again conceived a painting with more than four figures. Other artists followed his lead almost immediately, simplifying their own work dramatically. Big, celebratory narrative painting did not disappear—there was always a prince or a king who wanted his family's history represented in some pageant-like way, or a religious institution that wished to commission a painting representing the life of a saint or of Christ and the Virgin. But there was an unmistakable shift as more and more artists began to venture into psychological waters.

Leonardo would also never use layer upon layer of background again, nor fill it with figures. And he no longer attempted to traverse time or space in a painting but instead focused, laser-like, on representing a single moment. Even when he used multiple figures, there was always a focal point to the work, a place to which the eye gravitated because of some deep psychological pull. In his later works, he often selected details from the *Adoration*—individual figures, small scenes, an animal, specific gestures—and made whole paintings out of them. He learned to cut to the chase of a story, to eliminate extraneous details, and to concentrate on a select number of figures—often no more than one. He would set those figures in complex settings—in landscapes, loggias, or dining halls—but he would retain control over light

and shadow. He would no longer do what he had done in the *Adoration*.

One need only read the résumé he sent to the duke of Milan around 1483—a résumé that mentioned his skills as a painter only at the very end, saying simply that in painting he "can do everything possible as well as any other, whosoever he may be"—to understand how decisive the failure of the *Adoration* was. It is often said that Leonardo did not finish the *Adoration* because he left for Milan—but perhaps he left for Milan precisely because he did not complete the painting.

In any case, everything he painted after the *Adoration* suggests that it was this painting and his failure to complete it that forced him to rethink what he knew and did not know about the science of optics.

And what he learned would in turn lead him to rethink one of the core aspirations of Renaissance painting.

7

The *Virgin of the Rocks*

In 1483, or slightly earlier, Leonardo went to Milan on a diplomatic mission. Lorenzo de' Medici sent him there to present the duke of Milan with an extravagant gift, a silver lyre Leonardo himself had made "in the shape of a horse's skull." Leonardo found a bustling, cosmopolitan city of about 150,000 people with one of the largest markets in Europe—one could buy anything in Milan—and a powerful court that lay at the heart of the city's culture, politics, art, and intrigues. The duke resided in the imposing Sforza Castle, a fortress with moats, drawbridges, army barracks, artillery, and dungeons. Leonardo was called upon to play his unique musical instrument to entertain the Milanese court. But the man in his early thirties who arrived in Milan sponsored by the Medici hoped to get much more from the duke of Milan than a single audience.

His hope was to find work as a military engineer, as this was a well-paid position that would take him away from painting and from the creative impasse of the *Adoration*. He submitted a résumé to Duke Ludovico il Moro, claiming he had invented marvelous war machines to drain moats during a siege and unconventional weapons to destroy "every fortress or other stronghold." He could build portable cannons "to hurl small stones almost like a hail-storm" and "covered vehicles" to penetrate the enemy and their artillery as well as other unusual and

efficient machines such as "catapults, mangonels, trebuckets." It was at the end of this same résumé that he claimed he could paint as well as any man.

He was wrong on two counts. He was not a military engineer. He had no track record of building weapons or war machines, and so he found no employment as a military engineer, at least initially, and when he did years later he was tasked with building ordinary weapons such as cannons. The second lie was that he could paint as well as anyone: he had no equal as a painter in Milan, nor anywhere else in Italy. Painting would become his primary occupation in the city.

The first painting he delivered in Milan was a work the likes of which had never been seen—a psychological narrative that, in a single panel, with only four figures, emblematized a complex theological concept spanning the beginning of time until the moment of salvation, from creation to Christ's coming. Leonardo could accomplish this psychological narrative because he had mastered the art of condensing large spans of space and time—present, past, and future—into a single gesture, a slight turn of a head, a shadow (Figure 10). The painting represented a popular belief about the Virgin: that she did not carry the stain of Adam and Eve's original sin, which, according to Christian theology, all ordinary humans carry, because she was conceived before the beginning of time and before the creation of man. She was *sine macula*, immaculate, and did not require salvation because she had been born without sin in the first place.

This belief in Mary's Immaculate Conception, not yet an official dogma of the church, was hotly contested at the time.

By the time Leonardo painted his panel, this century-long theological dispute had resulted in clashes between the Franciscans, who supported this belief, and the Dominicans, who opposed it. Leonardo's painting was supposed to show what the Virgin's immaculate nature looked like, but he radically transformed the image in order to create a richly psychological narrative.

The Virgin and Child are the protagonists of the scene. They exchange glances and gestures with each other and with two additional

figures, an infant Saint John and an angel. But these sacred figures do not dominate the painting; the stratified rock formations in the background are the main attraction. The rocks are so mesmerizing that they gave their name to the panel: the *Virgin of the Rocks*. While there is still some debate over what story, exactly, Leonardo chose to represent, what is not a matter of debate is that this painting forever changed Renaissance art and made Leonardo's reputation among the powerful in Milan.

When Leonardo's patrons commissioned the work, they had no idea that his novel handling of light and shade would make visible Mary's grace in the world. Or that the reflections of the atmosphere, which the artist knew how to observe and paint so effectively, would become a metaphor for her role as the universal mediator of human salvation. Even more remarkable is the fact that Leonardo made a second version of the *Virgin of the Rocks*—quite an accomplishment for an artist who hardly ever finished anything (though, to be fair, he had his workshop partners paint most of it).

The story of the commission itself is straightforward, but what happened to the panel shortly after it was completed is still a mystery.

On April 23, 1483, Leonardo partnered with two Milanese painters, Giovanni Ambrogio de' Predis and his half brother Evangelista, to work on a major altarpiece for the Franciscan confraternity of the Immaculate Conception.

This lay confraternity had been founded in 1475 by a group of wealthy Milanese to counter the vitriolic attacks on the Immaculate Conception coming from Vincenzo Bandello (1435–1506), a prominent Dominican who had called the Immaculate Conception a "diabolical dogma" in a treatise he had written that same year. Twenty years later, in 1495, Bandello would become prior of the church of Santa Maria delle Grazie in Milan and play a role in Leonardo's *Last Supper*—but in 1475 his main focus was in the Franciscans. Pope Sixtus IV, who was a Franciscan and had been a devotee of the Immacu-

late Conception since his youth, promptly approved the new confraternity founded to rebut Bandello. Four years later, the pope granted it additional privileges and issued an official papal bull, written on a parchment that the brothers decorated lavishly with "their" image of the Immaculate Virgin.

In the image made by the brothers, Mary adores the Child as he lies on the ground. Her hair is loose and unveiled, her hands are crossed over her chest. Six angels appear in the scene: two angels play the lyre, two peer from behind the Virgin (one of them pointing to the Child), one angel holds the Child's head, and another prays with his hands clasped. The scene is set against a beautiful landscape: a view of rocky, stratified mountains on the left is balanced by a watery panorama on the right, while buildings, bridges, ships, animals, and small figures enliven the background. The image is filled with traditional Marian symbols—rocks, water, sea, iris—that were interpreted as references to the Immaculate Conception.

When the confraternity commissioned a painting for their new chapel in the Franciscan church of San Francesco Grande, which they had acquired in 1475 and promptly decorated, most likely they wanted it to be modeled after the image that appeared on their papal bull—this was their "official" image of the Immaculate Virgin. Indeed, in its contract with the artists, the confraternity specified that the panel had to represent "Our Lady with her son and the angels all done in oil to perfection with the two prophets painted on the flat surface in colors of fine quality" and that it had to be completed by side panels representing "four angels, each differing from one picture to the other, namely one picture where they sing, another where they play an instrument." The three panels that Leonardo and the de' Predis brothers had to paint, cumulatively, replicated the image on the papal bull. The panels were only part of an imposing wood altar, an *ancona*, that was divided into multiple sections and displayed wooden statues of the Virgin and God the Father as well as relief panels with stories from Mary's life. For eight hundred imperial lire, the artists committed to gild the entire ancona, paint the three panels, and complete their work by De-

cember 8, 1484, which was the feast day of the Virgin's Conception and the unofficial celebration of Mary's Immaculate Conception.

The artists were paid 40 lire each month, and by the end of 1484 they had received a total of 730 imperial lire, which was almost the entire agreed amount. This payment indicates that the artists worked at a steady pace, and that by then they were basically done with the work. Scholars wonder, though, how much of the work was actually complete, for disputes about compensation between the artists and their patrons arose in subsequent years. It is generally agreed that the gilding of the ancona was completed around 1484, and the two side panels in the early 1490s, but the question of the main panel remains unresolved. Was it delivered around this date, which would mean Leonardo painted this stunning panel at record speed—in just about two years? Or was it completed later? And if so, when was it delivered, if at all?

We do know, however, that what Leonardo painted was nothing like the image of the Virgin adoring her son that was on the confraternity's papal bull. Why and how did he ignore the confraternity's specific instructions on subject matter and even pigments?

In the panel he delivered, Mary is neither kneeling nor standing, but somewhere in between, and although it is unclear what she is actually doing, she is in motion, and she is most certainly not adoring her son. She turns her head slightly to the side and points her gaze diagonally toward her son, who sits in front of her but does not look at her. In profile, his legs crossed, he sits precariously at the edge of a precipice, directing his attention to the opposite side of the painting, to Saint John, whom he blesses with a gesture that has nothing of the lightheartedness of childhood and that foretells his dramatic future. Saint John kneels next to Mary, adoring the Child with clasped hands. Mary is between the children, one hand hovering over her son, the other embracing John. An angel invites viewers into the scene, directing his gaze toward them and pointing to Saint John with his hand.

FIGURE 1. Leonardo da Vinci, *Landscape of the Arno River and Valley*, 1473 (pen and two colors of brown ink, 19 × 28.5 cm, Florence, Gallerie degli Uffizi, Gabinetto Disegni e Stampe, 8Pr)

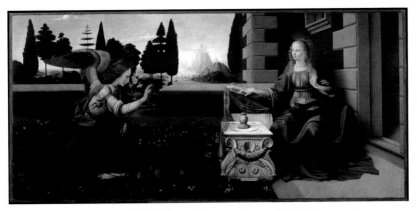

FIGURE 2. Leonardo da Vinci, *Annunciation*, ca. 1472 (oil on panel, 90 × 222 cm, Florence, Gallerie degli Uffizi, 1890 no. 1618)

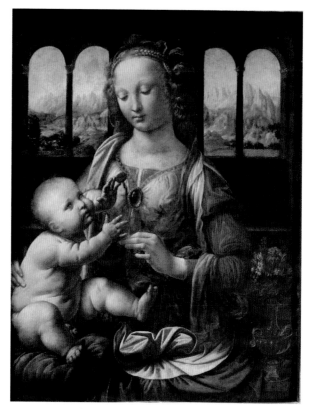

FIGURE 3. Leonardo da Vinci, *Madonna of the Carnation*, ca. 1475 (oil on panel, 62 × 48.5 cm, Munich, Alte Pinakothek, Bayerische Staatsgemäldesammlungen, 7779.
© *Alte Pinakothek, Bayerische Staatsgemäldesammlungen, Munich, Germany / Art Resource, NY*)

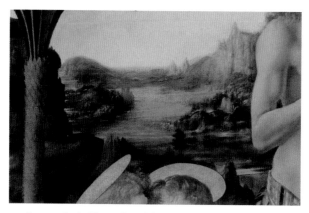

FIGURE 4. Leonardo da Vinci, detail from *The Baptism of Christ*, 1470–1475 (tempera and oil on panel, Florence, Gallerie degli Uffizi, 1890 no. 8358)

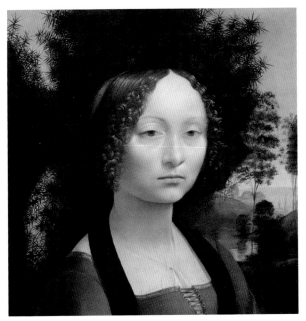

FIGURE 5. Leonardo da Vinci, *Ginevra de' Benci*, ca. 1475 (oil on panel,
38.1 × 37 cm, Washington, D.C., National Gallery of Art, 1967.6.1.a.
© *National Gallery of Art, Washington, D.C., USA*)

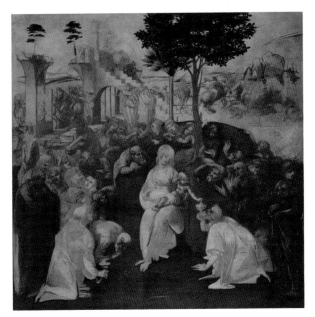

FIGURE 6. Leonardo da Vinci, *The Adoration of the Magi*, ca. 1482
(drawing in charcoal, watercolor ink, and oil on panel, 244 × 240 cm,
Florence, Gallerie degli Uffizi, 1890 no. 1594)

FIGURE 7. Detail from *The Adoration of the Magi*

FIGURE 8. Detail from *The Adoration of the Magi*

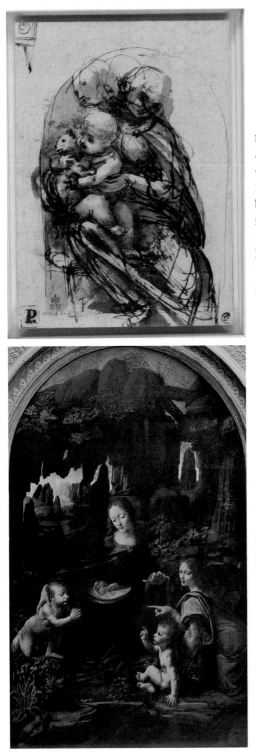

FIGURE 9. Leonardo da Vinci, *Study of the Madonna and Child with a Cat*, late 1470s–early 1480s (pen and brown ink, brush and brown wash over freehand stylus underdrawing, 13.1 × 9.5 cm, London, British Museum, 1856.0621.1v. © *The Trustees of the British Museum / Art Resource, NY*)

FIGURE 10. Leonardo da Vinci, *Virgin of the Rocks*, 1483–1485 (oil on panel [later transferred to canvas], 199 × 122 cm, Paris, Musée du Louvre, Département des Peintures, 777 [1599]. © *RMN-Grand Palais / Art Resource, NY*)

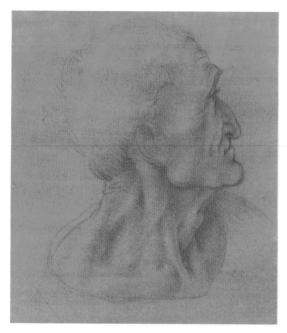

FIGURE 11. Leonardo da Vinci, *The Head of Judas*, ca. 1495 or later; outlines later retouched by Francesco Melzi (red chalk on red prepared paper, 18 × 15 cm, Royal Collection Trust, Windsor Castle, RCIN 912547r. *Courtesy of Royal Collection Trust / © Her Majesty Queen Elizabeth II, 2020*)

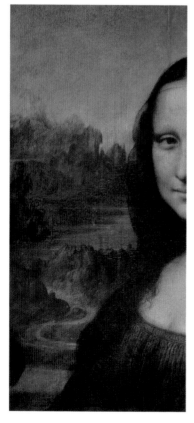

FIGURE 12. Leonardo da Vinci, detail from the *Mona Lisa*, ca. 1503–1517 (oil on panel, Paris, Musée du Louvre, Département des Peintures, 779. *© RMN-Grand Palais / Art Resource, NY*)

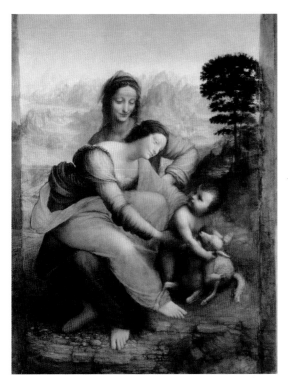

FIGURE 13. Leonardo da Vinci, *The Virgin and Child with Saint Anne*, ca. 1500–1517 (oil on panel, 168 × 112 cm, Paris, Musée du Louvre, Département des Peintures, 776. © *RMN-Grand Palais / Art Resource, NY*)

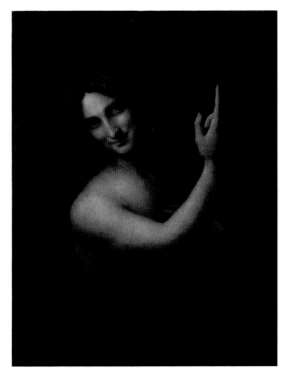

FIGURE 14. Leonardo da Vinci, *Saint John the Baptist*, 1510–1515 (oil on panel, 69 × 57 cm, Paris, Musée du Louvre, Département des Peintures, MR 318. © *RMN-Grand Palais / Art Resource, NY*)

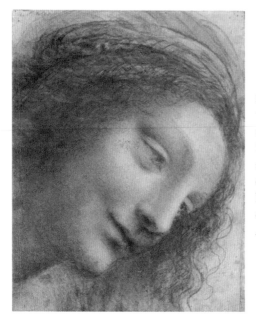

FIGURE 15. Leonardo da Vinci, *The Head of the Virgin in Three-Quarter View Facing Right*, 1510–1513 (black chalk, charcoal, and red chalk, with some traces of white chalk, 20.3 × 15.6 cm, New York, Metropolitan Museum of Art, 51.90. © *The Metropolitan Museum of Art / Art Resource, NY*)

FIGURE 16. Leonardo da Vinci, *The Alps Seen from Milan*, ca. 1510 (red chalk with touches of white chalk on orange-red prepared paper, 10.5 × 16 cm, Royal Collection Trust, Windsor Castle, RCIN 912410r. *Courtesy of Royal Collection Trust / © Her Majesty Queen Elizabeth II, 2020*)

Hands.

Leon Battista Alberti
had written in his essay "On
Painting" that hands are the
most effective way to indi-
cate the bond between fig-
ures in paintings. Verrocchio
had cast the hands of Christ
and Thomas one on top of
the other in his sculptural
group, and those hands tell
the story of their encounter.

Hands.

Clasped hands for a young Saint John, adoring another infant, hav-
ing recognized in him the presence of the divine.

A pointing hand for an angel beckoning the faithful into the scene.

A gesture of benediction from a child who, foreseeing his destiny,
already behaves like an adult.

A woman's hand wrapped around a toddler's shoulders to push him
gently in a new direction.

A mother's hand extended with palm fully open and fingers out-
stretched, hovering above her son, knowing she cannot protect him
from the unfolding of his tragic destiny.

Fingers that align with subtle body motions and slight turns of the
head.

The combination of backlighting with light from above, resulting in
shadows that fall underneath Mary's hand. Nobody had ever painted
such an expressive hand with such striking optical effects, although
many would in years to come.

What story, though, do these hands represent?

Although the Immaculate Conception was not official church dogma,
it had a liturgy of its own. The sacred texts that were to be read for the

Mass on the day of Mary's Conception (December 8) were traditional Marian texts from the Bible, from the church fathers, and from medieval mystical writers such as Saint Bridget. A Milanese expert in Marian theology, Bernardinus de' Bustis (1450–1513), had compiled these texts into the official liturgy of the Immaculate Conception, using as a model a famous sermon that Sixtus IV had written when he was a young professor of theology.

The liturgy for the Immaculate Conception opened with a passage from the Book of Proverbs about Lady Wisdom, a biblical prophetess who existed from the beginning of time and was present at God's creation. Theologians had always interpreted Lady Wisdom as a prefiguration of the Virgin. Both Lady Wisdom and the Virgin presided over the creation of the skies and the land; they were there before the beginning of the earth, before the heavens were established. In poignant verses, Lady Wisdom told about the time when she came to be:

> The Lord possessed me at the beginning of his work, the first of his acts of old.
>
> Ages ago I was set up, at the first, before the beginning of the earth.
>
> When there were no depths I was brought forward, when there were no springs abounding with water.
>
> Before the mountain had been shaped, before the hills, I was brought forth, before he had made the earth with its fields, or the first of the dust of the world.
>
> When he established the heavens, I was there [. . .].
>
> (PROVERBS 8:22–27)

Perhaps it was from these verses Leonardo got the idea that the Immaculate Virgin ought to be painted in the midst of a primordial landscape, where the earth had no fields, no springs, no mountains.

And no rocks, of course.

The rocks he painted were similar to those he had seen near Arezzo. They belonged to a single mountain chain that had broken down over

time, forming isolated and jagged peaks. Leonardo understood that "the stratified stones of the mountains are all layers of clay, deposited one above the other by the various floods of the rivers" and that "at the summit of the mountains we shall always find the division of strata in the rocks." He was among the first to have a sense that the physical earth had a history.

There were sedimentary rocks that showed different stages of erosion and conveyed the passage of time since the beginning of creation.

Peaks of sandstone that were cracked and had decomposed with plants growing in their interstices.

Subvolcanic, igneous rocks that formed high sills and looked like intruding black towers set against the blue sky—and were also perfect backdrops for the Virgin's head, her blond hair and fair complexion in perfect contrast to the dark stone.

A sort of cavern, like the cavern Leonardo had visited near Florence when he had stood "stupefied," both wishing to "see if there was any marvelous thing within it" and fearing its "menacing darkness."

In the painting, water cascades into this subterranean cavern to signify that Mary was the only one who had "penetrated the depths of divine Wisdom," and was the universal mediator of knowledge man could not otherwise access. The raw, unformed, rocky landscape also symbolizes the fact that Mary existed before creation.

The liturgy for the Immaculate Conception also included a famous passage from Luke recounting the words Gabriel addressed to Mary at the Annunciation: *Ave Maria, gratia plena* (Luke 1:28). These words proclaimed that Mary was filled with divine grace, and supporters of the Immaculate Conception interpreted them as a reference to her immaculate status: she was full of grace because she was without original sin. The liturgy explained that her name, Maria in Latin, corresponded to the Latin word for "seas," *maria*, and that because of these overlapping meanings her grace was often compared to the sea. In the words

of the liturgy's author, Bernardinus de' Bustis, Mary spreads divine grace throughout the world just as the seas gather water and return it back to earth for nourishment. Open seas and vast expanses of water had become Marian symbols in Christian thought and art, but some also interpreted them as symbols of her immaculacy: she lived in a primordial world, in which the waters had not yet been divided and no sin existed.

Could seas be painted in such a way that they recalled Mary's divine grace, which in turn would recall her freedom from original sin?

When Leonardo set out to draw rocks and caverns, he presumed their geological structure would help signify their age, and so he shaded them carefully in order to render their varied texture (recent infrared reflectography has made visible Leonardo's detailed underdrawing). He painted them with thin colors that contained minimal amounts of lead white because he wanted to modulate the appearance of erosion as carefully as he could. Those thin layers gave the landscape an even greater resonance than what we see today, since the colors have suffered over time and the rocks now look much flatter and darker than when Leonardo painted them. Among the rocks he painted bodies of water, and in front of them a meadow filled with flowers and other plants.

It took him time to develop this landscape. Mindful of the optical intricacies of outdoor settings, in which reflections from sunlight and the sky multiply infinitely, he painted a landscape that felt like an enclosed room and so simplified the reflections: it was as if the rocks were walls and the openings among rocks windows that opened to a distant view. Natural light filters through these openings, but another strong light source—the sun? divine light?—comes from the left, while the thick, moist, watery atmosphere envelops everything, its color fading away gently from a deep, saturated blue above the rocks to a subdued blue at the horizon.

One had to be an optical genius to imagine such a setting.

He painted the sky with a layer of azurite over a white primer, then applied lapis lazuli mixed with different concentrations of lead white (he had painted the sky in exactly the same way in his *Adoration*). He

used this same mixture to paint Mary's blue drapery, placing saturated colors in the most well-lit areas, which were also the most symbolically charged. Lead-tin yellow was the color he used for the bright drapery around Mary's womb, which he enlarged to evoke her miraculous pregnancy. He used yellow ochre for the delicate strands of golden hair and the nuanced shadows underneath his subjects' chins, effects that Leonardo had created in Ginevra's portrait and that he now repeated for the four figures in his *Virgin of the Rocks*. The contract specifically instructed him to render the golden edges of clothes with gold leaf and sgraffito, but Leonardo did not comply. He obtained the look of gold through the modulation of pigments and varnishes rather than using actual gold.

It is astonishing that he created these magical optical effects and these mesmerizing exchanges of glances and gestures with traditional pigments and varnishes. They looked even more astonishing in the dim light of the small chapel.

And yet the story Leonardo represented in the *Virgin of the Rocks* still remains unclear. What brought these figures together in this rocky landscape? At the very least, we can say that the scene he painted is not the one the patrons asked for in the contract. The contract mentioned two "prophets," which was a common way of identifying angels. But Leonardo painted only one. Instead of painting a second angel, he painted the infant Saint John. How was he able to ignore the patrons' specific instructions? The answer involves apocryphal writings about the lives of saints and Leonardo's affiliation with the city of Florence, whose patron saint was John the Baptist.

In popular Renaissance collections of saints' lives, such as Jacobus de Voragine's *The Golden Legend* and Domenico Cavalca's *The Lives of Saints*, which included the essay "Saint John the Baptist Who Stays Always in the Desert," Saint John was called the prophet who "announced the heavenly kingdom to us" and who was called "an angel in the flesh." To substitute Saint John for one of the prophets mentioned in the contract

was not so unorthodox, since the saint was called "the head of the angels." It was acceptable also from the standpoint of price, since the value of paintings was assessed on the number of full figures artists painted, and this substitution did not alter the number.

But there was another reason that this substitution was eminently fitting: a popular story told of a meeting between Christ and John when they were children in the wilderness. The story was considered apocryphal, since it was not mentioned in the Bible, but Florentines loved it. A Florentine author, Feo Belcari, wrote a popular play about the meeting. The Gospel of Matthew told the story of the holy family's flight into Egypt to avoid King Herod's "massacre of the innocents," but it did not mention their meeting with infant John in the desert. Belcari made this meeting the focus of his play. An angel appeared onstage to explain that the play took place in the desert, where John lived in his youth and where the holy family stopped on their way back from Egypt. For most of the play only the two children were onstage, conversing about their respective futures. Christ told John about his Crucifixion, and John knelt in adoration. When Mary and Joseph entered the stage, they embraced John. In the last scene, the angel appeared again to wrap up the performance and dismiss the audience. Florentine artists were inspired by this play and frequently painted the two infants in the desert with Mary; often, they added Joseph, or an angel, or another saint.

Leonardo knew these paintings, and possibly attended a staging of Belcari's play or read it in one of the popular, illustrated editions of the work.

But Saint John had also acquired a new, added significance for Franciscans and the supporters of the Immaculate Conception. While they believed that John was *conceived* with the stain of original sin, they also held that, unlike other humans, he was sanctified within his mother's womb and thus was born without sin. This meant that Mary and John existed in a hierarchy of sanctification: Mary was conceived sine macula, while John was conceived *cum macula*, but

later, before he was born, he was sanctified. Even though he was born without stain, like Mary, he still needed redemption because, unlike Mary, he was conceived with sin. Based on this theological view, Saint John was an eminently suitable addition to a painting celebrating the Immaculate Conception. His presence added theological depth while, at the same time, reinforcing the Virgin's unique role: unlike John, she was conceived without sin and, thus, did not need redemption.

It is possible that the patrons, who were well versed in the theology of the Immaculate Conception, came up with the idea to include John in the painting. But perhaps Leonardo inspired them.

Perhaps he showed them sketches from his Florentine years, in which he had explored a popular theme in Florentine art: Mary adoring her son. He had sketched her kneeling in different positions, her arms outstretched or folded over her chest, with her Child on the ground, either by himself or with the infant Saint John kneeling with his hands clasped. Perhaps he gently suggested that instead of painting multiple "prophets" it was better to paint only one angel and substitute John for the second, and that his sketches would work well as a model for their altarpiece.

Either way, what Leonardo delivered was a panel the likes of which had never been seen in Milan. He may have had in mind many texts and images—verses from Proverbs, Luke's writings, Belcari's sacred play, Renaissance paintings—but what he created was new and unique. And that is because he did not care about the story per se, about what happened when, or about who was present at each moment in time. What he cared about was that his patrons and viewers experienced divine revelation—by way of the most effective painterly means.

With the *Adoration*, he had learned that when it comes to portraying revelation, typology—the deep similarity of apparently unrelated figures and events—is more important than chronology, the temporal succession of events. This is because what is being presented is not a storia, a narrative, but a prefiguration that collapses time and space.

In the *Adoration*, he presented different moments of time on one panel. But in the *Virgin of the Rocks* he went further, collapsing time and space in the gestures of each individual figure. While the figures are physically present, together, in the rocky landscape, they also prefigure their futures and recall their pasts through carefully calibrated gestures, body motions, expressions, and glances.

Saint John recognizes the divine in the Child, and having foreseen the Child's future, he clasps his hands in adoration. The infant Christ acts like his adult self and blesses Saint John. The angel is either Uriel, the angel who guarded John in the desert, or Gabriel, the angel who protected the holy family during their journey, but since he was also the angel who announced to Mary the birth of her son, he may refer to the past as well. Saint John's baptism of Christ along the banks of the Jordan River is perhaps anticipated through the water seeping into the foreground, but water is also a symbol of Mary and of her Immaculate Conception and thus a reference to the past. The rocks are symbols of Mary, too, as she was identified as the rock of the church—but they also refer to a primordial past, to the origin of creation, to that distant time before man was created and when Mary was conceived.

The *Virgin of the Rocks* was a masterpiece of optics. But it was also a masterpiece of theology. Leonardo had seamlessly combined the two.

And yet there is still something mysterious about the *Virgin of the Rocks*: what Leonardo originally painted is not what we see today, unless we examine infrared images.

In 2009, curators and conservators in Paris examined the panel using improved techniques of infrared reflectography and X-ray emissography. They expected to document how paint has been lost over the years in preparation for a much-needed restoration of the panel. What they found was Leonardo's original underdrawing, which no camera had ever been able to record before.

What they discovered was striking.

Leonardo's original design did not include the angel's pointing

hand, which is one of the most memorable features of the painting. In its place there were details of the rocky landscape and of Mary's blue cloak.

Not only this.

The angel's head was turned slightly toward Saint John, which meant that he did not look out at the painting's viewers.

The Child was not in the enticing near-profile view that we see today but in a more common full profile.

Mary's outstretched hand was also slightly different.

Why did he rework these details?

Let's start with Mary's outstretched hand, the focal point of the painting. Leonardo retouched it at least three times. He drew it and then retouched it with a thick brush, changing the shape of forefinger, middle finger, and nails. After he painted it, he retouched it again, this time reshaping the fingers' contours, lowering the thumb slightly, and extending the other fingers toward the right. What was he searching for with these minute adjustments of fingers and nails? Perhaps a hand gesture that aligned so perfectly with Mary's body that it gave the impression that the motion of her hand came from the core of her body and the depth of her soul—as we have seen, for Leonardo the most admirable figure is that "which best expresses through its actions the passion of its soul [*la passione del suo animo*]."

Why did he change the direction of the gaze of two figures (the Child and the angel), and thus alter the interactions among all the figures? Was the group too inward-looking? Too oblivious of viewers? Perhaps. For Leonardo, art was supposed to draw people in—but this group did not engage the chapel's worshippers, who were left out of the scene as mere spectators. The playwright Belcari had an actor perform the part of an angel to introduce his sacred play to the audience, and Leonardo himself had painted a youth who pointed out the sacred event to worshippers in his *Adoration*. Did he rethink the angel to draw people into the world of the image? Perhaps.

Perhaps he retouched the full profile of the Child for the same reason. He turned the Child's head to the left and obtained a more alluring near-profile view, the Child now turning slightly toward the faithful praying in front of the picture.

Or perhaps Leonardo introduced these changes when the painting changed ownership. In fact, it remains a mystery what happened to Leonardo's *Virgin of the Rocks* after it was completed. All we know is that at some point the artists and patrons had a dispute about compensation, and that matters got so contentious that, sometime in the early 1490s, Leonardo and Ambrogio (Evangelista had died in 1491) addressed a petition to Ludovico: they claimed that the eight hundred imperial lire they had agreed upon with the confraternity covered only the coloring and gilding of the ancona, and that they needed to be compensated for the rest of their work, "a picture of Our Lady painted in oil and two pictures with two angels similarly painted in oil." By this point, the side panels were completed, too, and it seems that the entire agreed-upon sum had been paid to the artists. But the artists demanded an additional three hundred ducats and specified that "Our Lady done in oils by the said Florentine alone [. . .] may be valued at 100 ducats," an estimate they based on the price offered by "persons who wished to buy said Our Lady." The confraternity questioned the artists' estimate and offered to pay only twenty-five ducats. The artists boldly wrote "that the said members [of the confraternity] are not experts in such matters and that the blind cannot judge colors" and asked for two arbitrators, one for each side, to be appointed.

We do not know what happened next. The only thing we can be certain of is that in the early 1490s, shortly after it had been completed, Leonardo's *Virgin of the Rocks* was valued at one hundred ducats. We can speculate that, at this juncture, the dissatisfied artists sold the painting to another patron. He must have been a powerful man, as it was no small thing to break a contract between patron and artist. Or perhaps Leonardo did with the *Virgin of the Rocks* what he did with many of his later paintings. He kept it for himself. We simply do not know.

The paper trail surrounding Leonardo's *Virgin of the Rocks* resumes in 1503, when the artists submitted another petition asking that the panel be reevaluated or returned to them. But most likely this petition refers to a second version of the *Virgin of the Rocks* that they painted for the confraternity to replace the original.

By that time, the political situation in Milan had changed dramatically. Ludovico was no longer the duke. He had escaped the city in 1499 when the French invaded, and the French king was the new ruler. Leonardo himself had left Milan in 1500, eventually returning to Florence to work for the republic. Ambrogio, who was still in Milan, finally received a response to their petition in 1506, but it was not the response the artists had wished for. Their painting was declared "imperfect [*im-*

perfetto]" and the artists were told that the work had to be completed "well and diligently [. . .] within the next two years by the hand of the said master Leonardo." The confraternity agreed, however, to pay more for the work—two hundred imperial lire. By August 1508, the second version of the *Virgin of the Rocks* was installed on the altar of the chapel, and by October of the same year the artists had been paid in full.

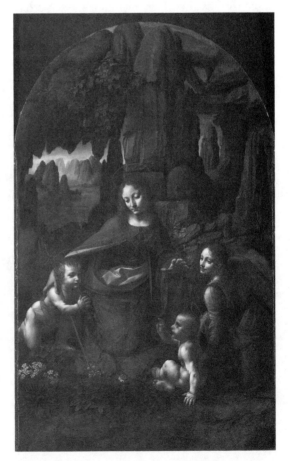

The final version of this new panel, which is now at the National Gallery in London, was identical to the original *Virgin of the Rocks* before Leonardo had reworked it, adding the angel's pointing finger and adjusting other details of Mary's hand and Christ's profile.

What happened next to the original *Virgin of the Rocks* is unknown. The panel reappears in the historical record 150 years later, in 1625, when the erudite Cassiano dal Pozzo, who was a Leonardo enthusiast and who ended up playing a big role in the dissemination of the posthumous version of Leonardo's book on painting, saw it at Fontainebleau as part of the French royal collection. But how the panel arrived there is unknown. Did the French king seize it from the confraternity? If so, when did he take it? When he conquered Milan? Or did the work enter the royal collection much later, perhaps even after Leonardo's death? At any rate, the painting remained in France and can now be seen at the Musée du Louvre in Paris.

No matter what happened to the original version of the *Virgin of the Rocks*, its history is a clear indication of the high esteem in which it was held. It was the "manifesto," we might say, of Leonardo's new psychological art—a style that, from about 1490 onward, was in high demand.

To meet the demand for his work, Leonardo would become the head of a large and busy workshop, teaching the science of his new way of painting to partners, assistants, and pupils. It was for these artists in training that his book on painting would be intended, and it would be a summation of everything he had been studying and practicing for almost twenty years.

How

LEONARDO

Taught the

Science of Art

//

The Idea of a Book on Painting

In the Renaissance, art was not created to express an artist's personal feelings or ideas. It was commissioned by patrons to serve specific purposes. Patrons decided *what* artists would depict. Luckily, patrons could not control *how* artists chose to interpret the subjects that were selected for them. Indeed, artists were constantly revising traditional interpretations of famous subjects and finding new techniques to differentiate their works from those of their peers in the ferociously competitive art scenes of Florence, Milan, and Rome.

Occasionally, artists were able to carve out time to create works that no patrons had commissioned but that reflected their personal interests. Typically, these were small works that did not require huge investments of time and materials. Renaissance artists also wrote books on their art, and while they often sought the favor of a patron for their books, they did so after they had already written them. In a way, the writings of Renaissance artists were some of the best examples of art (albeit not paintings or sculptures) made outside of the patronage system.

Like any Renaissance artist, Leonardo worked within this system of art patronage. His paintings were meant for confraternities, dukes, merchants, religious orders, and governments that told him what to paint, although not how to paint. But unlike most of his peers, he was

extraordinarily successful at setting aside time for his own interests, especially when he worked for the duke of Milan. In that city, in his large workshop in the Corte Vecchia, surrounded by a small but devoted group of assistants, enjoying the luxury of continuous employment over an extended period of time, he was able to "express" himself and to start work on his book. And not just a book, but a book for painters—a book about how philosophy and science would transform them into great painters.

We can identify the period when Leonardo started to convert his thoughts on art into book form. It was between 1489 and 1491. Leonardo was about forty, a mature artist, and the head of a hectic workshop. Leonardo called it "my factory," *la mia fabrica,* nearly five hundred years before Andy Warhol called his own studio "the factory." Leonardo's factory was incredibly busy, and yet the artist somehow found time for his book. He was determined to write it.

Let me give you a sense of how busy Leonardo's factory was. He got involved in architecture, no doubt thanks to his friend the ducal architect Donato Bramante, and even submitted a proposal for the tower that would crown Milan's cathedral—though he withdrew from the contest as he was not qualified to build it. Nonetheless, the experience gave him the opportunity to think about the relationship between architecture, the human body, and the cosmos. He wrote that the "ailing cathedral" needed "a doctor-architect" who knew "what are the causes whereby the building is held together, and is made to endure." He sketched churches with round, polygonal, or cruciform plans in a quarto-sized notebook (known today as Manuscript B), again following the example of Bramante, who had designed such churches as the ducal architect (Bramante also designed the dome of Santa Maria delle Grazie, next to the refectory where, later, Leonardo painted the *Last Supper*).

Leonardo also sketched water pipelines for the duchess's bathroom and imagined new urban structures to minimize contagion during pes-

tilence outbreaks. (A devastating one had swept through the city in the winter of 1485.) He became interested in Vitruvius's book *On Architecture*, and in order to understand it better he befriended several experts on Vitruvius. He also worked on a monumental bronze equestrian statue representing Ludovico's father.

He designed sets and costumes for court festivities, and on January 13, 1490, he dazzled the court with a stage set for the *Feast of Paradise*, a play that was to be performed at the celebration of a ducal wedding. Beams of colored light, projected through tinted glass, cast moving shadows on the walls around the hall. The light emanated from a golden globe with lamps suspended inside.

Leonardo painted, too, of course—but because demand for his work had increased so dramatically, he filled his factory with partners and assistants who helped him out. Some did more than help, in fact.

Several accomplished painters, such as Marco d'Oggiono, Andrea Boltraffio, and Andrea Solario, who had joined Leonardo's workshop as fully formed artists, were by and large responsible for the works that came out of the factory. Leonardo had taught them his way of painting, and they had become proficient at making small devotional images, altarpieces, and portraits based on his drawings and executed in his style. He supervised them and occasionally added finishing touches here and there, but these artists did the bulk of the painting. This may seem like a form of deception to us today, but in the Renaissance a work by a master was a work based on his design, made in his workshop, and executed under his supervision. It was not necessarily a work the master painted from beginning to end.

Other young boys came to Leonardo's workshop to be trained. One, Gian Giacomo Caprotti from Oreno, joined in 1490 at age ten and would remain with Leonardo until the master's death, but when he arrived he was more trouble than help. In less than a year, he managed to steal valuable tools from other assistants, money, and "Turkish leather to make boots" from Leonardo, as well as money from Leonardo's patrons—not to mention the copious amounts of food and wine he consumed. Leonardo called him "thief, liar, obstinate, and glutton" and nicknamed him

Salai, after the name of a little devil in a famous epic, *Morgante*, written by the Florentine Luigi Pulci. But Leonardo kept him, as he had become very fond of this handsome boy. Salai even became Leonardo's lover.

In short, Leonardo's factory was a busy place in those years, and a tough place to work. Leonardo supervised everything and everybody, but he played favorites, too.

He himself painted only works commissioned directly by the duke, such as the portrait of the duke's mistress, Cecilia Gallerani.

He represented the young lady with a slight twist to her body, to show that her attention had been caught suddenly by an unseen visitor (the duke?). She holds an ermine, which is a pun on her name— *galee* is the Greek word for "ermine" and the root of her family name, Gallerani. But the ermine was also a symbol of purity because, according to a popular belief, the animal would rather die than dirty its white coat. It was also one of Ludovico's emblems, and so a proxy for the duke. The portrait came out so well that a court

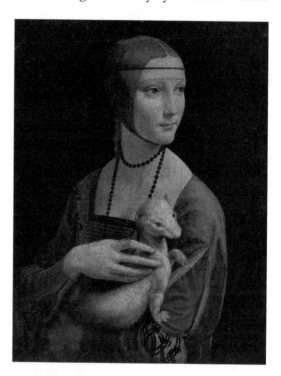

writer claimed that nature itself was envious of Leonardo because he portrayed one of nature's stars; for this writer, Leonardo was "the Apelles brought from Florence," a nod to one of the most famous painters in ancient Greece.

For another court portrait, *La Belle Ferronnière*—which most likely represented another of Ludovico's mistresses, Lucrezia Crivelli—he cre-

ated stunning reflections that bounce off the lady's red dress and onto her right cheek. As he wrote in those years: "Every object devoid of color in itself is more or less tinged by the color [of the object] placed opposite. This may be seen by experience [. . .] if the surface thus partially colored is white, the portion which has a red reflection will appear red [. . .]."

Optics was as central as ever to Leonardo's thoughts in those years. The connection between optics and art had received a major, unexpected boost a few years earlier, on March 16, 1485, when Leonardo witnessed a total solar eclipse. He observed it with a rudimentary tool he himself had made: a sheet of paper he had pricked with a needle to create a small

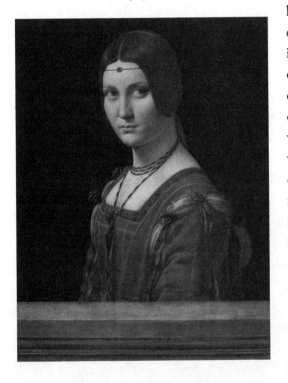

hole through which to observe, without hurting his eyes, the shadows and reflections created by the moon covering the sun. But what interested him was not the total eclipse in itself, but rather the optical effect of the moon seen against the backdrop of the sun. "The moon," he wrote, "though it is at a great distance from the sun, when, in an eclipse, it comes between our eyes and the sun, it appears to the eyes of men to be close to the sun and affixed to it, because the sun is then the background to the moon."

Backdrops meant a lot to him as a painter. He had learned from optical books that our perception depends a great deal on the background against which the edges of an object terminate, and if he read Alhacen's book he was familiar with innumerable such examples. He

himself wrote that "no visible object can be well understood and comprehended by the human eye excepting from the difference of the background against which the edges of the object terminate and by which they are bounded." He translated these theoretical ideas into practice when he painted human faces against dark backgrounds: Ginevra against a juniper bush, Mary against rocks. Rarely did optics and art come as close in Leonardo's mind as they did on that day in 1485 when he observed that total eclipse through a pinhole on a sheet of paper.

In those years, he was deliberate in his search for books. He knew exactly who owned the best and rarest books in Milan, as perhaps he knew as a youth who owned them in Florence. "The heirs of Maestro Giovanni Ghiringallo have the works of Pelacani"—Pelacani was an Alhacen expert and the author of optical books. "A grandson of Gian Angelo's, the painter, has a book on water which was his father's." "Messer Vincenzo Aliprando, who lives near the Inn of the Bear, has [the copy of] Vitruvius once owned by Giacomo Andrea," an architect and an expert on Roman architecture whom Leonardo used to visit with his assistants. Leonardo reminded himself to "Get the friar di Brera to show you '*de ponderibus*'"—this is Euclid's book on mechanics, a copy of which the physician Maestro Stefano Caponi also owned. "Ask Messer Fazio to show me *di proportione*," a complex text on proportions written by al-Kindi, a ninth-century philosopher.

He went after the classic books on optics, Witelo, Pecham, and Bacon. He sought out Aristotle's *Meteorology* because of its extensive discussion on the atmosphere.

He took field trips to scrutinize the effect of the atmosphere at different altitudes. He climbed the Monte Rosa, or Il Momboso, as he called the Alpine mountain between France and Italy, and observed that "the blueness we see in the atmosphere is not [its] intrinsic color" but the result of "warm vapor evaporated in minute and insensible atoms on which the solar rays fall, rendering them luminous against the infinite darkness of the fiery sphere which lies beyond and includes it."

In the midst of all these activities, he was also determined to find time to work on his book on the art of painting.

It would not read like any previous art book. Over the years, he had collected recipes for mixing colors and varnishes, but his book would not be a "recipe book" like Cennini's *The Craftsman's Handbook*, which had been written about a century earlier and remained invaluable as a guide to how to grind colors and prepare panels. Nor would it be a biographical account of previous artists or a hodgepodge of quotations from optical authors along the lines of Ghiberti's *Commentaries*, although he had learned a lot from that book, too.

Nor would it be an essay like Alberti's "On Painting," which was written in 1435 in Latin and Italian and was another book he read with great interest, although he got from it only very general principles. In fact, as noted earlier, Alberti had purposefully left out the most sophisticated parts of optics—"all the functions of the eye in relation to vision" as well as disquisitions on "whether sight rests at the juncture of the inner nerve of the eye, or whether images are represented on the surface of the eye, as it were in an animated mirror." Alberti thought these topics were not essential to painting.

Leonardo begged to differ.

His art book would teach artists about natural philosophy and science, about how we see and know the world, and all he had learned concerning the soul, the senses, and the emotions.

As he read philosophy and science books, he had taken notes from those parts that seemed most promising to him and tried to rephrase them in his own words. But he was an artist writing for other artists, and even though his book included philosophical discussions, its strength would lie in its many pictures and diagrams. He predicted that "many will say that this is useless work," but he regarded them as men who "possess a desire only for material wealth and are entirely devoid of the desire for knowledge [*sapienza*] which is the sustenance and truly dependable wealth of the soul [*anima*]." Instead, he planned to tell artists to "first study science [*scienza*], then follow the practice born of that science." His view was that painters "who are in love with

practice without science are like a sailor who boards a ship without rudder and compass." Those painters have to, in essence, reinvent the wheel each time they pick up a brush, hoping that through trial and error they will come upon a breakthrough. Those painters might succeed, but they will never know how they did it. And they might not be able to do it again. But the artist who develops a deep knowledge of the science of optics, "the signpost and gateway" of painting, understands the rules—born from experience and the senses—by which the passions of the mind can be brought alive. That artist can use those rules time and again to confidently guide his work.

The book would also offer very practical advice. It would teach the modern painter that "narrative paintings [*storie*] ought not to be crowded and confused with too many figures"—he had learned this lesson the hard way with the failed *Adoration*. And it would teach that the modern artist has to draw from nature the lights and shadows on each muscle, but that he cannot be satisfied with this. Leonardo's intention was to save his peers the efforts he went through to figure out that the core of art did not lie where everybody thought it did—in the narrative, or in the anatomy of the body, or in bright colors, or in the technical mastery of foreshortening—and that artists who painted figures that looked "like a sack of nuts rather than the surface of a human being or, indeed, a bundle of radishes rather than muscular nudes" were wrong. He did not mention any artist by name, but everybody knew whom he meant: the Pollaiuolo brothers. They were great artists, and they understood anatomy, but they were "wooden painter[s] [*pittore legnoso*]" because they did not recognize that anatomy and musculature did not lie at the heart of great art, but were only means to a greater end.

Art had to capture something else.

Leonardo tried to explain what he meant.

He jotted down notes about the "purpose of the soul" and about paintings in which the most praiseworthy thing is a figure that "best expresses through its actions the passion of its soul." He wrote a draft, and then another, and then a third, but he crossed them out before

finishing them. It took a while before he could find the right words to express what he meant:

> The good painter should paint two main things, and these are man and the intention of his mind [*concetti della mente sua*]; while the first is easy, the second is difficult, because it has to be captured through the gestures and the movements of the limbs, and these should be learned from mutes, who better actualize them than any other sort of man.

He also drafted an introduction, which is indicative of his feelings at the time. Part of him was defensive and insecure: "I know well," he wrote, "that, not being a man of letters, it will appear to some presumptuous people that they can reasonably belabor me with the allegation that I am a man without learning [*omo sanza lettere*]." He had no formal training in Latin and had never learned how to write an elegant essay with a beginning, a middle, and an end.

But another part of him was as assertive as ever. "Foolish people," he called those who accused him of not having "literary learning" and being unable to "express the things I wish to treat." Those fools "do not grasp that my concerns are better handled through experience rather than bookishness." Experience as knowledge acquired through the senses had been Alhacen's mistress. It also became Leonardo's mistress: "Though I may not know [. . .] how to cite from the authors, I will cite something far more worthy, quoting experience, mistress of their masters."

In order to produce his book, Leonardo went digging through the mess of disorganized notes he had accumulated over the years. He must have spent days and days searching for the best diagrams and observations, which he copied onto new folios. He left these folios unbound in order to write on them more easily, but he organized them into sets (effectively loose-leaf notebooks), each on a different topic. In the span of

two or three years, between 1489 and 1491, he filled pages and pages with notes on colors, shadows, and the atmosphere, and sketched dozens of optical drawings and skull and proportion studies. About two hundred pages and over one hundred diagrams have survived, but these may be only a portion of those he made. It was in these pages that he wrote that the illusion of relief created by shadows is "the soul of painting," that "painting is grounded in optics," and that optics is "a rational demonstration by which experience confirms that all things send their semblances to the eye by pyramidal lines."

These folio sets were his working draft, and we have to imagine them stacked on his desk for months on end, readily available to him for revisions and additions.

As in a painting, he looked for the right spot for everything. Things had to be spaced just right, images had to be balanced with words, the shape of blocks of text had to be adjusted to the shape of drawings, and things had to be shaded impeccably.

The fact that many of these folios are so carefully planned—word and image are beautifully combined, drawings are highly finished, and some are fully shaded—indicates that they were advanced versions of notes and sketches Leonardo drafted earlier; how much earlier is a matter for debate, but I would speculate years earlier, perhaps as early as his years in Florence. Many shadow drawings seem like studies for Ginevra's head, for details of the *Adoration*, and for the heads in the *Virgin of the Rocks*, for instance. Many notes on the atmosphere seem to explain the landscapes he had been painting since the 1470s.

Judging from Leonardo's notes from those years, around 1490, it seems that he planned his book as a collection of short chapters, each with a title posing a philosophical question and a short text solving that problem step-by-step. Many chapters would be illustrated by images.

For example:

How shadows fade away at long distances.
Shadows fade and are lost at long distances because the larger

quantity of illuminated air which lies between the eye and the object seen tints the shadow with its own color.

Or:

On the three kinds of light that illuminate opaque bodies.
The first kind of light which illuminates opaque bodies is called individual light [*lume particulare*] and this is the sun or any other light [coming] from a window or flame. The second is universal [light] [*universale*] such as we see in cloudy weather or in mist and the like. The third is composed [light] [*composto*], that is when the sun is entirely below the horizon, either in the evening or morning.

His book on painting would read more like Euclid's *Geometry* or Alhacen's *Optics*, and this fact alone would show that, like optics and geometry, painting was a branch of natural philosophy, and his art book was as authoritative as Euclid's and Alhacen's own works.

A folio set titled "On the Human Figure" was started on April 2, 1489.

Here, Leonardo gathered highly finished skull drawings and spaced them elegantly on the page, adjusting their accompanying text to the sketches' shape and size. He drew each bone and eye socket so masterfully that one has the illusion of handling a real skull and feeling the textures and recesses of each bone. He drew them in a sagittal view, as if the skull had been sliced open and viewed from the side. This was itself something of a revolution, as nobody had ever thought of cutting skulls—or any other part of the human body—into two halves to distinguish left from right and to make their interiors visible. These skulls revealed the hidden scaffolding of muscles, which, in turn, provided the hidden structure of facial motions. But they also indicated exactly where the soul and the *sensus communis*, the organ that combines sensory data and gives us knowledge of the world, resided. Most artists had no interest in the location of the sensus communis, but Leonardo

had learned from optical manuals that "the common sense is the seat of the soul," the place where sensory experience is gathered and ana-

lyzed. His view of art as philosophy demanded that artistic training begin with a study of the workings of the soul, starting with identifying its location in the body. This was why he took the trouble of locating the "chamber" containing "common sense," with cartographic precision, inside the head.

His ability to translate knowledge into images, to visualize even complex concepts, was unsurpassed, and nowhere was this more evident than in these stunning skull drawings. He also portrayed these skulls using yet another skill he wanted artists to master: proportion. Human proportions had always been of great interest to artists, even though each culture and time had different ideas on what perfect proportions were. Alhacen had considered proportion to be the second-hardest "visual intention" or characteristics of an object to judge (the hardest was beauty), but most Renaissance artists followed what Vitruvius said about proportions. The problem was that Vitruvius's technical language was hard to understand, and that the many handwritten copies of his text were corrupted and inconsistent. A typical instruction from Vitruvius might read something like this: the distance between the eye socket and the chin equals the distance between the eye and the top of the head, which in turn is the exact half of the distance between the chin and the

nose, or the distance between the nose and the eye socket. Vitruvius was not an easy read.

Being the great artist that he was, Leonardo made visible Vitruvius's instructions with unprecedented clarity. He superimposed Vitruvius's proportional division of the human face over his skulls, showing at a glance not only the location of the common sense but also the perfect proportions of the human head: nose, mouth, eyes, and forehead were proportionally related.

And then he went a step further than Vitruvius or any previous author of medical or optical texts had gone. He used the module, or unit, Vitruvius had used to measure the human face (Vitruvius had settled on one-third of its length) to place the chamber of the sensus communis inside the skull at one-third of the skull's depth.

Leonardo's famous *Vitruvian Man*, which was conceived in those same years, extended this exercise from the head to the whole body.

This pen-and-ink drawing, sketched in metal point on a large folio, has become an iconic image of Western culture, defining the relations between the universe and the human body. But for Leonardo this was only a draft, a personal *summa* of observations he had found in various Vitruvian manuscripts, each manuscript reporting different measurements due to the numerous discrepancies that appeared in handwritten copies. He transcribed the

contradictory measurements, planning to rework them later and come up with a clean version of Vitruvius's text. He never managed to combine Vitruvius's words into a single, coherent passage, although he summarized Vitruvian proportions in a sentence: "a man opens his arms as far apart as is his height." And he did visualize that sentence in a superb image of unique clarity.

In another folio set, which he had prepared using a blue wash, he captured the human body from within.

Anatomy was essential to understanding the force (*forza*), or motion (*moto*), that animates human beings. Similar to Aristotle, he called this force a "spiritual virtue" that flows "through the limbs of sensate animals, thickens their muscles, and whence these thickened muscles contract and pull with them behind the nerves with which they are conjoined, and from here the force of human limbs is caused." He wanted artists to learn human anatomy—if they did not they "will accomplish little." They had to know "which chord or muscle is the cause of such movement"—the muscles that close eyelids, raise eyebrows, part "lips with teeth clenched," and bring "lips to a point"; even those that make people laugh, sneeze, and yawn, or express wonder, thirst, sleep, hunger, fatigue.

These notes on anatomy are highly illustrated. His illustrations made it possible for artists to learn anatomy without having to find a corpse, convince a doctor or at least a barber to flay and dissect it, and struggle to capture its various parts before fluids spilled all over or the muscles got out of place or the blood vessels decomposed. Not only did Leonardo make anatomical drawings more accurately than anybody had ever done before, but he also peeled the skin off of the bodies he drew in order to visualize the tendons and muscles underneath. A head study showed each muscle of the mandible, face, and neck located in its proper place, the view unobstructed by blood, the form unaltered by decomposition. There simply was no better drawing to study the movements of facial muscles—and therefore the underlying anatomical structures of emotions.

Alberti had suggested previously a similar approach to painting a nude: "sketch in the bones, then add the sinews and muscles, and finally clothe the bones and muscles with flesh and skin." But Leonardo was the first to actually draw anatomy "in transparency," turning Alberti's generic instructions into a system for artistic practice.

At about the same time, he assembled another folio set, which he left untitled.

Here he gathered notes on colors and the atmosphere. He also included thoughts on the different arts—painting, sculpture, music, poetry—based on the senses they primarily engage—sight, touch, hearing. It would come to be known as Leonardo's *paragone*, or comparison of the arts. Here, also, is his famous description of the human body as a microcosm:

> The ancient called man a lesser world and certainly the use of this name is well bestowed, because his body is an analog for the world, in that it is composed of earth, water, air, and fire.

But the majority of this untitled notebook, known today as Manuscript A, dealt with painting as an activity that "embraces all the ten functions of the eye; that is to say darkness, light, body and color, shape and location, distance and closeness, motion and rest." As discussed earlier, these were an adaptation of Alhacen's functions of the eye. So much so that when Leonardo explained that "my little work [piccola opera] will comprise an interweaving of these functions" to help painters imitate nature with their art, he seemed to suggest that he thought of his book as an optical manual for artists—a sort of simplified "Alhacen for artists," one might say.

He adapted to artistic practice Alhacen's examples on the thickness of the medium, on distance, and on the intensity of light. Here is a note on reflected colors that demonstrates his use of optical literature, but that also brings to mind the reflected colors of his paintings—the blue reflections on Ginevra's bust, the red reflection on *La Belle Ferronnière*'s cheek: "The painter," he wrote, "must pay great attention in situating his bodies amongst objects which possess various strengths of light and various lit colors" because "the surface of every opaque body takes on the color of an object opposite to it." Here is another on his famous smoky effects: "Note [. . .] that your shadows and highlights blend together without hatching or strokes, in the manner of smoke [*a uso di fumo*]." In another passage he wrote that "shadows partake of universal matter" and asked a key question that shattered long-standing beliefs about painting:

Which is best, to draw from nature or from the antique? And
which is more difficult to do, outlines or lights and shadows?

For him the answer was unequivocal: it is best to draw from nature,
and it is more difficult to paint lights and shadow than outlines.

His advice was revolutionary. Florentine artists had worked to per-
fect their outlines, or *disegno*, for over a century, and Cennino Cennini
had codified the practice in the early fifteenth century when he told
artists in training to "Begin with drawing or outlines [*dal disegno t'in-
cominci*]." His view had never been challenged. But Leonardo thought
that there are no boundaries in nature: "The boundaries [*termini*] of
two conterminous bodies are interchangeably the surface of each. All
boundaries of a body are not parts of that body," he wrote, adapting the
teachings he had learned from optical literature and possibly from Al-
hacen. What the eye sees in nature are the blurred edges between
things, and he wanted artists to render the mingling of colors and
shadows at these edges with pigments and varnishes. If they did not,
their works would have "a wooden effect [*legnosa resultazione*]."

Leonardo's new art was about getting viewers to feel a certain way.
It was about connecting real people to painted figures at a very deep
level, having those who look at a work feel the same feeling that the
painted figures felt—fear, terror, joy, or amazement. It was about trans-
porting Renaissance viewers in time and place, giving them the illusion
of moving in the same landscape or building where the painted events
occurred, being immersed in the same atmosphere and light. This new
art had to capture hazy contours, soft edges, indistinct thicknesses,
smoky boundaries, reflected colors, misty air.

He told artists that if they wanted to move viewers, they had to
master three kinds of perspective, each based on how things appear as
they recede from the eye. Linear perspective, or *prospettiva liniale*,
deals with "the reasons behind the diminution of objects" in terms of
their quantity, or size, such as a building seen from afar or a tree line
along a road. This was the perspective Renaissance artists were most
familiar with, as Alberti had offered instruction on how to diminish

the size of objects geometrically; his instructions, which were based on Brunelleschi's perspective panels and on the practices the artist Masaccio adopted for his paintings, had become part of the training offered in workshops. The second and third kinds of perspective, perspective of color (*prospettiva di colore*) and perspective of disappearance (*prospettiva di speditione*) or aerial perspective (*prospettiva aerea*), were less familiar to artists, as Alberti had omitted discussions about color and the air. But for Leonardo, it was essential for artists to know "the way colors vary as they become more remote." Aerial perspective was "concerned with how objects [in a picture] ought to be less detailed as they become more remote."

Both color and aerial perspective are due to the intervening air, which for Leonardo was not inherently blue but took its color from a mixture of light and shade—that is, the light of the sun and the darkness of the atmosphere. For Leonardo, painters had to diminish the size of objects, soften the intensity of their colors, blend their details, smooth their boundaries, and tone down the contrast with their backgrounds according to universal rules that govern how we see.

A section of the planned art book would be devoted to light and shadows. In fact, this section was the most fully realized of all. Leo-

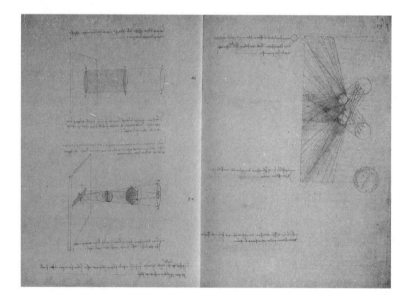

nardo filled an entire folio set with highly finished light and shadow drawings, which, like his skull studies, he positioned carefully on each page, adjusting the size of the accompanying notes.

This set on light and shade, which is known today as Manuscript C, was the largest in size, the most advanced in its concepts, and contained the greatest number of diagrams of all the folio sets he assembled in those years (or at least among those that survived).

Here can be found specific instructions on how to draw with geometric precision "the convergence of shadow [rays] with light rays," which always has "a mixed and blurred appearance," as well as famous principles such as that "no object [. . .] will ever appear separated from its background" and that "optics adds knowledge to things." Here is Leonardo's dictum to artists that painting is superior to the other arts because it is "the master and guide of optics."

The diagrams were works of art in their own right, a fact the art historian and Leonardo expert Anna Maria Brizio described in one of the first studies dedicated to these shadow drawings: although these are just geometrical diagrams, they have "an airy lightness, a transparency [. . .], a complex 'radiant' texture" that conveys "an extraordinarily vibrant suggestion of space and motion" thanks to how carefully Leonardo traced the multiple directions and intersections of light rays.

Some diagrams Leonardo enlarged to fill half a page, so as to make visible the blurred edges of shadows and penumbras with geometric precision—and not just the shadows and penumbras cast on discrete objects, which he called primary shadows (*ombre originali*), but also the shadows and penumbras cast on walls and on pavement, which he called secondary shadows (*ombre derivative*)—as well as the shadows that were projected in the air between these discrete objects and the walls or pavement forming the background.

Even a young artist in training would be able to follow his instructions. All he had to do was to imagine that a small circle, for instance, was a human head and then place the figure in similar lighting conditions. For instance, in one especially beautiful shadow drawing, two

suspended spheres with nuanced penumbras generated by different light sources provide the optical basis of the heads from the *Virgin of the Rocks*.

In these diagrams, he would reveal the secret behind his signature blurring effect, which came to be known as Leonardo's sfumato, although Leonardo never used the word.

This series of immensely complicated technical drawings on light and shadow was the centerpiece of the book. They were, in a sense, the core of his art as philosophy, for they revealed in a visual language that other artists could readily understand the immense power of the secret tool Leonardo had employed for many years in the service of a new type of painting. They taught artists to look at the surfaces of people—their skin, hair, and expressions, and even the smallest of motions—and to capture them with the slightest gradations of light, shadows, and penumbras, and with subtle colors or the smooth layering of glazes, to paint the purpose of their soul (*i concetti dell'animo loro*).

The section on light and shadow was where Leonardo's stunning originality resided. This was also where Leonardo explored a revered concept from Aristotelian philosophy that no artist had ever applied to shadows or painting.

Aristotle used the concept of infinite divisibility to explain the physical world. It stated that space, time, and motion, which are continuous, can be divided into smaller parts, which can themselves be further divided, the process never terminating in something that is indivisible. Some philosophers, the atomists first among them, had harshly criticized infinite divisibility because they believed that there are small elements in nature that are indivisible—namely, what they called atoms. But for other philosophers, infinite divisibility allowed them to break down and so better understand complex natural phenomena.

In fact, some Arab philosophers had applied Aristotle's principle of infinite divisibility to shadows. There are instances in Leonardo's writings that seem to suggest he did read some detailed work on shadows and penumbras in his twenties in the library of San Marco, which may

have inspired his own treatment of shadows based on Aristotle's concept of infinite divisibility. But there is no way to know for sure or to identify what those hypothetical sources were.

He wrote, however, that "shadow partakes of the nature of universal matter," and that like any other natural element, shadows can be divided endlessly into smaller units. As Aristotle had done with space, time, and motion, Leonardo divided objects and light sources into ever smaller units. What resulted was a web of lines that revealed how much light and how much shadow could be found in each spot in a drawing, which made it possible to show with geometric precision minute gradations in light and shade.

This was a clear instance of his originality, old ideas deployed to new ends.

In his optical diagrams, there are shadow rays (*razzi ombrosi*)— Leonardo had lifted the term from Ghiberti's *Commentaries*—that combine in the air with light rays (*razzi luminosi*). It was as if Leonardo was portraying, with geometrical precision, solid bodies rather than thin air.

He imagined sunlight coming into a room through a large window or small aperture, and he imagined how it sifted through the clouds, the sky reflecting filtered sunlight all around. Alhacen had analyzed in detail similar lighting situations, and Leonardo had painted a few.

Leonardo believed the optical effects described in the notebook on light and shadow and in other folios made the art of painting superior to all the other arts, an argument he planned to expand in his art book, perhaps even in its opening section. In fact, he felt so strongly about the superiority of painting that he defended it forcefully in public debates at court.

In Renaissance courts, a favorite entertainment was the staging of debates on controversial topics—prominent courtiers were called to participate, each courtier defending opposing views, each resorting to subtle and witty arguments to amuse the ruler and his guests. Given

his bright intellect, his wit, and his vast knowledge, Leonardo was the perfect courtier for such public debates. At least twice he argued for the supremacy of painting. One time, in 1498, in front of cardinals, generals, courtiers, and "eminent orators, experts in the noble arts of medicine and astrology," he faced his friend Luca Pacioli, a Franciscan polymath and Sforza courtier, whose job was to defend mathematics, one of the liberal arts.

Since antiquity, debates on the paragone had excluded painting and sculpture because they were considered manual rather than intellectual arts. Only poetry, rhetoric, and music were arts of the mind. But this view began to change in the fifteenth century, when artists started to write their own art books. Cennino Cennini said that painting ought to be "crowned with poetry." Leon Battista Alberti wrote that painting, like rhetoric, was meant to persuade viewers. Lorenzo Ghiberti argued forcefully that painting and sculpture were pursuits of the mind, not just of the hands. Ghiberti's expertise in optics was an indication of his intellectual interests, his friendship with scholars the proof he was not merely a craftsman.

Leonardo was familiar with the writings of his fellow artists from earlier generations—Cennino, Alberti, Ghiberti—but unlike them, he argued his case based on what was said in optical literature, including in Alhacen, in favor of sight over other sensory organs. There lay the origin of his genius.

For Leonardo, painting was superior to all the arts because it dealt with "subtle speculations" that no other art was concerned with. Unlike other artists, painters engage in a "higher mental discourse [*maggiore discorso mentale*]" because their work is based on sight, which is the noblest sense and the closest to the common sense. Painting is superior to poetry because it creates its own images, while poetry uses words to recall actions, places, and forms ("form" is another term used by Alhacen, which Leonardo may have lifted from Ghiberti's translation). It is also more universal than poetry because languages change from country to country, but the forms of painting are understood everywhere.

And painting can represent different things simultaneously, while poetry can evoke them only one after another.

Music is the "younger sister" of painting, because music addresses the sense of hearing, which is inferior to sight, although music is superior to poetry because it creates sounds simultaneously.

Above all, painting is superior to sculpture. Unlike painters, sculptors cannot "depict transparent bodies." They cannot "show the colors of all things and their diminution," nor can they represent "luminous sources, nor reflected rays, nor shiny bodies such as mirrors and similar lustrous things, nor mists, nor dreary weather." Nor they cannot render "veiled figures which show their nude skin under the veil that covers them; or small peddles of various colors underneath the surface of transparent water." In sculptural works, "aerial perspective is absent." This comparison between sculpture and painting was a constant in Verrocchio's bottega, where the same design could be rendered in paint, marble, bronze, or terra-cotta. Leonardo himself often painted objects his master had made in metal or marble—we have only to remember Mary's lectern in the *Annunciation* or the glass vase in the *Madonna of the Carnation* (Figures 2 and 3).

Around 1490, as a mature artist, Leonardo transcribed workshop conversations on painting and sculptures into a philosophical discourse based on the comparison of the senses that he had learned from optical literature.

Later in life, Leonardo would unabashedly say that the painter is "the lord and creator" of all sorts of people and "of all things man can think of," but also "the monstrous things which might terrify." But around 1490, he was content to state that painting was merely the "kin of god" and the "granddaughter of nature," and that those who despise painting do not love either philosophy or nature.

He would be equally categorical, later in life, about who should read his notes as well. "Let no one who is not a mathematician read my principles," he wrote next to a drawing of pulmonary valves that he may or may not have made with his art book in mind.

Leonardo worked consistently on his art book for a period of two or three years. He made concrete progress on themes that he planned to develop fully in the various sections of his book, or *libri*, as such sections were often called in the Renaissance. The folios about the skull located the common sense in the head, charted the way emotions travel through the body, and connected the skeleton to facial proportions. Other folios dealt with other parts of human anatomy, still others with the proportions of the entire body. Another notebook discussed colors and the atmosphere and offered a comparison of the arts. Another notebook dealt with the science behind penumbras.

Leonardo never came to a final decision about these various sections, not even about how many of them would be included.

But he did draft a table of contents of sorts: "On the Order of the Book."

"This work should begin with the conception of man," he wrote. It continued with the nature of the womb, then the anatomy of children and how their limbs grow, and proceeded to the anatomy of a grown male and female, showing their blood vessels, nerves, muscles, and bones.

The four "universal conditions of man" followed: he associated joy with various ways of laughing; weeping; combating with "various acts of killing, fight, fear, ferocity, boldness, murder"; and labor "with pulling, pushing, carrying, stopping, supporting and similar things."

Then there was a section on attitudes and a final section on effects, which was devoted to "optics through the function of the eye; on hearing, I shall speak of music; and describe the other senses."

The table of contents remained but a draft. He kept the different sections gathered in separate folio sets, each waiting to find its proper place within the overall structure.

Around the time he was drafting his art book, Leonardo also began to imagine an art academy, a school where—we presume—artists

would learn about the science of art from his book. All we know about this academy is what we can glean from an engraving somebody made, presumably after a drawing by Leonardo.

A beautiful, intricate knot is tied around the words, in Latin, "Academia Leonardi Vinci." According to the art historian and Leonardo scholar Pietro Marani, we have to think about Leonardo's academy as "a group of artists who freely gathered around Leonardo, who learned from him not only the rudiments of art but also theoretical teachings from his own voice." In fact, about seventy years later, a doctored selection of notes that Leonardo had written for his planned art book became the textbook for newly founded art academies in Florence and Paris, and possibly in Rome, too.

Later, Leonardo worked on his book on painting more and more sporadically. He sketched diagrams but did not provide accompanying texts. He stopped numbering his various folio sets, and soon he abandoned them altogether. On May 17, 1491, he started another notebook. That evening, sitting in candlelight at his desk, he wrote: "here a record shall be kept of everything related to the bronze horse, presently under execution." The horse he was designing for the duke had consumed Leonardo's attention, and the great book on the science of art was destined to be yet another of Leonardo's unfinished projects.

But even though he abandoned these drafts, he did not entirely abandon the idea of a book. He spent the rest of his life revising the principles he had so carefully extracted from optical literature, including Alhacen's work, while at the same time perfecting the technique of painting people's souls.

Why the *Last Supper* Fell to Pieces

The science of art remained Leonardo's overriding concern throughout his life, the main force behind his paintings, the motivation for his technical experimentation, the reason he delved into other fields, from anatomy to hydraulics, geology, botany, mechanics, astronomy, and cosmology. It was also the main reason he never finished his paintings, or, if he did finish them, the reason they deteriorated soon after he had completed them.

The *Last Supper* is perhaps the saddest example of Leonardo pushing experimentation too far.

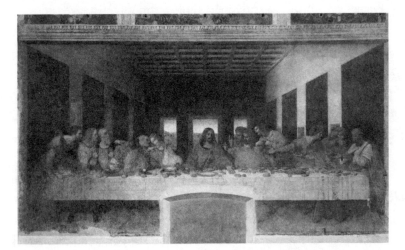

The *Last Supper*, one of the few paintings Leonardo ever completed, "started to fall into ruin" less than twenty years after he finished it. One charitable visitor commented that the cause was "the dump in the wall," but even he conceded that perhaps it was "because of some other inadvertent causes." By 1566 it "was nothing but a blurred stain," and by 1584 it was "in a state of total ruin." The cause of this ruin was Leonardo's experimentation with a technique—fresco—that was wholly unsuited to achieving the optical effects he deemed necessary to move viewers.

The *Last Supper* was made for the refectory of the Milanese Dominican church of Santa Maria delle Grazie. Duke Ludovico had grown attached to this convent, and every Tuesday and Saturday he dined with the friars there, sitting at one of the tables lining the refectory's walls, eating a frugal meal in silence, and listening to sacred readings. In 1492, he chose the church as his burial place and had Bramante redesign parts of it to accommodate his tomb. A couple of years later, Ludovico commissioned Leonardo to paint the *Last Supper* in the monastery's refectory. We can infer that this occurred in late 1494, right after he blocked Leonardo's work on the equestrian statues (the duke had changed his mind only a few years after he had eagerly commissioned the work), or in early 1495, around the time Vincenzo Bandello, the same Dominican who had attacked the idea of Immaculate Conception, was appointed prior of the convent.

Depictions of the Last Supper were commonly displayed in refectories, as it gave friars the impression they were partaking of Christ's last meal. The size of Leonardo's painting—about four and a half meters by nine meters (or about fifteen by twenty-nine feet)—was not at all typical, however. Given its dimensions, the work could not be painted on a separate panel, but only directly on the wall, in fresco, a technique Leonardo had never used before.

Leonardo was not pleased with this commission. It came to him as a consolation prize for the loss of the work he really wanted to complete, the monumental horse representing Ludovico's father. But the duke had repurposed the metal set aside for the horse to forge cannons to help his father-in-law, the duke of Ferrara, fend off a military attack.

Leonardo was gracious enough to at least pretend to understand: "[Of] the horse I shall say nothing because I know the times," he wrote Ludovico, adding, "my life in your service. I hold myself ever in readiness to obey." In his spare time, Leonardo kept working on a clay model of the horse, perhaps hoping the duke would change his mind. Ultimately, though, there was nothing Leonardo could do but follow his patron's orders.

He would paint the *Last Supper*.

(This was an unfortunate but common occurrence for court artists. Even Michelangelo faced a similar situation a few years later, when Pope Julius II commissioned the artist to design his tomb, a monumental sculptural project the artist was eager to complete but had to abandon when the pope changed his mind. Instead, the pope commissioned Michelangelo to paint a ceiling, a project the artist loathed as he regarded painting inferior to sculpture. But like Leonardo before him, he embraced the commission, and his fresco painting—the Sistine Chapel ceiling—is considered a masterpiece of Western art.)

In spite of his initial reservations, Leonardo made the *Last Supper* a masterpiece of art as philosophy.

He set the painted scene in a fictional room that seemed to be seamlessly integrated with the real space of the refectory. In the painting, the light appears to be coming from the left, which is the side where the refectory's real windows are placed. As a result, natural light seems to filter through the real windows and wash over both the refectory and the painted scene—in effect giving the friars the illusion of sharing the same light and glow of Christ and his disciples, as if they all were sitting in the same hall at the same time. But Leonardo also painted Christ and his disciples about fifteen feet above the friars' heads. The Dominicans could never fully inhabit the same space as the sacred figures. They could look at them only from below and imagine themselves partaking of the same mystical meal by mentally elevating themselves to the level of the sacred figures.

Leonardo designed the fictive space of the *Last Supper* according to the golden ratio, as he had done in previous paintings, but placed Christ's head at the exact center of the scene, rather than on the golden ratio's focal point. During the last restoration, the hole for the nail Leonardo used as an anchor while drawing the architectural background with mathematical precision was rediscovered on Christ's temple. Leonardo set Christ's head against a bright blue sky using a unique—and hard to paint—backlight effect that he himself discouraged painters from adopting, but that he rendered marvelously. The other heads he placed against dark backgrounds, just as he always recommended.

His greatest innovation, though, was his reinterpretation of the story itself. He read Matthew's account of the last meal Christ shared with his disciples before his Crucifixion (Matthew 26) and selected three distinct moments of the narrative, which he combined in one single image. One moment was the shock wave that traveled through the group right after Christ announced that "one of you will betray me." Leonardo imagined different reactions to the news as the apostles asked, "Lord, is it I?" The second moment was when Christ shared bread and wine with his disciples, anticipating the ritual of the Eucharist. A third moment was when Christ revealed the identity of the traitor as the one "who dips his hand with me in the dish," and Judas, portrayed dipping his hand in the plate in front of Christ, asks, "Is it I, Rabbi?" to which Christ replies, "You have said so." Leonardo's previous works, especially the *Adoration* and the *Virgin of the Rocks*, had prepared him well for this synthesis of events that occurred at different times.

Leonardo wrote a long note, which he possibly meant to include in his book on painting, detailing the apostles' different reactions:

> One, who was drinking and has left the glass back in its place, turned his head toward the speaker. Another [apostle] intertwined the fingers of his hand and with stern eyebrows turned to his neighbor; the other [man] with open hands shows the palms and raises his shoulders up to his ears and opens his

mouth in astonishment; another [apostle] talks into the ear of the other, and he who is listening turns to him and lends him an ear, holding a knife in one hand and in the other the loaf of bread cut in half with that knife; the other [man] in turning while he holds a knife knocks over a glass on the table; the other places his hands on the table and looks on, another [man] breathes a mouthful, the other leans forward to see the speaker and shades his eyes with his hand; the other throws himself behind the one who leans forward and looks at the speaker between the wall and the man leaning forward.

For the twelve apostles around the dinner table, he returned to a sketch he had drawn and then discarded for the *Adoration* about fifteen years earlier. In that sketch, he had divided a large group of people into small groups of three or four, each group engaged in animated conversation. He returned to the sketch because it provided a clever way to break down a narrative composition that required many people—and that could easily suffer from diminished optical accuracy and emotional intensity—into smaller narratives that instead enhanced these qualities.

For individual apostles, he drew from his stock of sketches made from life. Many figures display the likenesses of people he knew. Some are portraits of Milanese courtiers we can no longer identify, with the exception of Bartholomew, who has the facial features of Leonardo's friend Bramante.

In short, Leonardo had all the resources he needed to execute a successful painting.

What he had no experience with at all was the fresco technique itself—and for good reason, though not the reason one might expect.

Fresco painting, after all, was exceptionally well suited to large surfaces. It was quick, cheap, and durable. Florentine artists had mastered it over the centuries to great acclaim. Colors were applied to a wet layer of plaster, the *intonaco*, so that the colors were absorbed into the plaster itself (the word "fresco" comes from the Italian *fresco*, which means

"fresh" or "wet"). Great fresco painters worked fast, before the wet plaster dried, as they could not correct their mistakes once colors were sealed within the wall. They applied wet intonaco only over the patch they were able to paint in a day—indeed, each patch was called a *giornata*, from the Italian word for "day." If one looks carefully at Renaissance frescoes, one can detect the outline of each giornata joined to the next. Fresco painters did add details *a secco*—that is, on top of the sealed and dried colors—but they did so only rarely as they knew that a secco additions were extremely fragile and that sooner or later they peeled off.

In short, frescoes required discipline, speed, careful advance planning, and a tight work schedule.

No painting technique was less congenial to Leonardo's philosophical art—or his working habits—than this one.

In frescoes, he could not add a touch here, another there; he could not apply a layer of glaze atop a thin layer of color, or use glaze mixed with a hint of a pigment to create blurred edges and nuanced color reflections. Leonardo had never felt the urge to learn fresco painting, even though some of the artists who had passed through Verrocchio's workshop had become accomplished fresco painters: Botticelli, Perugino, Ghirlandaio. Now that he was asked to paint the *Last Supper*, he had to come to terms with fresco painting and its limitations.

Was it possible to paint a large mural as if it were a wood panel? No, it was not.

He tried to do so nonetheless.

Since the *Adoration*, Leonardo had prepared his panels using a bright layer of lead white so as to enhance the illusion that light came from within the work, as well as to add luminosity and modulation to the colors and varnishes he applied above. But lead white was not a good choice for murals, as it oxidizes in the presence of materials used to build walls and turns into a rather unappealing brownish color. Every

art manual mentioned this, and every beginner fresco painter knew better than to apply lead white to a wall.

But Leonardo disregarded this long-standing advice. He added a thin layer of lead white mixed in oil to the rough plaster on the wall. It was his intention to use this as a sort of imprimitura to isolate the plaster from the colors he would apply above—in other words, he was not trying to produce a fresco so much as a traditional painting atop the unstable and highly imperfect surface of a wall—a mural painting instead of a panel painting. This was wishful thinking.

And there was more to come.

Although he knew that a secco touches are perishable and should be used sparsely, only for minor details, he applied them extensively. In fact, he did what every art manual recommended he not do: he painted one layer, waited for it to dry, and applied another on top of it. Often, he repeated this layering technique three or four times.

There was still more.

He used azurite and malachite to paint blues and greens, as he wished to obtain the brightest possible colors. But, as every Renaissance artist knew, particles of azurite and malachite do not mix well with the lime plaster found in walls, and should be avoided in frescoes at all costs.

To paint the way he wanted, he stretched the fresco technique to its physical limits. On a layer of lead white, he sketched with whatever drawing media he pleased—ink, thin black paint, black charcoal, red chalk. He corrected outlines, adjusted colors of garments, added glazes, and balanced shades and reflections.

Truth be told, when he painted transparent and metal objects, such as glasses, dishes, and cutlery, and their delicate reflections and refraction, he painted images that had never before been seen on a wall. Richness of colors, balance of shades and reflections, transparent glasses, reflective metal surfaces: all those optical effects that were impossible to render with traditional fresco colors made Leonardo's *Last Supper* unique.

But the real reason he looked for ways to make fresco painting more malleable had to do with his desire to capture the essence of each of the apostles. He had created for them unique body motions that were appropriate for the scene but that also foretold the destiny of each. Peter, on the far right, holds a knife, which is more than a dining utensil—it is a reference to a gruesome event that happened right after the supper, which is recounted in the Bible: to defend Christ, Peter cut off the ear of a servant. Peter's knife points toward Bartholomew in what seems like a casual manner, but it is likely a reference to Bartholomew's death as a martyr by flaying. Similarly, Thomas (he is painted next to Christ) raises his finger to the sky in a gesture Leonardo favored, but which is also a pointed reference to his later encounter with Christ, when he stuck that same finger in Christ's chest wound out of doubt (Verrocchio's bronze statue for Orsanmichele showed the same story). John (also seated next to Christ) leans on the table with his hands clasped and his fingers intertwined, a gesture that anticipates how he grieved at the foot of the cross, as depicted by Renaissance painters. Judas holds a money bag, which is a clear reference to how he betrayed Christ for money; his neck displays pronounced muscles, which were associated with criminals in the Renaissance, and his face is in shadow. A beautiful drawing of Judas in red chalk is among the few preparatory drawings that has survived (Figure 11); it gives us a sense of the intensity of Leonardo's figures, a quality that has largely been lost owing to degradation of the mural.

Leonardo worked slowly and deliberately. We know this because Prior Vincenzo Bandello had a young nephew, Matteo Bandello, who lived at Santa Maria delle Grazie and who had the good fortune to be able to watch Leonardo at work. It is in turn our good fortune that young Matteo wrote down what he saw, providing an eyewitness account of Leonardo's idiosyncratic, unscheduled way of painting:

> Many times he used to go—and I witnessed him to do this quite often—in the very early morning, climb the scaffolding,

because the *Last Supper* is high off the ground, he would—I say—not put down the brush in his hands from sunrise till the shades of evening, forgetting to eat and drink, he would continuously paint. Then there would be two, three, and four days in which he would not touch the work with his hand, but he would stay for one or two hours of the day only to contemplate, consider, and examine his figures in solitude, in order to judge them. I would also see him, as the whim or fancy touched him, leaving at midday, when the sun reached its zenith, from the Corte Vecchia where he was making that stupendous [model of the] horse in clay, and come straight to the Grazie, climb on the scaffolding, seize the brush, give one or two brushstrokes to a figure, and then suddenly depart to go elsewhere.

The sight of Leonardo at work became something of an attraction. Many came to the refectory to watch. They stood there in complete silence, or at most whispering "with hushed voices," as if they were attending a religious function rather than watching an artist at work. But it was a genius at work they had come to watch, one who pondered every stroke of his brush as each changed the optical balance of the whole work. The *Last Supper* was already widely admired even before Leonardo finished it, probably around 1497–1498. His friend Luca Pacioli praised it for the emotions it portrayed. The mural was

an exquisite image of humans' burning desire for salvation, in which it is not possible to imagine the apostles responding more, even when they were alive, to the sound of the infallible voice of truth, as it said: "Unus vestrum me traditus est" [One of you will betray me]. With acts and gestures turning from one to the other, and from the other to the one, and with vivid and pained astonishment, they seemed to speak to one another. With his [elegant] lightness of touch, our Leonardo most worthily designed it so.

The French monarch Louis XII, who had become the ruler of Milan after Ludovico, wanted to detach the *Last Supper* from the wall and take it to Paris. The operation proved to be impossible, and the mural remained in the refectory.

But Leonardo's extreme technical experimentation in painting meant that, after less than twenty years, the mural was a ghost of its former self.

Leonardo's a secco touches peeled off.

Azurite and malachite lost their brightness and also peeled off.

The other colors were distorted by their reactions with the lime plaster.

The science of art that had been the reason for its success was also the reason for its ruin.

Over the centuries, various restoration efforts tried to slow the decay, but there was not much that could be done to halt or reverse the slow-motion disaster.

It is estimated that only about 20 percent of what we see today can be attributed to Leonardo's hand—the rest is the work of later restorers. And yet, thanks especially to those who conducted the last restoration, from 1977 to 1997, and who pushed restoration techniques to their physical limits, we can still sense Leonardo's skill at rendering the faces of the apostles, the pleats of the tablecloth, the metal dishes, the transparent glasses.

Leonardo would paint on a wall only one other time. It was in Florence, where he returned after the French takeover of Milan. After enduring the humiliation of seeing his clay model for Ludovico's horse used as a target by French bowmen, he grimly summed up his twenty years at the Milanese court: "the duke lost his duchy and his things and his freedom and none of the work I planned for him was carried out." On December 14, 1499, he transferred six hundred ducats to a bank in Florence, which was the revenue he got from a vineyard Ludovico had given him as a gift in 1498 (Salai would inherit this vineyard after Leonardo's death). Shortly thereafter he left Milan. He made brief stops in Mantua and Venice, and by the spring of 1500 he was in Florence.

The city had gone through major political changes. Lorenzo de' Medici had died in 1492, his son Piero was inept at keeping the family in control of Florentine politics, and the Medici were expelled in 1494. The Dominican friar Girolamo Savonarola ruled for a few years, proclaiming a republic ruled by the people in the name of Christ. To gather the five hundred citizens who were supposed to rule the city, Savonarola created a large audience hall in the Signoria palace, which came to be known as the Sala dei Cinquecento, or Hall of the Five Hundred. By 1498, Savonarola had lost his popular support and was burned at the stake. Machiavelli became the chancellor and created a new position: the standard bearer of justice for life, or *gonfaloniere di giustizia a vita*, to which he managed to have his friend Piero Soderini elected in 1502. Soderini was as acutely aware of the power of art as the Medici had been in previous decades. One of his first official acts was to ask Leonardo to paint a large fresco for the Hall of the Five Hundred that celebrated the Florentine republic.

At the size of eight by twenty meters, the mural was twice as wide as the *Last Supper*. Its subject was equally grand: the Battle of Anghiari, which the Florentines won against Milan thanks to a cloud of dust and smoke that alerted them to the impeding attack. "You must first represent the smoke from the artillery, mingled in the air with the dust stirred up by the movement of the horses and the combatants," Leonardo wrote in a passage he possibly intended to include in his book on painting. Thinking more like a physicist than an artist, he explained in the same passage that dust is made of particles of different weights: the finest particles, which get to the highest reaches, mingle with air and acquire its color; heavier particles stay closer to the ground, mingling with smoke and acquiring "the appearance of a dark cloud." And while dust mixes with smoke, the color of this mixture is different: it is "much more luminous" when seen from the side of the light source than from the opposite side. But "in the midst of the swirling mass [. . .] of foam, and water exploding into the air and among the legs and bodies of the horses," the mixture displays "less difference between light and shadows." The dust generated by galloping horses also looks different de-

pending on where the animals are: those that are more distant from the viewer create clouds of dust that are "thinly spread out" and minimally visible, but horses that are closer make clouds that are "more noticeable, smaller, and more tightly packed."

Leonardo's battle scene did not look like a traditional fight among mounted soldiers. The violence was not conveyed by the fight itself but by the thickness of a cloud made of dust, smoke, and blood, mixed with light and shadow: a denser cloud meant a more frenzied clash "in the midst of the swirling mass." His writings on dust and smoke, light and shadow, recall Alhacen's treatment of optical science in their style.

Leonardo went one step further in his written treatment of the battle scene. For him, the representation of a battle demonstrated the superiority of painting over poetry, a topic he intended to address in his book on painting:

> If you, poet, were to portray a bloody battle you would write about the dark and murky air amid the smoke of fearful and deadly engines of war, mixed with all the filthy dust that fouls the air, and about the fearful flight of wretches terrified by awful death [. . .] Your tongue will be impeded by thirst and your body by sleep and hunger, before you could show in words what the painter may display in an instant.

Like the *Last Supper*, this battle scene had to be painted in fresco. And the results, sadly, were just as disastrous, perhaps even more so. There is nothing left of Leonardo's *Battle of Anghiari*.

Leonardo did create a highly detailed, fully finished cartoon, a *ben finito cartone*, that consumed over four hundred sheets of royal paper, or *carta reale*; he made a copy of it, which he colored and brought to the Signoria palace for transfer to the wall. By June 6, 1505, he was painting—but as Leonardo himself reported, that day things took a wrong turn "at the very moment of laying down the brush." The weather

deteriorated. A jar broke. Water spilled. Rain poured in in great quantities. "It was as dark as night" and "the cartoon tore." People in the Renaissance believed transformational events were marked by exceptional natural occurrences. The storm that erupted that day and tore the cartoon was a bad omen for Leonardo's *Battle of Anghiari*.

To make matters worse, when Leonardo was in the midst of his preparatory work, the twenty-nine-year-old Michelangelo was asked to paint another battle scene next to Leonardo's. It was almost like a vote of no confidence in Leonardo's ability to deliver the mural.

Leonardo never finished his battle, and, for that matter, neither did Michelangelo finish his. Allegedly, they did not complete their respective battles because they both left Florence—Michelangelo for Rome, Leonardo for Milan. For brief periods they were in Florence at the same time, but by and large they avoided each other and made a point of leaving a city when the other was around, no matter what the city was. But from their rivalry came two cartoons that were regarded as *la scuola del mondo*, everybody's school. Generations of artists flocked to learn from them in the halls where they were kept, until they were completely torn into pieces and lost. Today, we know about these two battle scenes thanks only to copies by later artists.

Fresco, then, was most certainly not Leonardo's preferred medium, even though the demands of patrons and the contingencies of specific commissions forced him to use the technique. Because he was such a great experimenter, he tried to bend it to suit his artistic needs—namely, the need to retouch a work endlessly as every new brushstroke changed the optical balance of the whole. Others—Michelangelo and Raphael—would become the great fresco painters of the sixteenth century. We have only to think about the great fresco cycles they painted in the Vatican just a few years after Leonardo abandoned his *Battle of Anghiari*, and when his *Last Supper* was already showing signs of decay. The ceiling of the Sistine Chapel and the *Last Judgment* on its altar wall, the Vatican Stanze, the Loggias, the Pauline Chapel—those were

the great frescoes of the Renaissance, all done for popes at the Vatican.

As for Leonardo, he moved in a different direction. He came to value excellence of execution over everything else: "Excellent painters," he wrote, "will produce few works, although these will be of such quality that men will stop in admiration to contemplate their perfection." But excellent painters are never satisfied: "when the judgment disdains the work this is a perfect sign." He came to value his own critical thinking over the completion of a finished product. Whether it was a painting, a book, or an experiment, it was the process rather than the outcome that mattered to him.

//

Why the *Mona Lisa* Was Never Finished

When Ludovico fled Milan and the French occupied the city, Leonardo had to give up his position as court artist. But he could not readily give up the habits of mind he had developed there.

In that city, he had enjoyed the freedom, space, and support to make art the way he wanted. He wrote about the science and philosophy guiding his art and put these ideas into practice. He experimented with techniques, some less successful than others. As he grew older and more famous, he acquired privileges that most artists did not have.

In the last twenty years of his life, Leonardo made art in a way that anticipated what we consider "modern." He worked more and more in sync with what would later be known as a Romantic conception of art, according to which art expresses an artist's own feelings and views instead of those of others. But he also presaged, in a deep way, our modern notion of "art for art's sake": it is only the artwork, as a free-standing autonomous object, that matters, not the patron who commissioned it or the practical purpose it was meant to serve. These are key concepts we must understand if we want to start to grasp why, for Leonardo, the process of discovery was more important than the final outcome, why his writings remained drafts that never found a final form, why he painted so incredibly slowly that ten or fifteen years were

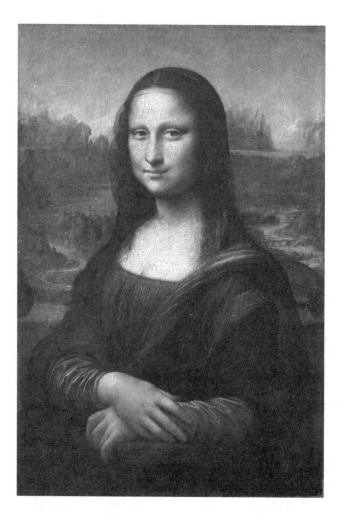

sometimes not enough to complete a work, and why even the *Mona Lisa* was never finished (Figure 12).

This shift in Leonardo's artistic practice was evident to those who saw him at work, although most did not understand what was really driving him. In April 1501, about a year after he had left Milan for Florence, a visitor came to the rooms he occupied in Santissima Annunziata, one of the largest monasteries in Florence. Leonardo's father had been the monastery's notary for over thirty years and must have helped him secure his accommodations there. It was a difficult transition:

Leonardo's main source of income consisted of revenue from his Milanese properties and from works his assistants painted after his drawings. This visitor reported that "from time to time he puts his hand" to some of his assistants' works. But otherwise, Leonardo seemed confused.

He lived day by day, *alla giornata.*

His life seemed scattered and unfocused, *varia et indeterminata forte.*

He was highly impatient with the brush, *impatientissimo al pennello.*

But beneath this apparent confusion were the underpinnings of a new phase in his art. He started to paint works that were absolutely revolutionary. What made them revolutionary was not their subject matter—one was a religious altarpiece, another a small devotional painting representing Saint John the Baptist. One represented the Greek mythological character Leda, and another was the *Mona Lisa*, a portrait of a silk merchant's wife (Figures 12, 13, and 14).

What made the *Mona Lisa* and a handful of other paintings new was the special treatment he reserved for them.

In fact, he never meant to deliver the *Mona Lisa* and the other paintings, although they were commissioned by specific patrons.

He never meant to finish them, even though he worked on them for over fifteen years.

He never meant them for anybody but himself, even though he let others copy them, and he kept them in his possession until his death, bringing them with him as he moved from city to city.

These works became "his" personal works. With them, he pushed the boundaries of his new art—they were high-concept experiments, explorations of how optics could be translated into pictorial practice. He was never satisfied with the results, and abided by his own dictum:

> If you will study and perfect your works in line with the theory
> of the two kinds of perspective [color and aerial perspective]

you will leave behind works which will bestow upon you more honor than money would do.

In other words, he sought renown, not money.

He conceived the *Mona Lisa* and these other special paintings at different moments of his life, for different patrons and with different goals in mind. But as the years went by, they started to merge in his mind. He worked on them simultaneously, moving freely from one to the other, adding touches to the landscape of the lady's portrait and then doing the same to the landscape of the religious work, or refining the transparency of the Virgin's fabrics and then using the same layering of glazes for the lady's dress and veil. An idea for the body of Leda was applied to the Virgin's own body.

His brushes became smaller and smaller, his brushstrokes almost invisible.

Today, the *Mona Lisa* is by far the most famous of these personal works. But it was not his first, nor was it the most important in his mind. The work Leonardo cared about most was an altarpiece created for an unknown patron, the *Virgin and Child with Saint Anne* (Figure 13).

Saint Anne's meeting with the Virgin and the Child was apocryphal, as Saint Anne was already dead when Christ was born, but it held immense religious and, in Florence, civic significance. In 1343, on Saint Anne's feast day (July 26), the Florentines won a decisive battle and saved the republic, making Saint Anne the "saint protector" of the republic, just as David was its biblical hero, Hercules its ancient god, and Saint John the city's patron saint. In 1481, Pope Sixtus IV declared the date of Saint Anne's conception a feast day, in part as a way to promote Mary's own Immaculate Conception (based on the belief that Saint Anne conceived Mary sine macula in her womb). A few years later, in 1494, another pope, Alexander VI, who was better known for his reckless pursuit of personal power than for his devotion, stipulated that those who prayed in front of an image of Saint Anne with Mary and the Christ Child would receive an indulgence. Undoubtedly, the

patron who commissioned the *Virgin and Child with Saint Anne*—whoever he was—had in mind Saint Anne's growing cult.

It has been suggested that Leonardo originally created this altarpiece for the Servite friars, who hosted him at Santissima Annunziata, as a way to repay them for their hospitality. But if there was an agreement between the friars and their notary's son—we do not know for sure—it was never enforced. Leonardo did finish a cartoon representing the *Virgin and Child with Saint Anne*, but he never delivered a finished painting. Two other artists who were deeply connected to Leonardo painted the work for the Servite friars years later. They were Filippino Lippi, who had painted the *Adoration of the Magi* for the Augustinian monks when Leonardo abandoned the work, and Pietro Perugino, who had been Leonardo's friend since their common training in Verrocchio's workshop.

But Leonardo continued to work on his version of the *Virgin and the Child with Saint Anne*, as it allowed him to explore fundamental aspects of his new philosophical art. What was the perfect composition, or *componimento inculto*, as he called it, to represent the intimate bond linking three generations, that timeless affection mothers have for their offspring? It took him over ten years, dozens of pen sketches, and three full-sized cartoons to discover the arrangement of figures he sought. His assistants copied these drawings and cartoons extensively and often documented intermediary stages of their master's work.

His contemporaries understood that Leonardo's *Virgin and Child with Saint Anne* was exceptional. Just as modern visitors flock to the museums where Leonardo's works are kept, Florentines rushed to admire a cartoon the artist displayed for the public in 1501, the first of his highly popular exhibitions.

And one Florentine in particular understood how deeply the altarpiece was connected to the *Mona Lisa* and, for that matter, to the mural of the *Battle of Anghiari*.

Agostino Vespucci was Machiavelli's secretary and the official in charge of overseeing work on Leonardo's *Battle of Anghiari*. He provided the artist with a translation of a historical account of the battle.

Eventually, he gained Leonardo's trust. The two became so close that Leonardo entrusted Vespucci with drafting a letter on his behalf to help him claim an inheritance that his stepbrothers had contested due to Leonardo's illegitimate status. Vespucci had a clear sense of his friend's worth. He was a regular visitor to his workshop, which from October 1503 was located in Santa Maria Novella. There he saw the cartoon for the *Battle of Anghiari*, along with other works in progress, including the *Virgin and Child with Saint Anne* and the *Mona Lisa*.

In October of 1503, Leonardo's unfinished works were on Vespucci's mind. That month Vespucci read Cicero's *Letters to Friends*, a book Renaissance humanists loved and used as a guide for their own lives. It is our good fortune that Vespucci's copy of Cicero's book has survived, having recently resurfaced in a German library. It is our even greater fortune that this humanist jotted in the margins the thoughts that the Roman orator inspired in him. Cicero reported that Apelles, the great artist from antiquity who was famous for his depictions of heads, "completed with the most polished art the head and bust of Venus but left the other part of her body [inchoate]." Vespucci could not help applying Cicero's comment to his own friend, the "Florentine Apelles." Vespucci wrote:

> Apelles the painter. This is what Leonardo da Vinci does in all his pictures, as in the head of Lisa del Giocondo, and Anne, the mother of Mary. We will see what he will do in the hall of the great council, about which he has made an agreement with the standard-bearer, October 1503.

By that same October, the *Mona Lisa*, like Leonardo's *Virgin and Child with Saint Anne*, had also become famous.

And by early 1504, at the latest, the *Mona Lisa* had even become the fashionable new paradigm for Renaissance portraiture.

Raphael, who at twenty-one had arrived in Florence from his native

Urbino, sketched Leonardo's *Mona Lisa* as the work was in progress and immediately began using it as a model for his own portraits. He swiftly absorbed Leonardo's work. Leonardo's assistants painted exact copies of the *Mona Lisa*, and perhaps one of these copies did make it to the silk merchant who had commissioned the portrait in the first place.

The *Mona Lisa* was in fact the portrait of Lisa Gherardini, a member of a rich and prestigious Florentine family—not as powerful and wealthy as the Medici or the Benci, but nonetheless prominent and well off. In 1495, at the age of sixteen, she married the widower Francesco del Giocondo, who was nineteen years older than she and a wealthy silk merchant with extensive business and political connections in Florence and across Italy. Lisa and Francesco had two daughters (one died in 1499) and, in 1502, their first son. Francesco likely commissioned his wife's portrait to celebrate the successful birth of his heir and to adorn the new family home he bought in the Via della Stufa, not far from the Medici palace, in April 1503.

How did Francesco del Giocondo, who was a respected merchant but not a leading civic figure, convince Leonardo—who was by then a legendary artist who refused commissions from duchesses and royals—to paint his wife? The answer must involve personal relations between Leonardo's father, Ser Piero; the del Giocondos; and the friars of Santissima Annunziata. Francesco and his family had close business relations with the Servite fathers and had obtained funerary rights to one of their chapels. Ser Piero served as the monastery's notary for many years, and on more than one occasion acted as an intermediary between the Servite friars and the del Giocondo family. Leonardo and Francesco del Giocondo must have met in Santissima Annunziata, where one lived and the other went to pray in his family chapel.

The *Mona Lisa* was supposed to be a conventional portrait that conformed to well-established ideas about women, beauty, and female behavior. But, as was always the case with Leonardo, what started as conventional ended up being exceptional.

In some respects, Leonardo did produce a conventional portrait.

The panel itself was typical of the genre: a single plank of poplar of about seventy-seven by fifty-three centimeters (or thirty by twenty-one inches). It was prepared with the usual layers of gesso and priming, onto which Leonardo transferred preparatory drawings. He sketched some of these drawings in front of Lisa, but none of them survive.

He represented Lisa in a decorously restrained posture, her hands crossed and close to her chest, her gaze directed toward the viewer but still modest, her head covered with a veil. She is dressed in silk, which was an expression of her social standing and sophistication but also a reference to her husband. She sits on a typical Florentine chair, her arm resting on the curved armrest, in a loggia that opens onto a vast, misty landscape filled with turning rivers, winding roads, deep valleys, and ragged mountains. As was common in portraits of the time, the sitter's close-up view stood in contrast with a distant landscape.

Even Mona Lisa's smile, which has become legendary since Leonardo painted it, conformed to expectations—it was simply the restrained expression married women were expected to display in their portraits. But viewers sought explanations for what was later perceived as a mysterious expression. For Giorgio Vasari, who never saw the portrait but who may have heard about it directly from Francesco's heirs or from Mona Lisa herself, she smiles because jousters and musicians were sent to amuse her while Leonardo painted. The story was complete fiction, but effective at explaining the mood of this Florentine woman. According to the art historian Paul Barolsky, her smile is a pun on her husband's family name, Giocondo—*giocondo* means "jocund" in Italian. Just like a juniper bush and an ermine were puns on the names of Ginevra de' Benci and Cecilia Gallerani, so Mona Lisa's smile was a pun on the family name of Lisa's husband. And *Gioconda*—the title of the painting in Italian and French—is a clear reference to Mona Lisa's mood: she is happy with her standing in life as the wife of Giocondo.

But this is where *Mona Lisa*'s conformity to traditional portraiture ends.

For Leonardo, the whole point of her smile, her body position, her hands, her dress, and even the landscape was for people to penetrate deeper and deeper into her emotions, to grasp the serene satisfaction she enjoyed.

And that was a hard response to elicit, in spite of his expertise.

To begin with, Leonardo did not paint jewels on Mona Lisa, although she surely owned many. Three decades earlier, with Ginevra's portrait, he had learned that their shimmering appearance detracted from the balance of the work.

Then he adjusted certain details atop the priming. He deleted a few curls, as they obstructed Lisa's face, just as he had done with Ginevra's portrait. He retouched the way her right hand rested on the armrest and modified the fingers and nails of her left hand so that they were better aligned with her body motion, as he had done with the Virgin's hand in the *Virgin of the Rocks* twenty years earlier. The science of art demanded these minute optical adjustments.

But one of the adjustments was highly unusual. After he sketched the landscape and the balcony, he added two barely visible columns at the margins—which, oddly enough, are not straight. Their bases on the balcony are clearly visible, but their trunks fade away at the top in ways that are inexplicable according to linear perspective. We are sure this is Leonardo's original design because the painting still has the barb, or ricciolo, all around, which means that the painted surface retains its original size. Why did Leonardo add these columns? And why did he design them in this way?

Although we do not know for sure, it seems that Leonardo imagined these columns as if they were reflected in a slightly curved mirror—this would explain why their trunks fade away at the top and also why the sitter seems to emerge from the frame. It was a small, almost imperceptible optical adjustment, but, with it, Leonardo changed the whole image. He enhanced the sitter's physical presence, as if she were jumping out toward the surface of the panel, her face and body as close as possible to the viewer, her smile emphatically connecting her inner world to ours, the landscape even more distant.

He experimented with other pictorial effects as well in the *Mona Lisa* and other later paintings. Transparency, flesh tones, and misty landscapes were among the things that mattered the most to him, and brushstrokes, even very minute ones, could alter the illusion of flesh, water, crystal, or air. He made his glazes thinner and thinner, and he experimented with colors and oils that had less and less pigment mixed with them. Veils, mountains, smiles, clouds, swirls of water emerged gradually from infinite layers of these thin glazes applied with minuscule brushes.

It is hard for us to understand how slow this process was. When we look at the *Mona Lisa* with the naked eye, we see no trace of brushwork, no layers. But modern quantitative X-ray fluorescence spectroscopy—an imaging technique that conservators who analyzed the *Mona Lisa* recently used because it "makes it possible to access the description of the paint layers used in flesh tones"—reveals how many layers of translucent glazes are present. There are many, perhaps as many as thirty. Some of these layers may be varnishes added by others over the centuries. But many are the original layers Leonardo himself applied to render his subject's flesh. Conservators were able to determine that some were applied "in very thin films, down to a micrometer scale"— that is, one-millionth of a meter. To use the modern terminology of chemistry, we would say that Leonardo painted these experimental paintings with materials that have low atomic density—that is, pigments and oil-based varnishes that are highly diluted and have a small concentration of particles whose thickness and color shade he could alter minimally. This is the secret of the *Mona Lisa*'s smile: multiple layers of colors and varnishes with low atomic density.

Leonardo's preparatory drawings for the *Mona Lisa* have been lost, but a few of those for the female heads in the *Virgin and Child with Saint Anne* have come down to us (Figure 15). In one beautiful drawing, he sketched her head in black and red chalk and blended the marks to create evanes-

cent effects. He rendered the shadows in gray pencil and with minuscule touches of white chalk that are virtually imperceptible.

Flesh tones, in general, were hard to get right, not least because skin does not have a uniform color or texture. Hands have thicker skin than cheeks or lips, eyelids are softer than foreheads, the complexions of women are smoother than those of men, and the complexions of children silkier still. Light reflects differently off of different skin textures, which is why for flesh tones Leonardo used multiple layers that would differentiate between the skin textures of different parts of the body.

And yet skin tones are what make emotions visible. These tones were perhaps the "real" subject of another painting on which Leonardo worked while painting the *Mona Lisa* and which, like his other "personal" paintings, stayed with him until his death. It is a small devotional work representing Saint John the Baptist (Figure 14). He portrayed the saint from the waist up, emerging from a dark background, his body partially covered by sheepskin, his face, bust, arm, and hand fully lit with nuanced shading to differentiate them. Infrared photography reveals that he sketched the saint and then traced over this sketch with red chalk, often correcting the initial drawing underneath. He shadowed this sketch with thin, almost transparent layers of lead white mixed with minimal amounts of earth tone, ochre, vermilion, and black. Was this a special work, intended to study the flesh tones of different parts of the body? It would seem so, especially if we consider Paul Barolsky's suggestion that in this painting, Leonardo investigated "the problematic relation between the spirit and the flesh" and made "visible the divine mystery of the spirit in flesh."

Leonardo applied the same techniques to the *Mona Lisa* as well. If we look carefully, we can see how hard Leonardo worked at differentiating the flesh tones of his subject's hands, which look more greenish than her face. He shaded her flesh with umber, an earth-colored pigment originating from the region of Umbria, sketching the shaded areas di-

rectly on the ground and building up the lighter areas with glazes. For her hands, he mixed more earth colors into the glazes—and on her lower neck there seem to be traces of azurite. Is this what captures her pulse, as Vasari famously observed? "In the pit of the throat, if one gazes upon it intently, one could see the beating of pulses."

Mountains and landscapes were easier to paint than flesh tones. For one, Leonardo did not need to plan every single detail but painted them directly on the panel, making adjustments as he moved along—there are no traces of a preparatory drawing underneath the landscape of the *Mona Lisa*. He conceived the landscape as being made up of three areas: valleys right behind the sitter, rocks in the middle, and mountains and lakes in the far distance. As usual, he painted the blue sky in two layers, first a layer of cheaper copper blue and above it highly transparent layers of expensive lapis lazuli. The combination of these blues made for a bright sky, which is hard to detect today because of the many varnishes painted over it by restorers over the centuries.

In other paintings, Leonardo did plan out mountains in detail and, in some instances, sketched them from nature (Figure 16). Some of his most sophisticated drawings of mountains were executed "red on red"—that is, with red chalk on paper that he had brushed with a reddish wash: this allowed him to capture the minutest changes in the pervading atmosphere. In one he created a fantastic view of three mountain chains, one after another: crests are drawn red on red, their lighted peaks are touched with white, and their shadows are rendered in nuanced tones of red, the colors differentiated by way of subtle transitions. But none of these mountain drawings was made specifically in preparation for the *Mona Lisa*.

Leonardo painted Mona Lisa's dress in verdigris and her sleeves in ochre. Again, the original colors were much brighter than those we see today due to layers of varnish that were added later and have yellowed. This bright dress with gold embroidery and minuscule pleats around the neckline also displayed beautiful see-through effects. Alhacen had written about the optical effects of flesh covered by fabric, and about how the two intermingle depending on the fabric's texture and threads.

And then there was the effect of fabric seen through fabric. Mona Lisa wears a voluminous, ethereal gauze "cloak" that envelops her fully. Her ochre sleeves and greenish dress with golden embroidery are seen through this gauze, each fold and pleat shimmering with its own peculiar reflections. Over her head she wears a veil whose edges are marked with a dark thread that overlaps with the gauze, resulting in additional see-through effects.

No drapery studies for the *Mona Lisa* have survived, but a few Leonardo made for the *Virgin and Child with Saint Anne* are still in existence. In that panel, he went further in blending materials to render the shimmering of fabrics. He painted the Virgin's dress on a red lake base, which allowed for a much more brilliant, translucent color than the pink primer he had used in his early paintings (remember the pink base of the gray palace in the *Annunciation*). Because Leonardo was sensitive to how fabrics were described in optical literature, especially in Alhacen, the colors of Mary's brilliant red dress are allowed to filter through the threads of her blue mantle. Meanwhile, he painted Saint Anne's gray dress over a preparation of red lake. He had become a master at modulating colors and glazes to render the transparency of fabrics— and of using his fingers to do so. His fingerprints are everywhere. On the Virgin's shoulder and Saint Anne's body, blurring their forms with the sky, and on the tree to the right. Was this blending another way to achieve the effect Alhacen had described: an atmosphere that makes outlines disappear?

The *Mona Lisa* is highly finished in many places. Leonardo painted the foreground and the background. He painted his subject's face and dress. He painted the distant landscape. But there is one crucial part that Leonardo left unfinished: the middle ground.

This middle ground was essential to an optically balanced painting. There, foreground and background must merge seamlessly. It was the

area Leonardo could paint only after he had firmed up everything else, only after the balance of the parts had been achieved.

But Leonardo did not finish the middle ground in the *Mona Lisa*—or, for that matter, in the *Virgin and Child with Saint Anne*. On the right of the *Mona Lisa* (Figure 12), there are two blocks of brownish color that look like they were reserved for hills or some other natural feature. On the opposite side, there are two similar areas that seem like an extension of Lisa's veil. All these unsightly brownish patches are hard to read today. But they were in fact a base color for the landscape. We cannot be sure what, exactly, Leonardo intended to paint there (a similar patch is also found in the middle ground of the *Virgin and Child with Saint Anne*, right behind Mary). But we can be sure that Leonardo never managed to paint over these preparatory layers and that the *Mona Lisa* is unfinished.

Part of the reason the *Mona Lisa* was never finished has to do with the fact that the optical science behind it was likewise unfinished business.

In fact, when Leonardo was not working on the *Mona Lisa* or on his other experimental paintings, he was writing.

He wrote incessantly.

He wrote with urgency.

He wrote into the wee hours of the night.

He wrote until he had no more paper to write on.

In a few months, between the fall of 1504 and the summer of 1505, while he was simultaneously working on the *Battle of Anghiari*, painting the *Mona Lisa*, perfecting the *Virgin and Child with Saint Anne*, and designing the *Leda*, he also assembled numerous notebooks on various topics. The titles do not capture the diversity of material he dealt with. One notebook was on the flight of birds. Other folios were about the squaring of the circle, a vexing geometrical problem that neither Euclid nor Archimedes had been able to solve but that, on November 30, 1504, Leonardo claimed he had: "on the night of Saint Andrew I found the end of the squaring of the circle; it was finished at the end of the candle, and of the night, and of the paper on which I was writing; at

the end of the hour." He also wrote about Euclidean geometry and about "the transformation of a body into another without diminution or augmentation of its matter."

The book on painting was constantly on his mind, and in order to write it properly he branched out into other fields, seeking the deep connections between man and nature. Often when he wrote about the body of the earth he was also thinking about the bodies of human beings. For instance, in a book on water, he planned to compare the earth's rivers, lakes, and mountains to human ribs, bones, and blood vessels:

> As man has in him bones [that are] the supports and framework of his flesh, the world has its rocks [that are] the supports of the earth; as man has in him a pool of blood in which the lungs rise and fall in breathing, so the body of the earth has its ocean tide which likewise rises and falls every six hours, as if the world breathed; as in that pool of blood veins have their origin, which ramify all over the human body, so likewise the ocean sea fills the body of the earth with infinite springs of water. The body of the earth lacks sinews and this is because the sinews are made expressly for movements and, being the world perpetually stable, no movement takes place and [since] no movement takes place, muscles are not necessary.
> But in all other points they are much alike.

One cannot help imagining that while he was forming these comparisons he was also painting female bodies and landscapes in the *Mona Lisa*, the *Virgin and Child with Saint Anne*, and the *Leda*. The landscapes were images of specific places, but the more he painted them, the more they transformed in front of his eyes into fantastic landscapes from primordial times: a cosmic view reflecting the microcosmos of mankind.

Beginning in 1507, Leonardo got some help with his writing. He took on a new apprentice, Giovanni Francesco Melzi, who was educated in

letters and who helped him keep his papers in order. In March of 1508, while lodging in the house of his Florentine friend Piero Martelli, he came up with a publication plan, which he described in a new notebook that he started for that purposes (today it is part of the manuscript known as the Codex Arundel, from the name of a previous owner):

> This [notebook] will be a collection without order, drawn from many pages which I have copied here, hoping to put them in order in their places, according to the subjects with which they will deal, and I believe that before I am at the end of this, I will have to repeat the same things many times—for which do not blame me, reader, because the topics are many and memory cannot retain them all and say: "I will not write this because it is written before." And if I wished not to fall into this error, it would be necessary that in every case which I wished to copy, in order not to duplicate it, I would always have to reread all the preceding material, and all the more so because of the long intervals of time between the writing of one thing and the next.

Unfortunately, the plan was not much of a plan at all. But he did make some progress. That same year, he reorganized his notes on light and shadow in a new manuscript, which Melzi later called Libro W and which contained his most polished thoughts on the topic. It has unfortunately been lost, for the most part, but the bits and pieces that survive are some of the clearest sentences Leonardo ever wrote on light and shade: "A shadow is made of infinite darkness and of infinite diminution of that darkness"; and there are shadows with "smoky imperceptible boundaries [*fumosi d'insensibile termine*]" and others with "firm ends [*termini noti*]." In another notebook, known today as Manuscript G, he wrote unequivocally that "without optics nothing can be done well in the matter of painting."

Around 1513 he wrote a detailed table of contents for a book entirely dedicated to shadows, but we do not know if that book ever went beyond the outline stage. He planned to write:

Of the usefulness of shadows

Of the motion of shadows

Of the figure of shadows

Of [their] quality

Of the quantities [of shadows]

Of the boundaries [of shadows]

Of simple shadow

Of composed shadow

Of decomposed shadow

Of darkness

Of light

Of light carried through holes of various shapes

Of light carried through various numbers of holes

Of the composition of several luminous rays

If it is possible that a luminous body originates luminous rays that intersect one another

If from a luminous body parallel rays can originate and whether they can go as such through a hole

He gathered his notes on the atmosphere and other natural phenomena in a small notebook, Manuscript F. He assembled his notes on vision and the eye into a set of ten folios, known today as Manuscript D. He compiled notes on water, which he called the *vetturale della natura*, on the moon's reflected light (*lumen cinereum*), and on the transformation of the earth's globe as documented by fossils and stratified rocks in a set of eighteen large folios, known today as the Codex Leicester. Often, he kept his papers as loose bifolios, which he gathered inside one another without binding. The most important folios were the largest, like the Codex Leicester. He obtained them by cutting a sheet of carta reale in two and then folding it in half.

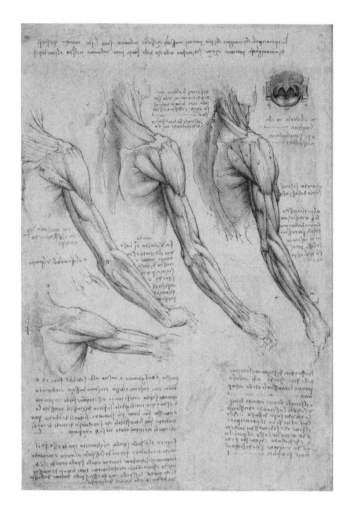

In the winter of 1510–1511, he returned to the study of anatomy and completed eighteen folios. As the Head of Prints and Drawings for Royal Collection Trust at Windsor Castle Martin Clayton described them, "On these pages Leonardo crammed more than 240 individual drawings and notes running to over 13,000 words." Anatomy was an early interest of his, dating back to at least his skull studies of 1489 and to a lost book that his friend Luca Pacioli said was titled *On Painting and Human Motion*, which dated from the late 1490s; it remains unclear how much of this lost book got into the last draft of his anatomical folios. At this time he also drafted a new table of contents for the

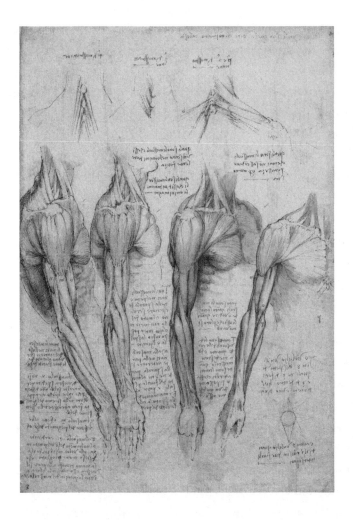

book. "My depiction of the human body," he wrote, "will be shown to you just as if you had a real man before you."

The bodies will be examined, he wrote, "from different aspects, from below, from above, and from the sides, turning the subject around [. . .] just as if you had the same limb in your hand and went on turning it gradually until you had a complete understanding of what you wish to know."

Among his most stunning anatomical drawings are those of the shoulder and arm stripped down to show their muscles, which are shown from multiple directions in eight consecutive views that move

through 180 degrees, from back right to front left. The sequence is now divided into two separate folios, but clearly Leonardo drew them on a single folio that was later cut in two. The accurate depiction of shoulders was paramount for him: their rotation was the most effective way to suggest the sinuous movements of people, as shoulders determine the motion of arms, busts, and legs. Just think about his female figures—the slight turn of Mona Lisa's shoulder, Leda's dramatically twisted body, and Mary's arms folded across her body.

Ptolemy had begun his atlas with a map of the entire world, followed by individual maps of the world's provinces. Leonardo wished to organize what he called his "cosmography of the Microcosmos," "in fifteen entire figures in the same order as was adopted before me by Ptolemy in his Cosmography." Echoing Ptolemy, Leonardo began his anatomy book with an overall anatomical table of the human body and moved from there to individual body parts. He reminded himself: "begin the anatomy at the head and finish at the sole of the foot."

His book was also based on Galen's classical text and on medieval compendia such as Mondino's *Anathomia* or Johannes de Ketham's *Fasciculus Medicinae*, which he owned—but he also relied on the over thirty corpses he dissected, including a centenarian man, a two-year-old child, and a seven-month-old fetus. His friend Paolo Giovio said Leonardo "dissected the corpses of criminals in the medical schools, indifferent to this inhuman and disgusting work," but in reality he dissected with doctors in Florentine and Roman hospitals and with Marcantonio della Torre, a physician at the University of Pavia who died of the plague in 1511. Mainly, though, he dissected animal corpses—cows, pigs, bears—which were easier to find than human cadavers.

His anatomical drawings look so realistic that we might almost be led to believe that he made them during dissections. Nothing could be further from the truth. He made them at his desk, reorganizing the notes he took during dissection, which must have been necessarily

brief—and spattered with blood. Because membranes intermingle with veins, arteries, nerves, cords, muscles, and bones, creating great confusion, and because blood stains every part the same color, he created many views of each body part to show—first its muscles and tendons, then its inner layers of nerves, veins, and arteries, and finally the structure of bones.

The anatomy book was quite advanced, and at some point, Leonardo finally realized that the end was in sight: "in the winter of this year, 1510, I hope to complete all this anatomy." Three years later, he confided to his friend Giovio in Rome that he wished to publish it "from copper engravings for the benefit of art." He even reminded himself: "have your books on anatomy bound." We do not know if he ever actually bound these loose folios. What we know is that in 1513 he was forced to move again. "I left Milan for Rome on the 24th of September 1513 with Giovan Francesco Melzi, Salai, Lorenzo, and Il Fanfoia," he wrote.

Rome was the art capital of Europe. Intrigue and corruption were everywhere, but the city was in the midst of change. In the course of the fifteenth century, a series of popes—all of whom loved antiquities, pagan literature, and art as much as they loved ruling a state and leading Christendom—had been transforming the city from the devastated ruin it had become in the late Middle Ages into a splendid capital. They erected palaces, opened ceremonial streets, and built bridges and churches. In the early sixteenth century, one pope, Julius II, was so bold as to demolish the old church of Saint Peter's and have a new one built in its place. The project took centuries to complete, but the architect who started it in 1505 was none other than Leonardo's good friend from his Milanese years, Donato Bramante.

Leonardo affectionately called him "Donnino," and Bramante regarded Leonardo as "a cordial, dear and delightful associate." While Donato was designing the new Saint Peter's for the pope, another artist, who admired Leonardo, was painting the pope's apartments. This

was Raphael. His frescoes of the *School of Athens* and the *Liberation of Saint Peter* show the extent of his debt to Leonardo: he could not have painted them without Leonardo's teachings on reflected colors and backlight effects.

Michelangelo, however, was not exactly Leonardo's friend, and luckily he had left Rome just before Leonardo arrived. But he had left behind the ceiling of the Sistine Chapel, which he had completed the year before and which had dazzled the city with its bold colors, the daring anatomy of its nude figures, and the sheer magnificence of biblical creation that it represented.

By and large, Leonardo stayed away—or was excluded—from what was happening in Rome, in spite of the fact that Bramante, Raphael, and even Michelangelo owed a great deal to him stylistically.

He settled in quarters next to a papal villa at the Vatican, on the top of the Belvedere Hill, which his patron Giuliano de' Medici, who was the pope's brother, had secured for him. This was where artists working at the papal court normally lodged, and the quarters were far from grandiose. There was a kitchen, a loft, a dining room, a studio, and a bedroom, as well as a few other features that had been added for his comfort. Floors were paved with tiles. Windows were enlarged. Beds for his assistants were added, and "a desk to grind colors" was added as well. Clearly, Leonardo intended to paint. Although his lodgings were less than half a mile away from the main papal palace, he lived immersed in nature, surrounded by ponds and ancient statues. In many respects, it was a perfect place to retreat from the frenzy of the papal court and to work on his philosophical art.

He brought his unfinished paintings to Rome, although it is unclear how much he worked on them. Mainly, he wrote. He worked on his anatomical studies until the pope abruptly ordered him to stop: in papal circles they resulted more in suspicion than in admiration. Leonardo shifted his focus to geometry, and in July 1514 he finished a book he titled *De Ludo Geometrico*. He returned to the question of the squaring of the circle and claimed that he had "given the rules for proceeding to infinity." His calculations were approximations, but he loved that he

was working at the limit of what the mind can imagine. In these years he also planned a "discourse on botany," which would be an illustrated book. He wrote on hydraulics, that branch of science concerned with practical applications of fluids and liquids in motion. The motion of human bodies and natural forces had been a lifelong fascination of his, and the leap into hydraulics came naturally to him. Since youth, he had observed the similar patterns of water swirls and spirals, which he compared to curls of human hair. He wrote:

> Observe the motion of the surface of water, which resembles the behavior of hair, which has two motions, of which one depends on the weight of the strands, the other on its line of revolving; thus water makes revolving eddies, one part of which depends on the principal current, and the other depends on the incidental and reflected motions.

He was also fascinated by fossils, especially those that came from high in the mountains. His explanations were insightful. He thought that high mountains were submerged in water, that ancient springs or lakes or seas were once there and had since disappeared. He was among the first to believe that the earth had a history and that its mountains, lakes, and rivers might bear the traces of it.

He was convinced that there were general laws of nature, rules that could be applied to its different aspects, and he went in search of them. "Write of swimming under water and you will have the flight of birds through the air," he wrote, connecting the study of water and air.

The leap from science to poetry and imagination also came easily: rivers and lakes brought to the imagination catastrophic scenes of deluges and destruction by water. Some of his writings on the topic came from observation but also from thoughts connected to his *Battle of Anghiari*: "You will show the degrees of falling rain at various distances and of varying degrees of obscurity, and let the darkest part be closest to the middle of its thickness." Some came from experiments that he imagined but did not actually conduct. His powers of observation were

legendary, as was his ability to think abstractly. He saw things in natural phenomena that nobody else could see and was able to conduct experiments in his head or in his drawings, which were for him an extension of the mind, the sketches simply making visible his train of thought. For no other artist of the Renaissance did the connection between hand and mind have such a strong resonance.

But for Leonardo, the ultimate confirmation that he had gotten something right came from painting. Could he paint curls of human hair like spirals found in nature? Could he show the passing of time through the erosion of mountains? Or the erosion of valleys by rivers?

His approach to painting left many baffled. Baldassare Castiglione, who was a prolific writer and an acute observer of court life, reported that Leonardo "despises that art in which he is exceptional and he set about learning philosophy, in which he has so strange concepts and new chimeras, that even he who has such talent in painting does not know how to paint them." Like many others, Castiglione did not grasp that Leonardo could understand natural phenomena only if he could paint them.

This is what the *Mona Lisa*—and the other experimental paintings— in fact were: a synthesis of the knowledge of the world Leonardo had acquired through observation.

In 1516, Leonardo moved again. After the death of Giuliano de' Medici, his patron and the pope's brother, he accepted an invitation from François I of France to join his court as royal painter for the handsome annual pay of one thousand scudi. In early October, he departed Rome with his longtime assistants Salai and Melzi. He packed his usual household items, his artist's tools, and the fancy clothes he liked to wear. But he also brought items that required extra care to preserve from the accidents of travel. These were his unfinished paintings, the *Mona Lisa*, the *Virgin and Child with Saint Anne*, the *Leda*, and *Saint John the Baptist*, among others. There were also his writings, thousands of pages, all unpublished, stored in heavy wooden chests. His time in

France would be a good opportunity to order them and perhaps finally publish a few.

The French king had given him a royal property at Cloux, in the Loire Valley, just about half a mile from the royal castle of Amboise. It included a comfortable house, where he settled with his assistants and servants. By then he was an old man, his health failing. A visitor who came to see him reported that he was "somewhat paralyzed in his right hand" and that he could "no longer color with such sweetness as he used to" but that he was able "to do drawings and to teach others." He has "trained up a Milanese pupil who works well." This Milanese pupil was either Salai or Melzi. For the French king, Leonardo planned marvelous set designs for plays and dinner parties to entertain royal guests. Perhaps he planned an ideal city and palaces for high-ranking royal courtiers.

Mainly, he wrote, with Melzi at his side.

His writings—"an infinity of volumes, all in the vernacular"—made an impression in France, especially those on anatomy. The same visitor reported that he had seen with his own eye illustrations of "limbs, muscles, nerves, veins, joints, intestines [. . .] never yet done by anybody else."

As the years went by, Leonardo's assistant and lover Melzi took charge of every aspect of Leonardo's life, arranging things for him, handling his correspondence and contacts, and putting his writings in order. In fact, all the master did in the last two years of his life was write. He kept going and going, draft after draft, sentence by sentence, page after page. Time passed, until there was no longer time.

On May 2, 1519, Leonardo died at Cloux. He was sixty-seven. Legend has it that he "expired in the arms of the king." This is only a legend, but although it is factually untrue, it suggests the genuine esteem the king had for his *première peintre du Roi*, first painter to the king. The truth was that François I was far away, at Saint-Germain-en-Laye. Beside Leonardo's deathbed sat Francesco Melzi, his assistant of twenty years, and the man he had nominated to be the executor of his will—and heir to his belongings, including his precious drafts.

How

LEONARDO's

Science of Art Was

Lost and Found

The Heir

Twelve years before his death, Leonardo had taken on an unusual apprentice: Giovanni Francesco Melzi, the son of Girolamo Melzi, captain of the Milanese army.

As a result of his status, this boy had something exceptional to offer to Leonardo. He was educated—all legitimate sons of the elite were, after all. He could help Leonardo with his writing.

It was around 1507. Melzi was about fifteen years old. He was "a very handsome youth." In the workshop he was known as "Cecho" or "Cechino," both diminutives for Francesco. His relationship with his master evolved quickly. Francesco and Leonardo became bound not just by work, not just by mutual respect, not just by a common love of art, but also—as Melzi described it after Leonardo's death—by "the consuming and passionate love he bore daily toward me."

Melzi became Leonardo's lover, replacing Salai, the other Milanese apprentice who had once filled that role and who was ten years older than Melzi. Leonardo and Salai had been close for almost fifteen years, but by the time Melzi joined the workshop Salai had exhausted the patience of his master and of others in the workshop. "Salai, I want peace, not war," somebody wrote in one of Leonardo's folios of those years. "No more wars, I give in."

It was in very different terms that Leonardo wrote to Melzi during a short trip to Florence, where he had gone to attend to family business. He begged his new assistant for help: "Good day Messer Francesco, God knows why of all the letters that I have written to you, you have never replied. Just wait till I am with you, by God, and I shall make you write so much that perhaps then you will be sorry."

As it turned out, Melzi would end up writing quite a bit, but apparently was never sorry for it—in fact, he stayed with Leonardo until the end of his master's life.

Like his fellow apprentices, Melzi started by copying his master's drawings—drapery studies, horse legs, male and female heads, hands and feet—until he was skilled enough to sketch three-dimensional objects such as plaster casts and statues. Leonardo insisted that his pupils not use colors until they learned how "to imitate with very simple marks the force of nature and the outlines of the bodies that appear to our eyes with such variety of motions." He did not want them to be seduced by the "charm of brushes and the magic of colors." Francesco was a quick study, and in about two years he learned how to draw in his master's style.

His first signed drawing is a profile of an old man in red chalk—Leonardo's signature technique. The drawing of the figure displays great depth, and the structure of his skull is well defined, the facial muscles are drawn appropriately to capture the man's age, his wrinkles are correctly rendered, and the skin is convincingly rough. Francesco had clearly studied his master's anatomical drawings and his red-on-red figure sketches. He had even been allowed to retouch a particularly beautiful drawing depicting the head of Judas, which Leonardo had made in preparation for the *Last Supper* (Figure 11).

Above all, Francesco had studied Leonardo's shadow drawings in order to apply the sfumato technique to the old man's facial muscles and, by way of this effect, seem to make visible the man's soul. Proud of what he had achieved, Melzi signed and dated the profile: "On the 14th of August 1510, first draft in relief. Francesco da Melzo 17 years

old." Two years later, he retouched this highly competent drawing and dated it again near the man's back: "19 years old, Francesco Melzi." His most famous red-on-red drawing, however, dates from just a couple of years later, around 1515: it is a stunning portrait of his master in old age, the most vivid image of Leonardo we have.

But apart from copying Leonardo's drawings, the real privilege of being in Leonardo's workshop was to work side by side with the master as he refined his experimental paintings, especially the *Virgin and Child with Saint Anne* and the *Mona Lisa*, two works that held a special place in Melzi's imagination as they did in Leonardo's own. Leonardo had not yet settled on the composition of these paintings, and Francesco watched him as he prepared drawing after drawing, trying to determine the best position for his figures, the best shapes for mountains and trees, and the right combination of glazes. Francesco copied many of these drawings, immersed in Leonardo's creative process.

Like other assistants, Francesco participated in the main activity of the workshop, which was to duplicate Leonardo's experimental paintings on new panels at the very same time as his master painted the originals. In those years, an exact copy of the *Mona Lisa*, now at the Prado Museum in Madrid, was created. It is of very high quality, even though its color scheme and execution are not at the level of Leonardo's original. Melzi watched the copy being prepared and perhaps even painted it himself (this work is variously attributed to Salai as well as to Melzi). Various versions of the *Virgin and Child with Saint Anne* were also painted in those years. Another highly successful work that came out of the workshop in many copies was the head of Christ in the act of blessing, the *Salvator Mundi*; many copies, each showing minor variations in Christ's garments, his hands or hair, are dispersed in museums around the world.

Melzi also borrowed freely, with Leonardo's blessing, from his master's stock of sketches, drawings, preparatory cartoons, and unfinished paintings to make his own works. His first "independent" painting, *Vertumnus and Pomona*, was in reality an adaptation of Leonardo's *Virgin and Child with Saint Anne*, its subject a pagan myth instead of a Christian story. Vertumnus, the Roman god of seasons, plant growth,

and change, approached Pomona, a goddess of fruitful abundance, in the disguise of an old woman to convince her to reciprocate his love. Leonardo had never painted this story, and had generally shown little interest in ancient myths even though they were highly popular among the cultural elite. But Leonardo had also learned from Verrocchio, and he taught his pupils that the same figure could be adapted to different scenes. A saintly woman could become a pagan goddess so long as her bodily motions and expressions were appropriate to the story.

Melzi's Pomona was almost an exact copy of Leonardo's *Virgin* from a cartoon, which is now kept at the National Gallery in London and known as the Burlington House Cartoon, after the name of a collection in which it was kept previously, although appropriately Melzi had her hold a basket of fruit instead of the Christ Child. The landscape was largely based on another version of Leonardo's *Virgin and Child with Saint Anne*, the one that is now at the Louvre. Trees, plants, and flowers came from his master's botanical drawings. Pomona's hairstyle was modeled on Leonardo's famous studies of female heads with floating tresses and swirling curls. Her foot is an exact copy of Mary's right foot, which Melzi had sketched in a separate drawing on a folio that had his master's writing on the other side—no other pupil got to sketch on the pages on which Leonardo wrote his notes. Melzi signed his *Vertumnus and Pomona* in Latin on the stone in the foreground, and although a Parisian art dealer erased the signature in the nineteenth century, probably in order to sell the painting as a work by Leonardo, a few letters have reemerged thanks to a recent restoration confirming that Melzi was the creator of this painting.

Melzi absorbed Leonardo's new art quickly, and even though he never reached a similar level of perfection and never managed to master the use of glazes, he nonetheless knew how to paint blurred edges and use color to depict soft smiles, half-open lips, and intense gazes. Eventually, Melzi gained a reputation as somebody who "paints extremely well" and whose works "are often confused with the master's works."

The first person to recognize Melzi's talent at interpreting Leonardo's new art was Leonardo himself, who trusted Francesco with two important tasks that he did not delegate to any other assistant. One was an urgent effort that pertained to his drawings. Leonardo loved to draw with silverpoint and soft chalk because these drawing tools leave only faint traces on the page. Silverpoint marks are so delicate that he could sketch in silverpoint on top of an already existing drawing without losing sight of the latter. He could blend chalk marks with his own fingers in order to soften edges and modulate shadows. But drawings in silverpoint and chalk are extremely fragile. Over time, particles of metal and chalk come loose from the folios, marks fade away, and drawings become almost illegible. Leonardo himself had used ink to redraw the fading lines of his early drawings that were disappearing in front of his very eyes, though there were so many of them that he could not possibly preserve them all himself. As a result, he entrusted Francesco with the job of retracing his own sketches, and we can see Francesco's work on drawings such as the *Head of Judas* (Figure 11).

Francesco's other assignment was to organize Leonardo's writings, which were a mess. Over the years, Leonardo had accumulated thousands of unbound and unnumbered folios and notebooks, on which he had jotted down, in no apparent order, quotations from his readings, his own thoughts, his personal notes, and his to-do lists, alongside his sketches and drawings. Most of these notes were working materials for his books, but he had never ordered his folios and notebooks in a coherent manner, let alone organized them into complete books. The methodical work that would be required to complete these books was not exactly Leonardo's forte.

But this sort of ability was precisely what Melzi brought to the table.

Having come from a patrician family, the boy was educated. Like other students of his standing, he was fluent in Latin and Greek. He also knew how to organize "commonplace books," which were collections of quotations from ancient authors that students were taught to assemble and to use in their own writing. He had learned how to select

passages from his reading, which was extensive, and copy them onto loose folios or into notebooks so that he would always have material for an essay at hand.

Leonardo himself had been exposed to this way of working, and had done something similar when he read optical texts. His optical writings were, in a way, commonplace books on optics, but he had never transformed them into complete essays. But Melzi knew what a book needed to look and sound like. He proved invaluable in helping Leonardo to write his own.

Melzi got to work right away. First he began to organize the thousands of pages of notes stuffed into chests in Leonardo's residence. Then, as his confidence increased, he began to do more than just organize. He started making suggestions to Leonardo as to where he could more clearly explain his ideas, leading to a new proliferation of writings by Leonardo around 1510. Even as Leonardo's mirror writing became harder and harder to read, Melzi became more and more adept at deciphering it, until he was the only one who could do so properly. His handwriting is everywhere on Leonardo's papers. Often, Melzi rewrote in conventional writing what Leonardo had written in reverse, and in the process, he adjusted the language and expanded its scope, perhaps following Leonardo's dictation.

Slowly, Melzi began to put Leonardo's notebooks in order. He assigned a letter of the classical Latin alphabet to each notebook, and that letter became its primary identifier: Libro A, Libro B—all the way through Libro Z. When he ran out of classical Latin letters, he used the Greek alphabet, meaning that there must have been more than twenty-three notebooks. He then numbered the pages of each notebook and counted them one more time. When he was confident of that number, he entered it into the record. For instance, on Libro G, which was a notebook dedicated to light and shade, he wrote, "The folios are 28, that is, twenty-eight." (Libro G is known today as Manuscript C, after the name given to it by a nineteenth-century librarian who adopted Melzi's same cataloging system based on letters of the Latin alphabet.)

This was tedious work, but this is what, by and large, Melzi did for Leonardo in Milan, in Rome, and at Cloux: he redrew Leonardo's fading drawings and kept his writings in order. In effect, Leonardo made Melzi the sole conservator of his legacy long before he drafted his will.

Because Melzi was the one who knew Leonardo's writings and drawings better than anybody else, Leonardo wanted him by his side on April 23, 1519, when he went to a notary to sign his will. That Leonardo could make a will and nominate an heir was in itself exceptional, as in France the custom was for foreigners who died without children "to forfeit everything" to the king at death. But in consideration of the fact that he did not own land in France, Leonardo had obtained a royal privilege directly from François I to draft a will and nominate an heir.

In the Renaissance, wills did not just stipulate how the deceased's worldly possessions were to be divided; they were also intended to assist in the soul's passage to heaven. Catholic dogma holds that the souls of common people—saints are different—must expiate their sins in purgatory before going to heaven. The length of time spent in purgatory depends on the nature of these sins, but it can be shortened by Masses celebrated in the name of the dead. As a result, people in the Renaissance left detailed instructions in their wills regarding Masses to be said on their behalf.

Leonardo was no exception. He left generous donations of cash and candles to three local churches to celebrate Masses for his soul. He asked to be buried in the local church of Saint Florentine, which he selected in honor of the city where he had matured as an artist. He asked that, at his funeral, sixty people be hired to carry tapers. After having taken care of his soul, he instructed that his earthly goods be distributed among his two Milanese servants, Maturina and Battista de Villanis, and his two longtime assistants, Salai and Melzi. Salai was

not at Cloux when Leonardo drafted his will, and indeed he got the short end of things, just half of a garden Leonardo owned in Milan. Perhaps Leonardo had given him some other things early on, including some paintings, but from the will, it seems he did not get much of Leonardo's legacy. In any case, he would not have had much use for it. Six years later, he was killed during a fight in Milan.

Melzi received the bulk of Leonardo's artistic and intellectual legacy: "each and all of the books of which the Testator [Leonardo] is currently in possession, and other tools and depictions connected with his art and the profession of painters." He also got "each and all of the clothes which he [Leonardo] presently possesses in the said palace of Cloux." Leonardo considered this to be remuneration for the "good and kind services done to him until now" instead of "for the cost, time, and trouble he may incur with regard to the execution of the present Testament." That work would indeed fall to him, for he was named the sole executor of Leonardo's will.

Ten days later, Leonardo died, and it was up to Melzi to carry out his last wishes.

Francesco was devastated by Leonardo's death, but soon composed himself. He found a proper burial chapel at the Church of Saint Florentine. He hired sixty poor people from the hospital of Saint Lazarus to carry tapers at the funeral and paid them seventy soldi out of his master's estate. He arranged for cash and candles to pay for Masses for Leonardo's soul. A month later, he wrote to Leonardo's stepbrothers in Florence. He told them that Leonardo had been to him "like an excellent father" and that "it is impossible to express the grief that I feel at this death." He lost "the consuming and passionate love he [Leonardo] bore daily toward me" and for that loss he will feel "perpetual unhappiness." Overcoming his hardly containable grief, he let the stepbrothers know that Leonardo had left them a small holding at Fiesole as well as a deposit he kept with the bursar of the hospital of Santa Maria Nuova in Florence, which Melzi estimated amounted to about four

hundred scudi, plus any accrued interest. It was not much. But it was plenty considering that Leonardo's relations with his stepbrothers were strained after years of legal battles over the will of a childless uncle who had left his belongings to Leonardo, a fact his stepbrothers resented.

After he was done carrying out Leonardo's wishes, there was nothing to keep Melzi in France. He gathered what he had of Leonardo's work—thousands of loose folios of many different sizes, hundreds of drawings, and some notebooks—and began the journey to his family home just outside Milan.

The Melzi villa was an idyllic spot, located at Vaprio d'Adda, about twenty miles northeast of Milan. The family had acquired it in the late fifteenth century because it sat in a strategic place along the banks of the Adda River, on the border between the Duchy of Milan and the Republic of Venice. Leonardo had been a guest at the villa in 1512, when the political situation in Milan had become so tense that he deemed it wise to accept the invitation of his assistant's family. To reciprocate such hospitality, he drew some landscape views on the walls of the villa, which are now lost, and suggested some architectural improvements, which were never implemented. Otherwise he spent his time in the study the Melzi family had arranged for him, most likely in the villa's high tower. From there he made a beautiful drawing of the river, showing the river's sudden turn around the villa and the cable ferry that transported people and cattle from one bank to the other. Occasionally, he wandered along the riverbank to observe "the flux and reflux of water as demonstrated at the mill of Vaprio." He became interested in the physics of water vortices, a problem of hydraulics that has not been fully resolved to this day.

Melzi must have had vivid memories of his master's visit to the family villa.

Soon Melzi settled into the life of a person of his standing. He married a patrician woman, Angela Landriani, who gave him eight children and an extensive network of friends and relations. He collected

books—one volume of Spanish poetry, now held in a Milanese library, still has his name on it: *Joannes Franciscus Meltius hic scripsit die xiij mensis Junij 1546.* He spent time in the company of the Milanese cultural elite and served the duchy in various capacities and often offered expert advice in matters of art. He continued to paint. He even trained another artist, the illuminator Girolamo Figino.

But in the quietness of that grand mansion Melzi spent most of his time working on his master's notes. For the rest of his life, he carefully guarded everything he had inherited. He kept "such papers together as if they were relics." He was determined to collect his master's writings into publishable books. He started with the one book that he knew his master had worked on for his entire adult life: Leonardo's book on painting.

Of course, Leonardo had never started assembling his notes into a coherent book.

And so Melzi had his work cut out for him.

Melzi spent years—five years, ten years, fifteen years—poring over the thousands of pages that he himself had classified and numbered. Leonardo's notes on painting were distributed across the folios and notebooks he had left behind. Melzi combed through these notebooks systematically, one after another, taking whatever he felt was relevant. If he did not find any material pertaining to painting in a given notebook, he would write on it "*N. di P.*"—an abbreviation for *Nulla di Pittura*, which means "Nothing on Painting." But when he found a relevant passage, he marked it with a small circle in black ink, a little sign to remind himself to go back to that page and copy the note.

When he was done reading the thousands of pages, he started from the beginning once again, this time going straight to the passages he had marked with a small circle. He copied the most significant passages onto small loose folios, which were not dissimilar to modern flash cards, and crossed out the small circles on the originals to remind himself that they had already been copied. Then he moved these flash cards of sorts around and rearranged them topically. When he was finally

satisfied with the order of the notes, he copied them into a new notebook, which he titled *Book on Painting by Messer Leonardo da Vinci, Florentine Painter and Sculptor* (*Libro di pittura di Messer Lionardo da Vinci pittore et scultore fiorentino*).

He assembled this new notebook from reams of large paper. He selected the highest-quality paper commonly available in Lombardy and Veneto at the time. He cut the folios in half and then folded them to obtain folios of about eight by six inches, which he gathered into sets of eight folios, or quires (*quaderni* in Italian). He calculated with great accuracy the notebook's size based on the amount of text he expected to place on each page: 28 lines of approximately 50 characters per line. This would require a notebook of 344 folios (43 quires, with a few pages left over), which in turn corresponded to 688 pages, as one could write on both the front and back of each folio. (Today, one quire has only 6 folios, another has only 2 folios, but the remaining 41 quires have 8 folios, just as Melzi calculated.)

Melzi assembled the quires into a stack, but he did not bind them, as it was easier to write on them when they were loose. To make sure he did not mix up the sequence of these loose folios, he numbered them and devised a system for cross-referencing them.

His estimate of the notebook's size was slightly off, as he eventually discarded two quires because he did not copy any notes on them. It was not unusual at the time to plan books so carefully. Writing was a laborious exercise, and paper was expensive. Even Leonardo had attempted a few such calculations when thinking about his various books. On a scrap of paper, he imagined a book made of 160 folios, which would

have corresponded to 320 pages, each page having 21 lines of text. We do not know what book Leonardo had in mind when he made these calculations. But there is no doubt that he was planning to write a book and to print it.

Melzi copied Leonardo's notes into the notebook he had so carefully planned.

He wrote with regular handwriting using the cursive script, which was the script preferred by Renaissance humanists. If an illustration accompanied a note, which was often the case, he left an empty space in the middle of the text where he planned to sketch the illustration. If the image was a geometrical diagram, he added to the sketch the letter keys that were mentioned in the accompanying text. If it represented a human figure, he sketched it first in charcoal and later fixed it in pen and ink, and then shaded it.

To maintain regular margins and consistent line and letter spacing throughout, Melzi used a lined sheet, which he placed underneath each folio: the lines were visible through the paper and served as a guide as he wrote. The way Melzi assembled the *Book on Painting* suggests that he wanted to create a clean, legible copy with well-spaced characters to give to a typographer, who would typeset the letters following Melzi's

handwritten example, and then make woodcut prints in the empty spaces after the text itself had been printed.

In giving form to Leonardo's scattered notes, what Melzi wanted to preserve for posterity was Leonardo's unique view that "painting is philosophy." Here is how Melzi organized Leonardo's ideas about the science of art:

He divided the book into eight parts, each dedicated to a different topic. He did not conceive of these parts as being equal in either length or significance. Unmistakably, the core of the *Book on Painting* was part 5, "On Shadow and Light" (*De ombra e lume*). With its more than 130 pages, 277 chapters, and 107 optical drawings, it was in effect a book within a book. It was the longest, the most complex, and the most original section of all. And it was stunning. Nobody had ever written anything of the sort. Leonardo had worked his entire life on this section, refining the drawings until he was satisfied both with their beauty and with their scientific rigor—after all, he thought that "optics is the signpost and gateway of painting." Melzi assembled this section from his master's most refined sketches and notes on the topic, selecting primarily those Leonardo made later in his life. Those were contained in a notebook Melzi had titled Libro W, which has unfortunately been lost. As a result, by and large we have access to Leonardo's most advanced work on light and shadows only because of Melzi's *Book on Painting*.

Part 5 was in many ways the culmination of the preceding sections of the work. The *Book on Painting* started with a chapter titled "Whether Painting Is a Science or Not" and insisted on the importance of experience, "the mother of every certainty"—the foundational tenet of Alhacen's optics. It included Leonardo's comparison of the arts, which he had written around 1490, and other Alhacen-inspired formulations he elaborated in later years, such as that painting is "a mental discourse" that passes through the power of vision, or *virtù visiva*. Painters work with "greater mental exertion [*maggior fatica di mente*]" than other artists because they have to follow "ten different discourses [. . .] light,

shadow, color, body, figure, site, distance, vicinity, motion, and still-ness." Here are Leonardo's thoughts on "the science of painting" and his explanation on "how the eye is less deceived than any other sense in its workings in luminous or transparent and uniform mediums." Here is spelled out Leonardo's belief that painting is the highest art form because the sense of sight is superior to the other senses— all thoughts that were inspired by optical literature, including Alhacen's.

Section 2 contained notes on studio practice, or *precetti del pittore*: 216 chapters designed to teach artists how to become a "universal painter." Here, Melzi copied some of Leonardo's most memorable in-structions: painting represents "man and the intentions of his mind"; narrative paintings (*istorie depinte*) "ought to move those who behold and admire them in the same way as the protagonist of the narrative is moved." About one hundred of these precetti del pittore deal with var-ious aspects of aerial and color perspective, including reflections and transparent colors—all topics Leonardo had discussed from around 1490 onward, explaining both their philosophical underpinnings and the geometric procedures needed to render them in paint. Even the instructions Melzi selected on how to paint nudes, landscapes, faces, heads, night scenes, natural disasters, battles, deluges, and storms were informed by optics, as Leonardo taught artists that in order to move viewers more deeply, it was not enough to arrange figures on a panel— the traditional Renaissance understanding of "composition." Rather, they had to select the right light sources and atmospheric effects and to render them on the basis of scientific principles.

Optical science also informed the 266 chapters of section 3, which was titled "Various Accidents and Movements of Man and Proportions of His Body." This was a topic Leonardo had written about since at least 1489, when he began planning his book on the human figure, which he never completed. Interestingly, however, Melzi did not in-clude notes about human proportions per se, but rather about how the atmosphere affects our perception of bodily motion.

The fourth section, "On Drapery and Ways to Dress Figures with

Grace and on Clothes and the Nature of Drapery," follows logically from the discussion of the human body: drapery has "to show the disposition and motion of figures and one should avoid the confusion of many folds," which obscure movement and thus the visible outward expression of the soul. It is a very short section—only sixteen chapters. The fifth section, "On Shadow and Light," followed, while three short sections on trees, clouds, and the horizon that dealt with landscape concluded Leonardo's *Book on Painting*, at least according to Melzi's organization.

But it was the fifth section, "On Shadow and Light," that was the most important. Leonardo had been sketching shadow drawings since the 1470s and had written advanced drafts on the topic since at least the early 1490s. In his *Book on Painting*, Melzi had Leonardo start this section with general principles that were common to optical books, but he had him soon delve into examples of increasing complexity that were completely original. These examples pertain to delicate, blurred shadows that can be perceived only under conditions of faint light and at a close distance. Following the example of optical texts, he taught artists that the human eye cannot precisely delineate the border between light and shadow, or distinguish minute differences in color, and that to be great painters they had to learn to capture smoky shadows and subtle reflections with mathematical precision.

The previous sections of the book had conveyed their lessons by way of qualitative examples—that is to say, concrete situations in defined settings, such as riders in battle or mothers playing with sons. But the fifth section, "On Shadow and Light," offered a strictly conceptual analysis of the same phenomena—that is to say, one based on the "mathematical demonstration" of optical principles.

To round out the volume, Melzi added a thirty-page-long table of contents and his own *Memoria e Nota*, which was a list of the eighteen notebooks by Leonardo, out of the many more he possessed, from which he had extracted notes on painting for his compilation. It is only thanks to this list that we have a sense of how many of Leonardo's writings have been lost. Of these eighteen notebooks, only six are still

in existence. The other twelve are missing. In other words, only about a third of Leonardo's writings on painting have survived. If we apply the same ratio of dispersal to all of Leonardo's writings, not just to those that dealt with painting, we get a sense of how much of Leonardo's legacy was lost overall.

By the time Melzi was done with compiling the *Book on Painting*, or at least most of it, roughly twenty years had passed. By around 1540, he had assembled 662 pages containing 944 notes and over 200 drawings. This was the closest anyone would ever get to the book that Leonardo had dreamed of writing. He kept refining his compilation and may have considered also adding some more notes in the empty pages. He must have thought about finding a publisher, too, as every detail of the *Book on Painting*—the layout, the spacing of words and characters, the illustrations within the text—suggests that he had a printed book in mind.

At the time, most books were published in Latin. Some publishers, though, had also started to publish books in Italian, especially manuals and other technical works that were of interest to a non-Latin-speaking public. In Milan, there were several publishers that had assembled a decent catalog of art books in Italian. But the European capital of book publishing was Venice, and chances are that Melzi went to Venice to find a publisher.

In the preceding fifty years, Venetian presses had put out some of the most beautiful books of the Renaissance. The most prolific and forward-looking publisher was Aldus Manutius. He had published ancient authors in Greek and Latin and modern works by historians, poets, jurists, architects, and artists. Some of his books were lavishly illustrated, and many dealt with various aspects of art. His son Paolo continued the family tradition. The design of Melzi's *Book on Painting* suggests that he had books from Manutius's press in mind when he began work. The generous spacing of margins and letters, the placement of images within the text, the table of contents at the end, the list of sources—all these elements were trademarks of Manutius's publica-

tions. At that publishing house, Leonardo's text would have received the same philological and linguistic attention, the same editorial care, the same elegant layout that Manutius and his heirs had given to the great authors of the past.

But Melzi did not publish his compilation. We do not know why. Perhaps when he set about finding a publisher, he could find no takers. Or perhaps he was dissatisfied with the result.

Nonetheless, news of the book he had compiled began to circulate. Visitors went to see Melzi, and were often impressed by his own art as well. The Milanese painter Gian Paolo Lomazzo, who later wrote several long and convoluted art books, knew Melzi well and regarded him as a "wonderful miniature painter." The aristocrat Giovanni Ambrogio Mazenta, who was also a Leonardo buff and who later played a big role in the dissemination of Leonardo's work, thought Melzi had come nearer than anyone else to the manner of his master: his pictures were so finished that they were "often confused with the master's works."

The most important and consequential visitor of all, though, was Giorgio Vasari. Vasari was a Florentine artist turned writer who also served as the official artist of the Medici court. He found Melzi "a beautiful and kind old man" and remarked that he had been "a very beautiful young man, much loved" by Leonardo. Vasari was in the process of revising his own celebrated art book, *The Lives of the Most Excellent Italian Architects, Painters, and Sculptors from Cimabue to Our Times*, which he had first published in 1550 and was now enlarging and correcting for an augmented second edition. He wanted to know more about Leonardo and his famous notebooks, and so in 1566 he went to see Melzi. Melzi showed him Leonardo's notebooks on human anatomy. He also showed him "a portrait of Leonardo of happy memory," which presumably was the portrait Melzi himself had sketched when the master was an old man. Vasari used the image in his revised book.

Did Melzi, then, also show Vasari the *Book on Painting* he had compiled from his master's notes?

The Biographer and the Doctored Book

Giorgio Vasari was an excellent artist and a formidable storyteller. He was the perfect court artist for the Florence of the 1550s and 1560s, which was a very different place from the city Leonardo had known. No longer a republic, the city was now the capital of the Duchy of Tuscany, a state ruled by the Medici, who, in 1532, had taken over the republic in a coup and established a hereditary monarchy in its place.

It might seem hard to imagine what a book on painting could possibly have to do with a political coup. And, furthermore, how Leonardo—thirteen years dead by the time of that coup and buried in France, no less—was still relevant in this new Florence and these new times. But art *was* highly relevant, and Leonardo's in particular. For in these preliteracy days, when very few people could read or write in the vernacular, let alone Latin, art was never just about pretty pictures. It was the medium in which every institution, from the government to the church, told its story—the *lingua franca*, so to speak, through which those in power communicated what was expected of those under their authority. If you wanted to change the ways or values of a society, you did it through art.

No one understood this better than the second duke of Florence, Cosimo I de' Medici, not to be confused with the founder of the Medici dynasty, Cosimo the Elder. Think what you will about the entire

Medici clan (in large part an unpleasant bunch), and the ruthless and violent Cosimo I in particular (he had his brother-in-law and sister killed when they challenged his authority). Still, it is no exaggeration to suggest that, in all of Europe, no ruling family had ever showed more panache or sophistication in its artistic tastes, or devoted more time and attention to "painting" its way to public acceptance and legitimacy. During his reign of almost forty years, Cosimo I spent a king's ransom paying artists to paint over the great murals of republican Florence, including the wall that had been destined for Leonardo's *Battle of Anghiari*, and replace them with new murals that seamlessly intertwined the Medici story with those of ancient heroes and Roman emperors. In this way, Cosimo made the Medici takeover seem like a natural outgrowth of the republic in the service of the greater good.

At Cosimo's court, no position was more coveted than that of chief court painter. The court painter was influential. He worked closely with the duke, making sure that each fresco, parade, stage for a play, altarpiece, or display for festivities, court entertainment, or public event reinforced the same basic message: that the Medici were the legitimate heirs of the Florentine republic. The court artist worked efficiently—often under pressing deadlines—to create artwork to mark special events such as ducal marriages, baptisms, funerals, ambassadors' visits, or religious festivities. An army of artists, each specializing in a specific subject—wars, soldiers, landscapes, buildings, flowers, city views, etc.—worked with him, side by side. Each artist understood he was merely part of a team, charged primarily with working in concert with others as a cohesive unit. These artists were not universal painters (*pittori universali*). They did not know the science behind what they painted, nor were they familiar with Leonardo's notes on painting. They did not need to be. Their job was to follow exactly the instructions of the court artist.

Giorgio Vasari aspired to the position of court painter, and eventually he got it—but thanks only to his old friend Vincenzo Borghini (1515–1580), who was one of Cosimo's trusted advisors. This old friend knew

how to convince Cosimo, Renaissance-style, to appoint Vasari: to ensure that the duke was indebted to the artist. That was easily accomplished by Vasari following his friend's suggestion to dedicate the book he was writing to Cosimo.

Vasari, furthermore, was not writing just any old book. His *Lives of the Most Excellent Italian Architects, Painters, and Sculptors from Cimabue to Our Times*, then acclaimed as the definitive history of Renaissance art, is still in print today. It told the story of art from the Middle Ages to Vasari's time through brief biographies of individual artists. In the introduction, Vasari declared that he did not expect fame "as a historian or writer of books" as his "business in life is to paint, not to write." He wished merely to write "as a simple painter" using his "own language" and to offer artists a history of their predecessors and a good vocabulary with which to describe their craft.

Little did he know that his fame would come from this book, not his paintings.

He intended to write accurate biographies that portrayed the real character of each artist. "It is my task to dwell upon those actions which illuminate the workings of the soul," he wrote, "and by this means to create a portrait of each man's life." But when his research did not provide the information he had hoped for or yielded contradictions, he made things up. Today, we might call it fiction at best. He invented great stories. Dramatic stories. Stories that always found a way to express an artist's character, or at least Vasari's impression of it. His biography of Leonardo was filled with invented facts and anecdotes, all quite charming. Had that been his only sin, Leonardo aficionados might be able to forgive him.

But Vasari explicitly promoted the view that Florentine art was the pinnacle of Renaissance art, and that Michelangelo was the greatest artist of all. He also argued that the first obligation of a painter was to please his patron, and that the second was to work quickly and efficiently. These "obligations" did not correspond to the actions and beliefs of Leonardo, who nonetheless figured prominently in the book.

Leonardo, after all, painted very little, and what he did paint he

painted slowly. He failed to complete much of what he began. And above all, he painted on his own terms. Leonardo argued fiercely that the speed of execution and judgments of patrons were not the criteria by which art should be judged: "If you wish to study well and profitably," Leonardo told artists, "accustom yourself in your drawing to work slowly and use your judgement as to

LIONARDO DA VINCI PITT.
E SCVLTOR FIOR.

which lights have the highest degree of brightness, and similarly, among the shadows, which are the ones that are darker than the others, and in what way they merge."

How, then, could Vasari give a fair account of Leonardo's art—of his marriage of extraordinary competence with a distinctive vision and voice—while at the same time defending his own, very different notion of what art should accomplish? It seemed impossible to deny that Leonardo's genius was the result of his curiosity and deep intelligence at work. Yet Vasari found a way, and the new Leonardo he created began to take on a life of its own.

Vasari's chapter on Leonardo begins with an outright fabrication. It is written as though he personally knew Leonardo.

He did not.

Vasari was eight years old when Leonardo died. He did, however, interview many people who actually knew the master (strangely, he interviewed Melzi, who knew Leonardo best, only for the second edition of his book, although he surely knew of Melzi all along by way of a mutual friend, the doctor and historian Paolo Giovio). As a result,

Vasari did manage to record some true stories. People who had met Leonardo told of his legendary beauty, that he was so strong that, with his right hand, "he could bend the iron ring of a door-bell set in a wall, and a horseshoe as if it were lead." They reported that he was great fun to be around and "so pleasing in conversation that he drew everyone's mind to his way of thinking." He kept a large retinue of servants, assistants, and horses even though "he owned nothing and worked but little."

But when his contacts did not produce the information he needed, he made it up.

The story of the French king at Leonardo's deathbed is one of the most memorable fictional anecdotes. Another is the story of caged birds that the artist bought at the market and then freed because he loved nature so much. Another still is that he was a vegetarian. These are great stories—they show that royals paid their respects to Leonardo and that the artist loved nature above all else, and in this respect, they were truthful.

In another inventive lie, Vasari claimed that Leonardo worked in a trance, forgetting food, time, friends, and everything else. The artist had lizards, crickets, serpents, butterflies, grasshoppers, bats, and other animals brought into the studio and labored on them with such concentration he did not notice the stench of the dead animals in the room because "such was the great love he bore his art." Guided by these dead creatures, he painted a monster on a small shield or "buckler," which, Vasari tells us, terrified whoever saw it. The point of the story was that Leonardo was so talented at imitating nature that people thought his painted figures were alive.

Vasari's Leonardo did in fact love nature—the properties of herbs, the motions of the heavens, the path of the moon, and the course of the sun—and believed it was "far more important to be a philosopher than a Christian." But in Vasari's account this interest in the natural world and in the scientific explanation of natural phenomena seemed unrelated to his art.

Five hundred years ago, Vasari was the first author to praise Leonardo for moving Renaissance art away from exterior beauty to the inner thoughts of people, a view we share to this day. He remarked that the apostles in the *Last Supper* expressed in their faces "love, fear, and indignation, or rather, sorrow," and that Mary's face in the *Virgin and Child with Saint Anne* showed "the modesty and humility of a virgin most content and joyous to witness the beauty of her son." Vasari was the first to name Leonardo the initiator of modern art, which Vasari called "the third manner of painting." Leonardo was so gifted and had such talent (*talento*) that "whenever his mind turned to difficult matters, he wholly resolved them with ease."

Notably, Vasari did not say much about Leonardo's science of art, nor did he acknowledge Leonardo's view that "painting is philosophy." But in all likelihood, Vasari knew much more than he revealed about Leonardo's "obsession" with the role of optics in painting, a curious lapse in his Leonardo chapter.

Vasari was a good friend and frequent dinner companion of Paolo Giovio, the doctor-scholar who had gone to school with Francesco Melzi in Milan and who had met Leonardo in Rome in 1513. Giovio had reported that "nothing was more important to him than the rules of optics, which he followed to study the principles of light and shadow exactly and minutely." Back then, what people knew about they talked about at these dinnertime "salons." In fact, at a dinner in the Farnese palace in Rome, Giovio was the first to have the idea of writing an entire book dedicated to the lives of artists. Vasari, who was present, offered to assist him. Of course, Vasari did more than assist Giovio with this book—he stole the idea for the project entirely and wrote the book himself. It stretches credulity to believe that Vasari was absolutely in the dark about Leonardo's fascination with optics. He was, more accurately, a man with his eyes on a very particular prize—a position at the Medici court.

In his chapter, Vasari claimed Leonardo had exceptional ingeniousness (*ingegno*) and imagined marvelous "complexities," but that these marvels "could never be realized," not even by his skillful hands.

Leonardo gave "special power and relief" to his figures but "in the art of painting he contributed a certain shadowed manner [*oscurità*] of coloring in oil."

Leonardo liked to learn about many subjects and begin many things but he was so "various and unstable [*vario et instabile*]" that he finished none of them.

The artist was exceptional, in other words, but "he had given offense to God and to the people of the world for not having worked on his art as he should have done."

Was Vasari, then, really praising Leonardo?

In fact, Vasari was just being true to a vision of art that suited his ambitions. He had already demonstrated that murals could be painted quickly and efficiently with one master designer overseeing a group of artisans, who would execute the coloring. He had even achieved a degree of fame—some said notoriety—as a result of a mural he had produced in just this manner in 1547 for Cardinal Alessandro Farnese's residence in Rome. The mural was finished in a hundred days, a feat so sensational that the hall came to be known as the Sala dei Cento Giorni, Hall of the Hundred Days, a name it retains today. Of course, not everyone was impressed with the results. Michelangelo, having already fled Florence for Rome, knew about the haste, commenting, "And it shows! [*e si vede!*]" Even Vasari himself later admitted that in retrospect, he wished he had painted it "in 100 months" and "done the whole thing myself." Nonetheless, the Sala dei Cento Giorni had given him the handy reputation of being the fastest and most reliable painter in the whole of Italy. Most important, the patron was pleased.

Efficiency, control, a happy patron: those were precisely the matters Vasari believed were important to painting, not the science of optics. He had no patience for Leonardo's subtle pictorial effects, his blurred edges, his atmosphere, his elusive smiles, his delicate shifts in body

motions, his imperceptible shades of skin tones—all traits that were achingly time-consuming to achieve and that defined Leonardo's work. They distracted artists and inhibited their ability to produce work at the fast pace patrons demanded.

And so Vasari went out of his way to discredit Leonardo's science of art.

And the best way to discredit is to misinform, which is precisely what Vasari did by way of a fictional story. It goes something like this:

Leo X, who was a Medici pope, commissioned Leonardo to make a painting. This was true. The artist took his time to start work, which was also true. When the pope learned that the artist spent his time distilling oils and herbs for varnishes rather than painting, he said: "Alas! This man will not do anything, in that he begins by thinking about the end before beginning the work." The pope never uttered those words. Vasari made them up. His aim was to conceal how Leonardo painted.

For Leonardo did not finish his paintings with varnishes. He built them from the ground up with varnishes, one layer after another, and had become a master of glaze painting. Nobody knew this better than Vasari.

Vasari wrote extensively on painting techniques, including the use of varnishes and glazes. He saw some of Leonardo's work firsthand and owned some of his drawings. He knew what Leonardo's art was really about. But because he found this way of painting so deeply unsuitable to his own goal of pleasing his patrons, he misled generations of readers. He did not explain that Leonardo built a painting with varnishes from the start, one thin layer after another. Rather, he let his readers think that Leonardo was so scattered and disorganized that "he begins by thinking about the end before beginning the work."

Not only this. Some of Vasari's claims are dead wrong, such as the assertion that Leonardo left the head of Christ unfinished in the *Last Supper* because "he did not think it was possible to convey the celestial divinity required for Christ." Vasari cannot possibly have missed Leo-

nardo's head of Christ—either from copies of the *Last Supper* he had seen or from his own observations when he saw the work in 1566. But his lie makes the point that while Leonardo was good at painting nature, he did not know how to paint the divine, which was what Michelangelo did best.

There was another reason for these claims, too. Vasari's hero was in fact Michelangelo, not Leonardo. He favored Michelangelo's stark, contrasting colors, his masculine bodies, his sharp lines. He also related deeply to the theology with which Michelangelo imbued his works.

And so Vasari disparaged what made Leonardo Leonardo, even his ability to copy nature: the master wasted his talent on marginal pursuits such as painting a monster on a buckler.

When Vasari seemed to praise Leonardo, he was actually demolishing him. And he demolished him by deleting what had made Leonardo Leonardo. Not a single word is dedicated to his science of art. Nor to Leonardo's notes on painting. Did none of his interviewees or correspondents mention that Leonardo thought that "painting is philosophy" or that without knowledge of optics, you cannot be a great painter?

Vasari's Leonardo was highly talented and versatile, but his philosophical and scientific interests were completely detached from his art. He did not portray Leonardo as the artist who took painting to new heights through his determination to rethink its role, nor as the painter who mastered the science of optics to part the curtains of the human soul. He skipped over the importance of optics in Leonardo's art and fixated instead on war machines and other scientific pursuits that were unrelated to painting. His very popular book created a different impression of Leonardo: one of the most striking examples in human history of a polymath, a brilliant artist whose mind was so fertile that he turned to science as an outlet for his intellect.

This is not just a semantic distinction without a difference. It is a view of Leonardo that leaves no role for philosophy or science in his

painting—the "dual genius" hypothesis in its earliest and most consequential form.

The damage Vasari's book did to Leonardo's reputation was just beginning.

But *Lives* did a lot for Vasari and his career. Vasari wrote extensive parts of the book in Florence in 1546 and 1547, when his old friend Borghini was also in town. Later, between 1549 and 1550, when Vasari was away, Borghini saw the book through publication on his friend's behalf. Borghini read the galleys, made the indexes, revised the conclusions, and advised Vasari on its dedication to Cosimo. In 1550, the book was printed. Four years later, the *Lives* achieved its intended goal when Cosimo appointed Vasari his chief court artist.

This meant that from 1554 until the end of his life, twenty years later, Vasari shared with Borghini the responsibility of pleasing the Medici duke in all matters related to art. They trusted each other, and the Medici duke trusted them. In fact, it was the three of them—Cosimo, Vasari, and Borghini—who determined the narratives depicted on the walls of the ducal palace.

Borghini suggested to Vasari the best stories to paint: Heroic stories. Accurate stories. He was assiduous, testing the accuracy of every historical event, the interpretation of each text, the meaning of every word, which he skillfully twisted to serve the master narrative of his patron. He was the mind behind Cosimo's dramatic exercise in revisionist history that highlighted the positive role of the Medici family.

Cosimo almost invariably approved the selected stories, though he sometimes suggested revisions to how he was portrayed. Vasari oversaw the actual painting, employing an army of artists to do the work.

Vasari and Borghini worked together on much more than the murals of the ducal palace: they designed the sets and pageantries to celebrate all the major events of Cosimo's reign. In 1565, when Cosimo's son and heir, Francesco, married the Holy Roman emperor's daughter, Johanna of Austria, they worked on her triumphal entry into Florence. When

Francesco wanted a special room in which to keep his most precious collectibles, a "cabinet of curiosities" to rival those that European rulers had in their residences, Borghini devised a sophisticated series of mythological stories, which Vasari had painted by his assistants. In 1564, they planned a parade for Michelangelo's state funeral, skillfully glossing over the fact that the artist was a staunch republican and refused to return to Florence after the Medici takeover. Ten years later, they organized Cosimo's own elaborate funeral parade celebrating a reign that had lasted almost forty years.

They made sure that a steady supply of competent and docile artists was available to meet the artistic and propagandistic needs of their duke.

They created an art school.

Cosimo funded it.

Vasari designed its curriculum—some of it hands-on and some of it theoretical.

Borghini served as its first director, or *luogotenente*.

In late January 1563, the academy convened for the first time. It was named the Accademia del Disegno because its main tenet was that the arts were united under disegno, design. Borghini delivered the opening speech to the first class of students, exhorting them to "unity" under disegno and to "turn their [minds] to create works and improve through study." It was the first art school of this kind, and the idea behind it was so compelling that soon other rulers founded their own and modeled them after Cosimo's.

Another tenet was that it was "an academy to DO rather than TALK [*accademia di FARE e non RAGIONARE*]," as Borghini declared in another public lecture he delivered in 1564. He himself capitalized the words in the written remarks to remind himself where to place the emphasis.

In this academy premised on doing instead of talking, artists were fully trained in questions of design but not expected or permitted to do anything except execute the orders of others. Nor were they supposed to engage in conversations of a more theoretical or speculative bent.

Since the director Borghini was part of Cosimo's inner circle and Vasari's good friend, we can take his view to be the official position on art at the Medici court at that time.

Leonardo had also imagined an academy, but Leonardo's academy could not be more different: there artists would learn how to become pittori universali, which for Leonardo meant that they had to be able to debate the nature of art and the paragone, and to learn the science of optics. The book on painting he had planned to write had been meant as a textbook for pittori universali.

One of the major differences between Leonardo's academy and the Accademia del Disegno had to do with this paragone.

Years earlier, at a dinner party in Milan, Leonardo had articulated his reasons for believing that there was a hierarchy in the arts and that painting stood at the pinnacle—because it is "a mental discourse" that passes through the virtù visiva. So important to Leonardo was this idea that Francesco Melzi had dedicated the first thirty pages of his compilation to it. Even absent the publication of the *Book on Painting*, the idea took on a life of its own. Indeed, right around the time Melzi compiled the *Book on Painting*, a question was sent out to ten major artists (including Michelangelo and Vasari) by a famous scholar, Benedetto Varchi, asking their opinion on whether painting or sculpture was the superior art. Artists loved the debate on the paragone. For them, it was part of their struggle for power and recognition, as it argued that the visual arts were on a par with literature and poetry. And it was also an occasion to articulate the specific qualities of different forms of art: painting, sculpture, architecture, drawing.

But Borghini and Vasari were utterly committed to erasing the paragone and the philosophical speculation connected to it from artistic training, as they did nothing to meet the needs of their duke. The paragone also undermined their firm belief in disegno as the unifying principle of art. Borghini made clear to his students that whenever artists try to discuss intellectual questions, they are like "a tortoise

which if it stays in its house is secure but as soon as it pulls out its head it gets beaten." Anyone who expected to survive at that school no doubt got the message. Speculation on the nature of art was unwelcome. A new order had begun.

These views did not go unchallenged for long, however. Soon, Borghini and Vasari butted heads with Florentine artists, including with some associated with the new art academy.

The occasion was none other than Michelangelo's funeral, which Borghini and Vasari had planned as an elaborate public ceremony to honor the great Florentine sculptor, celebrate the continuous glory of Florentine art thanks to Cosimo's patronage, and promote the views of their new art academy. But they insisted on placing a personification of painting above one of sculpture in their design for their triumphal arch, which was the focal point of the entire celebration. The fact was puzzling since Michelangelo regarded himself as a sculptor, and also because it contradicted the academy's teaching that the arts are united under disegno. In fact, the sculptor Benvenuto Cellini led a revolt, other sculptors withdrew in protest, and even Borghini lost his cool. "That pig Benvenuto," Borghini called the leading dissenter in a letter to his friend Vasari.

Another major difference between Leonardo's academy and the Accademia del Disegno had to do with shadow drawings and the science behind them.

There were plenty of books on linear perspective, architecture, and sculpture that could be adopted as textbooks by the academy—we have only to recall that in 1568 Leon Battista Alberti's books on painting, architecture, and sculpture had been reprinted in Venice by a Florentine scholar and Medici courtier, Cosimo Bartoli. Melzi's compilation based on Leonardo's notes, the *Book on Painting*, was the only book that dealt with shadow projections, and with aerial and color perspective,

and that contained both a qualitative or descriptive discussion and a quantitative or scientific analysis of those topics. It was not printed, but it was known that Melzi had written it.

And yet, as the academy prospered, the designer of its curriculum and its director would end up learning a great deal more about Leonardo's writings and his art.

Emboldened by their successes, Vasari and Borghini made plans for a second edition of Vasari's book. This enterprise led to Vasari finally meeting Melzi.

In 1566, sixteen years after the publication of his *Lives*, Vasari traveled to northern Italy to learn more about art in Venice and Milan. His friend Borghini helped him a great deal with this revised edition, reminding him that his task was to gather facts and that the work had to be "finished and perfect in every part." It had to be "a universal HISTORY of all the paintings and sculptures of Italy." He instructed his friend: "Here you have as your only object the art and work of [artists'] hands." He wanted his friend to see "Genoa, Venice, Naples, Milan, and altogether as many things in each of these principal cities—paintings as well as sculpture and architecture—as possible, and to adorn your work with them." During this research trip, Vasari visited Francesco Melzi and found him "a beautiful and gentle old man."

Vasari did update his Leonardo chapter with information he gathered from Melzi. He learned from Melzi that on his deathbed Leonardo "wished to be fully cognisant of all things Catholic" and revised his earlier account of Leonardo's death, although it is possible that Vasari adapted it to the expectations for pious artists living, as Vasari lived, in the age of the counterreformation—Leonardo took the last rites. From Melzi he learned that Leonardo followed people in the streets for a whole day to draw them, and that he made a silver lyre "in the shape of a horse's cranium" for the duke of Milan.

We know that Melzi showed Vasari Leonardo's anatomical drawings, which Vasari mentioned in the updated Leonardo chapter, although he scaled back their significance. Basically, admitting that he had not read a word, Vasari complained that all the pages were written "in ugly characters, made with the left hand, in reverse" and that "those who are not familiar with them cannot understand them, because they cannot be read without a mirror."

Even more consequential was Vasari's assertion that Leonardo's anatomical drawings were intended as illustrations for Marcantonio della Torre, the doctor from the university of Pavia with whom Leonardo dissected cadavers. They were not part of Leonardo's philosophical art at all.

It is impossible to imagine that Melzi did not at least mention to Vasari Leonardo's belief that "painting is philosophy," and tell him that he had gathered his master's thoughts in the *Book on Painting*. And it is impossible to imagine that Vasari, looking for new material for his revised edition and for textbooks for his art academy, did not eventually read Melzi's *Book on Painting* himself or have someone else review it on his behalf.

Perhaps Melzi also showed Vasari some of Leonardo's shadow drawings. But if he did, Vasari did not understand much. His report on Leonardo's light and shadows is rather wanting.

> It is a remarkable thing that this genius, having the ambition to endow the things he was painting with the strongest modeling [rilievo], went so far with dark shadows as to exploit the darkest grounds, seeking blacks to make deep shadows, darker than the other blacks, and by their means to make his highlights seem the brighter. In the end this method of coloring was such that no light remained there, and his pictures assumed the guise of things represented at night-time, rather than in the brilliance of daylight. All this came from seeking to render things in greater relief, and to achieve the ultimate perfection in this art.

It is hard to imagine Melzi describing Leonardo's construction of light and shadow the way Vasari reported it. Melzi would never have said that "no light remained" in Leonardo's paintings or that his master represented things "at night-time, rather than in the brilliance of daylight." More important, he would have taken the time to connect his master's optical studies with the representation of emotions, as this was their ultimate goal.

When a painter from Milan came to see Vasari in Florence sometime before 1568, Vasari was no more receptive to Leonardo's writings. This unknown painter had brought with him "other writings" by Leonardo "written in left-handed characters in reverse, which treat of painting and the methods of drawing and coloring." The Milanese artist wanted to print them but found no takers in Florence. Vasari certainly did not provide any help. The Milanese painter subsequently traveled to Rome, but nothing came of it, as far as Vasari knew.

The undeniable fact is this: because Vasari's biography was largely complimentary and appeared to accommodate all the generally known facts about Leonardo, Vasari's Leonardo not only went unchallenged from 1550 onward—Vasari's portrayal became dogma. The revised edition of the *Lives*, published in 1568, was even more popular.

Leonardo was a polymath, and his art was separate from his science.

Another undeniable fact is that sometime after Vasari published his revised book in 1568, a mess of a book about painting started to circulate in handwritten copies among an elite group of artists, scientists, philosophers, and other educated members of the public.

The first copies appeared in Florence, but soon they spread to other cities—Milan, Venice, Rome, Paris. The book was some two hundred pages long, and it contained some fifty diagrams. Its title changed from copy to copy. Sometimes it was *Book*. Other times it was *Discourse on Drawing*. In other copies the title was *Precepts, Rules, Writings, Aphorisms*, or *Opinion*. In one instance it had a long but precise title: *How to paint perspective views, shadows, objects that are distant, high, low, both from nearby and from afar*. Other times it bore no title at all. Sometimes "the second part" appeared in the title, implying that a first part existed but was not included. Most versions reported that the author was Leonardo da Vinci.

We still have no idea who put together this book, or where it was done. But whoever created the first of these handwritten copies unquestionably had access to Melzi's work and his *Book on Painting*.

This book "by Leonardo" was a highly condensed version of Melzi's *Book on Painting*. It was one third as long as Melzi's original and included only a quarter of the drawings Melzi had intended. What was removed entirely from this new book were the sections on philosophy and science that were at the core of Leonardo's art, and that Melzi had included in his *Book on Painting*. Reading this condensed copy, no one would ever know that Leonardo believed that painters engage in a "higher mental discourse" because their work is based on sight, which is the noblest sense, or that he taught that "the soul of painting" resided in the illusion of relief created by light and shadow. These sentences and the entire section titled "On Shadow and Light" of which they were part had been cut. And the paragone that opened Melzi's *Book on Painting* was gone as well.

Clearly, this book "by Leonardo" was a heavily doctored edition that had neither Melzi's nor Leonardo's wishes at heart.

Extensive portions of what remained were highly disorganized: text and figures did not correspond. And even when they did, the key letters in the figures did not necessarily match those in the text. The Leonardo of this book wrote about light and shadow in vague terms.

One wonders what artists were supposed to make of statements such as "Painter, if you want to be universal and please people of different taste, you must have in the same painting figures with very deep and very soft shadows, but you have to make sure that the reason for such diversity is apparent." No instruction was given on how to achieve those soft lights and shadows.

Where was this doctored version of Melzi's book created? In Milan, where Melzi had compiled the *Book on Painting* and where the private library containing Melzi's version was being stored? Or in Florence, where the oldest doctored copies survive? Or in Rome, where perhaps Melzi sent the book for consideration to some potential patron? We do not know. But whoever put this version together understood that the times had changed. The spirit that animated them is evident in a revision to the very first chapter of the doctored version, titled "What a Youth Needs to Learn First." It read:

> First a youth needs to learn optics [prospettiva] to understand the measure of all things, then, little by little, learn from a good master to get used to well-formed limbs; and then [learn] from nature to reinforce the reasons for the things learned; eventually youth should look at works from the hands of different masters in order to form the habit of putting [the things learned] into practice and *make art*.

But the editor of the doctored version changed the last few words from "make art [*operare l'arte*]" to "implementing everything learned [*operare le cose imparate*]." The intention was to limit what an artist was expected to do: not art, but just what one had learned.

The partial Leonardo of the doctored version seems perfectly suited to Cosimo's Florence and his art academy. Is it possible that somebody in the immediate circle of Vasari and Borghini took Melzi's *Book on Painting* and turned it into something more useful for these very different times, guided by a very different artistic philosophy? In Cosimo's

Florence, art served the ruler and his power and was not concerned with the inner lives of painted figures or with their impact on the inner lives of their beholders.

It is difficult to settle scholarly quandaries of this sort, but there is ample reason to suppose that the butchered *Book on Painting* was the work of Vasari and Borghini's circle and may have been the work of either Vasari himself or, more likely, of Borghini. Vasari's activities at the Medici ducal court, his circle of friends, and his role in the creation of the Accademia del Disegno, as well as the kind of art he was making at the time, seem to suggest so. Borghini was a skilled editor and had just acquired great fame for a censored edition of Boccaccio's *Decameron* (it took generations of modern philologists to undo what Borghini did to Boccaccio's text). In addition, the names of Vasari's and Borghini's closest friends and associates are revealing. They match the names of the owners of the oldest copies of the doctored *Book on Painting*. These owners kept this doctored book as a precious item in their libraries and made copies for their friends and for other artists in Florence and elsewhere. They were the de facto promoters and disseminators of a partial Leonardo.

One early owner was Carlo Concini, who was related to Bartolomeo Concini, the longtime secretary of Duke Cosimo. He owned one of the oldest and most polished copies. Its well-composed title page features Leonardo's portrait, clearly copied from the portrait Vasari added to the 1568 edition of his Leonardo chapter, which means that Concini's copy must date to after 1568. Its title, *Discourse on Drawing: Second Part*, refers more generally to disegno rather than to painting, and while this was a dramatic departure from Melzi's original title (*Book on Painting*), it fit neatly within the scope of the Accademia del Disegno, which had disegno as the unifying principle of the arts. It also contained the telling reference to the claim that the text was only the "second part [*parte seconda*]" of Leonardo's book, suggesting that a first part existed but was not included. Clearly, the text had been truncated, but there was no way to know the nature of this abridgment: did it just make the text shorter than the original, or did it alter

the author's intended meaning profoundly? In addition, the reference to the "second part" showed that this particular copy was one of the closest copies to Melzi's *Book on Painting*, and in later copies, this reference was lost.

The book itself was made of large folios of heavy paper. A professional scribe wrote the text between red margins. It was a clean copy, with hardly any corrections between the lines, the text neatly arranged on the page, the same number of lines on each. This particular codex was so well organized that one might think it was conceived as a presentation copy for a patron, hoping perhaps to entice him to sponsor its printing. One crucial aspect of Concini's copy was that the images were placed in the margins, rather than imbedded in the text as Melzi had done. This simple rearrangement, though, complicated matters incredibly for later scribes, who often could not determine exactly which illustration belonged to which specific passage.

Another early owner of the doctored book was Niccolò Gaddi, a passionate Florentine bibliophile who kept an outstanding art collection in his palace that was thought to rival that of the Medici. His library was at the heart of Florentine cultural life, and Gaddi routinely had his books copied for his friends. To Cosimo's sons, Francesco and Ferdinando, he was what Borghini had been for their father: a trusted courtier and a skilled disseminator of their cultural politics. In 1579, he was nominated director (*luogotenente*) of the Accademia del Disegno. Ten years later, he designed the pageantry to celebrate Ferdinando's wedding. His library was one of the centers for the dissemination of Leonardo's doctored *Book on Painting*. Not only did he own one of the oldest copies, but he bound it together with Giacomo Vignola's manual on perspective. His copy offered a complete, albeit succinct, training program for young artists: basic instructions on linear perspective from Vignola, and abridged notes on aerial and color perspective from Leonardo.

Cosimo's cosmographer Ignazio Danti, who also taught at the Accademia del Disegno, owned a copy of the doctored book, which he took with him to Bologna and Rome.

A copy belonged as well to Lorenzo Giacomini, another Medici courtier and a member of the Florentine literary academy who wrote, among other things, the funerary oration for Duke Francesco de' Medici.

Whoever it was who actually abridged Melzi's text, it seems he belonged to the Medici circle. Certainly this would explain why the paragone was removed and why the section titled "On Shadows and Light" was not included. For Borghini, the paragone was a waste of time, while Vasari thought that Leonardo's way of painting left "no light" in his paintings. The finished product was a sloppy piece of work. It was not done by someone who sympathized with Leonardo's wishes. It was done by people who wanted to appropriate Leonardo's name and reputation for their own, more commercial attitude toward art.

And so, by way of Vasari's approving but selective biography, his silence on the science of art, and a massacred version of the *Book on Painting*, a new Leonardo emerged. He was a polymath, and his art owed nothing to science. The Leonardo that emerged from the doctored text was a fake Leonardo, or at best, an incomplete Leonardo. Knowing little else, people regarded this figure as the man himself.

During the 1580s, interest in the doctored *Book on Painting* increased, and a flurry of activity around it emerged. Perhaps the idea of its formal publication resurfaced. In 1582, the academic painter Gregorio Pagani made a fully shaded drawing, which appears to be a preparatory drawing for a frontispiece for a book titled *Advices and Discourses on the Art of Painting by Leonardo da Vinci*, but this book was never printed. A woman dressed in a garment from antiquity, painting at an easel, is a personification of the art of painting. Two years later, the Florentine author Raffaello Borghini mentioned in his book *Il Riposo* that Leonardo "wrote some very beautiful precepts on the art of painting, which as far as I know have not been printed yet." Between 1585 and 1586, some of the owners of the oldest doctored copies—Giacomini, Gaddi, and Danti (the latter had since moved to Rome)—exchanged letters

about Leonardo's doctored book among themselves and with collectors from other cities. One of these collectors was the scholar Gian Vincenzo Pinelli from Padua, who knew humanists and scholars across Europe.

The book had become a collector's item in its own right, sought by top scholars and collectors throughout Italy.

Bibliophiles in Florence, Rome, Bologna, and Padua were all in search of accurate copies of the doctored *Book on Painting*. They consulted with one another and made copies for one another—and since errors in hand-copied books were common, they inadvertently set in motion a further corruption of Leonardo's text. None of them had knowledge of Melzi's compilation, which by then—we may safely assume—had disappeared from public sight.

It would take at least four decades before a little of the real Leonardo emerged—for just a brief moment. An artist with a talent very different from Vasari's and an editor with knowledge much wider than Borghini's would grasp what was behind Leonardo's art. But the real Leonardo was so different from the Leonardo of the doctored treatise that even the most educated scientists and artists did not know what to make of this "new" Leonardo.

They hardly even tried.

The Best Editor, an Obsessed Painter, and a Printed Book

It never occurred to readers to wonder if the text of what they thought was Leonardo's book on painting had been tampered with or was in any way inauthentic. In those days, errors in handwritten books were common, but readers were used to them and knew how to compensate for them, either by ignoring them or by mentally correcting the incongruences. As far as everybody knew, what they read in those handwritten copies was the real Leonardo, plus some minor mistakes. Nobody knew that the book was only a doctored version of a compilation assembled by a pupil (albeit a skilled one) from his master's notes. So much so that one of the most learned and influential men in Baroque Rome thought it would be "for the common good" to publish Leonardo's writings for the first time, even a small selection of them, even only his notes on painting. Such a book would bring the genius back to life, so to speak.

Books were everything to Cassiano dal Pozzo (1588–1657) because learning was everything. But it took Cassiano several years and the help of many to get this book into shape. His attempt to publish it succeeded—and yet it also failed. It succeeded because eventually the book was printed and some of Leonardo's thoughts became easily accessible to a broad public. His edition was a failure, however, because despite Cassiano's best efforts, he excluded from the book the glimpses of

the real Leonardo he had been afforded by pure chance—circumstances that surely constitute one of the great what-ifs of art history.

What was printed instead was a beautiful book crafted for the high-end market, one that perpetuated the incomplete version of Leonardo in spite of Cassiano's extraordinary encounter with some of Leonardo's notes—notes that had remained virtually unseen for decades.

Here is what happened:

Cassiano was a powerful man from a family deeply connected to the Medici (an uncle was the secretary of Grand Duke Ferdinando). Raised in Florence, he had become a discerning art collector and bibliophile from a young age. His palace in Rome, where he moved in 1612 at the age of twenty-four, was filled with medals, prints, paintings, anatomical drawings, precious stones, and mechanical instruments. Anything and everything stoked his endless curiosity. One day it might be a new scientific discovery that a friend in Paris wrote to him about. Another day, an exotic item brought to him by travelers returning from Mexico. His library, which he filled with five thousand volumes, was the Roman equivalent of a salon, the place to be for everybody who was anybody in Rome. A special treat for favored guests was to peek over the desks of the scribes and artists who worked on what Cassiano called his "paper museum," or *museum cartaceum*, an immense collection of over seven thousand drawings he commissioned to record ancient and medieval buildings and specimens from the natural world—plants, fruits, minerals. To give you a sense of its scope, the paper museum filled twenty-three volumes; an entire book of 118 drawings was dedicated solely to different types of citrus.

Cassiano's library was at the center of everything because Cassiano was at the center of everything. He befriended artists, scholars, travelers, collectors, and, above all, influential cardinals. Among his dearest friends was Federico Cesi, the founder of the Accademia dei Lincei, an association of prominent scientists who professed an experimental approach to the study of nature, especially astronomy and botany. Cas-

siano was a member (as was Galileo Galilei). Another close friend was Cardinal Francesco Barberini, who was a prominent man of culture, art, and science; when his uncle Maffeo Barberini was elected pope with the name of Urban VIII, Cassiano's influence grew exponentially. Cassiano became Cardinal Francesco's secretary and had access to any book or curiosity or artwork he wished.

In 1625, during a diplomatic trip to the French court, Cassiano saw the *Mona Lisa* and the *Virgin of the Rocks* in the royal collections at Fontainebleau; in his travel diary he reported that the *Mona Lisa* was in a frame of "carved walnut" and that it "lacks only the power of speech." Around the same time, or slightly earlier, he learned that Leonardo's original notebooks still existed and that a fellow bibliophile, Giovanni Ambrogio Mazenta, had once owned thirteen of them, all written *alla mancina*, or in the artist's signature mirror-writing—although by the time Cassiano met Mazenta in Rome, the notebooks were no longer in his possession. Mazenta told him about the dispersal of Leonardo's writings, which Francesco Melzi revered as relics but which Francesco's son and heir Orazio had allowed to "lie neglected under the roof in his villa" for years before selling them off. Now Leonardo's writings were scattered across various private libraries, and even if one managed to gain access to them, it was hard to get anything useful out of them because of the intrinsic difficulty of deciphering Leonardo's incomplete drafts (much less his mirror writing).

To make Leonardo's legacy even more difficult to gauge, almost all his paintings were in private collections; the only exceptions were the *Last Supper*, which was quickly deteriorating, and a version of the *Virgin of the Rocks* that hung in a dimly lit chapel in Milan.

The artist was considered a genius, but very little was available to show for it.

Cassiano thought he could rectify the situation.

He brought to the table one distinctive talent: he was a highly skilled editor. No editorial project was too daunting for him, and this is why the publication of what was believed to be Leonardo's book on painting seemed like just the right project for him to take on. Like

everybody else, he did not know that the text he wanted to edit was only a doctored version of what Leonardo and Melzi had intended.

By the early 1630s, he was at work.

In the past, Cassiano had corrected corrupted texts by gathering multiple copies of each book and comparing one to another: where one copy made no sense, another eventually did. Given his reputation for quality work and his access to a vast intellectual network, no man was better positioned to locate whatever copies of Leonardo's book were available and start the long and tedious process of comparing one with another, word by word. He put together a team and worked to come up with a publishable copy to give to a printer.

Soon, a task that had begun with excitement led to despair.

The job of checking every single word, paragraph, and figure across many manuscripts was thankless. Often it was also useless. Numbers mentioned in the text did not match the figures that were supposed to illustrate them. But that was just the beginning of the problems Cassiano and his team had to deal with. Some paragraphs were cut off midsentence. Phrases appeared several different times, and there was no way to know for sure where the sentence really belonged. Illustrations looked so different from one manuscript to the next that there was no way to tell what Leonardo even intended.

And then a most unusual offer of help arrived from Milan.

A Milanese nobleman, Galeazzo Arconati, volunteered his services. His offer was not completely disinterested: in exchange for his assistance, he wanted Cassiano to lobby Cardinal Barberini to appoint his illegitimate son to the post of "master of theology" in Rome. This was no small request. But in return he had something exceptional to offer Cassiano.

A Leonardo enthusiast, Arconati owned twelve notebooks written by Leonardo in mirror writing, in addition to two large cartoons—one representing *Leda* (now lost) and another representing the *Virgin and Child with Saint Anne* (the so-called Burlington House Cartoon now in London).

The Milanese scholar was not offering to sell the notebooks or even

to send them to Rome for examination. Unlike Orazio Melzi, he knew exactly their worth. In fact, he had already arranged for their safekeeping for posterity. In 1636, he donated them to a private library in Milan, the Veneranda Biblioteca Ambrosiana. He did retain, though, the privilege of consulting them whenever he wished. In exchange for a favor for his son, he offered to go through the notebooks and answer any questions of Cassiano's upon which they might shed light.

And so the process began.

Cassiano sent to Milan dozens of questions on specific "chapters in which we have difficulty in understanding the work of Leonardo da Vinci." Arconati sat in the Veneranda Biblioteca Ambrosiana with two assistants, searching for relevant passages and reporting back to Cassiano: "the marked chapters have been compared and the others are not to be found in these books."

In the midst of this back-and forth process, the Milanese aristocrat let Cassiano know something else. He sensed the importance of one notebook in particular, a notebook in Leonardo's handwriting filled with geometrical diagrams. The topic was so different from any other he knew. Leonardo gathered there notes on light and shadows. (This was the notebook that is known today as Manuscript C.) Although Cassiano had sent no questions about "shadow and light," and the Milanese scholar was aware of the fact that these were not part of Leonardo's book on painting—that is, they were not part of the doctored version he knew—he thought they might be of interest to Cassiano. Clearly, they were optical drawings, which suggested to him that they were meant to answer some question related to painting.

Did Cassiano want the scholar to copy these notes and drawings on light and shadow? Of course.

Arconati promised to send a copy of these materials. Months later, on May 21, 1639, Cassiano was still waiting "to receive what I am expecting about light and shadow." He even begged Arconati, through an intermediary, "to have the book on light and shadow copied." But after whetting Cassiano's appetite, Arconati was now withholding the copy

in the hopes of getting a maximum return on his investment—a better chance of winning Cardinal Barberini's favor.

Eventually, sometime in 1639, the materials arrived in Rome, all grouped under one heading: "Shadow and Light" (*Ombra e luce*).

The Leonardo that emerged from this dispatch was very different from the Leonardo Cassiano knew.

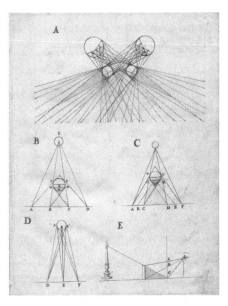

Cassiano had no way of knowing that Leonardo intended these notes and sketches to be a key part of his book on painting.

But Arconati, who had deep, firsthand knowledge of Leonardo's writings, offered him some thoughts.

These notes showed "the capricious, or better still the mysterious, disorder of their author" as Leonardo did not "express clearly all that would have been required to make this treatise perfect." At times, the artist talked about light but forgot to talk about shadows; other times he did exactly the opposite, talking about shadows and omitting mention of light. Readers could paste the pieces together and understand his thoughts, but the notes were not an easy read. And yet Arconati felt strongly that this new section and the shadow drawings that accompanied it "had to be united" with the book on painting because they dealt with the same topic: "To this same treatise belong all the chapters on reverberations and reflections which are from number 75 to 88 on the topic on painting."

Arconati was the first to sense that the book on painting by Leonardo he knew was not as complete as he had thought it was. And he also understood that Leonardo's shadow drawings did not study only

light and shadows scientifically but also the entities that are inseparable from them, colors and their reflections.

The Milanese scholar also told Cassiano that he wanted to capture "Leonardo's style" as a writer and did not want to "alter Leonardo's wording," no matter how awkward and unclear it often was. If he "found something that did not make sense, or that some words were missing," he wrote, "we left it as is to keep it in conformity to the original, but these matters will have to be corrected by someone with better judgment." He hoped Cassiano would be the editor who might polish these writings for publication.

Not knowing Melzi's *Book on Painting*, Cassiano had no way of finding the right place for the shadow drawings in the book by Leonardo he was editing. Ultimately, after frequent correspondence with his Milanese contacts, he did nothing with them. He merely cataloged the drawings and put them on the shelf.

He stuck with his original plan: to "copyedit" the existing text as best he could. He decided to trust the earliest copies that had originated in Florence in the library of Niccolò Gaddi and made for himself a master copy. He kept updating his master copy as new information reached him. He improved some passages and corrected spellings and other minor details, but ultimately his master copy was not that different from the doctored version of Melzi's *Book on Painting*. It contained only one-third of Melzi's original text and only one-fourth of the drawings he had intended. Cassiano had seen the shadow drawings and had sensed their relevance to Leonardo's art, but even he had been unable to restore them to their proper place within Leonardo's book.

Cassiano also decided to have the illustrations redrawn.

Melzi had based his sketches on Leonardo's original drawings. Some were geometrical diagrams; to redraw them, a competent draftsman was sufficient, and Cassiano hired Pierfrancesco degli Alberti (1584–1638), who had worked for him previously and who delivered his sketches. But many were sketches of human figures in various active

poses—lifting weights, preparing to throw a stone, or holding a stick. All these drawings showed exactly how the limbs were activated by each movement. The details were beautiful but hard to see, as the drawings were so tiny. For these human figures, Cassiano wanted the best.

He knew just the man for the job. Indeed, his choice was far better than even he realized.

Years earlier, a struggling French artist, Nicolas Poussin (1594–1665), had come to Cassiano's attention, and the editor had helped the young man launch himself in Rome. Now the painter was one of the most sought-after artists in the city, and their friendship had grown closer and closer. Cassiano had never asked Poussin for anything in return for his support. That is, he never asked until Cassiano had the idea of redrawing Leonardo's sketches. The job was simple—even demeaning. All Cassiano asked was for Poussin to create figures "for the demonstration and for the understanding of [Leonardo's] discourse as in the original these were only sketches."

But Poussin found the work compelling, and soon was not "satisfied to simply read Leonardo's writings" or to draw "very correctly all the figures." He wanted to know more about Leonardo, and that led him to poke around Cassiano's library. He found the notebook with the shadow drawings that had been sent from Milan and asked to borrow it. Cassiano, who was meticulous about keeping track of his books, recorded that "Mr. Poussin must return one [book] on light and shadow with separate illustrations."

Like Leonardo, Poussin had been a keen observer of nature since childhood. In his native Normandy, he had grown up surrounded by spectacular views that were not dissimilar to the ones Leonardo saw as a child around Vinci. And like Leonardo, he was a compulsive draftsman: he filled "without cease [. . .] his books with an infinite number of different figures that his imagination alone made him produce"; there was nothing his father or master could do to stop him. Unlike

Leonardo, though, Poussin was schooled in Latin, rhetoric, mathematics, and the classics. In Paris he befriended artists and learned men, but his dream was to move to Rome, which he did in 1624.

As soon as he arrived in Rome, in his thirties, handsome, and a great talker, he acquired the fame of "a young man who has the fury of a devil." In the Eternal City, Poussin learned how to combine the depiction of nature with the art of the ancients. His small, intimate, superbly executed canvases—by now artists preferred to paint on canvas rather than wood—illustrated learned themes inspired by the classics. Influential patrons sought his company, opened the doors of their palaces, and could not get enough of his works.

Cassiano welcomed the artist to his library and helped him when Poussin fell sick with "*un autre mal de France*," most probably syphilis. "I beg you with all my strength to help me with something," Poussin wrote to Cassiano, "as I am in great need: most of the time I am sick and I have no resource to live upon except the work of my hands." Cassiano sent him forty scudi, which was help enough. More important, Cassiano became a close friend, the fulcrum of a group of like-minded French expats Poussin gathered around him. Years later, many of Poussin's friends ended up playing a role in the printing of what people believed was Leonardo's book on painting.

What united Poussin and his friends, and what brought them close to Cassiano, was a deep dissatisfaction with the art of their contemporaries. They admired ancient art and had grown increasingly critical of the Tenebrists—the followers of Caravaggio—who favored highly dramatic indoor scenes illuminated by candlelight that resulted in sharp contrast between light and shadow. It was reported that Poussin said that Caravaggio "came to the world to destroy painting." The judgment was harsh, but no doubt Caravaggio and his followers paid little attention to delicate expressions and subtle atmospheric effects. The dramatic Tenebrist paintings that many patrons admired looked highly simplified to Poussin and his friends.

For they were seeking a new balance in art. They sought it in nature and the works of the ancients. They took long strolls around "one Rome

and the other [*l'una e l'altra Roma*]," modern Rome and ancient Rome, along the Tiber riverbanks, and in the Roman countryside. They measured all the body parts of ancient statues, from fingernails to busts, heads, limbs, and noses, trying to obtain from those ancient figures the secrets of their timeless perfection. Poussin was more obsessed than the others, and patrons delighted at guessing the exact ancient model he used for the figures of his paintings.

Poussin and his friends also experimented with novel ways to render nuanced colors and shadows. They preferred outdoor settings with many intermediary planes between the foreground and background; as one proceeded toward the background, each plane would be characterized by less saturated colors, less defined outlines, lighter shadows, and more suffused light.

Poussin took a personal liking to painting after nature. On his excursions, he collected pebbles, flowers, and moss to paint in his studio later. He painted with tiny brushstrokes. He became meticulous about the execution of his art. As he said later to a friend who asked him why his art was so great, it was because he "did not neglect anything [*n'a rien négligé*]."

The secret of Poussin's art lay in the perfection of the smallest details.

Leonardo would have agreed.

Building on Cassiano's instructions, Poussin redrew the illustrations for Leonardo's book—and just as Vasari had done fifty years earlier, he remade Leonardo to fit his own artistic purposes. For instance, he rendered all the human figures in motion with the proportions of *Antinous*, an ancient statue he admired.

Cassiano was pleased with Poussin's work, and pasted his drawings into his master copy of the treatise with the intention of

including them in the printed edition. Indeed, about ten years later, Poussin's sketches would become the model for the illustrations in the finished book.

Though he, too, ended up playing a role in the adulteration of Leonardo's work, Poussin was nonetheless fascinated by the shadow drawings from Milan that Cassiano kept in his library.

Poussin made his own personal copy of these shadow drawings. It was later said that Poussin "spoke cleverly on optics" and that he wrote "a book on lights and shadows." At times, he was even portrayed holding in his hands a book titled *Light and Shadow* (*Lumen et Umbra*). But the reality is that Poussin never wrote his own book on light and shadow. He did keep a copy of Leonardo's shadow drawings close at hand, however, because these drawings were becoming increasingly important to his own art.

A painting on canvas, *The Israelites Gathering Manna in the Desert*, that Poussin painted while working on the sketches for Cassiano's book shows the extent of his debt to the shadow drawings of the Renaissance master. He painted it for his dear friend Paul Fréart de Chantelou (1609–1694), describing the figures as "a mix of women, children, men of different temperament and age." There are those "who languish, those who admire, or have pity, those who do charity, some who show great necessity, or desire, repentance, consolation, and so on . . . read the story and the canvas, to know if everything is appropriate to the subject." Some figures were enlarged copies of the small sketches from Leonardo's art book that he had redrawn. Others were based on ancient statues and Renaissance paintings.

But what made the work a masterpiece in the vein of Leonardo was the way Poussin treated colors, outlines, shadows, and lights. Each color gradually diminishes in brightness, each outline becomes less sharp, each light less bright, each shadow less dark, as the foreground gives way to the background. Poussin understood Leonardo's shadow draw-

ings and their relation to color—that light and color are inseparable—like no other artist had before him.

In Poussin's estimation, the painting was worth "five hundred ecus," but because of the effort it required, it was the result of "five hundred minds."

Poussin did not keep Leonardo's shadow drawings to himself. He shared them, or at least one of them (representing "shadows and penumbra created by sunlight in the countryside"), with his fellow painters in Paris. We are not absolutely sure to whom he sent it, but we know that the drawing was popular—and not just among the Parisian artistic community that gathered around the Louvre, the royal palace then undergoing renovation. The mathematician Girard Desargues (1591–1661), who pioneered the field of projective geometry and whose name is still attached to a geometrical theorem, for instance, praised it highly in his own writings: "the procedure" used to make it, he wrote, was "very difficult to execute if one wished to make it similar to reality." This was no run-of-the-mill drawing.

The arrival of this copy of a shadow drawing at the Louvre buoyed Leonardo's reputation in France—a development that culminated in 1651 with the publication of two sumptuous books bearing Leonardo's name.

But why France?

Although a Florentine, Leonardo was viewed as something of a Frenchman as well; after all, he was said to have died in the arms of a French king (at least according to Vasari's erroneous account). Many of Leonardo's paintings were housed in Paris, too. But more important, Leonardo's reputation helped to affirm the authority of the French royal family, just as he had helped to affirm the power of the Medici family some eighty years earlier.

During the seventeenth century, Paris grew into the second-largest city in Europe (Naples was the first)—and by far the liveliest. After the

devastation of the Wars of Religion, Paris developed a unique reputation—for freedom, for energy, for transgressiveness. It was where people made fortunes, achieved fame, and accumulated power. Noblemen and commoners flocked to Paris from all over Europe, and stories of *libertinisme* and *excentricité* abounded. One of Poussin's friends and early patrons, the poet Giovambattista Marino, told the best of them, capturing the spirit of the place.

The city itself was undergoing major changes: new bridges were built across the Seine, gardens were created, churches founded, trees planted along newly opened streets. The aim was to use art, architecture, garden design, and urban planning to make Paris the magnificent national capital that it still is.

The Louvre—which had been the stronghold of Paris for centuries until François I, the king who had brought Leonardo to France, started its transformation into the primary royal palace in 1528—was now the main royal residence and the epicenter of French art. New wings were erected, apartments and enfilades were created, galleries were decorated with frescoes and stuccoes, lawns were designed with beautiful parterres, and gardens were filled with exotic plants.

The Louvre was the product of many hands: those of painters, carpenters, and stonemasons, of course, but also scientists. Their knowledge of hydraulics was used to build waterways, design irrigation systems for gardens, and make fountains spray. Their geometrical skills were put to use for stonecutting, as precisely cut stones saved both time and money.

Girard Desargues, the mathematician who wrote about the copy of Leonardo's shadow drawing, also worked at the Louvre. He was regarded as "one of the great minds" of Baroque Paris, a fact that may come as a surprise today, considering that he is no longer so well known. But at the time, he was at the center of a forward-looking circle of scientists who met informally in private houses to discuss new ideas (the French Academy of Sciences would not be established until 1666 under Louis XIV).

Among the people Desargues met regularly were some of the most

original thinkers of the period. There was the philosopher René Descartes, who wrote extensively on optics although, unlike Alhacen and Leonardo, he separated the eye from the mind. According to Descartes, we understand the world through ideas, not perceptions. Then there was the mathematician Pierre de Fermat, who pioneered infinitesimal calculus; the tax collector turned scientist Étienne Pascal and his son Blaise Pascal, who designed a sophisticated computational machine to help his father collect taxes; and Marin Mersenne, who described a subset of prime numbers and is often regarded as the father of acoustics. Desargues himself pioneered the field of projective geometry, which had practical applications related to stone cutting—hence Desargues's position at the Louvre and his association with artists.

Although these scientists had different interests, they were all interested in continuous quantities—sound, numbers, distances—which they divided into smaller and smaller units. In this respect, the question of their basic research was not that different from the question that had animated Leonardo's optical studies—how to break down light and shadow into smaller and smaller sections in order to understand the geometry of penumbras. There is no question, though, that the mathematical skills of this Parisian group were considerably more sophisticated than Leonardo's own.

We have no evidence that Poussin met Desargues or that he knew of him, but we do know that the reverse was true. Desargues wrote about Poussin and the shadow drawing the artist sent to Paris. He wrote about it because the procedure for defining penumbras geometrically was very similar to a method Desargues himself had developed to define the intensity of colors. Desargues called it the rule for the use of strong and delicate colors (*règle du fort ou faible*); for him it was "of such consequence in painting that it is in this part that resides mostly the ways that make us admire works of this nature." It was almost as if the great Renaissance genius validated Desargues's own règle du fort ou faible, even though Desargues thought his method was more accurate than Leonardo's.

More Leonardo-inspired shadow drawings arrived in Paris in 1640,

when Poussin was appointed première peintre du roi. We do know he brought with him copies of the shadow drawings Cassiano had given him, for he had had his brother-in-law Jean Dughet make the copies. His friends and travel companions, Paul Fréart de Chantelou and his brother Roland Fréart de Chambray (1606–1676), who had been dispatched to Rome to summon him to Paris, brought back their own bounty: a copy of Leonardo's book on painting. And not just any copy, but a copy of Cassiano's master copy, the one version Cassiano kept improving day after day.

And so Poussin and the Fréart brothers returned to Paris bearing an incredible treasure trove—the most advanced studies on painting by Leonardo known to exist, materials that would prove helpful in training artists in principles of Poussin's own art. The French court believed that Poussin would push French art to new heights, and his appointment as première peintre du roi was meant to further this end, not just provide embellishments for the royal residence.

Poussin was lodged at the Louvre, in the Jardin des Tuileries, upon his return to Paris. His friend Chantelou sent a barrel of wine to greet him upon his arrival. He lived surrounded by exotic plants, and reported back to Cassiano and Cardinal Barberini about the jasmine planted at Les Tuileries—for his Roman friends were both passionate about this plant, always on the lookout for new specimens in the gardens of Europe. Poussin worked for the king mainly at the Louvre, at times side by side with his old friends, the artists who shared his strong belief in the close connection among art, nature, and the art of the ancients. He helped Cassiano with the financing of some printing projects and designed frontispieces for the royal printing house. Occasionally, he painted for private collectors.

He was busy.

He was too busy.

He was busy with things that did not matter to him—book frontispieces, furniture, fireplaces—"bagatelles," as he called them.

He was busy working for a royal patron, à la Vasari.

After just twenty-one months, he had had enough. Using the excuse of going to Rome to bring back his wife, he left.

In his absence, the political situation changed dramatically, making a return to Paris inadvisable. As a friend wrote to Cassiano from Paris, "Poussin is comfortable where he is [in Rome], and he should stay there."

Poussin did stay in Rome—for the rest of his life.

And he did continue to value the teachings he had gleaned from Leonardo's shadow drawings. Nowhere is this more evident than in a self-portrait he painted in 1650, right before Leonardo's book on paint-

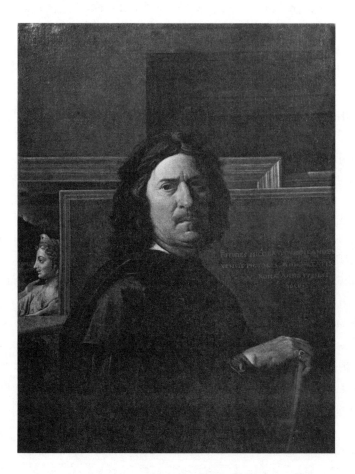

ing was printed with the title *Treatise on Painting*. Poussin depicted himself as a Baroque version of the "painter-philosopher" Leonardo had epitomized a century and half earlier.

Poussin was by this point fifty-six years old, accomplished and famous. His friend Paul Fréart de Chantelou commissioned the self-portrait for display in the French Royal Academy, and with it, Poussin hoped to cement his standing in the history of art. He painted himself inside his studio, looking straight out at his patron friend, wearing an elegant black cape of heavy fabric. He holds a gray folder, containing drawings, or writings, or both, closed by a length of red leather. Soft natural light filters in from a window to the left, creating subtle shadows and reflections. There are infinite variations of gray and blue, but only two areas of reddish paint—one depicting a chest on the left side of the painting, and another capturing the red leather of the folder's closure. A few framed paintings lean against the studio's wall, but, except for one in the back, they all appear blank. Poussin signed his name on one of these empty canvases—which on that uniform, grayish surface looks like the writing on a tombstone, immortalizing his name for posterity. The one painted canvas depicts a woman in a landscape lit by sunlight filtering through clouds—the style of illumination that Leonardo recommended for portraits, and that Poussin adopted in many of his canvases. The woman is embraced by another figure, and although all we see of this second figure is its arms, the meaning of their embrace is a clear reference to the friendship between artist and patron. The tiara this woman wears has an eye, the traditional symbol of optics, nestled at its center. She is a personification of the art of painting, but not a generic personification.

Rather, she is a personification of painting as an art based on optics, suggesting that this is what lay behind Poussin's own art.

One wonders, then, if the folder that Poussin holds contains copies of Leonardo's shadow drawings. This would be in keeping with the apparent message of his self-portrait: that he was a painter-philosopher à la Leonardo.

It was not Poussin but his friend Roland Fréart de Chambray, however, who saw to the publication of Cassiano's version of Leonardo's book on painting in France. Chambray and his brother Chantelou were both good friends and devoted patrons of Poussin, and when in Rome frequent visitors to Cassiano's library. In the 1640s, they held important positions at the French royal court in matters of art and continued to do so in the following decades.

To publish Leonardo's book, Chambray enlisted the help of two longtime friends, Raphael Trichet du Fresne (1611–1661) and Charles Errard (1606–1689), who had benefited immensely from his family's patronage and had spent time with Poussin and Cassiano in Rome. Now they were frequent visitors to his family's château at Dangu, the headquarters for editing Leonardo's book, just as Cassiano's library had been in Rome a decade earlier.

Chambray translated the text from Italian into French, focusing on capturing the sense of Leonardo's thought rather than literally translating word for word. He did not hesitate to rework sentences when they were not clear. Trichet worked on the Italian text that Cassiano had prepared but that nonetheless Trichet further revised as Leonardo "did not give it the final edit." Most chapters had "some snag" (*qualche intoppo*). Errard helped out with the illustrations, adding to Poussin's sketches a plant here, a tree trunk there, and columns and balconies to suggest that the figures occupied ancient settings and bucolic landscapes. He invented new diagrams for chapters that had none, and added an engraving of the *Mona Lisa* to the chapter titled "How to Paint Portraits That Have Relief and Grace"—this was intended as an homage to the French king, who owned the work. Chambray was pleased with Errard's work, and praised him as a modern Apelles in the dedication.

The French editors also consulted additional copies of the book that they were able to access beside Cassiano's, and they must have had access to the shadow drawings that were available in Paris—but, like Cassiano before them, they did not integrate them into the printed book they were preparing.

When the translated text, images, notes, and dedication letters were ready, Chambray delivered them all to a publisher.

In 1651, Leonardo's book on painting appeared in two printed volumes—one in Italian, which was based on Cassiano's master copy (plus some additional edits by the French editors), and one in French, based on Chambray's translation of Cassiano's master copy.

Its title was *Trattato della pittura*, or *Traité de la peinture*—in English, *Treatise on Painting*.

It was a sumptuous book, with one specific goal in mind: to present Leonardo's theories as the authoritative guide for modern art.

Every single detail was designed to reinforce this message.

The book was printed on folios of about fifteen by ten inches, a format that was reserved for special books. An elegant copper engraving with Leonardo's likeness opened the book; his unmistakable profile, which was based on Vasari's woodcut from his *Lives*, which was in turn based on Melzi's portrait, sat above a structure that looked like an ancient sarcophagus. His name and the book's title were sculpted in capital letters on the marble slab: LIONARDO DA VINCI *TRATTATO DELLA PITTURA*. The message of this first page was clear: Leonardo was the equal of the greatest authors of the past.

For page after page, the marvels continued: A luxurious title page displaying a royal privilege and decorative figures. Dedicatory letters addressed to famous people. Engravings inserted within the text, some representing diagrams, others human figures, other still landscapes and portraits. Additional decorative ornaments filled any blank spots on the page. Different fonts and typesetting to distinguish the text of chapters from the text of their titles.

Only the Bible and books by highly respected authors such as Ptolemy, Vitruvius, Pliny, Palladio, Vignola, and Vesalius were published in a comparable manner. Leonardo's *Treatise on Painting* was printed like these special books: a luxury item targeted at the high end of the book market and dedicated to prominent people.

Those who read the French translation found a dedication to Poussin. Chambray saw in Poussin a second author because he had "given the final perfection to this rare book" with "the linear demonstrations" for the chapters that needed additional clarification. But the real reason Chambray dedicated the book to Poussin was because he wanted the whole world to know that this famous artist was a dear friend, *un très cher ami*, and because he wanted to use Poussin's reputation to claim that the book ought to be "the rule and guide for all true painters." We do not know what Chambray expected from Poussin in exchange—whether a deeper friendship, or a painting, or something else. Whatever he sought, he must have been disappointed. Poussin was quite critical of the finished book, as we shall see.

Those who read the Italian edition encountered a different dedication, as its editor had another agenda. Trichet, who was hunting for a job, dedicated the book to Christina, queen of Sweden, a royal who had achieved fame across Europe as a passionate student of Italian art and culture, and who eventually abdicated in order to move to Rome and dedicate her life to the arts. Trichet praised her as "the queen of Parnassus [. . .] the most educated and glorious princess of the universe [. . .] the protector and possessor of all the most recondite sciences." The dedication achieved the desired outcome, and Trichet was appointed Christina's keeper of medals and paintings.

Trichet also wrote a new biography of Leonardo based on his own knowledge of "things from Italy," and it related accurate information on Leonardo's notebooks that had not been seen in print before. For

the first time, readers learned from Trichet's biography that Leonardo had planned an extensive list of books and that some of these books were mentioned in various chapters of the text that was printed. Leonardo's book on anatomy, Trichet reminded readers, was mentioned in chapter 22 of the printed book, another on perspective was referenced in chapters 81 and 110, another on the movement of the human body and its parts, "a topic that had never been touched by any author," was referred to in chapters 112 and 123 of the printed book. "The book on light and shadow today in the Biblioteca Ambrosiana in Milan," Trichet reported, "is a folio-size notebook with a cover in red velvet" in which Leonardo treated the topic "as a philosopher, a mathematician and a painter" (this is the notebook known today as Manuscript C). Trichet reminds his readers that Leonardo referred to this work in chapter 278 of the printed book and that the artist was "miraculous" in this aspect of painting because he imitated "the effects of light on colors with such knowledge that his works looked as if they were more natural than artificial." Like Cassiano and Poussin before him, Trichet understood that the shadow drawings pertained to colors as well, but like them he did nothing to reintegrate them into Leonardo's book.

Many were enthusiastic about the new French and Italian editions of Leonardo's book. Charles Le Brun, an academic painter who was skeptical about the use of science in art, praised the French edition precisely because there was no science in it. In 1653, he brought a copy to a meeting of the Académie Royale, the French equivalent of the Florentine art academy that had been founded in 1648, and unequivocally announced: "Here is the book to use when it comes to the things we have to discuss."

The Leonardo that emerged from these sumptuous publications seemed authoritative. He was sensitive to light, shadow, and the effects of the atmosphere, but his instructions were not grounded in the science of optics—hardly any of it was included in these books. They circulated widely, and they did contribute to the dissemination of

knowledge of Leonardo's art, but a great deal was lost because his fascination with optics was obscured.

These printed books were based on the doctored version of Melzi's *Book on Painting*. Like the heavily doctored, handwritten versions that took neither Melzi's nor Leonardo's wishes to heart, these new printed books were missing the sections on philosophy and science that were at the core of Leonardo's art and that Melzi had included in his compilation.

Reading these printed books, no one would ever know that Leonardo had argued for the supremacy of painting by way of a philosophical discussion of sensory experience that was adapted from books on optics. The paragone that opened Melzi's version of the book had been cut. Nor would anyone know that Leonardo's seemingly generic piece of advice to artists—that they should strive to become "universal painters"—was backed by detailed, geometrical instructions on how to paint soft light and shadow. The entire section titled "On Shadow and Light" was missing.

Of course, had Leonardo himself finished his book on painting, or had his writings been more lucid, there would have been no issue in the first place. But no matter how much Leonardo wanted to write a book on painting, and no matter how intensely he worked and reworked his drafts, he never completed it. His notes on painting remained buried within his notebooks, to be unearthed by the dedicated work of his pupil and assistant Melzi. No doubt Melzi edited his master's notes heavily, both their order and the wording itself. No doubt, too, he thought he understood better than anybody else his master's intentions.

And yet even Melzi's efforts did not pan out. Not only was his version of the *Book on Painting* never published, but it inadvertently provided the basis for the truncated and doctored versions to come that would end up distorting his master's thoughts.

In some cases, these versions did more than distort the real Leonardo: they negated him entirely.

The printed books that, from 1651 onward, were considered the definitive version of Leonardo's *Treatise on Painting* were in fact nothing of the sort. They normalized the view of Leonardo as a typical Renaissance polymath, a "dual genius," instead of as the brilliant, synthetic thinker that he in fact was.

The authority ascribed to Trichet and Chambray's *Treatise* remained unchallenged for centuries. Even when Melzi's version of the *Book on Painting* was rediscovered and finally printed in 1817, it was held that the *Treatise* was simply an abridged version of the original—and perhaps this is the most serious misunderstanding of them all. To "abridge" implies the deletion of the merely incidental, with the aim of revealing what lies at the heart of a text. But the abridged *Book on Painting* possessed only an unfaithful heart: its intention was to deceive, to disguise the fact that Leonardo the artist and Leonardo the scientist were in fact one and the same, and to keep hidden from the world the true author of one of the most extraordinary bodies of work in the history of painting.

Epilogue

The *Treatise on Painting* that was printed in Paris in 1651 was one of art history's great missed opportunities. It fostered a skewed view of Leonardo, and a version of the man that would prevail among readers for the next 150 years.

Nicolas Poussin, however, knew better.

He criticized the printed *Treatise on Painting* harshly, indifferent to the fact that the French editors were his personal friends and that they had singled him out as the "second author" of the book. Poussin knew Leonardo's shadow drawings and had assimilated Leonardo's teachings on shadows, colors, and reflections into his own practice like no other painter. He admired Leonardo so deeply that he had fashioned himself as a painter-philosopher after Leonardo's example.

And so he was horrified by the illustrations for both the French and the Italian editions.

He could hardly recognize "the clumsy landscapes" that were situated behind the human figures he had drawn for Cassiano; these landscapes "were added by a certain Errard, without me having known anything about it." For him, the printed treatise had little to recommend it: "[all] that is good in this book can be written on a sheet of paper in capital letters," he wrote to a fellow artist.

And yet, apart from expressing his views in private letters, Poussin

did not do much to promote a more comprehensive view of Leonardo. Nor did the publication of one of these critical letters in 1665, as part of a tract authored by another French artist, do much to rectify the situation.

In addition to Poussin, there were others who knew better, as they also had seen Leonardo's shadow drawings. But despite holding prominent positions in the artistic circles of Paris and Rome, they could do little to reverse the damage inflicted by the printed *Treatise*.

In 1662, the treatise's primary editor, Roland Fréart de Chambray, wrote a book titled *The Idea of Perfection in Painting*, in which he argued that Leonardo's teachings and Poussin's artistic practice should serve as guides for further developments in art. But even though he had seen the shadow drawings Poussin owned, he did not use them to substantiate his view or discuss Leonardo's science of art explicitly.

A few years later, in 1665, his brother Paul Fréart de Chantelou became Gian Lorenzo Bernini's official guide during the sculptor's five-month Parisian sojourn. Chantelou described Bernini's visit in a journal that has since become fundamental to our understanding of the court of Louis XIV. But Chantelou did nothing to disseminate knowledge of Leonardo's science of art.

Errard became première peintre du roi after Poussin left Paris. He had been among the founders of the French art academy, and eventually became the first director of its branch in Rome, which opened in 1666. But he, too, did almost nothing to promote a more truthful view of Leonardo.

One particularly important figure in the history of Leonardo's legacy is the art connoisseur André Félibien, who served the French court for over thirty years as a historian and secretary of a new royal academy for architecture. He wrote extensively on artistic subjects, including optics and aerial perspective, and promoted an aesthetic based on ancient art, Raphael, Poussin, and Leonardo. He was uniquely well informed about Poussin's knowledge of optics. He also had a more comprehensive view of Leonardo, since he had received, directly from Cassiano in Rome in 1649, an updated copy of Cassiano's master copy

of the *Book on Painting*, and was also familiar with the shadow drawings. But he never acknowledged that he was indebted to Leonardo for his knowledge of aerial perspective.

In the meantime, Melzi's *Book on Painting* lay buried in various libraries. At some point it ended up in the library of the court of Urbino, at the time one of the most famous in all of Europe. We do not know exactly when it arrived. Had it been there all along? Had it sojourned at smaller private libraries along the way, been sold at one point or another to improve the finances of its owners? Of one thing we are certain: when the ruling family of Urbino was unable to produce a male heir, the pope incorporated their lands into the papal states, and, as a result, the library's contents were transferred to Rome in 1657.

At first, Melzi's compilation was stored in the Biblioteca Universitaria Alessandrina, a beautiful library the Baroque architect Francesco Borromini had designed for Pope Alexander VII next to "La Sapienza," the University of Rome. In later years, it was moved to the main Vatican Library, which was located in the Vatican palace. There, a low-level functionary cataloged a book on painting by Leonardo da Vinci.

Year after year, decade after decade, the Melzi edition sat quietly in the Vatican Library. Another 150 years would pass before a librarian named Guglielmo Manzi came to the rescue. He not only realized the value of the book in the Vatican's possession but also saw to its publication. In 1817, the Melzi version of the *Book on Painting* finally appeared, with a brief introduction indicating that only "part of this treatise was published" in the past and that Leonardo's "ideas will be complete for the first time." Manzi offered no comparison of the authentic version with either the early hand-copied versions or with the printed *Treatise*, although he did say that these texts were "truncated and mutilated [*tronco e smozzicato*]." Nor did he investigate why this truncated version of the original had been created, or determine what exactly had been cut.

You might imagine that in the following decades scholars from all

over the world would pore over Melzi's *Book on Painting* and assess its contents and impact on Leonardo's reputation. But shortly after the publication of the entire *Book on Painting*, over four thousand pages of Leonardo's original papers—which had until then been scattered and buried in various private libraries—began to be published. Although these texts were extremely confusing, and it was impossible to get a clear sense of what Leonardo meant to say about painting from them, scholars concentrated on this new outpouring of work. After all, they were primary-source documents. No matter that Melzi had lived with Leonardo and learned about painting directly from him; no matter that it was Melzi to whom Leonardo had described his personal thoughts; no matter that it was Melzi to whom Leonardo willed his papers— Melzi's edition could not be construed as a primary source.

And so it took over 150 *more* years for scholars to do the work of comparing Melzi's version to the supposedly abridged versions. Only when this work was finally completed, in the 1950s and 1960s, did people understand that the "abridged" versions that were disseminated by way of handwritten copies and printed books were not just "abridged," but in fact doctored—one might say travestied.

By this time, scholars had also completed significant research on Leonardo's original notebooks, which were edited, annotated, and published in beautiful facsimile editions. This expert scholarship has also allowed us to develop a more holistic view of Leonardo, a view that Melzi had but that escaped the many who came after him.

Today, when we look at the layout of Leonardo's folios, the content of his language, and the physical characteristics of the paper and ink, we are in a much better position than we were just a few decades ago to decode their meaning. We can determine with a good degree of certainty whether we are reading a passing thought the artist jotted down while on the move, words he copied from a book by another author as he read at his desk, a rough draft of an idea inspired by observations or an experiment, or a revised text based on earlier, messier drafts. We can access

the notebooks worldwide thanks to the Internet. We can even imagine a day when advanced digital technology will take our knowledge of the artist even further. We will be able not only to consult Leonardo's writings as they are preserved today—notebook by notebook, folio by folio— but also to "see" them as Leonardo kept them on his desk when he composed them. We will be able to virtually reassemble folios that are now dispersed across different libraries, but that Leonardo kept in the same set or notebook, and we will be able to study the detailed evolution of his thoughts over time. And we will be able to reorder according to Leonardo's intentions folios that later owners assembled only randomly— including the folios that contain many of the shadow drawings.

The shadow drawings—and the knowledge required to create them— testify to Leonardo's deep interest in the science of optics, "the soul of painting." They also reveal the roots of Leonardo's belief that "painting is philosophy," and how those thoughts took shape in his mind from a young age. They form part of the growing body of evidence that is helping us revise the traditional view that science came to play a role in Leonardo's thinking only after his artistic vision was formed. Today, it seems more and more plausible that Leonardo had been steeped in philosophy and science since his youth, and that he started to read and write at a young age, although admittedly not much of what he wrote as a young man has survived. A new understanding of the artist is slowly emerging: Leonardo became the painter he became because his artistic training involved traditional workshop instruction *and* a deep engagement with optics and philosophy. The stunning optical effects that are a defining characteristic of even Leonardo's early work can be connected with his shadow drawings—which, in turn, were made possible by the people he met in his youth, the places he lived, the books he read, and, not least of all, the master who trained him and who designed the golden palla atop Florence's cathedral.

The shadow drawings also help us to understand why, for Leonardo, painting was a means of investigating the natural world—or, as he put it, "a subtle invention, which with philosophical and subtle speculation considers all manner of forms: sea, land, trees, animals, grasses, flowers, all of which are enveloped in light and shade." When he eventually delved into geology, botany, zoology, optics, and the study of water, he did so because all these fields also pertained to painting. At times, these other subjects took over his life entirely. Others were lifelong interests to which he returned intermittently. All, though, were subordinate to painting.

His unparalleled artistic skills allowed him to make visible complex bodies of knowledge, complex interrelations between humans and nature. He explored abstract concepts from geology, hydraulics, philosophy, physics, and optics, and he translated them into images and diagrams, based in part on what he read in books but also what he saw with his own eyes. He never ceased thinking about the world the way artists do, in visual terms. He always remained an artist, and especially a painter, first and foremost—a painter who happened to believe that "painting is philosophy."

Yet the shadow drawings also force us to rethink what is perhaps the most commonly held belief about Leonardo: that for him, art was about copying the appearance of nature, what he called the "ornaments of the world"—sea, land, trees, animals, grasses, flowers. It wasn't. Before the word "psychology" was invented, before empathy existed as a concept, before neuroscientists discovered the neural basis of our ability to feel what others feel, Leonardo was determined to be the artist who took Renaissance painting where it had never gone before—into the inner, invisible worlds of its subjects. He understood that the subtlest change of heart or mind involuntary triggered an alteration in the appearance of bodies and faces, and that what made these minute shifts visible were the unexpected shadows cast by human figures exposed to light.

This is why the final result of Leonardo's inquiry was not a book (he drafted many and finished none), or an experiment (though he per-

formed many and designed even more), or even a drawing (though he drew compulsively). The final result was always an oil painting. Because only at an easel, practicing his technique at the highest level, could he capture the variations of light and shadow on people's faces and bodies, which in turn revealed the subtlest movements of muscles and tendons, which in turn revealed changes in their states of mind. The medium—oil painting—was integral to the idea itself.

This integrated approach to painting, philosophy, and science lay at the heart of Leonardo's project. And yet we find it easier to simply marvel at the work of "his hand" than to understand this work as the lost way of comprehending the world that it in fact is.

The news that a painting recently attributed to Leonardo was bought for $450 million (the highest price ever paid for a work of art at auction) made headlines worldwide. And the collective gasp grew only louder when the painting's unveiling at the Louvre Abu Dhabi was canceled without explanation, before the work disappeared from public view altogether. Sensational discoveries of new works by Leonardo are announced every once in a while—to discover a "new" Leonardo is the holy grail of art history. Meanwhile, old works seem to only be growing in fame. The *Mona Lisa* was the backdrop of a video by Beyoncé and Jay-Z that instantly reached millions of viewers. The fascination with Leonardo reached a peak in 2019, the year that marked the five hundredth anniversary of the artist's death. Today, we place Leonardo and his paintings in such a gilded frame (sometimes literally) that we often miss their true value.

But those among his contemporaries who knew him had a very clear sense of what made his art great—the shadow drawings and the philosophical and scientific knowledge that informed them. As the doctor-scholar Paolo Giovio said of Leonardo, "[Nothing] was more important to him than the rules of optics, which he followed to study the principles of light and shadow exactly and minutely."

Any educated person in the Renaissance would have heard the

ancient myth that the first painting was born from a shadow. Pliny recounted it, countless other authors repeated it, and Leonardo jotted it down in a note that he intended for his book on painting: "The first painting was merely a line drawn round a shadow of a man cast by the sun upon a wall," he wrote. But unlike the authors who came before him, who were either silent about the source of light that generated this mythical shadow or mentioned a torch or a candle, Leonardo specified that it was "cast by sun." Painting was about depicting outdoor shadows generated by sunlight and by the universal light of the sky—shadows that "seem to have no end [*che paia senza fine*]." His sfumato technique originated in these natural shadows, and was his means of situating his figures in relation to one another, to the viewer, and to the cosmos. No fixed boundaries divided people from one another, from objects, or from nature. Painting was a technique for revealing the human soul that existed in such a universe—and doing so by way of light and shadow. That's what art—and the science that informed it—could accomplish. And for Leonardo, that was enough.

Notes

I have profited enormously from previous scholarship on Leonardo da Vinci, a field of study that keeps growing. In the notes to the chapters, I point to the specific sources, but here is a review of the books, exhibition catalogs, and critical editions of Leonardo's works that I have used throughout.

Numerous biographies have been written on Leonardo. Carmen Bambach, *Leonardo da Vinci Rediscovered*, 4 vols. (New Haven, CT: Yale University Press, 2019), is a recent, perceptive, and unsurpassed four-volume biographical account that integrates writings, drawings, and paintings. I found most helpful also two classical biographies: Kenneth Clark, *Leonardo da Vinci: An Account of his Development as an Artist* (Cambridge: Cambridge University Press, 1939; 2nd ed., 1989), a courageous and early attempt to look at Leonardo's entire career as an artist, although Clark's view that Leonardo's writings were a distraction from his paintings has been superseded; and Martin Kemp, *Leonardo da Vinci: The Marvelous Works of Nature and Man* (Cambridge, MA: Harvard University Press, 1981; 2nd ed., Oxford: Oxford University Press, 2007), a superb, comprehensive, and pioneering account of the artist's work in the arts, sciences, and technology. Equally important is Carlo Vecce, *Leonardo* (Rome: Salerno Editrice, 1998), which adds considerable information on the literary context and provides a useful selection of early primary biographies on the artist. Vasiliy Pavlovich Zubov, *Leonardo da Vinci* (1st ed., trans. David Kraus, Leningrad, 1961; Cambridge, MA: Harvard University Press, 1968), is a significant, early assessment of Leonardo's scientific work, as is the more recent book by Fritjof Capra, *The Science of Leonardo: Inside the Mind of the Great Genius of the Renaissance* (New York: Doubleday, 2007). Richard Turner, *Inventing Leonardo* (New York: Knopf, 1993), is an engaging account of how Leonardo's fame grew over the centuries. David A. Brown, *Leonardo da Vinci: Origins of a Genius* (New Haven, CT: Yale University Press, 1998), is a superb study on Leonardo's early training as an artist, although it does not address the artist's scientific and technological interests. Accurate, engaging, and well-written bi-

ographies are Charles Nicholl, *Leonardo da Vinci: Flights of the Mind* (New York: Viking, 2004), and Walter Isaacson, *Leonardo da Vinci* (New York: Simon and Schuster, 2017), a masterfully written book.

I have found most useful Martin Kemp's recent new translation of Giorgio Vasari, *The Life of Leonardo da Vinci* (New York: Thames and Hudson, 2019), as it integrates the 1550 edition and the expanded version of 1568.

Very useful also are the beautifully illustrated, complete catalogs of Leonardo's paintings by Frank Zöllner, *Leonardo da Vinci, 1452–1519*, 2 vols. (Cologne: Taschen, 2007; 3rd ed., 2011); and Pietro C. Marani, *Leonardo da Vinci: The Complete Paintings* (New York: Harry N. Abrams, 2000). Leonardo's drawings are in catalogs published by the museums that hold them, but more comprehensive books are Bernard Berenson, *The Drawings of the Florentine Painters*, 3 vols., 2nd ed. (Chicago: Chicago University Press, 1939); A. E. Popham, *The Drawings of Leonardo da Vinci* (New York: Reynal and Hitchcock, 1945; 2nd revised ed. with an introduction by Martin Kemp, London: Pimlico, 1994); Kenneth Clark and Carlo C. Pedretti, *A Catalogue of the Drawings of Leonardo da Vinci in the Collection of His Majesty the King at Windsor*, 2nd ed. (London: Phaidon, 1968). Extremely helpful, highly readable, and incredibly perceptive are the recent publications by Martin Clayton, especially Martin Clayton with Ron Philo, *Leonardo da Vinci: The Mechanics of Man* (London: Royal Collection Enterprises, 2010); and Martin Clayton, *Leonardo da Vinci: A Life in Drawing* (London: Royal Collection Trust, 2018).

A boost to Leonardo scholarship came in the past twenty years from important exhibitions of his works and their accompanying catalogs, which often include informative reports on recent restorations. Carmen Bambach, ed., *Leonardo da Vinci: Master Draftsman*, exhibition catalog (New York: Metropolitan Museum of Art, 2003), is a superb study of Leonardo's drawings over his entire career. Martin Kemp, ed., *Leonardo da Vinci: Experience, Experiment, and Design*, exhibition catalog, Victoria and Albert Museum, London (Princeton, NJ: Princeton University Press, 2006), visualizes Leonardo's projects with a special attention to Leonardo's thinking process. Paolo Galluzzi, ed., *The Mind of Leonardo: The Universal Genius at Work*, exhibition catalog, Gallerie degli Uffizi, Florence (Florence: Giunti, 2006), focuses on Leonardo's thought processes in his scientific works. Luke Syson and Larry Keith, eds., *Leonardo da Vinci: Painter at the Court of Milan*, exhibition catalog (London: National Gallery, 2011), was a groundbreaking exhibition as it exhibited together, for the first time ever, the two versions of the *Virgin of the Rocks*; fundamental also is the report on the important restoration of the London painting. Vincent Delieuvin, ed., *La Sainte Anne: L'ultime chef-d'-oeuvre de Léonard de Vinci*, exhibition catalog, Musée du Louvre, Paris (Paris: Louvre Éditions, 2012), was another pathbreaking exhibition occasioned by the recent restoration of Leonardo's *Saint Anne*, which was exhibited together with the London Cartoon. Paolo Galluzzi, ed., *L'acqua microscopio della natura: Il codice Leicester di Leonardo da Vinci*, exhibition catalog, Gallerie degli Uffizi, Florence (Florence: Giunti, 2018), is an updated assessment of Leonardo's research on water. Three recent exhibitions focused on Leonardo's master, Andrea del Verrocchio: Laurence

Kanter, ed., *Leonardo: Discoveries from Verrocchio's Studio*, exhibition catalog, Yale University Art Gallery, New Haven (New Haven, CT: Yale University Art Gallery, 2018); Francesco Caglioti and Andrea De Marchi, eds., *Verrocchio: Master of Leonardo*, exhibition catalog, Palazzo Strozzi, Florence (Venice: Marsilio, 2019); and Andrew Butterfield, ed., *Verrocchio: Sculptor and Painter of Renaissance Florence*, exhibition catalog, National Gallery of Art, Washington, DC (Princeton, NJ: Princeton University Press, 2019). The recent exhibition, Vincent Delieuvin and Louis Frank, eds., *Léonard de Vinci*, exhibition catalog, Musée du Louvre, Paris (Paris: Louvre Éditions, 2019), offered an in-depth view of the career of the artist as a painter.

Recent restorations of Leonardo's paintings and drawings have provided a new archive of information, images, and analysis that help us understand Leonardo's practice and thought processes when he painted. An overview of recent restorations is the important volume Michel Menu, ed., *Leonardo da Vinci's Technical Practice: Paintings, Drawings, and Influence* (Paris: Hermann Éditeurs, 2014), while Alan Donnithorne, *Leonardo da Vinci: A Closer Look: Exploring the Beauty and Complexity of Leonardo's Drawings through a Study of His Materials and Methods* (London: Royal Collection Trust, 2019), is a superb, illuminating analysis of a selection of Leonardo's drawing with a focus on the tools, media, and papers the artist used. More in-depth reports are available for each major restoration; they are mentioned in the notes of the pertinent chapters.

The most comprehensive list of documents pertaining to Leonardo's life is Edoardo Villata, *Leonardo da Vinci: I documenti e le testimonianze contemporanee* (Florence: Giunti, 1999). Elisabetta Ulivi, *Per la genealogia di Leonardo: Matrimoni e altre vicende nella famiglia da Vinci sullo sfondo della Firenze rinascimentale*, 2 vols. (Vinci: Museo Ideale Leonardo Da Vinci, 2008), offers numerous additional details on Leonardo's family. Vanna Arrighi, Anna Bellinazzi, and Edoardo Villata, eds., *Leonardo da Vinci: La vera immagine, documenti e testimonianze sulla vita e sull'opera*, exhibition catalog, Florence, Archivio di Stato (Florence: Giunti, 2005), reproduces many documents pertaining to Leonardo's life.

Leonardo's writings have been published in facsimile editions to make them available to a broader public since Leonardo's original notebooks are extremely fragile and basically out of consultation. These facsimiles are always accompanied by transcriptions of Leonardo's texts and learned apparatus to help their interpretation. Sometimes there are also translations in English. I have used the editions edited by Augusto Marinoni: *I manoscritti dell'Institut de France*, 12 vols. (Florence: Giunti, 1986–1990), which provide facsimiles, transcriptions, and critical apparatus for the twelve notebooks by Leonardo kept in Paris (Manuscripts A, B, C, D, E, F, G, H, I, K, L, M); *Il Codice Atlantico della Biblioteca Ambrosiana di Milano*, 24 vols. (Florence: Giunti, 1975–1980), which covers the over one thousand loose folios that were assembled in this codex in the late sixteenth century; *Leonardo da Vinci: I Codici Forster del Victoria and Albert Museum di Londra*, 3 vols. (Florence: Giunti, 1992); and *Il Codice 2162 della Biblioteca Trivulziana di Milano* (Florence: Giunti, 1980). I also consulted the following critical and facsimile editions: Carlo Pedretti, *The Codex Atlanti-*

cus of *Leonardo da Vinci: A Catalogue of its Newly Restored Sheets*, 2 vols. (Los Angeles: University of California Press, 1978–1979); Carlo Pedretii and Carlo Vecce, eds., *Il Codice Arundel 263 nella British Library* (Florence: Commissione Nazionale Vinciana, 1998); Ladislao Reti, ed., *The Madrid Codices of Leonardo da Vinci*, 4 vols. (New York: HarperCollins, 1974); Kenneth Keele and Carlo Pedretti, eds., *Leonardo da Vinci: Corpus of Anatomical Studies in the Collection of Her Majesty the Queen at Windsor Castle*, 3 vols. (Florence: Giunti, 1980); Carlo Pedretti, ed., *The Codex Hammer of Leonardo da Vinci* (Florence: Giunti 1987)—Martin Kemp and Domenico Laurenza are preparing a new edition of this codex (only the facsimile of their volume has been published to date; a new transcription and critical apparatus are expected in the near future); and Edoardo Zanon, ed., *Il libro del codice del volo: Dallo studio del volo degli uccelli alla macchina volante* (Milan: Leonardo 3, 2009).

A comprehensive discussion of Leonardo's notebooks is in Carmen Bambach, *Leonardo da Vinci Rediscovered*, 4 vols. (New Haven, CT: Yale University Press, 2019), vol. 2:61–235; vol. 4:1–3, 29–31.

Among the digital resources, the most helpful is Romano Nanni and Monica Taddei, eds., *e-Leo: Archivio digitale di Storia della Tecnica e della Scienza* (Vinci: Biblioteca Leonardiana), which contains facsimile pages and transcriptions of all notebooks by Leonardo (https://www.leonardodigitale.com/).

Even in facsimile and with the help of transcriptions and critical apparatus, Leonardo's writings are extremely hard to handle given his idiosyncratic form of writing and the fragmentary status of his notes. To ease entry into Leonardo's writings, numerous anthologies have been published that assemble Leonardo's notes topically, taking them from a variety of notebooks and folios. The great advantage of these anthologies is that they give a sense of Leonardo's thoughts on a specific topic quite easily. The cautionary note is that these anthologies do not allow for an assessment of what kind of note Leonardo is writing (an early draft of an original thought, a quote from a book by another author, a fully formed thought), nor of the development of his thought over time. Nonetheless they are helpful, and I consulted the classic volumes assembled by Jean Paul Richter over a century ago, *The Literary Works of Leonardo da Vinci Compiled and Edited from the Original Manuscripts* (London, 1883; 2nd ed., Oxford, 1939; facsimile, London: Dover, 1970). Richter should be complemented with Carlo Pedretti, *The Literary Works of Leonardo da Vinci: Compiled and Edited from the Original Manuscripts by Jean Paul Richter; Commentary*, 2 vols. (Berkeley, CA: University of California Press, 1977). Edward MacCurdy, *The Notebooks of Leonardo Da Vinci*, 2 vols. (New York: Reynal and Hitchcock, 1935–1939), is an anthology that focuses on Leonardo's scientific writings. Eminently readable and extremely helpful is the anthology by Martin Kemp and Mary Walker, *Leonardo on Painting* (New Haven, CT: Yale University Press, 1989).

On the authors Leonardo read and the books he owned, fundamental is Edmondo Solmi, *Scritti vinciani: Le fonti dei manoscritti di Leonardo da Vinci e altri studi* (Florence: La Voce, 1924; rist. Florence: La Nuova Italia, 1976). Solmi's work has been updated by Carlo Vecce, *La biblioteca perduta: I libri di Leonardo*

(Rome: Salerno Editrice, 2017); and Carlo Vecce, ed., *Leonardo e i suoi libri*, exhibition catalog, Biblioteca dell'Accademia Nazionale dei Lincei e Corsiniana, Rome (Rome: Bardi Edizoni, 2019).

Specifically, on the book on painting that Leonardo planned but never completed, there are some fundamental studies that I have used extensively. Carlo Pedretti, *Leonardo da Vinci on Painting: A Lost Book (Libro A) Reassembled from the Codex Vaticanus Urbinas 1270 and from the Codex Leicester* (Berkeley: University of California Press, 1964), reconstructs Leonardo's last draft of the book on painting, now lost. Carlo Pedretti and Carlo Vecce, eds., *Libro di pittura: Codice Urbinate lat. 1270 nella Biblioteca Apostolica Vaticana* (Florence: Giunti, 1995), is the definitive edition of Melzi's compilation titled *Book on Painting* and based on Leonardo's notebooks. A. Philip McMahon, *Treatise on Painting: Codex urbinas latinus 1270*, 2 vols. (Princeton, NJ: Princeton University Press, 1956), is an English translation of Melzi's compilation. Claire Farago, *A Critical Interpretation of Leonardo da Vinci's "Paragone," with a New Edition of the Text in the Codex Urbinas* (Leiden: Brill, 1992), offers an in-depth analysis of the cultural and philosophical context of Leonardo's art theory. See also Claire Farago, ed., *Re-reading Leonardo: The Treatise on Painting Across Europe 1550–1900* (London: Routledge, 2009); and Claire Farago, Janis Bell, and Carlo Vecce, eds., *The Fabrication of Leonardo da Vinci's "Trattato della Pittura,"* 2 vols. (Leiden: Brill, 2018), which includes an English translation of the doctored copy of Melzi's compilation that was printed in 1651. The digital publication Francesca Fiorani, ed., *Leonardo da Vinci and His Treatise on Painting*, provides online access to Melzi's *Book on Painting*, to over forty doctored copies of Melzi's compilations, to the 1651 printed editions in Italian and French, and to the first English translation from 1721 (http://www.treatiseonpainting.org/home.html).

Significant studies on Renaissance scientific culture that I consulted include (in chronological order) Antony Grafton, *Defenders of the Text: The Traditions of Scholarship in an Age of Science, 1450–1800* (Cambridge, MA: Harvard University Press, 1991); Thomas DaCosta Kaufmann, *The Mastery of Nature: Aspects of Art, Science and Humanism in the Renaissance* (Princeton, NJ: Princeton University Press, 1993); Paula Findlen, *Possessing Nature: Museums, Collecting and Scientific Culture in Early Modern Italy* (Berkeley: University of California Press, 1994); Lorraine Daston and Katherine Park, *Wonders and the Order of Nature* (Cambridge, MA: Zone Books, 1998); Peter Galison and Caroline A. Jones, *Picturing Science, Producing Art* (New York: Routledge, 1998); Ingrid D. Rowland, *The Culture of the High Renaissance* (Cambridge: Cambridge University Press, 1998); David Freedberg, *The Eye of the Lynx: Galileo, His Friends, and the Beginning of Modern Natural History* (Chicago: Chicago University Press, 2002); Pamela H. Smith, *The Body of the Artisan: Art and Experience in the Scientific Revolution* (Chicago: Chicago University Press, 2004); Brian W. Ogilvie, *The Science of Describing: Natural History in Renaissance Europe* (Chicago: Chicago University Press, 2006); Lorraine Daston and Katherine Park, eds., *The Cambridge History of Science*, vol. 3: *Early Modern Science* (Cambridge: Cambridge University Press, 2006); Lorraine Daston and Peter Galison, *Objectivity* (Cambridge, MA: Zone Books, 2007); Pamela H. Smith and Benjamin

Schmidt, eds., *Making Knowledge in Early Modern Europe: Practices, Objects, and Texts, 1400–1800* (Chicago: Chicago University Press, 2007); Pamela O. Long, *Artisan/Practitioners and the Rise of the New Sciences, 1400–1600* (Corvallis: Oregon State University Press, 2011); Alexander Marr, *Between Raphael and Galileo: Mutio Oddi and the Mathematical Culture of the Renaissance* (Chicago: Chicago University Press, 2011); and Sachico Kusukava, *Picturing the Book of Nature: Image, Text, and Argument in Sixteenth-Century Human Anatomy and Medical Botany* (Chicago: Chicago University Press, 2012).

On optics and art, I found most helpful the following books (in chronological order): Graziella Federici Vescovini, *Studi sulla prospettiva medievale* (Turin, Italy: G. Giappichelli, 1965); Samuel Edgerton, *The Renaissance Rediscovery of Linear Perspective* (New York: ACLS History E-Book Project, 1975); David Summers, *The Judgment of Sense: Renaissance Naturalism and the Rise of Aesthetics* (Cambridge: Cambridge University Press, 1987); Martin Kemp, *The Science of Art: Optical Themes in Western Art* (New Haven, CT: Yale University Press, 1990); Victor I. Stoichita, *A Short History of the Shadow* (London: Reaktion Books, 1997); David Hockney, *Secret Knowledge: Rediscovering the Lost Techniques of the Old Masters* (New York: Thames and Hudson, 2001); Roberto Casati, *The Shadow Club: The Greatest Mystery in the Universe—Shadows—and the Thinkers Who Unlocked Their Secrets* (New York: Alfred A. Knopf, 2003); Sven Dupré, *Renaissance Optics: Instruments, Practical Knowledge and the Appropriation of Theory* (Berlin: Max-Planck Institut für Wissenschaftsgeschichte, 2003); David Summers, *Real Spaces: World Art History and the Rise of Western Modernism* (London: Phaidon Press, 2003); A. M. Smith, "What Is the History of Medieval Optics Really About?," *Proceedings of the American Philosophical Society* 147 (2004): 180–94; Jeffrey F. Hamburger and A. M. Bouchè, eds., *The Mind's Eye: Art and Theological Argument in the Middle Ages* (Princeton, NJ: Princeton University Press, 2006); Vincent Ilardi, *Renaissance Vision from Spectacles to Telescopes* (Philadelphia: American Philosophical Society, 2007); David Summers, *Vision, Reflection and Desire in Western Painting* (Chapel Hill: University of North Carolina Press, 2007); Hans Belting, *Florence and Baghdad: Renaissance Art and Arab Science* (Cambridge, MA: Harvard University Press, 2011); Mary Quinlan-McGrath, *Influences: Art, Optics, and Astrology in the Italian Renaissance* (Chicago: University of Chicago Press, 2013); Margaret S. Livingstone, *Vision and Art* (New York: Harry N. Abrams, 2014); Sarah Dillon, *Seeing Renaissance Glass: Art, Optics, and Glass of Early Modern Italy, 1250–1425* (New York: Peter Lang, 2018).

For Ibn al-Haytham's *Book on Optics*, I used the recent edition in six volumes edited by A. M. Smith and published by the American Philosophical Society between 2001 and 2010: *Alhacen's Theory of Visual Perception: A Critical Edition with English Translation and Commentary of the First Three Books of Alhacen's "De aspectibus,"* 2 vols. (2001); *Alhacen on the Principles of Reflection: A Critical Edition with English Translation and Commentary of Books 4 and 5 of Alhacen's "De aspectibus,"* 2 vols. (2006); *Alhacen on Image-formation and Distortion in Mirrors: A Critical Edition with English Translation and Commentary of Book 6 of Alhacen's "De aspectibus,"* 2 vols. (2008); *Alhacen on Refraction: A Critical Edition with English Translation and Commentary of Book 7 of Alhacen's "De aspectibus,"* 2 vols. (2010). On

Alhazen's influence on Renaissance optics, fundamental are the studies by Graziella Federici Vescovini, including her pioneering essay "Contributo per la storia della fortuna di Alhazen in Italia: il volgarizzamento del MS Vat. 4595 e il Commentario terzo del Ghiberti," *Rinascimento* 5 (1965): 17–49; and Graziella Federici Vescovini, *Arti e filosofia nel secolo XIV: Studi sulla tradizione aristotelica e i "moderni"* (Florence: Nuove Edizioni Enrico Vallecchi, 1983).

Specifically on Leonardo and optics, indispensable are Martin Kemp's studies, especially Martin Kemp, "*Il concetto dell'anima* in Leonardo's Early Skull Studies," *Journal of the Warburg and Courtauld Institutes* 34 (1971): 115–34; Martin Kemp, "Dissection and Divinity in Leonardo's Late Anatomies," *Journal of the Warburg and Courtauld Institutes* 35 (1972): 200–225; Martin Kemp, "Leonardo and the Visual Pyramid," *Journal of the Warburg and Courtauld Institutes* 40 (1977): 128–49; and Martin Kemp, "The Hammer Lecture (1992): The Beholder's Eye: Leonardo and the 'Errors of Sight' in Theory and Practice," *Achademia Leonardi Vinci* 5 (1993): 153–62.

Also important are (in chronological order) Anna Maria Brizio, *Razzi incidenti e razzi refressi*, Lettura Vinciana 3 (Florence: Barbera Editore, 1963); Kenneth D. Keele, "Leonardo da Vinci's Physiology of the Senses," in *Leonardo's Legacy* (Berkeley: University of California Press, 1969), 35–56, which provides an effective overview of Leonardo's thoughts on the senses, although it does not connect it to medieval optics; James Ackerman, "Leonardo's Eye," *Journal of the Warburg and Courtauld Institutes* 41 (1978): 108–46; Corrado Maltese, "Gli studi di Leonardo sulle ombre tra la pittura e la scienza," *Arte lombarda* 61 (1983): 95–101; Corrado Maltese, "Leonardo e la teoria dei colori," *Römisches Jahrbuch für Kunstgeschichte* 20 (1983): 209–19; Janis Bell, "Color Perspective, c. 1492," *Achademia Leonardi Vinci* 5 (1992): 64–77; Janis Bell, "Aristotle as a Source of Leonardo's Theory of Color Perspective After 1500," *Journal of the Warburg and Courtauld Institutes* 56 (1993): 100–118; Claire Farago, "Leonardo's Color and Chiaroscuro Reconsidered," *Art Bulletin* 73 (1993): 63–88; Alexander Nagel, "Leonardo and Sfumato," *Res* 24 (1993): 7–20; Frank Fehrenbach, *Licht und Wasser: Zur Dynamik naturalphilosophischer Leitbilder im Werk Leonardo da Vincis* (Tübingen, 1997); Fabio Frosini, "Pittura come filosofia: Note su *spirito* e *spirituale* in Leonardo," *Achademia Leonardi Vinci* 10 (1997): 35–59; Frank Fehrenbach, "*Veli sopra veli: Leonardo und die Schleier*," in *Ikonologie des Zwischenraums: Der Schleier als Medium und Metapher*, ed. J. Endres, B. Wittmann, and G. Wolf (Munich, 2005), 121–47; Janis Bell, "Sfumato and Acuity Perspective," in *Leonardo da Vinci and the Ethics of Style*, ed. Claire Farago (Manchester: Manchester University Press, 2008), 161–88; L. Luperini, ed., *L'ottica di Leonardo tra Alhazen e Keplero*, exhibition catalog, Museo Leonardiano, Vinci (Milan: Skira, 2008); Alessandro Nova, "Il vortice del fenomeno atmosferico e il grido metaforico: le *Tempeste* di Leonardo e il *Piramo e Tisba* del Poussin," in *Wind und Wetter: Die Ikonologie der Atmosphäre*, ed. Alessandro Nova and Tanja Michalsky (Venice: Marsilio, 2009), 53–66; Francesca Fiorani and Alessandro Nova, eds., *Leonardo da Vinci and Optics: Theory and Pictorial Practice* (Venice: Marsilio, 2013); Margherita Quaglino, *Glossario Leonardiano: Nomenclatura dell'ottica e della prospettiva nei codici di Francia* (Florence: Olschki, 2014).

PROLOGUE

4 *"nothing was more important to him than the rules of optics"*: Paolo Giovio, published in Carlo Vecce, *Leonardo* (Rome: Salerno Editrice, 1998), 355. Vecce published Paolo Giovio's brief biographical accounts of Leonardo, which are "Leonardi Vincii vita" and "Dialogi de viris et foeminis aetate nostra florentibus," Vecce, *Leonardo*, 349–57 (partial English translation in Carlo Pedretti, *The Literary Works of Leonardo da Vinci: Compiled and Edited from the Original Manuscripts by Jean Paul Richter; Commentary*, 2 vols. (Berkeley: University of California Press, 1977), vol. 1:9–11.

4 *"Every shadow"*: Leonardo da Vinci, Manuscript A, fol. 93v. English translation in Jean Paul Richter, *The Literary Works of Leonardo da Vinci: Compiled and Edited from the Original Manuscripts* (London: Dover, 1970), no. 148; and Martin Kemp and Mary Walker, *Leonardo On Painting* (New Haven, CT: Yale University Press, 1989, 110–11). Facsimiles of Leonardo's notebooks are available online in Romano Nanni and Monica Taddei, eds., *e-Leo: Archivio digitale di Storia e Tecnica della Scienza* (https://www.leonardodigitale.com/).

4 *"An opaque body"*: Leonardo da Vinci, Manuscript C, fol. 22r.

4 *"Just as the thing"*: Leonardo da Vinci, Manuscript C, fol. 4v.

7 *"painting is philosophy"*: Leonardo da Vinci, from Melzi, *Libro di pittura* (*Book on Painting*) fol. 4r, published in Carlo Pedretti and Carlo Vecce, eds., *Leonardo da Vinci. Libro di pittura. Codice urbinate lat. 1270 nella Biblioteca Apostolica Vaticana*, 2 vols. (Florence: Giunti, 1995), chapter 9; English translation in Kemp and Walker, *On Painting*, 18. Melzi's *Libro di pittura* is available online in Francesca Fiorani, ed., *Leonardo da Vinci and His Treatise on Painting* (University of Virginia: Institute for Advanced Technology in the Humanities, 2012), http://www.treatiseonpainting.org/cocoon/leonardo/pages/vu/array; and in Nanni and Taddei, https://www.leonardodigitale.com/.

7 *"few painters [. . .] their art as science"*: Leonardo da Vinci, from Melzi, *Libro di pittura*, fol. 20r (Pedretti and Vecce, *Libro di pittura*, chapter 34; English translation in Kemp and Walker, *On Painting*, 13).

8 *"vast accumulation"*: Kenneth Clark, *Leonardo da Vinci: An Account of His Development as an Artist* (London and New York: Penguin, 1989), 97.

11 *"experience does not err"*: Leonardo da Vinci, Codex Atlanticus, fol. 417r (English translation in Richter, *Literary Works*, no. 1153; and Kemp and Walker, *On Painting*, 10).

11 *"embraces all the ten functions of the eye"*: Leonardo da Vinci, Manuscript A, fol. 102v (English translation in Richter, *Literary Works*, no. 23; and Kemp and Walker, *On Painting*, 16).

11 *"distance between eye"*: A. M. Smith, *Alhacen's Theory of Visual Perception: A Critical Edition with English Translation and Commentary of the First Three Books of Alhacen's "De aspectibus,"* 2 vols. (Philadelphia: Philosophical Society, 2001), vol. 2:588–89 (book 3, 3.5).

11 *"little work"*: Leonardo da Vinci, Manuscript A, fol. 102v (English translation in Richter, *Literary Works*, no. 23; and Kemp and Walker, *On Painting*, 16).

12 *"grounded in optics [. . .] a rational demonstration"*: Leonardo da Vinci, Manuscript A, fol. 3r (English translation in Richter, *Literary Works*, no. 50; and Kemp and Walker, *On Painting*, 52).

12 *"the mother of every certainty"*: Leonardo da Vinci, from Melzi, *Libro di pittura*, fol. 19v (Pedretti and Vecce, *Libro di pittura*, chapter 33; English translation in Kemp and Walker, *On Painting*, 10).

13 *dated it convincingly*: Carmen Bambach, *Leonardo da Vinci Rediscovered*, 4 vols. (New Haven, CT: Yale University Press, 2019), vol. 1:306–11. I thank her for bringing this drawing to my attention.

13 *"soul of painting"*: Leonardo da Vinci, Manuscript A, fol. 81r.

14 *"sang beautifully [. . .] arbiter and inventor"*: Giovio, in Vecce, *Leonardo*, 357.

14 *beard that "came to the middle"*: Anonimo Gaddiano, in Vecce, *Leonardo*, 362.

15 *"Read me"*: Leonardo da Vinci, Codex Madrid I, fol. 6r.

15 *"was never quieted"*: Anonimo Gaddiano, in Vecce, *Leonardo*, 361.

15 *perfect works "will bestow upon you"*: Leonardo da Vinci, from Melzi, *Libro di pittura*, fol. 34v (Pedretti and Vecce, *Libro di pittura*, chapter 65; English translation in Kemp and Walker, *On Painting*, 194).

15 *without touching "the work with his hand"*: Matteo Bandello, *Tutte le opere*, ed. Francesco Flora (Milan: Mondadori, 1933–34), 646–50 (English translation in Bambach, *Leonardo Rediscovered*, vol. 1:416).

15 *"he knew so much [. . .] volubility of character"*: Antonio Billi, in Vecce, *Leonardo*, 359.

1. THE RIGHT PLACE AT THE RIGHT TIME

19 *"nature seemed to have produced a miracle"*: Anonimo Gaddiano, in Vecce, *Leonardo*, 360.

19 *"sciences, particularly geometry"*: Giorgio Vasari, "The Life of Andrea del Verrocchio," in Giorgio Vasari, *Lives of the Most Excellent Italian Architects, Painters, and Sculptors from Cimabue to Our Time*, trans. Gaston du C. de Vere, 2 vols. (New York: Alfred A. Knopf, 1996), vol. 1:549; written in 1550 and revised in 1568, Vasari's biography is a fundamental document on Verrocchio's art, vol. 1:549–57. Important studies on Verrocchio are Andrew Butterfield, *The Sculptures of Andrea del Verrocchio* (New Haven, CT: Yale University Press, 1997); Andrea Covi, *Andrea del Verrocchio: Life and Work* (Florence: Olschki, 2005); Luke Syson and Jill Dunkerton, "Andrea del Verrocchio's First Surviving Panel Painting and Other Early Works," *Burlington Magazine* 153 (2011): 268–78; and Christina Neilson, *Practice and Theory in the Italian Renaissance Workshop: Verrocchio and the Epistemology of Making Art* (Cambridge: Cambridge University Press, 2019). Two recent exhibitions shed further light on Verrocchio and his workshop: Francesco Caglioti and Andrea De Marchi, eds., *Verrocchio: Master of Leonardo*, exhibition catalog, Palazzo Strozzi, Florence (Venice: Marsilio, 2019); and Andrew Butterfield, ed., *Verrocchio: Sculptor and Painter of Renaissance Florence*, exhibition catalog, National Gallery of

Art, Washington, DC (Princeton, NJ: Princeton University Press, 2019).

20 *"There was born to me"*: Edoardo Villata, *Leonardo da Vinci: I documenti e le testimonianze contemporanee* (Milan: Castello Sforzesco, 1999): 3 (on Leonardo's birth); 6–7 (on the 1457 tax return of Leonardo's grandfather and the 1469 return of Leonardo's father). Additional documents on Leonardo's family, their residences in Vinci and Florence, their tax returns, and Leonardo's possible abacus teachers are in Elisabetta Ulivi, *Per la genealogia di Leonardo: Matrimoni e altre vicende nella famiglia Da Vinci sullo sfondo della Firenze rinascimentale* (Vinci: Museo Ideale Leonardo Da Vinci, 2008). On the education of children, see Paul Grendler, *Schooling in Renaissance Italy* (Baltimore: Johns Hopkins University Press, 1989); and Paul Grendler, "What Piero Learned in School: Fifteenth-Century Vernacular Education," in *Piero della Francesca and His Legacy*, ed. Marylin Aronberg Lavin (Washington, DC: National Gallery of Art, 1995), 161–74. On the Tuscan fiscal system, see David Herlihy and Christiane Klapisch-Zuber, *Tuscans and Their Families* (New Haven, CT: Yale University Press, 1985). On the raising of children in the Renaissance, see Christiane Klapisch-Zuber, *Women, Family and Rituals in Renaissance Italy* (Chicago: Chicago University Press, 1985).

24 *"come to the shop"*: Contract published in Creighton Gilbert, *Italian Art, 1400–1500* (Evanston, IL: Northwestern University Press, 1992), 31.

25 Ugolino Verino's comment on Verrocchio: Published in Neilson, *Practice and Theory*, 48.

25 *"to avoid growing weary"*: Vasari, "Verrocchio," vol. 1:552–53. On technical experimentation by artists in the Renaissance see Michael W. Cole, "The Technical Turn," in *Florence and Its Painters: From Giotto to Leonardo da Vinci*, ed. Andreas Schumacher, exhibition catalog, Munich, Alte Pinakothek (Munich: Hirmer Publishers, 2018).

26 Verrocchio's death masks: Ibid., 555.

28 Leonardo in Verrocchio's workshop: Significant studies are David A. Brown, *Leonardo da Vinci: Origins of a Genius* (New Haven, CT: Yale University Press, 1998); Jill Dunkerton, "Leonardo in Verrocchio's Workshop: Re-examining the Technical Evidence," *National Gallery Technical Bulletin* 32 (2011): 4–31; and Bambach, *Leonardo Rediscovered*, vol. 1:81–193. Also helpful are the pertinent chapters in the many biographies on the artist, especially those by Kenneth Clark, 1939; Martin Kemp, 1984; Carlo Vecce, 1998; Charles Nichols, 2004; Frank Zöllner, 2003; and Walter Isaacson, 2017, as well as Larry Feinberg, *The Young Leonardo* (Cambridge: Cambridge University Press, 2011). Laurence Kanter, *Leonardo: Discoveries from Verrocchio's Studio*, exhibition catalog, New Haven, Yale Art Museum (New Haven, CT: Yale University Press, 2018), is an interesting attempt to identify the hands of Verrocchio, Leonardo, and other artists in works that came out of Verrocchio's workshop, which, however, downplays the workshop's collaborative nature. Per Alessandro Cecchi, "New Light on Leo-

nardo's Florentine Patrons," in *Leonardo da Vinci: Master Draftsman*, ed. Carmen Bambach, exhibition catalog (New York: Metropolitan Museum of Art, 2003), 121–40. Verrocchio was Ser Piero's client between 1465 and 1471.

30 *"move those who behold"*: Leonardo da Vinci, from Melzi, *Libro di pittura*, fol. 61v (Pedretti and Vecce, *Libro di pittura*, chapter 188; English translation in Kemp and Walker, *On Painting*, 220).

31 *"folds with dark shadows [. . .] seem to be a pile"*: Leonardo da Vinci, from Melzi, *Libro di pittura*, fol. 167r–v (Pedretti and Vecce, *Libro di pittura*, chapter 532; English translation in Kemp and Walker, *On Painting*, 153). On drapery and folds as marker of human expressions and emotions in art, see Kurt Foster and David Britt, eds., Aby Warburg, *The Renewal of Pagan Antiquity: Contribution to the History of the European Renaissance* (Los Angeles: The Getty Research Institute for the History of Art and the Humanities, 1999); Gilles Deleuze, *The Fold: Leibnitz and the Baroque*, trans. Tom Conley (Minneapolis: University of Minnesota Press, 1992); and Georges Didi-Huberman, *Ninfa moderna: Essai sur le drapé tombé* (Paris: Gallimard, 2002).

31 *"as much as you can, imitate"*: Leonardo da Vinci, from Melzi, *Libro di pittura*, fols. 168r (Pedretti and Vecce, *Libro di pittura*, chapter 533; English translation in Kemp and Walker, *On Painting*, 156–57).

33 *"the most beautiful thing"*: Luca Landucci, *Diario fiorentino dal 1450 al 1516, continuato da un anonimo fino al 1542*, ed. Iodico del Badia (Florence: G.C. Sansoni, 1883; new edition, ed. Antonio Lanza, Florence: Sansoni Editore, 1985), 45.

33 *"an immense relief in bronze"*: Vincent Delieuvin, "La licence dans la règle," in *Léonard de Vinci*, ed. Vincent Delieuvin and Louis Frank, exhibition catalog, Musee du Louvre, Paris (Paris: Louvre Éditions, 2019), 57.

33 *"not only by sight"*: Jacobus de Voragine, *The Golden Legend* (Princeton, NJ: Princeton University Press, 2012), vol. 1:30; on this relation between sight and touch, see Neilson, *Practice and Theory*, chapter 3.

34 *"to draw in company"*: Leonardo da Vinci, Manuscript A, fol. 106v (English translation in Kemp and Walker, *On Painting*, 205).

35 casts in Verrocchio's workshop: Vasari, "Verrocchio," vol. 1:555.

35 *"Whatever painters have that is good"*: Ugolino Verino as quoted in Butterfield, *Verrocchio: Sculptor and Painter*, 2.

36 *"not to pass on to the second stage"*: Leonardo da Vinci, Manuscript A, fol. 108r (English translation in Richter, *Literary Works*, no. 491; and Kemp and Walker, *On Painting*, 197).

38 *"a concave sphere that makes fire"*: Leonardo da Vinci, Codex Atlanticus, fol. 87r.

2. BRUNELLESCHI'S DOME, VERROCCHIO'S *PALLA*, AND LEONARDO'S EYE

39 *"enormous construction towering"*: Leon Battista Alberti, *On Painting*, trans. Cecil Grayson (New York: Penguin, 1991), 35. For an engaging discussion of Brunelleschi's dome for Florence's cathedral, see Ross King,

Brunelleschi's Dome (New York: Penguin, 2000); and Paolo Galluzzi, *Mechanical Marvels: Invention in the Age of Leonardo* (Florence: Giunti, 1997), 58–67, 93–115, for a penetrating analysis of Brunelleschi's machines to build the dome.

41 *golden ball*: Andrea Covi, "Verrocchio and the *Palla* of the Duomo," in *Art, the Ape of Nature: Studies in Honor of H. W. Janson*, ed. Moshe Barasch and Lucy Freeman Sadler (New York: Harry N. Abrams, 1981), 151–69, on which my discussion is based; and Covi, *Andrea del Verrocchio*, 63–69, 309–29, for a discussion of pertinent documents. Gustina Scaglia, "Alle origini degli studi tecnologici di Leonardo," Lettura Vinciana 20 (Florence: Giunti, 1980), 6–16, offers a good overview of Leonardo's early involvement with technology. Verrocchio's palla is illustrated in a Florentine abacus book: Pier Maria Calandri, *Trattato d'abbacho*, Florence Biblioteca Medicea Laurenziana, Codex Acquisti e Doni 154, fol. 219v.

42 *"it should be made by casting [. . .] under no circumstances"*: Cesare Guasti, *La cupola di Santa Maria del Fiore illustrata con i documenti dell'archivio dell'Opera Secolare* (Florence: Barbera Bianchi, 1857), 112 (partially quoted in Covi, "Verrocchio and the *Palla*," 152).

44 *Paolo dal Pozzo Toscanelli*: Important essays on Toscanelli are Thomas Settle, "Dating the Toscanelli's Meridian in Santa Maria del Fiore," *Annali dell' Istituto e Museo di Storia della Scienza di Firenze* (1978): 69–70; Alessandro Parronchi, "Introduction," in *Paolo dal Pozzo Toscanelli: Della prospettiva* (Milan: Il Polifilo, 1991); and Eric Apferstadt, "Christopher Columbus, Paolo dal Pozzo Toscanelli and Fernao de Roris: New Evidence for a Florentine Connection," *Nuncius: Journal of the Material and Visual History of Science* (1992): 69–80. On the possible relations between Toscanelli and Leonardo, see Dominique Raymond, "Un Fragment du De speculis comburentibus de Regiomontanus copié par Toscanelli et insérér dans let Carnets de Leonardo (Codex Atlanticus, 611rb/915ra)," *Annals of Science* 72 (2015): 306–66.

46 *"Remember the welds"*: Leonardo da Vinci, Manuscript G, fol. 84v (English translation in Edward McCurdy, *The Notebooks of Leonardo da Vinci* [New York: 1939], 1178). On Leonardo's study of burning mirrors, see David Hockney, *Secret Knowledge: Rediscovering the Lost Techniques of the Old Masters* (New York: Viking Studio, 2001), 244; Sven Dupré, "Optics, Pictures and Evidence: Leonardo's Drawings of Mirrors and Machinery," *Early Science and Medicine* 10 (2005): 211–36; and Francesca Fiorani, "Leonardo's Optics in the 1470s," in *Leonardo da Vinci and Optics: Theory and Pictorial Practice*, ed. Francesca Fiorani and Alessandro Nova (Venice: Marsilio, 2013), 265–92.

47 *Biagio Pelacani da Parma*: Graziella Federici Vescovini, ed., *Blaise de Parme, Quaestiones super perspectiva commini* (Paris: J. Biard, 2009), 240–43, for Pelacani's apparitions in the air; Hans Belting, *Florence and Baghdad: Renaissance Art and Arab Science* (Cambridge, MA: Harvard University Press, 2011), 146–50. On apparitions in the air, see also Sven Dupré, "Images in the Air: Optical Games, Magic and Imagination," in *Spirits Unseen: The*

Representation of Subtle Bodies in Early Modern European Culture, ed. Christine Goettler and Wolfang Neuber (Brill: Leiden and Boston, 2007), 71–92, who, however, does not discuss Pelacani's apparitions.

48 *simplified version of Pelacani's* Questions: An important manuscript in Italian that is based on Pelacani's *Questions on Perspective* is Codex Riccardianus 2110, in the Biblioteca Riccardiana in Florence, on which see Parronchi, *Paolo dal Pozzo Toscanelli: Della prospettiva*, attributing it to the Florentine polymath Paolo dal Pozzo Toscanelli; and Eugenio Battisti and Giuseppa Saccaro Battisti, eds., *Le macchine cifrate di Giovanni Fontana* (Milan: Arcadia Edizioni, 1984), attributing it to Giovanni Fontana (1395–1455), an elusive figure who declared himself Pelacani's student, although he entered the University of Padua when Pelacani was already dead. There are good reasons to think that the author of this vernacular text was Antonio Manetti (1423–1497), who was listed as a "master of optics" (*maestro di prospettiva*) in Florence in 1470 (see Benedetto Dei, *Descrizioni e rappresentazioni della città di Firence nel XV secolo*, ed. Giuseppina Carla Romby [Florence: Libreria Editrice Fiorentina, 1976], 73). Manetti was regarded also as a talented translator of science books in the vernacular; he also wrote the first biography of Brunelleschi, which is the main source of our knowledge on the architect and the only one on the perspective panels, now lost, that the architect painted to demonstrate linear perspective. On Antonio Manetti, whom I suggest could be the author of this manuscript, see Domenico De Robertis, "Antonio Manetti copista," in *Tra Latino e Volgare: Per Carlo Dionisotti*, ed. Gabriella Bernardoni Trezzini and Ottavio Beson (Rome: Salerno Editrice, 1974), 2 vols, vol. 2:367–409; Giuliano Tanturli, "Per l'interpretazione storica della Vita del Brunelleschi," *Paragone Arte* 26 (1975): 6–24.

50 *"how to make a concave sphere"*: Leonardo da Vinci, Codex Atlanticus, fol. 87r. This folio and others similarly related to burning mirrors and glassmakers' workshops are dated between 1478 and 1480 by experts on Leonardo's handwriting: Gerolamo Calvi, *I manoscritti di Leonardo da Vinci* (Bologna: Zanichelli, 1925; new edition, Bologna: Zanichelli, 2019), and Carlo Pedretti, *The Codex Atlanticus of Leonardo da Vinci: A Catalogue of Its Newly Restored Sheets*, 2 vols. (Los Angeles: University of California Press, 1978–1979).

52 *"the canons [of the cathedral]"*: Landucci, *Diario fiorentino*, 10–11; and Agostino Lapini, *Diario fiorentino dal 252 al 1596*, ed. Giuseppe Odoardo Corazzini (Florence: Sansoni, 1900), 24.

52 *"was most skillful in lifting weight"*: Anonimo Gaddiano, in Vecce, *Leonardo*, 361.

52 *"Those who are in love with practice"*: Leonardo da Vinci, Manuscript G, fol. 8r (English translation in Richter, *Literary Works*, no. 19; and Kemp and Walker, *On Painting*, 52).

53 *"chained books"*: Leonardo da Vinci, Codex Atlanticus, fol. 801r.

53 *Brunelleschi's screw*: Leonardo da Vinci, Codex Atlanticus, fols. 808r, 808v, and 847r.

54 *"Giovanni d'Amerigo Benci and company"*: Leonardo da Vinci, Codex Atlanticus, fol. 879v.

54 *list of people*: Leonardo da Vinci, Codex Atlanticus, fol. 42v. The names in this list may refer to individuals or to books written by these individuals: Paolo dal Pozzo Toscanelli; the astronomer Carlo Marmocchi; the notary Benedetto da Cepperello; the abacus teacher Benedetto, who was possibly Leonardo's abacus teacher; the painter Domenico di Michelino, who had painted Dante's *Comedy* in the cathedral; the architect Pietro Averlino Filarete; and the scholar John Argyropoulos. On this list, see: Bambach, *Leonardo Rediscovered*, vol. 1:301.

54 *notes in Toscanelli's handwriting*: Leonardo da Vinci, Codex Atlanticus, fol. 915r, on which see Raymond, "Un Fragment du De speculis comburentibus."

56 *"drafts for passages"*: Bambach, *Leonardo Rediscovered*, vol. 1:306–11. Bambach connected the candle studies on the drawing's back to a page of Manuscript C, fol. 12r, on light and shadows, datable ca. 1490, a view I share. I would add that the text and diagram on the back of the recently discovered *Saint Sebastian*, now in private collection, are copied in fol. 8v of the same Manuscript C.

56 *"the wall will be darker or more luminous"*: Leonardo da Vinci, Manuscript C, fol. 12r.

3. BODY AND SOUL

58 *"the science of astronomy"*: Leonardo da Vinci, from Melzi, *Libro di pittura*, fol. 2v (Pedretti and Vecce, *Libro di pittura*, chapter 6; English translation in Kemp and Walker, *On Painting*, 16, but note that I translated "prospettiva" with "optics" rather then "perspective"). A great introduction to Renaissance natural philosophy is Charles B. Schmitt and Quentin Skinner, eds., *The Cambridge History of Renaissance Philosophy* (Cambridge: Cambridge University Press, 1988); particularly helpful to understand the place of optics in Renaissance thought is the essay by Katherine Park, "Psychology: The Concept of Psychology," ibid., 455–63. See also James Hankins, ed., *The Cambridge Companion to Renaissance Philosophy* (Cambridge: Cambridge University Press, 2007), especially the essay by Christopher S. Celenza, "The Revival of Platonic Philosophy," ibid., 72–96. On optics and Renaissance art, see the books quoted in the general bibliography above.

58 *"The light of grace"*: Saint Antoninus (Archbishop of Florence), *Summa theologica*, 2 vols. (Parma: Fiaccadori, 1852), vol. 1, titulus III, caput III, column 118; and vol. 4, titulus IX, caput 1, column 462 (quoted in Samuel Edgerton, *The Renaissance Rediscovery of Linear Perspective* [New York: ACLS History E-Book Project, 1975], 63).

58 *"difficult questions involving symmetry"*: Vitruvius, *Ten Books on Architecture*, trans. Ingrid Rowland (Cambridge: Cambridge University Press, 1999), book 1:4.

59 *"drawing things of the world"*: Ristoro d'Arezzo, *La composizione del mondo: testo italiano del 1282*, ed. Enrico Narducci (Rome: Tip. delle Scienze matematiche e fisiche, 1859), 68.

59 *"master of optics"*: Dei, *Descrizioni di Firenze*, 73.

59 *"the most highly developed sense"*: Aristotle, *On the Soul*, book 3:4.

59 *"sight can never be in error"*: Ibid., book 3:6.

60 *"the optics [. . .] part of philosophy"*: Michele Savonarola, *Libellus de Magnifici Ornamentis Regies Civitatis Paduae*, ed. Arnaldo Segarizzi (Cittá di Castello: Editore S. Lapi, 1902), 55, lines 20–25 (quoted in Edgerton, *Rediscovery of Linear Perspective*, 63).

60 *"without optics"*: Leonardo da Vinci, Manuscript G, fol. 8r (English translation in Kemp and Walker, *On Painting*, 52).

61 *"reserve until the end of my book"*: Leonardo da Vinci, Notes on the Art of Painting, Royal Collection Trust, Windsor Castle, RCIN 919076r (English translation in Kemp and Walker, *On Painting*, 265). Although this note dates to 1511–13, Leonardo's meeting with Gherardo di Giovanni di Miniato must date to before 1483, when the artist left for Milan; when he returned in 1500, Gherado was dead (he died in 1492).

62 *"Latin optical source"*: Dominique Raymond, "A Hitherto Unknown Treatise on Shadows Referred to by Leonardo da Vinci," in *Perspective as Practice: Renaissance Cultures of Optics*, ed. Sven Dupré (Turnhout, Belgium: Brepols Publishers, 2019), 275.

62 *"Witelo in San Marco"*: Leonardo da Vinci, Codex Arundel, fol. 79v (*"Vitolone in San Marco"*); on Witelo see also Leonardo da Vinci, Codex Atlanticus, fol. 669r (*"il libro di Vitolone"*); and fol. 611r (*"fa d'avere Vitolone ch'è nella libreria di Pavia, che tratta delle matematiche"*). On Bacon see Leonardo da Vinci, Codex Arundel, fol. 71v (*"Rugieri Bacon fatto in istampa"*). On Pecham see Leonardo da Vinci, Codex Madrid II, fol. 2v (*"prospettiva comune"*).

62 *Alhacen's book was the only major optical book:* On Alhacen, see the studies quoted in the general bibliography. The Italian translation of Alhacen's *Book of Optics* survived in a single copy, which is now kept in the Biblioteca Apostolica Vaticana, Codex Vaticanus Latinus 4595. On this important translation, see the foundational essay by Graziella Federici Vescovini, "Contributo per la storia della fortuna di Alhazen in Italia." It is worth mentioning that Alhacen also wrote a book by the title *Epistle on the Properties of Shadows* (*Maqala fi kayfiyyat al-azlal*) that dealt with shadows and penumbra, but we do not know if this text, documented in Arabic and now kept in Instanbul, was ever translated into Latin or whether it was known to the Latin West, let alone to Leonardo. He also wrote a book *On Burning Mirrors or On the Parabolic Section* (*De speculis comburentibus seu de sectione mukefi*), which was known in the Latin West, while another text, "On Twilight" (*De crepuscolis*), also translated into Italian, that was attributed to him in the Renaissance is regarded today the work of another, unknown author. An Italian copy of "On Twilight" is bound with Alhacen's Italian translation of his *Book of Optics*.

63 *"he took an overwhelmingly empirical, or inductive, tack"*: A. M. Smith, *Alhacen's Theory*, vol. 1:cxv.

64 *"a mere agglomeration of past ideas"*: Ibid., cxvii.

65 *"experience does not err"*: Leonardo da Vinci, Codex Atlanticus, fol. 417r (English translation in Richter, *Literary Works*, no. 1153; and Kemp and Walker, *On Painting*, 10).

65 *"The form of color"*: Smith, *Alhacen's Theory*, vol. 2:356 (book 1:6.3).

65 *"the quality of colors"*: Leonardo da Vinci, Manuscript A, fol. 113r (English translation in Kemp and Walker, *On Painting*, 72).

66 *"vision cannot be due"*: Ibid., vol. 2:373 (book 1:6.56).

67 *"visual intentions"*: Ibid., vol. 2:437 (book 2:3.42).

67 eight conditions of sight: Ibid., vol. 2:588 (book 3:3.5).

68 *"proper range"*: Ibid., vol. 2:593 (book 3:3.34).

68 *"[the] only reason"*: Ibid.

68 *"If a sheer cloth"*: Ibid., vol. 2:599 (book 3:6.18–22).

68 *"Do not make the boundaries around your figures"*: Leonardo da Vinci, from Melzi, *Libro di pittura*, fols. 46r–v (English translation in Kemp and Walker, *On Painting*, 210).

69 *"transparency of the air"*: Smith, *Alhacen's Theory*, vol. 2:599 (book 3:6.18).

69 *"If the air is misty"*: Ibid., vol. 2:621 (book 3:7.193–94).

69 *"There is another perspective"*: Leonardo da Vinci, Manuscript A, fol. 105v (English translation in Kemp and Walker, *On Painting*, 80–81).

70 hair and texture in painting: Smith, *Alhacen's Theory*, vol. 2:607–608 (book 3:7.39, 7:42, 7:43).

70 beauty as composition: Ibid., vol. 2:504–505 (book 2:3.200–203).

70 *"proportionality or harmony"*: Ibid., vol. 2:509–10 (book 2:3.230).

70 *"Proportions create beauty"*: Lorenzo Ghiberti, *I commentarii*, ed. Lorenzo Bartoli (Florence: Giunti, 1998), 159. On Lorenzo Ghiberti, see Richard Krautheimer, *Lorenzo Ghiberti*, in collaboration with Trude Krautheimer-Hess (Princeton, NJ: Princeton University Press, 1970); and Amy Bloch, *Lorenzo Ghiberti's Gates of Paradise: Humanism, History, and Artistic Philosophy in the Italian Renaissance* (Cambridge: Cambridge University Press, 2016). Lorenzo's workshop was near Santa Maria Nuova and was known by the nickname *le porte* as Lorenzo cast there his second set of doors for the Baptistery of Florence. The workshop passed to his son Vittore and later to his grandson Bonaccorso. Verrocchio and his apprentices were familiar with the Ghiberti foundry and workshop, and some art historians think that Verrocchio learned in that workshop the art of bronze casting; at the very least he worked with Vittore Ghiberti on major projects for the Florentine Baptistery. It is documented that Pietro Perugino, one of Leonardo's close friends from his training years, rented studio space from the Ghibertis from 1487 to 1511.

71 *"all the functions of the eye"*: Alberti, *On Painting*, book 1:6, book 1:8, book 1:9.

71 *"Note that Aristotle and Alhacen"*: Ghiberti, *Commentarii*, 102, 282–83. On Ghiberti's *Commentaries*, see Federici Vescovini, "Contributo per la storia della fortuna di Alhazen in Italia"; Lorenzo Bartoli, "Introduzione," in

Ghiberti, *Commentarii*, 5–42; Fiorani, "Leonardo's Optics in the 1470s"; Fabian Jonietz, Wolf-Dietrich Lohr, and Alessandro Nova, eds., *Ghiberti teorico: Natura, arte, e coscienza storica nel Quattrocento* (Milan, Officina Libraria, 2019), especially the following essays: Dominique Raynaud, "Lorenzo Ghiberti's Optical Sources Revisited Through the Traces Method," 89–102; Mandy Richter, "'O doctissimo, nessuna cosa si vede senza luce': Darkness, Light, and Antiquity in Ghiberti's Third Book," 183–90.

72 *Bonaccorso Ghiberti, one of Leonardo's acquaintances*: See Gustina Scaglia, "A Miscellany of Bronze Works and Texts in the 'Zibaldone' of Buonaccorso Ghiberti," *Proceedings of the American Philosophical Society* 120 (1976): 485–513; Gustina Scaglia, "A Translation of Vitruvius and Copies of Late Antique Drawings in Buonaccorso Ghiberti's Zibaldone," *Transactions of the American Philosophical Society*, New Series 69 (1979): 1–30; Fabrizio Ansani, "The Life of a Renaissance Gunmaker: Bonaccorso Ghiberti and the Development of Florentine Artillery in the Late Fifteenth Century," *Technology and Culture* 58 (2017): 749–89. Bonaccorso Ghiberti's *Zibaldone* is kept in Florence, Biblioteca Nazionale Centrale (Codex Banchi Rari, 228).

72 *"painters and sculptors should be learned"*: Ghiberti, *Commentarii*, 46.

73 *"I followed art with great study and discipline"*: Ibid., 92.

75 *"Men wrongly complain of experience"*: Leonardo da Vinci, Codex Atlanticus, fol. 417r (English translation in Richter, *Literary Works*, no. 1153; and Kemp and Walker, *On Painting*, 10).

75 *"little work [. . .] will comprise"*: Leonardo da Vinci, Manuscript A, fol. 102v (English translation in Richter, *Literary Works*, no. 23; and Kemp and Walker, *On Painting*, 16).

75 *"man and the intentions of his mind"*: Leonardo da Vinci, from Melzi, *Libro di pittura*, fol. 60v (Pedretti and Vecce, *Libro di pittura*, chapter 180; English translation in Bambach, *Leonardo Rediscovered*, vol. 1:427; see also Kemp and Walker, *On Painting*, 144).

75 Leonardo and Alhacen: Martin Kemp, "The Hammer Lecture (1992): The Beholder's Eye; Leonardo and the 'Errors of Sight' in Theory and Practice," *Achademia Leonardi Vinci* 5 (1993): 156; at the same time Kemp remarked that "there is no evidence that Ghiberti's translations were known to Leonardo" (156). On Alhacen's influence on Leonardo, see also Brian S. Eastwood, "Alhazen, Leonardo, and Late Medieval Speculation on the Inversion of Images in the Eye," *Annals of Science* 43 (1986): 413–46; Janis Bell, "Leonardo and Alhazen: The Cloth on the Mountain Top," *Achademia Leonardi Vinci* 6 (1993): 108–11; Dominique Raynaud, "La perspective aérienne de Léonard de Vinci et ses origins dans l'optique d'Ibn al-Haytham (De aspectibus, III, 7)," *Arabic Sciences and Philosophy* 21 (2009): 225–46; Dominique Raynaud, "Leonardo, Optics and Ophthalmology," in *Leonardo da Vinci and Optics*, ed. Fiorani and Nova, 293–314; Fiorani, "Leonardo's Optics in the 1470s," ibid., 265–92.

76 *"boundary of a thing"*: Leonardo da Vinci, Manuscript G, fol. 37r (English translation from Richter, *Literary Works*, no. 49; and Kemp and Walker, *On Painting*, 53).

77 *"the air and natural heavens"*: Antonio Manetti, *The Life of Brunelleschi*, ed. Howard Saalman (University Park: Penn State University Press, 1970), 45. These panels, now lost, are described in detail by Manetti; they have generated intense scholarly debate. For a possible reconstruction, see Edgerton, *Re-Discovery of Linear Perspective*, 124–52; Martin Kemp, *The Science of Art: Optical Themes in Western Art from Brunelleschi to Seurat* (New Haven, CT: Yale University Press, 1990), 11–14, 344–45; David Summers, *Real Spaces: World Art History and the Rise of Western Modernism* (London, Phaidon Press, 2003); and David Summers, *Vision, Reflection and Desire in Western Painting* (Chapel Hill: University of North Carolina Press, 2007), 61–67.

77 *"subtle engravings"*: Smith, *Alhacen's Theory*, vol. 2:345 (book 1:4.11).

77 "sculture sottili": Ghiberti, *Commentarii*, 110. See Christopher R. Lakey, "'Le sottili sculture': Light, Optics, and Theories of Relief in Ghiberti's Third Commentary," in *Ghiberti teorico*, ed. Jonietz, Lohr, and Nova, 191–205.

78 *"the air between the eye and the visible object"*: Smith, *Alhacen's Theory*, vol. 2:591 (book 3:3.10).

4. LANDSCAPES À LA LEONARDO AND THE FIRST SOLO PAINTING

81 *modern devotion*: A good and comprehensive introduction on religious practices in the Renaissance and on *devotio moderna* in particular is John Van Engen, *Sisters and Brothers of the Common Life: The Devotio Moderna and the World of the Later Middle Ages* (Philadelphia: University of Pennsylvania Press, 2008). Rachel Fulton Brown, *Mary and the Art of Prayer: The Hours of the Virgin in Medieval Christian Life and Thought* (New York: Columbia University Press, 2017), is an effective overview of Marian devotion showing how men and women read the Book of Hours in the Middle Ages and the Renaissance.

82 Leonardo's landscape of 1473: See Alessandro Nova, "Addj 5 daghossto 1473: L'oggetto e le sue interpretazioni," in *Leonardo da Vinci on Nature: Knowledge and Representation*, ed. Fabio Frosini and Alessandro Nova (Venice: Marsilio Editore, 2015), 285–302; Bambach, *Leonardo Rediscovered*, vol. 1:136–40; and Roberta Barsanti, ed., *Leonardo da Vinci: Alle origini del genio*, exhibition catalog, Museo Leonardiano, Vinci (Florence: Giunti, 2019), especially the following essays: Pietro C. Marani, "Leonardo e la natura: paesaggi senza figure, figure nel paesaggio," 151–59; Carlo Vecce, "I giorni di Leonardo: Santa Maria della Neve," 159–66; Roberto Bellucci, Cecilia Frosinini, and Letizia Montalbano, "'Disegnar paesi': Il foglio 8 P del Gabinetto dei Disegni e Stampe degli Uffizi di Leonardo da Vinci," 241–89, on a recent technical analysis.

82 *"to paint objects in relief"*: Leonardo da Vinci, from Melzi, *Libro di pittura*, fol. 69v (Pedretti and Vecce, *Libro di pittura*, chapter 219).

82 *"landscape did not start as an autonomous"*: Nova, "L'oggetto," 298.

83 *"how to portray a place accurately"*: Leonardo da Vinci, Manuscript A, fol. 104r (English translation in Richter, *Literary Works*, no. 523; and Kemp and Walker, *On Painting*, 216).

84 Jan van Eyck, Florentine art, and Leonardo: Paul Hills, "Leonardo and Flemish Painting," *Burlington Magazine* 122 (1980): 609–15; Paula Nuttall, *From Flanders to Florence: The Impact of Netherlandish Painting, 1400–1500* (New Haven, CT: Yale University Press, 2004); and Paula Nuttall, ed., *Face to Face: Flanders, Florence, and Renaissance Paintings*, exhibition catalog (Los Angeles: The Huntington Library Press, 2013).

84 Saint Mary of the Snow: A confraternity named after Santa Maria della Neve had been founded in 1445, and since then it met regularly in the parish of Sant'Ambrogio, where Verrocchio's bottega was located. It was one of the very few mixed confraternities with both male and female members. And it was steeped in the neighborhood's life. It had close connections with nearby male and female monasteries, including those of Le Murate, Santa Croce, and San Salvi, all of which were connected somehow to Verrocchio and his patrons. Every year on August 5, the confraternity held public festivities in the neighborhood. On the first Sunday of May, it organized a trip to the Sanctuary of Saint Mary in Impruneta, on the outskirts of Florence, where a miraculous image of the Virgin was kept. It also kept contacts with communities in the countryside through a network of small oratories in and around Florence, one of which was near Vinci, and another at Le Murate in the neighborhood of Santa Croce. On the confraternity of Santa Maria della Neve in the parish church of Sant'Ambrogio, see Eve Borsook, "Cult and Imagery in Sant'Ambrogio," *Mitteilungen des Kunsthistorischen Institutes in Florenz* 25 (1981): 147–202.

86 *commission for a new painting of Gabriel's visit to Mary*: See Brown, *Origins of a Genius*, 75–99; Antonio Natali, *L'Annunciazione di Leonardo: La montagna sul mare* (Milan: Silvana Editoriale, 2000). In Natali's book are also two important essays by restorers: Alfio Del Serra, "L'incanto dell'Annuncio: Rendiconto di restauro," which clarified Leonardo's painting technique and his possible use of spolvero to transfer his figure drawings, although no dots of pouncing are visible in infrared images but only black lines in liquid ink; and Roberto Bellucci, "L' 'underdrawing' dell'*Annunciazione* e la prospettiva di Leonardo," which explained how Leonardo built the architecture on the panel. See also Francesca Fiorani, "The Shadows of Leonardo's *Annunciation* and Their Lost Legacy," in *Imitation, Representation and Printing in the Italian Renaissance*, ed. Roy Eriksen and Magne Malmanger (Pisa and Rome: Fabrizio Serra Editore, 2009), 119–56, for a more detailed analysis of the painting's optical effects in relation to Leonardo's writings. On sacred representations, see Nerida Newbigin, *Feste d'Oltrarno: Plays in Churches in Fifteenth-Century Florence* (Florence: Olschki, 1996), including those by Feo Belcari.

88 *Mary who "looked as if"*: Leonardo da Vinci, from Melzi, *Libro di pittura*, fols. 32v–33r (Pedretti and Vecce, *Libro di pittura*, chapter 58; English translation in Kemp and Walker, *On Painting*, 200).

89 *golden ratio*: Bellucci, *"L'* 'underdrawing' dell'*Annunciazione.*" For an engaging study of the golden ratio, see Mario Livio, *The Golden Ratio: The Story of PHI, the World's Most Astonishing Number* (New York: Broadway Books, 2013).

92 *"I remind you, O painter"*: Leonardo da Vinci, from Melzi, *Libro di pittura*, fol. 34r–35r (Pedretti and Vecce, *Libro di pittura*, chapter 65; English translation in Kemp and Walker, *On Painting*, 194).

93 *"gradations" of light and shadow*: Leonardo da Vinci, Codex Atlanticus, fol. 534v (English translation in Richter, *Literary Works*, no. 548).

94 *"the resplendent beauty of youth"*: Leonardo da Vinci, from Melzi, *Libro di pittura*, fols. 130v–131r (Pedretti and Vecce, *Libro di pittura*, chapter 404; English translation in Kemp and Walker, *On Painting*, 196).

94 *"for those colors which you wish to be beautiful"*: Leonardo da Vinci, from Melzi, *Libro di pittura*, fol. 62v (Pedretti and Vecce, *Libro di pittura*, chapter 192; English translation in Kemp and Walker, *On Painting*, 71).

95 *Copper resin green*: Leonardo da Vinci, from Melzi, *Libro di pittura*, fol. 67v (Pedretti and Vecce, *Libro di pittura*, chapter 211).

95 *"universal light"*: Leonardo da Vinci, Manuscript G, fol. 3v (English translation in Richter, *Literary Works*, no. 118).

95 *"shadows generated by the redness of the sun"*: Leonardo da Vinci, from Melzi, *Libro di pittura*, fol. 148v (Pedretti and Vecce, *Libro di pittura*, chapter 467; English translation in Kemp and Walker, *On Painting*, 76).

96 *"with a single color placed at various distances"*: Leonardo da Vinci, from Melzi, *Libro di pittura*, fol. 65r–v (Pedretti and Vecce, *Libro di pittura*, chapter 199; English translation in Kemp and Walker, *On Painting*, 78).

97 *"The surface of every opaque object"*: Leonardo da Vinci, from Melzi, *Libro di pittura*, fol. 148v (Pedretti and Vecce, *Libro di pittura*, chapter 467; partial English translation in Kemp and Walker, *On Painting*, 76).

99 *"the soul of painting"*: Leonardo da Vinci, Manuscript A, fol. 81r.

99 *"if you avoid shadows"*: Leonardo da Vinci, from Melzi, *Libro di pittura*, fol. 133r (Pedretti and Vecce, *Libro di pittura*, chapter 412).

99–100 *"makes very sorry landscapes"* . . . nature *"was of no use"*: Leonardo da Vinci, from Melzi, *Libro di pittura*, fol. 33v (Pedretti and Vecce, *Libro di pittura*, chapter 60; English translation in Kemp and Walker, *On Painting*, 201–202).

100 Leonardo's *Madonna of the Carnation*: See the important restoration report of Jan Schmidt (and others), "The Madonna with a Carnation: Technological Studies of an Early Painting by Leonardo," in *Leonardo da Vinci's Technical Practice: Paintings, Drawings and Influence*, ed. Michel Menu (Paris: Hermann, 2014), 40–55.

100 *"bodies against backgrounds"*: Leonardo da Vinci, Manuscript A, fol. 101v (English translation in Richter, *Literary Works*, no. 552; and Kemp and Walker, *On Painting*, 209).

101 Verrocchio's and Leonardo's *Baptism of Christ*: See Antonio Natali, *Lo sguardo degli angeli: Verrocchio, Leonardo e il Battesimo di Cristo* (Milan: Silvana Editoriale, 1998), which contains Alfio Del Serra, "Il restauro," 95–118, on the painting's restoration. Natali suggested that Verrocchio began the panel around 1468–1470, then left it unfinished until around 1478, when Leonardo completed it. He also identified the role of Verrocchio's brother Simone, who was abbot of San Salvi in 1468, and again from 1471 to 1473, and from 1475 to 1478.

5. THE PAINTING OF THE YOUNG BRIDE-TO-BE

104 women's portraits in the Renaissance: See David A. Brown, ed., *Virtue and Beauty: Leonardo's Ginevra de' Benci and Renaissance Portraits of Women*, exhibition catalog (Washington, DC: National Gallery of Art, 2001). Effective overviews of the cultural climate of Renaissance Florence in the 1470s are Patricia Fortini Brown and Alison Wright, eds., *Renaissance Florence: The Art of the 1470s*, exhibition catalog (London: National Gallery Publications, 1999); Charles Dempsey, *The Early Renaissance and Vernacular Culture* (Cambridge, MA: Harvard University Press, 2012); and Schumacher, *Florence and Its Painters*.

105 *The Benci family*: See Alessandro Cecchi, "New Light on Leonardo's Florentine Patrons"; Megan Holmes, "Giovanni Benci's Patronage of the Nunnery Le Murate," in *Art, Memory, and Family in Renaissance Florence*, ed. Giovanni Ciappelli and Patricia Lee Rubin (Cambridge: Cambridge University Press, 2000), 114–34; Raymond de Roover, *The Rise and Decline of the Medici Bank, 1397–1494* (Cambridge, MA: Harvard University Press, 1963). The involvement of Ginevra's father, Amerigo, in the Pitti plot against the Medici is documented in Jacopo Pitti, *Istoria Fiorentina* (Naples: Liguori Editore, 2007), 43.

105 *"Giovanni d'Amerigo Benci and company"*: Leonardo da Vinci, Codex Atlanticus, fol. 879v. Leonardo also mentioned Ginevra's brother in Codex Atlanticus, fol. 331r (datable around 1500): "my world map that Giovanni Benci has [. . .] Giovanni Benci's world map"; Manuscript L, fol. 1v (dated 1502): "Giovanni Benci's book"; Codex Arundel, fol. 190v: "Giovanni Benci, my book and jaspers" (all published in Richter, *Literary Works*, nos. 1416, 1444, 1454; and quoted in Cecchi, "New Light," 138).

106 *"painted with such perfection"*: Antonio Billi, in Vecce, *Leonardo*, 359; another early biographer, the Anonimo Gaddiano, repeated Billi's judgment almost word by word (ibid., 361). On Leonardo's *Ginevra de' Benci*, see John Walker, "Ginevra de' Benci by Leonardo da Vinci," *Report and Studies in the History of Art* 1 (1967): 1–38; Brown, *Origins of a Genius*, 100–121; Jennifer Fletcher, "Bernardo Bembo and Leonardo's Portrait of Ginevra de' Benci," *Burlington Magazine* 131 (1989): 811–16; Mary D. Garrard, "Who Was Ginevra de' Benci? Leonardo's Portrait and Its Sitter Re-contenxtualized," *Artibus et Historiae* 27 (2006–7):

23–56; Caroline Elam, "Bernardo Bembo and Leonardo's *Ginevra de' Benci*: A Further Suggestion," in *Pietro Bembo e le arti*, ed. Guido Beltramini, Howard Burns, and Davide Gasparotto (Venice: Marsilio, 2013), 407–20; Bambach, *Leonardo Rediscovered*, vol. 1:113–17; Delieuvin and Frank, *Léonard de Vinci*, 82–84. Its relation to northern portraits is discussed in Hills, "Leonardo and Flemish Painting," 609–15; and Nuttall, *From Flanders to Florence*. The portrait's painting technique is analyzed superbly by Elizabeth Walmsley, "Technical Images and Painting Technique in Leonardo's Portrait of *Ginevra de' Benci*," in *Leonardo da Vinci and Optics*, ed. Fiorani and Nova, 55–77. The patronage of Ginevra's portrait is hotly debated. Most scholars think the Venetian humanist Bernardo Bembo commissioned it based on the emblem on the panel's back (Brown, Fletcher, Bambach, Elam, and Delieuvin, among others); they interpret the portrait as a representation of a platonic lover (no other portraits of platonic lovers exist, although one is mentioned in Renaissance sources). Others (Garrard, first among them) think the portrait is closely related to Ginevra and her family and interpret it as an expression of Ginevra's mind. I find the latter interpretation more convincing, as it aligns better with conventions of Renaissance women's portraiture, Leonardo's artistic interests in depicting the souls of his sitters, and the fact that the painting never belonged to Bembo, the supposed patron.

106 *"a most beautiful thing"*: Giorgio Vasari, *The Life of Leonardo da Vinci*, ed. Martin Kemp (New York: Thames and Hudson, 2019), 94.

106 *"purpose of their soul"*: Leonardo da Vinci, Codex Atlanticus, fol. 383r (English translation in Richter, *Literary Works*, no. 593, although I changed Richter's translation of *animo* from "mind" to "soul.")

106 *"The Lord, in a short time"*: Giustina Niccolini, *The Chronicle of Le Murate*, ed. Saundra Weddle (Toronto: Center for Reformation and Renaissance, 2011), 87. On the convent Le Murate, see Kate Lowe, *Nuns' Chronicles and Convent Culture in Renaissance and Counter-Reformation Italy* (Cambridge: Cambridge University Press, 2004); and Sharon Strocchia, *Nuns and Nunneries in Renaissance Florence* (Baltimore: Johns Hopkins University Press, 2009).

107 la cella *de' Benci*: Niccolini, *Chronicle*, 89.

107 *Platonic Academy*: A great introduction to Marsilio Ficino and his academy is Christopher S. Celenza, "Marsilio Ficino," in *The Stanford Encyclopedia of Philosophy* (fall 2017 edition), ed. Edward N. Zalta, https://plato.stanford.edu/archives/fall2017/entries/ficino/. Important are also Arthur Field, *The Origins of the Platonic Academy of Florence* (Princeton, NJ: Princeton University Press, 1988); James Hankins, *Plato in the Italian Renaissance* (Leiden: Brill, 1990); and Michael J. B. Allen, Valery Rees, Martin Davies, eds., *Marsilio Ficino: His Theology, His Philosophy, His Legacy* (Leiden, Netherlands: Brill, 2001). Still informative, although dated, on the relations between Platonism and Renaissance art is André Chastel, *Marsile Ficin et l'art* (Geneva: Droz, 1954).

108 *"our co-philosophers"*: Marsilio Ficino's letter to Lionardo di Tone Pagni, August 18, 1462, published in Arnaldo della Torre, *Storia dell'Accademia platonica di Firenze* (Florence: Tip. G. Carnesecchi e figli, 1902), 553–55, a text that is important more broadly to document the relations between Ficino and the Benci family. Della Torre, *Storia*, 396–67, reports also on Amerigo Benci, Ginevra's father, as a diner at the inaugural *banchetto platonico*, a fact reported also in Marsilio Ficino, *Commentarium in convivium de amore* (a copy of this book that belonged to Tommaso Benci is now kept in the Biblioteca Medicea Laurenziana in Florence [Codex Laurentianus Strozzi 98]). Later, Ficino rewrote the early history of the Platonic Academy and omitted Amerigo Benci from the inaugural banquet and listed instead Bernardo del Nero, who in later years had become a protagonist of the Neoplatonic Academy and who translated (with Antonio Manetti) Ficino's Latin text of Plato's *Convivium* into Italian. See also the important essay by Giuliano Tanturli, "I Benci copisti: vicende della cultura fiorentina volgare fra Antonio Pucci e il Ficino," *Studi di Filologia italiana* 36 (1978): 197–313, documenting the extensive relations between Ficino and the brothers Tommaso and Giovanni Benci, and their family connections with the branch of the Benci to which Ginevra belonged.

109 *Ficino was an expert in optics*: An early biographer whose identity remains unknown reported that Ficino "wrote a work on perspective, of which I saw some notes on vision and on concave and convex mirrors" (Florence, Biblioteca Nazionale Centrale, Codex Palatino 488).

109 *platonic love*: Marsilio Ficino, *Platonic Theology*, ed. Michael J. B. Allen and James Hankins, 6 vols. (Cambridge, MA: Harvard University Press, 2001–6) vol. 6:3.2.6.

110 *"the younger artist's characteristic left-handed"*: Brown, *Origins of a Genius*, 124.

111 *"I ask your forgiveness"*: Ginevra's only surviving line of poetry is mentioned in a letter that an unidentified author who signed himself as "G + H" wrote to Ginevra, August 12–17, 1490 (published in Walker, "Ginevra," 24–27).

113 *"master of optics"*: Dei, *Descrizioni*, 73. Ficino dedicated to Manetti the Italian translation of his commentary to Plato's *De amore*.

114 *Giorgio Antonio Vespucci (1453–1512)*: See Karl Schlebusch, *Giorgio Antonio Vespucci 1434–1514 Maestro canonico domenicano* (Florence: Nerbini, 2017). In addition see Luciano Formisano, ed., *Amerigo Vespucci, la vita e i viaggi* (Florence: Banca Toscana, 1991), on the Vespucci family's history, art patronage, and connections to Ficino; and Angelo Cattaneo, *Shores of Vespucci: A Historical Research of Amerigo Vespucci's Life and Context* (Frankfurt: Peter Lang, 2017). Ficino wrote personalized dedication letters for Giorgio Antonio Vespucci as a sign of his special connection to this member of the Vespucci family (now available in Marsilio Ficino, *Opera omnia*, ed. Paul O. Kristeller [Turin, Italy: Bottega d'Erasmo, 1959; facsimile of edition: Basel, 1576], 841). This Giorgio Antonio Vespucci, who was related to the Benci family, engaged in business transac-

tions with the Benci for properties in Florence and in Val d'Elsa. Around 1500, Leonardo jotted a note to himself: "Vespucci wants to give me a book on geometry" (Codex Arundel, fol. 132v). In 1503, another Vespucci, Agostino, who was Machiavelli's secretary, gave Leonardo a description of the Battle of Anghiari, which the artist had agreed to paint in the Signoria palace. This Agostino Vespucci was also familiar with Leonardo's portrait *Mona Lisa* as the artist was painting it.

114 *the garden of San Marco*: See Caroline Elam, "Lorenzo de' Medici's Sculpture Garden," *Mitteilungen des Kunsthistorischen Institutes in Florenz* 36 (1992): 41–84, which discusses Leonardo's presence in Lorenzo's garden.

114 Leonardo and Lorenzo de' Medici: Cecilia Frosinini, "L'*Adorazione dei Magi* e i luoghi di Leonardo," in *Il restauro dell'*Adorazione dei Magi *di Leonardo: La riscoperta di un capolavoro*, ed. Marco Ciatti and Cecilia Frosinini (Florence: Opificio delle Pietre Dure, 2017), 30.

116 *"the resplendent beauty"*: Leonardo da Vinci, from Melzi, *Libro di pittura*, fol. 131r (Pedretti and Vecce, *Libro di pittura*, chapter 404; English translation in Kemp and Walker, *On Painting*, 196).

119 *"a bit transparent"*: Leonardo da Vinci, Manuscript A, fol. 111v (English translation in Richter, *Literary Works*, no. 561).

119 *"the window to the soul"*: Leonardo da Vinci, Manuscript A, fol. 99r (English translation in Richter, *Literary Works*, no. 653; and Kemp and Walker, *On Painting*, 20).

120 *"the chaste love of Bembo"*: Landino's poems, published in Walker, "Ginevra," 32–35.

121 *an unidentifiable admirer*: Walker, "Ginevra," 24–27.

121 Lorenzo's sonnet for Ginevra: Ibid., 38.

122 Ginevra's tomb at Le Murate: Niccolini, *Chronicle*, 386.

6. THE UNFINISHED PAINTING

124 *"move those who behold"*: Leonardo da Vinci, from Melzi, *Libro di pittura*, fol. 61v (Pedretti and Vecce, *Libro di pittura*, chapter 188; English translation in Kemp and Walker, *On Painting*, 220).

124 *"I have universally observed"*: Leonardo da Vinci, from Melzi, *Libro di pittura*, fol. 32v (Pedretti and Vecce, *Libro di pittura*, chapter 58; English translation in Kemp and Walker, *On Painting*, 200).

124 Leonardo's *Adoration of the Magi*: See the early monograph by Tens Thiis, *Leonardo da Vinci: The Florentine Years of Leonardo and Verrocchio* (London: H. Jenkins, 1913), 181–246, which although written over a century ago is still illuminating (he counted over sixty figures in Leonardo's *Adoration*); see also the pertinent chapters in the main artist's biographies: Kenneth Clark, 1939; Martin Kemp, 1981; Carlo Vecce, 1998; Charles Nichols, 2004; Frank Zöllner, 2003; and Walter Isaacson, 2017. Among the most recent studies on the painting, see Edoardo Vil-

lata, L'*Adorazione dei Magi* di Leonardo: Riflettografie e riflessioni," *Raccolta Vinciana* 32 (2007): 5–42, which argues that Leonardo returned to the painting around 1500. Fundamental for our understanding of Leonardo's *Adoration* is the important volume on the recent restoration, Marco Ciatti and Cecilia Frosinini, eds., *Il restauro dell'*Adorazione dei Magi *di Leonardo: La riscoperta di un capolavoro* (Florence: Opificio delle Pietre Dure, 2017). A summary of this restoration in English is Roberto Bellucci, Patrizia Riitano, Marco Ciatti, Cecilia Forsinini, and Antonio Natali, "Leonardo's *Adoration of the Magi* at the Uffizi: Preliminary Technical Studies at the OPD," in *Technical Practice*, ed. Menu, 32–39. The recent restoration revealed that Leonardo used the same pigment for shadows throughout the panel, a fact that, in my view, provides the strongest evidence that the artist worked on the *Adoration* in a concentrated period of time. Even if he returned to it later, as it has been suggested (the matter remains debatable), he conceived the entire painting in 1481–1482.

126 "*is with Verrocchio*": The judiciary record is published in Vecce, *Leonardo*, 55; and Villata, *Documenti*, 8–10.

126 contract for the *Adoration*: Villata, *Documenti*, 12 (partial English translation in Kemp and Walker, *On Painting*, 268).

127 "*a barrel of red wine*": Ibid., 13–14.

128 "*An angel from the Lord*": Luke 2:8–20. On the Adoration in the Renaissance, see Richard C. Turner, *The Journey of the Magi: Meanings in History of a Christian Story* (Princeton, NJ: Princeton University Press, 1997); Rab Hatfield, "The Compagnia de' Magi," *Journal of the Warburg and Courtauld Institutes* 33 (1970): 107–61; Stephen M. Buhler, "Marsilio Ficino's De stella magorum and Renaissance Views of the Magi," *Renaissance Quarterly* 43 (1990): 348–71. Paula Nuttall, *From Flanders to Florence*, discussed the influence of Hugo van der Goes's *Adoration of the Shepherds* in Renaissance Florence. Bambach, *Leonardo Rediscovered*, vol. 1:199, suggests that Leonardo's sketches for the *Adoration of the Shepherds* and for the *Adoration of Magi* were actually for the same project, the altarpiece for the Augustinian church of San Donato, a view I share.

129 "*typology*": Bonaventura, *Legenda maior* (Milan: Antonio Zarotto, 1477), *Prologus*, IV, 505a, quoted in Rona Goffen, *Piety and Patronage in Renaissance Venice: Bellini, Titian, and the Franciscans* (New Haven, CT: Yale University Press, 1986), 239. Contemporary philosophers have identified the "time of revelation" as the "time of art," starting with Walter Benjamin, "The Work of Art in the Age of Mechanical Reproduction" (1935).

129 "*terror, fear, or flight*": Leonardo da Vinci, from Melzi, *Libro di pittura*, fol. 61v (Pedretti and Vecce, *Libro di pittura*, chapter 188; English translation in Kemp and Walker, *On Painting*, 220).

130 "*the same pose [. . .] same movements*": Leonardo da Vinci, from Melzi,

Libro di pittura, fols. 106v–107r (Pedretti and Vecce, *Libro di pittura*, chapter 280; English translation in Kemp and Walker, *On Painting*, 220).

130 *"attend first to the movements"*: Leonardo da Vinci, from Melzi, *Libro di pittura*, fol. 61v (Pedretti and Vecce, *Libro di pittura*, chapter 189; English translation in Kemp and Walker, *On Painting*, 222).

130 *"do not draw the limbs"*: Ibid.

131 painting technique of the *Adoration*: Roberto Bellucci, "L'*Adorazione dei Magi* e i tempi di Leonardo," in *Il restauro*, ed. Ciatti and Frosinini, 63–107, on which my discussion is based.

133 *"observe and contemplate"*: Leonardo da Vinci, Manuscript A, fol. 107v (English translation in Kemp and Walker, *On Painting*, 199).

135 *Giovanni Battista da Bologna, the prior of San Donato a Scopeto*: Bellucci, "L'*Adorazione*," 94. Bellucci also explains that in this figure's hand the "extreme contrast between dark and light would have been mitigated by a series of successive layers of glazes applied one over another," ibid., 89.

136 *"Leonardo thought in terms of light and shadows"*: Ibid., 64.

137 *"First give a general shadow"*: Leonardo da Vinci, Manuscript A, fol. 108v (English translation in Richter, *Literary Works*, no. 555).

137 *"fading into light"*: Leonardo da Vinci, from Melzi, *Libro di pittura*, fol. 175r–v (Pedretti and Vecce, *Libro di pittura*, chapter 548).

137–138 *"what part of a body [. . .] The shadow made by the sun"*: Leonardo da Vinci, from Melzi, *Libro di pittura*, fol. 201r (Pedretti and Vecce, *Libro di pittura*, chapter 694; English translation in Kemp and Walker, *On Painting*, 93).

139 Leonardo's *Saint Jerome*: Bambach, *Leonardo Rediscovered*, vol. 1:322–34. It should be noted, though, that the church Leonardo sketched in the background is very close to Bonaccorso Ghiberti's sketches from his *Zibaldone*, thus reinforcing the close relation between the *Saint Jerome* and the *Adoration of the Magi* in conception, composition, and technique (see Gustina Scaglia, "Three Renaissance Drawings of Church Facades," *Art Bulletin* 47 [1965]: 173–85, fig. 2, for images from Bonaccorso's *Zibaldone*).

140 Leonardo's *Benois Madonna* and *Study of the Madonna and Child with a Cat*: Bambach, *Leonardo Rediscovered*, vol. 1:199–229.

142 *"the work with his hand"*: Bandello, *Tutte le opere* (English translation in Bambach, *Leonardo Rediscovered*, vol. 1:416).

143 Leonardo's drawing for an instrument to measure air pressure: Bambach, *Master Draftsman*, 324–28.

143 *Evangelista Torricelli*: Torricelli's letter to Michelangelo Ricci, June 11, 1644, published in *Opere dei discepoli di Galileo: Carteggio 1642–1648*, ed. Paolo Galluzzi and Maurizio Torrini, 2 vols. (Florence: Giunti-Barbera, 1975), vol. 1:122; quoted in Gabrielle Walker, *An Ocean of Air: A Natural History of the Atmosphere* (London: Bloomsbury, 2007), 10.

145 Leonardo's letter to Ludovico il Moro: Leonardo da Vinci, Codex Atlanticus, fol. 1082r (published in Vecce, *Leonardo*, 78–79; and Villata,

Documenti, 16–17; English translation in Kemp and Walker, *On Painting*, 251–53).

7. THE *VIRGIN OF THE ROCKS*

146 *"in the shape of a horse's skull"*: Vasari, *Life of Leonardo*, 82. Excellent books on Renaissance Milan are Evelyn S. Welch, *Art and Authority in Renaissance Milan* (New Haven, CT: Yale University Press, 1996); and Monica Azzolini, *The Duke and the Stars: Astrology and Politics in Renaissance Milan* (Cambridge, MA: Harvard University Press, 2013).

146 *résumé to Duke Ludovico il Moro*: Leonardo da Vinci, Codex Atlanticus, fol. 1082r (published in Vecce, *Leonardo*, 78–79; English translation in Kemp and Walker, *On Painting*, 251–53).

147 *Immaculate Conception*: A good introduction to this religious belief, its relation to the Franciscan order, to Pope Sixtus IV, and to art, is Kim Butler, "The Immaculate Body in the Sistine Chapel," *Art History* 32 (2009): 250–89.

148 Leonardo's *Virgin of the Rocks*: The literature on Leonardo's two versions of the *Virgin of the Rocks*, currently kept at the Musée du Louvre in Paris and at the National Gallery in London, is extensive and far from unanimous on the interpretation of why Leonardo painted two versions of the same panel, or on when he did it. Part of the difficulty has to do with the incomplete documentary records. All the documents that have thus far surfaced are published in Villata, *Documenti*, 18–34, 224–26 (English translations of some documents in Kemp and Walker, *On Painting*, 253–55, 268–70). Janice Shell and Grazioso Sironi, "Un nuovo documento di pagamento per la Vergine delle Rocce di Leonardo," in *Hostinato rigore: Leonardiana in memoria di Augusto Marinoni*, ed. Pietro C. Marani (Milan: Electa, 2000), 27–31, discovered another document showing that Leonardo and his partners received a payment of 730 scudi by the end of 1484, suggesting that they were almost done with their work. In their first petition to Ludovico il Moro, datable to the early 1490s, the artists imply that they had received the entire agreed sum of 800 scudi, suggesting that they had completed the agreed-upon work, that is the gilding of the entire ancona, and the painting of the main panel with the Virgin and of the two side panels with angels.

Luke Syson and Rachel Billinge, "Leonardo da Vinci's Use of Under-drawing in the *Virgin of the Rocks* at the National Gallery and *Saint Jerome* in the Vatican," *Burlington Magazine* 147 (2005): 450–63, discusses important discoveries on the London panel that emerged in 2005. Infrared photography revealed that underneath the painted surface, Leonardo had sketched a different composition, which is now known as Composition A; for unknown reasons, Leonardo abandoned it. He covered it with a grayish preparation that effectively erased it, and proceeded to draw over it the exact same composition of the original Paris *Virgin of the Rocks*, which he painted together with his partner Ambrogio de'

Predis. In 2011–2012, the London panel went through a major restoration, on which see Larry Keith, A. Roy, R. Morrison, and P. Schade, "Leonardo da Vinci's *Virgin of the Rocks*: Treatment, Technique and Display," *National Gallery Technical Bulletin* 32 (2011): 32–56.

Among the most important studies that attempt to interpret the complex history of the two versions of Leonardo's *Virgin of the Rocks* are Luke Syson and Larry Keith, eds., *Leonardo da Vinci Painter at the Court of Milan*, exhibition catalog (London: National Gallery of Art, 2012), published on the occasion of a spectacular exhibition that brought together, for the first time, the London and Paris panels. Bambach, *Leonardo Rediscovered*, vol. 1:337–49, which offers the interpretation that the Paris panel was done for another patron (possibly a chapel in Milan's Palazzo Reale) and that the London panel was the only one ever meant for the confraternity of the Immaculate Conception in San Francesco Grande. Delieuvin, "La licence dans la règle," in *Léonard de Vinci*, ed. Delieuvin and Frank, 126–39.

149 *"Our Lady with her son"*: Kemp and Walker, *On Painting*, 270.

153 *"stratified stones"*: Leonardo da Vinci, Codex Leicester, fol. 10r (English translation in Richter, *Literary Works*, no. 980). On Leonardo's view on geology, see Ann Pizzorusso, "Leonardo's Geology: The Authenticity of the *Virgin of the Rocks*," *Leonardo* 29 (1996): 197–200, and Domenico Laurenza, "Leonardo's Theory of the Earth: Unexplored Issues in Geology from the Codex Leicester," in *Leonardo and Nature*, ed. Frosini and Nova, 257–67.

153 *A sort of cavern*: Leonardo da Vinci, Codex Arundel, fol. 155r, on which see Carlo Vecce, "Leonardo e il 'paragone' della natura," in *Leonardo on Nature*, ed. Frosini and Nova, 183–205.

153 *"penetrated the depths of divine Wisdom"*: Romans 11:33–36.

154 *Marian symbols*: Bernardinus de' Bustis, *Mariale*. See also Syson and Keith, *Leonardo Painter*, 163, who commented that in this work Leonardo "established the 'living presence' of Mary and conveyed her spirit."

155 *collections of saints' lives*: de Voragine, *Golden Legend*, vol. 1:328–36; vol. 2:132–40; and Domenico Cavalca, *Vite de' Santi Padri*, ed. Bartolommeo Sorio and A. Racheli (Milan: Presso l'Ufficio Generale di Commissione ed Annunzi, 1870), 403–40.

156 *Feo Belcari*: Feo Belcari, "Rappresentazione di San Giovanni Battista quando andò nel deserto," in Feo Belcari, *Sacre rappresentazioni e laude*, ed. Onorato Allocco-Castellino (Turin, Italy: Unione Tipografico-Editrice Torinese, 1926), 31–51; Belcari wrote this text before 1470 and it was later expanded by Tommaso Benci.

157 *sketches from his Florentine years*: Leonardo da Vinci, Codex Atlanticus, fol. 888r (English translation in Kemp and Walker, *On Painting*, 263–64).

158 infrared photography of the Paris panel: Vincent Delieuvin, Bruno Mottin, and Élisabeth Ravaud, "The Paris *Virgin of the Rocks*: A New Approach Based on Scientific Analysis," in *Technical Practice*, ed. Menu, 72–99.

159 *"which best expresses through its actions the passion of its soul"*: Leonardo da Vinci, Manuscript A, fol. 109v (English translation in Richter, *Literary Works*, no. 584; and Kemp and Walker, *On Painting*, 144, although these

authors translated the word *animo* as "mind," and I prefer to translate it as "soul").

160 *addressed a petition to Ludovico*: Kemp and Walker, *On Painting*, 253–55).

8. THE IDEA OF A BOOK ON PAINTING

166 *"my factory"*: Leonardo da Vinci, Codex Leicester, fol. 9v.

166 *"doctor-architect"*: Leonardo da Vinci, Codex Atlanticus, fol. 730r (English translation in Kemp and Walker, *On Painting*, 256).

168 Leonardo on Salai: Leonardo da Vinci, Manuscript C, fol. 15v.

168 *Leonardo's factory*: Pietro C. Marani, "The Question of Leonardo's Bottega, and the Transmission of Leonardo's Ideas on Art and Painting," in *The Legacy of Leonardo: Painters in Lombardy 1490–1530*, exhibition catalog, ed. Giulio Bora, Maria Teresa Fiorio, and Pietro Marani (Milan: Skira Editore, 1998), 370–80. Claire Farago, "Leonardo's Workshop Procedures and the *Trattato della Pittura*," in *The Fabrication of Leonardo da Vinci's "Trattato della Pittura,"* ed. Claire Farago, Janis Bell, and Carlo Vecce, 2 vols. (Leiden: Brill, 2018), vol. 1:81–181.

168 Bernardo Bellincioni on Cecilia Gallerani: Villata, *Documenti*, 76.

169 *"Every object devoid of color"*: Leonardo da Vinci, Manuscript A, fol. 19v (English translation in Richter, *Literary Works*, no. 281).

169 *total solar eclipse*: Leonardo da Vinci, Codex Trivulzianus, fol. 6v.

169 *"The moon"*: Leonardo da Vinci, Manuscript C, fol. 23r (English translation in Richter, *Literary Works*, no. 251).

170 *"no visible object"*: Ibid.

170 Leonardo's search for books: Carlo Vecce, *La biblioteca perduta: I libri di Leonardo* (Rome: Salerno Editrice, 2017), which includes the list of books Leonardo owned in 1494 and in 1503. See also Carlo Vecce, ed., *Leonardo e i suoi libri*, exhibition catalog, Biblioteca dell'Accademia Nazionale dei Lincei e Corsiniana, Rome (Rome: Bardi Edizoni, 2019).

170 *"the blueness we see in the atmosphere"*: Leonardo da Vinci, Codex Leicester, fol. 4r (English translation in Richter, *Literary Works*, no. 300).

171 *"all the functions of the eye"*: Alberti, *On Painting*, 41.

171 *"many will say that this is useless work"*: Leonardo da Vinci, Codex Atlanticus, fol. 327v (English translation in Richter, *Literary Works*, no. 10; and Kemp and Walker, *On Painting*, 9, although they translate the word *sapienza* as "wisdom," while I prefer "knowledge," and the word *anima* as "mind," while I prefer "soul").

171 *"first study science [scienza]"*: Leonardo da Vinci from Melzi, *Libro di pittura*, fol. 32r (Pedretti and Vecce, *Libro di pittura*, chapter 54; English translation in McMahon, *Treatise*, no. 67).

171–72 painters *"who are in love with practice"*: Leonardo da Vinci, Codex Atlanticus, fol. 207r (English translation in Kemp and Walker, *On Painting*, 52).

172 *"the signpost and gateway" of painting*: Leonardo da Vinci, Manuscript G,

fol. 8r (English translation in Kemp and Walker, *On Painting*, 52, al-though they translated the word *prospettiva* as "perspective," and I prefer to translate it as "optics").

172 *"narrative paintings [*storie*] ought not to be crowded"*: Leonardo da Vinci, Manuscript A, fol. 97v (English translation in Richter, *Literary Works*, no. 578).

172 *"like a sack of nuts"*: Leonardo da Vinci, Manuscript L, fol. 79r (English translation in Kemp and Walker, *On Painting*, 130).

172 *"wooden painter[s]"*: Leonardo da Vinci, Manuscript E, fol. 19v (English translation in Richter, *Literary Works*, no. 363; and Kemp and Walker, *On Painting*, 131).

172 *"best expresses through its actions the passion of its soul"*: Leonardo da Vinci, Manuscript A, fol. 109v (English translation in Richter, *Literary Works*, no. 584; and Kemp and Walker, *On Painting*, 144).

173 *"The good painter should paint two main things"*: Leonardo da Vinci, from Melzi, *Libro di pittura*, fol. 60v (Pedretti and Vecce, *Libro di pittura*, chapter 180; English translation in Bambach, *Leonardo Rediscovered*, vol. 1:427; see also Kemp and Walker, *On Painting*, 144).

173 *"I know well"*: Leonardo da Vinci, Codex Atlanticus, fol. 327v (English translation in Kemp and Walker, *On Painting*, 9).

173 *"Foolish people"*: Ibid.

173 *"Though I may not know"*: Leonardo da Vinci, Codex Atlanticus, fol. 323r (English translation in Richter, *Literary Works*, no. 11; and Kemp and Walker, *On Painting*, 9).

174 *"soul of painting"*: Leonardo da Vinci, Manuscript A, fol. 81r.

174 *"painting is grounded in optics [. . .] a rational demonstration"*: Leonardo da Vinci, Manuscript A, fol.3r (English translation in Richter, *Literary Works*, no. 50; and Kemp and Walker, *On Painting*, 52).

174 *"How shadows fade away at long distances"*: Leonardo da Vinci, Manuscript A, fol. 100v (English translation in Richter, *Literary Works*, no. 176).

175 *"On the three kinds of light"*: Leonardo da Vinci, Manuscript E, fol. 3v (my translation revising Richter, *Literary Works*, no. 117).

177 Vitruvian Man: Bambach, *Leonardo Rediscovered*, vol. 2:226. See Toby Lester, *Da Vinci's Ghost* (New York: Free Press, 2012), for an engaging overview of this famous image.

178 *"spiritual virtue"*: Leonardo da Vinci, Codex Arundel, fol. 151r (English translation in Bambach, *Leonardo Rediscovered*, vol. 1:428).

178 *"accomplish little [. . .] which chord or muscle"*: Leonardo da Vinci, from Melzi, *Libro di pittura*, fols. 110v–11r (Pedretti and Vecce, *Libro di pittura*, chapter 303; English translation in Kemp and Walker, *On Painting*, 130).

178 *"lips with teeth clenched"*: Leonardo da Vinci, Notes on Topics to Be Investigated, 1489, Royal Collection Trust, Windsor Castle, RCIN 919059v; this note is on the back of one Leonardo's skull studies.

179 *"sketch in the bones"*: Alberti, *On Painting*, 41.

180 *"The ancient called man"*: Leonardo da Vinci, Manuscript A, fol. 55v.

180 *"embraces all the ten functions of the eye"*: Leonardo da Vinci, Manuscript A, fol. 102v (English translation in Richter, *Literary Works*, no. 23; and Kemp and Walker, *On Painting*, 16).

180 *"The painter [. . .] must pay great attention [. . .] manner of smoke"*: Leonardo da Vinci, Manuscript A, fol. 107v (partial English translation in Bambach, *Leonardo Rediscovered*, vol. 1:446).

181 *"Which is best"*: Leonardo da Vinci, Manuscript A, fol. 105v (English translation in Richter, *Literary Works*, no. 486).

181 *"Begin with drawing"*: Cennino Cennini, *Il libro dell'arte: A New English Translation and Commentary and Italian Transcription*, ed. Lara Broecke (London: Archetype Publications, 2015), 26–27.

181 *"The boundaries [termini] of two conterminous bodies"*: Leonardo da Vinci, Codex Arundel, fol. 130r (English translation in Richter, *Literary Works*, no. 46).

181 *"wooden effect"*: Leonardo da Vinci, Manuscript A, fol. 94v.

181 *three kinds of perspective*: Leonardo da Vinci, Manuscript A, fol. 98r.

183 *"the convergence of shadow [rays] with light rays"*: Leonardo da Vinci, Manuscript C, fol. 4r.

183 *"a mixed and blurred appearance"*: Ibid., fol. 9v.

183 *"no object [. . .] will ever"*: Ibid., fol. 23r.

183 *"optics adds knowledge"*: Ibid., fol. 27v.

183 *"the master and guide of optics"*: Ibid., fol. 27v.

183 *first studies dedicated to these shadow drawings*: Anna Maria Brizio, *Razzi incidenti e razzi refressi*, Lettura Vinciana 3 (Florence: Barbera Editore, 1963), 3.

185 *"shadow partakes of the nature of universal matter"*: Leonardo da Vinci, Manuscript A, fol. 101v (English translation in Richter, *Literary Works*, no. 122).

186 *"eminent orators"*: Luca Pacioli, *De divina proportione* (Venice: Paganino Paganini, 1509), 1r.

186 *"crowned with poetry"*: Cennini, *Libro dell'arte*, 20.

186 *"subtle speculations"*: Leonardo da Vinci, Manuscript A, fol. 99r.

186 *"higher mental discourse"*: Leonardo da Vinci, from Melzi, *Libro di pittura*, fol. 24v (Pedretti and Vecce, *Libro di pittura*, chapter 40).

187 *"depict transparent bodies"*: Leonardo da Vinci, Manuscript A, fol. 105r (English translation in Kemp and Walker, *On Painting*, 42).

187 *"show the colors"*: Ibid.

187 *"veiled figures which show their nude skin"*: Leonardo da Vinci, from Melzi, *Libro di pittura*, fol. 25r–26v (Pedretti and Vecce, *Libro di pittura*, chapter 41).

187 *"aerial perspective is absent"*: Leonardo da Vinci, Manuscript A, fol. 105r (English translation in Kemp and Walker, *On Painting*, 42).

187 *"the lord and creator"*: Leonardo da Vinci, from Melzi, *Libro di pittura*, fol. 5r (Pedretti and Vecce, *Libro di pittura*, chapter 13).

187 *"kin of god [. . .] granddaughter of nature"*: Leonardo da Vinci, Manuscript A, fol. 100r (English translation in Kemp and Walker, *On Painting*, 13).

187 *"Let no one"*: Leonardo da Vinci, The Heart and Coronary Vessels, 1511–13, Royal Collection Trust, Windsor Castle, RCIN 919073v (English translation in Richter, *Literary Works*, no. 3).

188 *"On the Order of the Book"*: Leonardo da Vinci, Codex Atlanticus, fol. 676r (per Pedretti, *Richter: Commentary*, vol. 1:153, this folio was once part of Manuscript C) (English translation in Richter, *Literary Works*, no. 111; and Martin Clayton and Ron Philo, *Leonardo da Vinci: The Mechanics of Man* [Los Angeles: J. Paul Getty Museum, 2010], 10).

189 *"a group of artists"*: Marani, "Leonardo's Bottega," 15.

189 *"here a record shall be kept"*: Leonardo da Vinci, Codex Madrid II, fol. 157v.

9. WHY THE *LAST SUPPER* FELL TO PIECES

192 Leonardo's *Last Supper*: See Ross King, *Leonardo and the Last Supper* (London: Bond Street Books, 2012), for an overview; and Bambach, *Leonardo Rediscovered*, vol. 1:412–57, for a detailed assessment. On the last restoration, which lasted twenty years, from 1977 to 1997, see the important book by Pinin Brambilla Barcilon and Pietro C. Marani, *Leonardo: The Last Supper* (Chicago: Chicago University Press, 2001). For a detailed analysis of the gestures of each figure and of the moments of the history that are represented in Leonardo's mural, see Leo Steinberg, *Leonardo's Incessant Last Supper* (New York: Zone Books, 2001), which is an enlarged and revised version of his foundational essay from 1973. See Villata, *Documenti*, 262–65, on Cardinal d'Aragona and Antonio de Beatis's visit to the *Last Supper* in December 1517; de Beatis remarked that the apostles were "portraits made from life after many figures from the court and after Milanese men of that time who were of great stature."

192 *"started to fall into ruin"*: Steinberg, *Leonardo's Incessant*, 16.

192 *"the dump in the wall"*: Ibid.

192 *"nothing but a blurred stain"*: Ibid.

192 *"in a state of total ruin"*: Ibid.

193 *"[Of] the horse I shall say nothing"*: Leonardo da Vinci, Codex Atlanticus, fol. 914r (English translation in Richter, *Literary Works*, no. 1345; and Kemp and Walker, *On Painting*, 255).

194 *"One, who was drinking"*: Leonardo da Vinci, Codex Forster II, fols. 62v and 63r (English translation in Bambach, *Leonardo Rediscovered*, vol. 1:435–36; see also Richter nos. 665 and 666; and Kemp and Walker, *On Painting*, 227–28).

198 *"Many times he used to go"*: Bandello, *Tutte le opere*, 646–50 (English translation from Bambach, *Leonardo Rediscovered*, vol. 1:416).

199 *"with hushed voices"*: Ibid.

199 *"an exquisite image"*: Pacioli, *De divina proportione* (English translation from Bambach, *Leonardo Rediscovered*, vol. 1:417); Pacioli wrote his comments in February 1498, although they were published eleven years later, in 1509.

200 *"the duke lost his duchy"*: Leonardo da Vinci, Manuscript L, inside of front cover.

201 *"You must first represent the smoke"*: Leonardo da Vinci, Manuscript A, fols. 110v and 111r (English translations in Richter, *Literary Works*, nos. 601 and 602; and Kemp and Walker, *On Painting*, 228–33). On this passage by Leonardo, see the beautiful essay by Carlo Vecce, *Le battaglie di Leonardo: Codice A, ff 111r e110v, "Modo di fare una battaglia,"* Lettura Vinciana 51 (Florence: Giunti, 2012). For an engaging overview, see Jonathan Jones, *The Lost Battles: Leonardo, Michelangelo and the Artistic Duel That Defined the Renaissance* (London: Vintage Books, 2013). For a thorough scholarly analysis, see Michael W. Cole, *Leonardo, Michelangelo, and the Art of Figure* (New Haven, CT: Yale University Press, 2015); and Roberta Barsanti, Gianluca Belli, Emanuela Ferretti, and Cecilia Frosinini, eds., *Leonardo e la Sala Grande: Un nuovo approccio* (Florence: Leo S. Olschki Editore, 2020). The size of Leonardo's *Battle of Anghiari* is estimated in Bambach, *Leonardo Rediscovered*, vol. 2:370; see ibid., 346–80, for an exhaustive discussion of Leonardo's mural. On the Tavola Doria, the oldest copy of Leonardo's battle scene, see Cecilia Frosinini, "Del cartone e della pittura nella vexata questio della *Battaglia di Anghiari*," in *La Tavola Doria tra mito e storia*, ed. Cristina Acidini and Marco Ciatti (Florence: Edifir, 2015), 23–34.

202 *"If you, poet"*: Leonardo da Vinci, from Melzi, *Libro di pittura*, fol. 6r (Pedretti and Vecce, *Libro di pittura*, chapter 15; English translation in Kemp and Walker, *On Painting*, 28).

202 *"at the very moment"*: Leonardo da Vinci, Codex Madrid II, fol. 1r (English translation in Kemp and Walker, *On Painting*, 264).

203 la scuola del mondo: Benvenuto Cellini, *La Vita*, ed. Lorenzo Bellotto (Parma, Italy: Fondazione Pietro Bembo and Ugo Guanda Editore, 1996), 45. On these cartoons, see the important essay by Carmen Bambach, "The Purchase of Cartoon Paper for Leonardo's *Battle of Anghiari* and Michelangelo's *Battle of Cascina*," *I Tatti Studies: Essays in the Renaissance* 8 (1999): 105–33. Leonardo worked on another mural painting for the duke of Milan, the Sala delle Asse in the Sforza Castle, but did not move beyond the drawing stage in that work, on which see the important book by Michela Palazzo and Francesca Tasso, eds., *Leonardo da Vinci: The Sala delle Asse of the Sforza Castle: Diagnostic Testing and Restoration of the Monochrome* (Milan: Silvana Editoriale, 2017).

204 *"Excellent painters [. . .] when the judgment"*: Leonardo da Vinci, from Melzi, *Libro di pittura*, fol. 131v (Pedretti and Vecce, *Libro di pittura*, chapter 406; English translation in Kemp and Walker, *On Painting*, 197).

10. WHY THE *MONA LISA* WAS NEVER FINISHED

207 *"from time to time he puts his hand"*: Pietro da Novellara's letter from Florence to Isabella d'Este in Mantua, April 3, 1501, about his visit to Leonardo (Villata, *Documenti*, 134–35; English translation in Kemp and Walker, *On Painting*, 271–75).

207 Leonardo's *Leda*: In addition to chapters in biographies on the artist, see Gigetta Dalli Regoli, Romano Nanni, and Antonio Natali, eds., *Leonardo e il mito di Leda: Modelli, memorie e metamorfosi di un'invenzione* (Milan: Silvana Editoriale, 2001); and Romano Nanni and Maria Chiara Monaco, eds., *Leda: storia di un mito dalle origini a Leonardo* (Florence: Zeta Scropii, 2007).

207 *"If you will study"*: Leonardo da Vinci, from Melzi, *Libro di pittura*, fol. 34v (Pedretti and Vecce, *Libro di pittura*, chapter 65; English translation in Kemp and Walker, *On Painting*, 194).

208 Leonardo's *Virgin and Child with Saint Anne*: In addition to chapters in biographies on the artists, see Vincent Delieuvin, ed., *La Sainte Anne: L'ultime chef-d'-oeuvre de Léonard de Vinci*, exhibition catalog, Paris Musée du Louvre (Paris: Louvre Éditions, 2012); and Cinzia Pasquali, "Leonardo's Painting Technique in the *Virgin and Child with Saint Anne*," in *Leonardo da Vinci and Optics*, ed. Fiorani and Nova, 185–93, for an excellent assessment of the painting technique.

209 componimento inculto: Leonardo da Vinci, from Melzi, *Book on Painting*, fol. 62r (Pedretti and Vecce, *Libro di pittura*, chapter 189).

210 *"Apelles the painter"*: Agostino Vespucci, published in Delieuvin, *La Sainte Anne*, 120.

210 Leonardo's *Mona Lisa*: The scholarship on the *Mona Lisa* is extensive. In addition to chapters in biographies on the artist, I have found most helpful the following books: Paul Barolsky, *Why Mona Lisa Smiles and Other Tales by Vasari* (University Park: Penn State University, 1991), for an important interpretation of Vasari's famous text; Donald Sassoon, *Becoming Mona Lisa* (New York: Harcourt, 2001), as a great introduction to the painting and to how it became an icon of Western civilization; Jean-Pierre Mohen, Michel Menu, and Bruno Mottin, eds., *Mona Lisa: Inside the Painting* (New York: Abrams, 2006), for a superb analysis of its painting technique; Martin Kemp and Giuseppe Pallanti, *Mona Lisa: The People and the Painting* (Oxford: Oxford University Press, 2017), for a thorough analysis of documents pertaining to the Gherardini and del Giocondo families; and Delieuvin, *La Sainte Anne*, 162–65, 234–35, for discussion of the Madrid *Mona Lisa* and in general the issues of copies made in Leonardo's workshop.

211 Leonardo and the del Giocondo family: Kemp and Pallanti, *Mona Lisa*, 47–51.

212 *Mona Lisa's smile*: Vasari, *Life of Leonardo*, 94–97; Barolsky, *Why Mona Lisa Smiles*.

214 *"paint layers used in flesh tones"*: Laurence de Viguerie, Philippe Walter, Éric Laval, Bruno Mottin, and V. Armando Solé, "Revealing the Sfumato Technique of Leonardo da Vinci by X-Ray Fluorescence Spectroscopy," *Angewandte Chemie International Edition* 49 (2010): 1.

215 Leonardo's *Saint John the Baptist*: Valeria Merlini and Daniela Storti, eds., *Leonardo a Milano: San Giovanni Battista* (Milan: Skira, 2009); Delieuvin and Frank, *Léonard de Vinci*, 314–15.

215 *"the problematic relation between the spirit"*: Paul Barolsky, "The Mysterious Meaning of Leonardo's *Saint John the Baptist*," Source: *Notes in the History of Art* 8 (Spring 1989): 15.

216 *"In the pit of the throat"*: Vasari, *Life of Leonardo*, 94; on this important sentence, see Fredrika H. Jacobs, *The Living Image in Renaissance Art* (Cambridge: Cambridge University Press, 2005).

218 *"on the night of Saint Andrew"*: Leonardo da Vinci, Codex Madrid II, fol. 112r.

219 *"the transformation of a body"*: Leonardo da Vinci, Codex Forster I, fol. 3r.

219 *"As man has in him bones"*: Leonardo da Vinci, Manuscript A, fol. 55v (English translation in Richter, *Literary Works*, no. 929).

220 *"This [notebook] will be a collection"*: Leonardo da Vinci, Codex Arundel, fol. 1r (English translation in Kemp and Walker, *On Painting*, 264–65). On Leonardo's anatomical studies, see the excellent book by Clayton and Philo, *Mechanics of Man*, on which my discussion is based: 10 (on the four "universal conditions of man"); 20 (on the order of his anatomy book around 1510, and on Leonardo's intention to bind his anatomical studies); 20 (on Leonardo's claim that he did "more than thirty" dissections); 21 (on Paolo Giovio's comment that Leonardo intended to publish his anatomy "from copper engravings for the benefit of art"); 77 (on "the purpose of each muscles" and why it is good for sculptors to know about it); 97 (on views showing the turning of shoulders). See also Domenico Laurenza, *De figura humana: fisiognomica, anatomia e arte in Leonardo* (Florence: Olschki, 2001).

220 *"A shadow is made of infinite darkness"*: Leonardo da Vinci, Notes on Painting, Royal Collection Trust, Windsor Castle, RCIN 919076r.

220 *"without optics nothing can be done"*: Leonardo da Vinci, Manuscript G, fol. 8r (English translation in Richter, *Literary Works*, no. 19; and Kemp and Walker, *On Painting*, 52).

221 *"Of the usefulness of shadows"*: Leonardo da Vinci, Codex Atlanticus, fol. 752r (English translation in Pedretti, *Richter: Commentary*, vol. 1:154.

221 vetturale della natura: Leonardo da Vinci, Manuscript K, fol. 2r. On Leonardo and water, see Leslie A. Geddes, *Watermarks: Leonardo da Vinci and the Mastery of Nature* (Princeton, NJ: Princeton University Press, 2020).

223 *"My depiction of the human body"*: Leonardo da Vinci, Notes on the structure of the treatise on anatomy, 1489 and c. 1508, Royal Collection Trust, Windsor Castle, RCIN 919037v.

224 *"cosmography of the Microcosmos"*: Leonardo da Vinci, Notes on the Study of Anatomy, c. 1510–13, Royal Collection Trust, Windsor Castle, RCIN 919061r.

224 *"begin the anatomy"*: Leonardo da Vinci, The Throat and the Muscles of the Leg, Royal Collection Trust, Windsor Castle, RCIN 919002r (English translation in Richter, *Literary Works*, no. 800).

224 *"dissected the corpses of criminals"*: Giovio, in Vecce, *Leonardo*, 355.

225 *"in the winter of this year, 1510"*: Leonardo da Vinci, The tendons of the

lower leg and foot, 1510–11, Royal Collection Trust, Windsor Castle, RCIN 919016 (English translation in Kemp and Walker, *On Painting*, 265).

225 *"have your books on anatomy bound"*: Leonardo da Vinci, miscellaneous notes and anatomical sketches, Royal Collection Trust, Windsor Castle, RCIN 919070v (English translation in Richter, *Literary Works*, no. 7).

225 *"I left Milan for Rome"*: Leonardo da Vinci, Manuscript E, fol. 1r (English translations in Richter, *Literary Works*, no. 1465; and Kemp and Walker, *On Painting*, 267).

225 *called him "Donnino"*: Leonardo da Vinci, Manuscript M, fol. 53v (English translations in Richter, *Literary Works*, no. 1427).

225 *"a cordial, dear and delightful associate"*: Donato Bramante, *Antiquarie prospettiche Romane* (Rome, c. 1500), 1.

226 Leonardo's lodging in the Vatican: Villata, *Documenti*, 244–46.

226 on finishing a book on geometry: Leonardo da Vinci, Codex Atlanticus, fol. 244v (English translations in Richter, *Literary Works*, no. 1376B; and Kemp and Walker, *On Painting*, 265).

226 *"rules for proceeding to infinity"*: Leonardo da Vinci, Codex Atlanticus, fol. 124v.

227 *"Observe the motion of the surface of water"*: Leonardo da Vinci, Studies of Water and Seated Old Man, Royal Collection Trust, Windsor Castle, RCIN 912579.

227 *"Write of swimming under water"*: Leonardo da Vinci, Codex Atlanticus, fol. 571r.

227 *"You will show the degress of falling rain"*: Leonardo da Vinci, Studies of Clouds, Royal Collection Trust, Windsor Castle, RCIN 912380.

228 *Baldassare Castiglione*: Baldassarre Castiglione, *Il libro del cortigiano* (Turin, Italy: Einaudi, 1998), 176 (quoted in Roberto Antonelli and Antonio Forcellino, eds., *Leonardo a Roma: Influenze ed Eredità*, exhibition catalog, Rome, Villa La Farnesina [Rome: Bardi Edizioni, 2019], 133).

229 visitor at Cloux: Report by Antonio de' Beatis on the visit of Cardinal Luigi d'Aragona to Leonardo in 1517, published in Vecce, *Leonardo*, 332–33; and Villata, *Documenti*, 262–65.

229 Leonardo's death: Vasari, *Life of Leonardo*, 102–104.

11. THE HEIR

233 *Giovanni Francesco Melzi*: See the brief but important essay by Kenneth Clark, "Francesco Melzi as Preserver of Leonardo da Vinci's Drawings," in *Studies in Renaissance and Baroque Art Presented to Anthony Blum on His 60th Birthday* (London: Phaidon, 1967), 24–25, which first identified Melzi's fundamental role in preserving Leonardo's drawings and notebooks. Also important are Bora, Fiorio, and Marani, eds., *The Legacy of Leonardo*, 370–80; Bambach, *Leonardo Rediscovered*, vol. 3:519–33), which elucidates how Melzi retouched Leonardo's drawings and writings; Cecilia Frosinini, Claudio Gulli, Letizia Montalbano, and

Francesca Rossi, "La Testa di Leda del Castello Sforzesco fra Leo-
nardo e Francesco Melzi," *OPD Restauro: Rivista dell'Opificio delle Pietre
Dure e Laboratori di Restauro di Firenze* 25 (2013): 324–42, for an assess-
ment of Melzi's work as an artist; and Rossana Sacchi, "Per la biografia
(e la geografia) di Francesco Melzi," *ACME* (2017): 145–61, for docu-
ments on the Melzi family, including those showing that from 1531 on-
ward, Francesco Melzi no longer resided in the Villa at Vaprio, where
Leonardo had stayed, but in a nearby villa at Pontirolo, in a locality called
Canonica, where he must have kept Leonardo's papers.

233 *"the consuming and passionate love"*: Melzi's letter from Cloux to Leo-
nardo's brothers in Florence announcing the artist's death, June 1, 1519,
published in Kemp and Walker, *On Painting*, 279.

233 *"Salai, I want peace"*: Leonardo da Vinci, Codex Atlanticus, fol. 663v,
published in Pedretti, *Richter: Commentary*, vol. 1:342.

234 *"Good day Messer Francesco"*: Leonardo da Vinci, Codex Atlanticus, fol.
1037v (English translation in Richter, *Literary Works*, no. 1350; and
Kemp and Walker, *On Painting*, 259–60).

234 *"to imitate with very simple marks"*: Giovio in Vecce, *Leonardo*, 355 (En-
glish translation in Pedretti, *Richter: Commentary*, vol. 1:11).

234 Melzi's first drawing: Bambach, *Leonardo Rediscovered*, vol. 3:519–33.

236 *"paints extremely well"*: Giovanni Ambrogio Mazenta, *Alcune memorie de'
fatti di Leonardo da Vinci a Milano e de' suoi libri* (Milan: Editori Alfieri e
Lacroix, 1909); Mazenta wrote this text in the early 1630s.

240 *Leonardo's will*: Published in Kemp and Walker, *On Painting*, 275–78. On
Salai's inheritance of Leonardo's paintings, see Janice Shell and Grazioso
Sironi, "Salaì and Leonardo's Legacy," *Burlington Magazine* 133 (1991):
95–108.

240 Melzi's letter to Leonardo's stepbrothers: Published in Kemp and Walker,
On Painting, 279.

242 *"as if they were relics"*: Vasari, *Life of Leonardo*, 92.

242 Melzi's work on Leonardo's notebooks: Fundamental and unsurpassed is
Pedretti and Vecce, *Libro di pittura*, on which my discussion is based.
Another important book for an in-depth analysis of the cultural and phil-
osophical context of Leonardo's art theory is Claire Farago, *A Critical
Interpretation of Leonardo da Vinci's* Paragone, *with a New Edition of the
Text in the Codex Urbinas* (Leiden: Brill, 1992).

245 *"optics is the signpost and gateway of painting"*: Leonardo da Vinci, Manuscript
G, fol. 8r (English translation in Kemp and Walker, *On Painting*, 52).

245 *"Whether Painting Is a Science or Not"*: Leonardo da Vinci, from Melzi,
Libro di pittura, fol. 1 (Pedretti and Vecce, *Libro di pittura*, chapter 1;
English translation in Kemp and Walker, *On Painting*, 13–14).

245 *"the mother of every certainty"*: Leonardo da Vinci, from Melzi, *Libro di
pittura*, fol. 19r (Pedretti and Vecce, *Libro di pittura*, chapter 33; English
translation, Kemp and Walker, *On Painting*, 10).

245 *"a mental discourse"*: Leonardo da Vinci, from Melzi, *Libro di pittura*, fol.
1 (Pedretti and Vecce, *Libro di pittura*, chapter 1).

245 *"greater mental exertion"*: Leonardo da Vinci, from Melzi, *Libro di pittura*, fol. 20v (Pedretti and Vecce, *Libro di pittura*, chapter 36).

245 *"ten different discourses"*: Leonardo da Vinci, from Melzi, *Libro di pittura*, fol. 21v (Pedretti and Vecce, *Libro di pittura*, chapter 36).

246 *"how the eye"*: Leonardo da Vinci, from Melzi, *Libro di pittura*, fol. 4v (Pedretti and Vecce, *Libro di pittura*, chapter 11).

246 *"man and the intentions of his mind"*: Leonardo da Vinci, from Melzi, *Libro di pittura* (Pedretti and Vecce, *Libro di pittura*, chapter 180; English translation in Bambach, *Leonardo Rediscovered*, vol. 1:427; see also Kemp and Walker, *On Painting*, 144).

246 *"ought to move those who behold"*: Leonardo da Vinci, from Melzi, *Libro di pittura*, fol. 61v (Pedretti and Vecce, *Libro di pittura*, chapter 188; English translation in Kemp and Walker, *On Painting*, 220).

247 *"to show the disposition"*: Leonardo da Vinci, from Melzi, *Libro di pittura*, fol. 167r (Pedretti and Vecce, *Libro di pittura*, chapter 529).

247 *fifth section, "On Shadow and Light"*: In his list of notebooks by Leonardo that he used to compile the *Libro di pittura*, Melzi mentioned two notebooks on light and shadow although he ended up using only one. One notebook was marked with the letter *G* and corresponds to the notebook known today as Manuscript C (it still has Melzi's identifying *G* on its cover); Leonardo had written it in 1491–1492, when he was in his forties, had completed the first version of the *Virgin of the Rocks*, and had taken Salai into the workshop, but Melzi did not use this notebook. The second notebook was marked with the letter *W* but unfortunately did not come down to us; Melzi must have used this second notebook as his primary source for section five; we can surmise that he knew that this notebook marked *W* was more advanced than the notebook marked *G*. This means that section five of Melzi's compilation is the best source we have to document Leonardo's most advanced thoughts on light and shadow, a fundamental part of his art theory.

247 *The previous sections of the book*: A glaring omission from Melzi's *Book on Painting* is anatomy. As we know, anatomy was fundamental to Leonardo's science of art and the artist had illustrated it in numerous, stunning drawings, many at an advanced stage of elaboration. We do not know why Melzi did not include human anatomy in his compilation. But one possible explanation is that he planned to do so but that after 1543 that section became obsolete. That year, Andreas Vesalius, *On the Fabric of the Human Body* (*De humani corporis fabrica*) (Basel: *Ex officina* Joannis Oporini, 1543), was published, a fact that made Leonardo's anatomy for artists obsolete. Vesalius's book followed closely Leonardo's scheme in stripping the body down to the bones step-by-step in a series of splendid anatomical tables that moved from the general body to its parts. Today, Melzi's *Libro di pittura* has some missing pages, the folios from 86r to 103v, which were originally placed between sections 2 and 3 and which most likely were discarded later. One wonders, though, what Melzi had in mind for those pages—were they reserved for human anatomy?

249 Lomazzo on Melzi: Gian Paolo Lomazzo, *Trattato della pittura, scoltura et architettura* (Milan: Pier Paolo Gottardo Pontio, 1584), 106.

249 Mazenta on Melzi: Mazenta, *Alcune memorie,* no pagination.

249 Vasari on Melzi: Vasari, *Life of Leonardo,* 92.

12. THE BIOGRAPHER AND THE DOCTORED BOOK

250 Renaissance rulers and art for political legitimacy: Loren Partridge and Randolph Starn, *Arts of Power: Three Halls of State in Italy 1300–1600* (Berkeley: University of California Press, 1992); and Julian Klieman, *Gesta dipinte: La grande decorazione nelle dimore italiane dal Quattrocento al Seicento* (Milan: Silvana Editoriale, 1993).

251 Cosimo I de' Medici and art for political legitimacy: Janet Cox Rearick, *Dynasty and Destiny in Medici Art: Pontormo, Leo X, and the Two Cosimos* (1984); Partridge and Starn, *Arts of Power,* 151–255; Francesca Fiorani, *The Marvel of Maps: Art, Cartography, and Politics in Renaissance Italy* (New Haven, CT: Yale University Press, 2005), 17–139.

252 Giorgio Vasari's *Lives:* Patricia Rubin, *Giorgio Vasari: Art and History* (New Haven, CT: Yale University Press, 1995); Paul Barolsky, *Why Mona Lisa Smiles*; Thomas Frangenberg, "Bartoli, Giambullari and the Prefaces to Vasari's 'Lives' (1550)," *Journal of the Warburg and Courtauld Institutes* 65 (2002): 244–58; Charles Hope, "Vasari's *Vite* as a Collaborative Project," in *The Ashgate Research Companion to Giorgio Vasari,* ed. David J. Cast (London: Routledge, 2013), 11–22; Eliana Carrara, "Reconsidering the Authorship of the 'Lives': Some Observations and Methodological Questions on Vasari as Writer," *Studi di Memofonte* 15 (2015): 53–90. For further reading in Italian: Barbara Agosti, *Giorgio Vasari: Luoghi e tempi delle "Vite"* (Milan: Officina Libraria, 2013).

252 *"as a historian"*: Vasari from *Lives,* quoted in Rubin, *Vasari,* 40–41.

252 *"It is my task to dwell upon those actions"*: Ibid.

253 *"If you wish to study well"*: Leonardo da Vinci, Manuscript A, fol. 107v (English translation in Richter, *Literary Works,* no. 492; and Kemp and Walker, *On Painting,* 198).

253 Vasari's biography on Leonardo: Vasari, *Life of Leonardo* integrates the 1550 and the 1568 editions of Vasari's biography of Leonardo; for an analysis of Vasari's biography see Patricia Rubin, "What Men Saw: Vasari's *Life of Leonardo da Vinci* and the Image of the Renaissance Artist," *Art History* 13 (1990): 34–46; Paul Barolsky, "Vasari and the Historical Imagination," *Word and Image* 15 (1990): 286–91; Richard Turner, *Inventing Leonardo* (Berkeley: University of California Press, 1994), 55–67; Charles Hope, "The Biography of Leonardo in Vasari's *Lives,*" in *The Lives of Leonardo,* ed. Thomas Frangenberg and Rodney Palmer (London: Warburg Institute, 2013), 11–28. None of these studies comment on Vasari's view of Leonardo's optics.

255 *Paolo Giovio:* Giovio, in Carlo Vecce, *Leonardo,* 355, and in Villata,

Documenti, 291. No other biographer mentioned optics among Leonardo's accomplishments. Antonio Billi, who wrote his biography between 1516 and 1525, is silent on the matter. Anonimo Gaddiano briefly mentions that Leonardo "was knowledgeable in mathematics and optics" (quoted in Vecce, *Leonardo*, 360). See also Barbara Agosti, "Qualche nota su Paolo Giovio ('gonzaghissimo') e le arti figurative," *Prospettiva* 97 (2000): 51–62, for an important assessment of Giovio's biography vis-à-vis Vasari's. Giovio was among those who suggested to Vasari to dedicate his book to Cosimo I (Silvia Ginzburg, "Filologia e storia dell'arte: Il ruolo di Vincenzio Borghini nella genesi della Torrentiniana," in *Testi, immagini e filologia nel XVI secolo*, ed. Eliana Carrara and Silvia Ginzburg (Pisa: Edizioni della Normale, 2007), 147–203.

256 *"And it shows!"*: Annibale Caro's letter to Giorgio Vasari, May 10, 1548, published in Annibale Caro, *Lettere familiari*, ed. Aulo Greco, 3 vols. (Florence: Le Monnier, 1957–61), vol. 2:62–64.

256 *"in 100 months [. . .] done the whole thing myself"*: Giorgio Vasari, "Descrizione delle opere di Giorgio Vasari pittore e architetto Aretino," in Giorgio Vasari, *Le vite de' più eccellenti pittori scultori e architettori, nelle redazioni del 1550 e 1568*, ed. Paola Barocchi and Rosanna Bettarini, 6 vols. (Florence, Sansoni, 1966–1987), vol. 6:388.

257 *"Alas! This man will not do anything"*: Vasari, *Life of Leonardo*, 102.

259 relations between Vasari, Borghini, and Cosimo: Richard Scorza, "Borghini and the Florentine Academies," in *Italian Academies of the Sixteenth Century*, ed. David S. Chambers and Francois Quiviger (London: Warburg Institute, 1995), 137–53; Robert Williams, "Vasari and Vincenzo Borghini," in *Companion to Giorgio Vasari*, ed. Cast, 23–39; Richard Scorza, "'Ricerca storica e invenzione': la collaborazione di Borghini con Cosimo I e Francesco, rapporti con gli artisti, gli apparati effimeri," in *Vincenzo Borghini: Filologia e invenzione nella Firenze di Cosimo I*, ed. Gino Belloni and Riccardo Drusi, exhibition catalog, Biblioteca Nazionale Centrale, Florence (Florence: Olschki, 2013), 61–148.

260 Accademia del Disegno: Nikolaus Pevsner, *Academies of Art: Past and Present* (New York: Da Capo Press, 1973; reprint of 1st ed., 1940), which investigates also how later academies were modeled after the Accademia del Disegno; Zygmunt Wabiski, *L'Accademia medicea del Disegno a Firenze nel Cinquecento* (Florence: Olschki, 1987), 2 vols.; K. Barzman, *The Florentine Academy and the Early Modern Discipline of Disegno* (Cambridge: Cambridge University Press, 2000); Eliana Carrara, "Vincenzo Borghini, Lelio Torelli e l'Accademia del disegno di Firenze: alcune considerazioni," *Annali di critica d'arte* (2006): 556 (on the Vincenzo Borghini quote "That pig of Benvenuto"); Chambers and Quiviger, *Italian Academies*. Alyna Paine, *The Architectural Treatise in the Italian Renaissance: Architectural Invention, Ornament and Literary Cultue* (Cambridge: Cambridge University Press, 1999), on textbooks on architecture used at the academy. Robert Williams, "Leonardo and the Florentine Academy," in *Re-reading Leonardo*, 61–76, discusses a lecture on Leonardo delivered at the academy.

260 Borghini's inaugural lecture at the art academy: Published in Karl Frey, *Der Literarische Nachlass Giorgio Vasaris*, 3 vols. (Munich: G. Muller, 1923–30; reprint edition, Hildeshiem, Germany: 1982); Borghini delivered it at the first meeting of the academy on January 31, 1563.

260 *"an academy to DO rather than TALK"*: Published in Robert Williams, *Art, Theory, and Culture in Sixteenth-Century Italy* (Cambridge: Cambridge University Press, 1997), 61.

262 *"a tortoise"*: Vincenzo Borghini, "Sulle lettere del Tribolo, del Tasso e di Michelangelo," in Paola Barocchi, *Scritti d'arte del Cinquecento*, 2 vols. (Turin: Einaudi, 1979), see vol. 1:614; vol. 1:613–73, for Borghini's views on the paragone, which were inspired by the letters written by various artists around 1540 but possibly also by knowledge of Leonardo's views as they were reported in Melzi's *Book on Painting*, which may have been in Florence in the 1560s.

263 *"a universal HISTORY"*: August 11, 1564, published in Frey, *Nachlass*, vol. 2:98.

264 *"in ugly characters"*: Vasari, *Life of Leonardo*, 92.

264 *"It is a remarkable thing"*: Ibid., 77–78.

266 The doctored copies of Melzi's *Book on Painting* (*Libro di pittura*): Kate T. Steinitz, *Leonardo da Vinci's "Trattato della Pittura": A Bibliography* (Copenhagen: Munksgaard, 1958), is a pioneering study, and although it is now largely superseded, it did gather for the first time the then-known doctored copies. Carlo Pedretti, *Leonardo da Vinci on Painting: A Lost Book (Libro A)*, 95–174, is a fundamental study of Leonardo's intention in writing his own book on painting and a perceptive assessment of the genesis and circulation of the doctored copies. Carlo Pedretti, *Richter: Commentary*, vol. 1:12–86, studies the doctored copies. See also Ernst Gombrich, "The *Trattato della Pittura*: Some Questions and Desiderata," in *Leonardo e l'età della ragione*, ed. Enrico Bellone and Paolo Rossi (Milan: Scientia, 1982), 141–58; Francesca Fiorani, "Danti Edits Vignola: The Formation of a Modern Classic on Perspective," in *The Treatise on Perspective: Published and Unpublished*, ed. Lyle Massey (Washington, DC: National Gallery of Art, 2003), 127–59; Francesca Fiorani, "The Shadows of Leonardo's *Annunciation*"; Claire Farago, *Re-reading Leonardo*, especially the following essays: Martin Kemp and Juliana Barone, "What Might Leonardo's Own *Trattato* Have Looked Like? And What Did It Actually Look Like up to the Time of the Editio Princeps?," 39–60; Claire Farago, "Who Abridged Leonardo da Vinci's Treatise on Painting?," 77–106; and Michael W. Cole, "On the Movement of Figures in Some Early Apographs of the Abridged *Trattato*," 107–26. Farago, Bell, and Vecce, *The Fabrication*, especially the following essays: Claire Farago, "On the Origins of the *Trattato* and the Earliest Reception of the *Libro di pittura*," 213–40; and Anna Sconza, "The Earliest Abridged Copies of the *Libro di pittura* in Florence," 241–62. Most of the existing doctored copies of Melzi's *Book on Painting* are available digitally in *Leonardo da Vinci and His Treatise on Painting*, ed. Francesca Fiorani.

267 *"Painter, if you want to be universal"*: Leonardo da Vinci, from Melzi, *Libro di pittura*, fol. 34r (Pedretti and Vecce, *Libro di pittura*, chapter 61). In one of the earliest doctored copies, titled "Discorso sopra il disegno di Lionardo da Vinci, Parte second a," this passage corresponds to chapter 9 (Florence, Biblioteca Riccardiana, Codex Riccardiano 3208, fol. 3r).

267 place of origin of doctored copies: Farago, "On the Origins," argues that Melzi's *Book on Painting* was abridged in Milan, while Pedretti, *Richter: Commentary*, vol. 1:12–46, and Sconza, "The Earliest Abridged Copies," argue that it was abridged in Florence. I share the latter view.

267 *"First a youth needs to learn optics"*: Florence, Biblioteca Riccardinana, Codex Riccardiano 3208, fol. 1v.

270 *"wrote some very beautiful precepts"*: Raffaello Borghini, *Il Riposo* (Florence: Giorgio Marescotti, 1584), 371.

13. THE BEST EDITOR, AN OBSESSED PAINTER, AND A PRINTED BOOK

272 *"for the common good"*: Galeazzo Arconati's letter from Milan to a "Reverendissiomo Padre" in Rome, August 7, 1635 (published in Steinitz, *Trattato*, 218). An excellent introduction to art and patronage in seventeenth-century Rome, with special attention to Urban VIII, Cardinal Francesco Barberini, and Cassiano dal Pozzo, is Francis Haskell, *Patrons and Painters: Art and Society in Baroque Italy* (New Haven, CT: Yale University Press, 1980), 3–166. David Freedberg, *The Eye of the Lynx: Galileo, His Friends, and the Beginnings of Modern Natural History* (Chicago: Chicago University Press, 2002), is a superb study on the interactions between art and science in Baroque Rome.

272 *Cassiano dal Pozzo*: Donatella L. Sparti, *Le collezioni dal Pozzo: Storia di una famiglia e del suo Museo nella Roma seicentesca* (Modena, Italy: Panini, 1992); Francesco Solinas, ed., *I segreti di un collezionista: Le straordinarie raccolte di Cassiano dal Pozzo 1588–1657*, exhibition catalog, Galleria Nazionale d'Arte Antica, Palazzo Barberini, Rome (Rome: Edizioni De Luca, 2000); Anna Nicolò, ed., *Il carteggio di Cassiano dal Pozzo: Catalogo* (Florence: Olschki, 1991).

273 *"paper museum"*: These volumes are now kept at Windsor Castle, Royal Collection Trust, and other European museums. They are available digitally at https://warburg.sas.ac.uk/research/research-projects/paper-museum-cassiano-dal-pozzo.

273 Cassiano's volume on citrus: David Freedberg and Enrico Baldini, eds. (with contributions by Giovanni Continella, Eugenio Tribulato, and Eileen Kinghan), *Citrus Fruit* (London: Harvey Miller, 1997).

274 Cassiano's visit to Paris: Cassiano dal Pozzo, "Diarium," published in Daniela del Pesco, "Au château de Fontainebleau avec Cassiano dal Pozzo en 1625," in *Fontainebleau: La vraie demeure de rois, la maison des siècles* (Paris: Swan Editeur, 2015), 21–71; 55 (for comments on the *Mona Lisa*).

274 *"lie neglected under the roof"*: Mazenta, *Memorie*, no pagination. On the

dispersion of Leonardo's writings after Francesco Melzi's death, see Bambach, *Leonardo Rediscovered*, vol. 4:1–3, 30–31, which discusses also the notebooks by Leonardo Mazenta may have owned.

275 Cassiano's editorial work on Leonardo's book on painting: Juliana Barone, "Seventeenth-Century Transformations: Cassiano dal Pozzo's Manuscript Copy of the Abridged *Libro di pittura*," in Farago, Bell, and Vecce, *Fabrication*, vol. 1:263–99, on which my discussion is based. Barone clarified that "Cassiano's project aimed at rescuing textual accuracy, while the illustrations offered a different visual message in the service of a new aesthetic ideal" (vol. 1:263). On Cassiano's work on Leonardo's writings as well as his relations to Mazenta, Arconati, and other scholars and collectors, see Janis Bell, "Zaccolini, Dal Pozzo and Leonardo's Writings in Rome and Milan," *Mitteilungen des Kusthistorishes Institutes im Florenz* 61 (2019): 309–33; and Janis Bell, "Zaccolini e Milano: Nuove indagini, nuove attribuzioni," in *L'eredità culturale e artistica di Matteo Zaccolini*, ed. Marino Mengozzi (Cesena: Biblioteca Malatestiana, 2020), 43–72.

276 *"chapters in which we have difficulty"*: Arconati's letter from Milan to Cassiano in Rome, Milan, Venerabile Biblioteca Ambrosiana, Codex H 227 inf., fol. 125, published in Barone, "Seventeenth-Century Transformations," 269–70. The twelve notebooks by Leonardo that Arconati owned and used to answer Cassiano's queries were eleven notebooks Leonardo himself assembled, and one gigantic volume that had been assembled by the sculptor Pompeo Leoni in the early seventeenth century, out of thousands of loose folios, known today as Codex Atlanticus because its size is as big as the Atlantic Ocean.

276 *"to receive what I am expecting"*: Cassiano dal Pozzo's letter from Rome to Padre Gallo and Galeazzo Arconati in Milan, October 16, 1639 (published in Steinitz, *Trattato*, 228).

277 *"the capricious, or better still"*: Milan, Venerabile Biblioteca Ambrosiana, Manuscript H227 inf., fol. 57r–57v, published in Carlo Pedretti, "Copies of Leonardo's Lost Writings in the MS H227 inf. of the Ambrosiana Library in Milan," *Raccolta Vinciana* 19 (1962): 64–65.

277 shadow drawing from Milan: Milan, Veneranda Biblioteca Ambrosiana, Codex H227 inf., fols. 1–54, on which see Pedretti, "Copies of Leonardo's Lost Writings"; Pedretti established that the shadow drawings were copies of Leonardo's originals contained in the notebook known today as Manuscript C.

278 Cassiano's handwritten master copy: Milan, Veneranda Biblioteca Ambrosiana, Codex H228 inf. Cassiano included in this master copy the text of the doctored version of Melzi's *Book on Painting* and some additional materials he thought would be useful for the editing work, including Vasari's chapter on Leonardo and Mazenta's *Memorie*, the essay Mazenta had written at Cassiano's request to document the whereabouts of Leonardo's notebooks. On this master copy, see Barone, "Seventeenth-Century Transformations."

279 Nicolas Poussin: Engaging introductions on Poussin are Jacques Thuillier,

Nicolas Poussin (Paris: Fayard, 1988); and Elizabeth Cropper and Charles Dempsey, *Nicolas Poussin: Friendship and the Love of Painting* (Princeton, NJ: Princeton University Press, 1996). Jacques Thuillier, ed., *Nicolas Poussin: Lettres et propos sur l'art* (Paris: Collection Savoir Hermann, 1989), is a collection of Poussin's letters and his writings on art.

279 Poussin's work on Leonardo's sketches: Elizabeth Cropper, "Poussin and Leonardo: Evidence from the Zaccolini MSS," *Art Bulletin* 62 (1980): 570–83; Janis Bell, "Cassiano dal Pozzo's Copy of the Zaccolini Manuscripts," *Journal of the Warburg and Courtauld Institutes* 51 (1988): 103–25; Francesca Fiorani, "Abraham Bosse e le prime critiche al 'Trattato della Pittura' di Leonardo," *Achademia Leonardi Vinci* 5 (1992): 78–95; Francesca Fiorani, "The Theory of Shadow Projection and Aerial Perspective: Leonardo, Desargues and Bosse," in *Desargues en son temps*, ed. Jean Dhombres and Jean Sakarovitch (Paris: Librairie scientifique A. Blanchard, 1994), 267–82; Juliana Barone, "Illustrations of Figures by Nicholas Poussin and Stefano della Bella in Leonardo's *Trattato*," *Gazette des Beaux-Arts* 143 (2001): 1–14; Juliana Barone, "Seventeenth-Century Illustrations for the Chapters on Motion in Leonardo's *Trattato*," in *The Rise of the Image: Essays on the History of the Illustrated Art Book*, ed. Thomas Frangenberg and Rodney Palmer (London: Routledge, 2003), 23–49; Donatella L. Sparti, "Cassiano dal Pozzo: Poussin and the Making and Publication of Leonardo's *Trattato*," *Journal of the Warburg and Courtauld Institutes* 66 (2003): 143–88; Juliana Barone, "Poussin as Engineer of the Human Figure: The Illustrations for Leonardo's *Trattato*," in *Re-reading Leonardo*, ed. Farago, 197–236; Pauline Robison, "Leonardo's *Trattato della pittura*, Nicolas Poussin, and the Pursuit of Eloquence in Seventeenth-Century France," in *Leonardo da Vinci and the Ethics of Style*, ed. Claire Farago (Manchester: Manchester University Press, 2008), 189–236; Barone, "Seventeenth-Century Transformations."

279 *not "satisfied to simply read"*: André Félibien, *Life of Poussin*, ed. Claire Pace (London: Zwemmer, 1981), 114.

279 *"Mr. Poussin must return one [book]"*: Veneranda Biblioteca Ambrosiana, Codex H227 inf., title page, published in Steinitz, *Trattato*, 99–100). This manuscript contains added materials Cassiano had received from Milan, including the shadow drawings copied from Leonardo's Manuscript C (see Pedretti, "Copies of Leonardo's Lost Writings," 62 and fig. 1).

279 *"without cease"*: Félibien, *Life of Poussin*.

280 *"a young man who has the fury"*: Giovambattista Marino's letter to Cardinal Barberini, quoted in *Poussin: Lettres*, 11.

280 *"I beg you"*: Poussin's letter to Cassiano, 1629, in *Poussin: Lettres*, 35.

280 Poussin's friends in Rome: The sculptor François Duquesnoy (1597–1643), with whom Poussin lodged for a while in 1626, when he had no other place to go. The painters Jean Lemaire (1598–1659) and Jacques Stella (1596–1657), who were already in Rome when Poussin arrived in 1624.

The engraver Charles Errard (1606–1689), who worked for Cassiano and later engraved the illustrations for Leonardo's printed book. Raphael Trichet Du Fresne (1611–1661), an avid book collector and expert in numismatics and antiquity who lived in Rome from 1637 to 1639 and who edited Leonardo's printed book. The libertine philosopher Pierre Bourdelot (1610–1685), to whom Trichet dedicated the Italian printed book. The French brothers Roland Fréart de Chambray (1606–1676) and Paul Fréart de Chantelou (1609–1694), who were steeped in artistic matters at the French court as their uncle François Sublet de Noyers (1589–1643) was the secretary of state of the French king and his superintendent of royal buildings.

280 Poussin on Caravaggio: Félibien, in *Poussin: Lettres*, 196.

281 *"did not neglect anything"*: Quoted in Thuillier, *Poussin*, 21.

282 *Poussin "spoke cleverly on optics"*: Félibien, in *Poussin: Lettres*, 195.

282 Poussin's comments on the Israelites: Poussin's letter from Rome to Chantelou in Paris, April 28, 1636, published in *Poussin: Lettres*, 45.

283 *"the procedure"* . . . *was "very difficult to execute"*: Abraham Bosse, *Manière universelle de Mr. Desargues, pour pratiquer la perspective par petit-pied, comme le geometral* (Paris, 1648), 177–78, reporting the opinion of his master, Girard Desargues, which was first expressed in an essay on stone cutting that Desargues wrote in 1640, on which see Judith V. Field and J. J. Gray, *The Geometrical Works of Girard Desargues* (London: Springer-Verlag, London, 1987), 14–15. Bosse's book includes over one hundred pages (out of three hundred) and fifteen illustrations on aerial perspective and on light and shade, a discussion that was based on Leonardo's shadow drawings, although Bosse never credited Leonardo for it. Poussin could have sent this shadow drawing to either Jacques Stella, who had left Rome for Paris in 1635, become royal painter, and lived at the Louvre (the two wrote each other regularly, and their letters were treasured in the Stella family for centuries but have since been lost), or to Jean Lemaire, who also was back in Paris from at least 1637 and who often helped Poussin as an intermediary with his Parisian patrons; or to one of the Fréart brothers. See also Fiorani, "The Theory of Shadow Projection."

285 *rule for the use of strong and delicate colors*: Field and Gray, *Desargues*, 157.

285 shadow drawings Poussin brought to Paris: Félibien, *Life of Poussin*, 110; although Felibien says that the copies came from Matteo Zaccolini rather than Leonardo, it should be pointed out that Zaccolini was following closely Leonardo's art theory and thus his shadow drawings were deeply "Leonardo-inspired." On the Fréart brothers, see Isabel Pantin, *Les Fréart de Chantelous. Une famillie d'amateurs au XVIIe siècle, entre le Mans, Paris et Rome* (Le Mans: Creation and Recherche, 1999).

286 *"bagatelles"*: Poussin's letter from Paris to Cassiano in Rome, April 4, 1642, published in *Poussin: Lettres*, 64.

287 *"Poussin is comfortable where he is"*: Abbé Bourdelot's letter from Paris to Cassiano in Rome, April 18, 1643, ibid., 86.

289 editorial work for the printed book: Janis Bell, "The Final Text," in Farago,

Bell, and Vecce, *Fabrication*, vol. 1:300–372; Bell, "Zaccolini, Dal Pozzo and Leonardo's Writings in Rome and Milan," which discusses that copies of Leonardo's shadow drawings were available in Paris during the editorial work for the printed edition. I suggest Leonardo's shadow drawings were available there as early as 1639, when Poussin sent one shadow drawing to a friend and Desargues wrote about it.

289 *"did not give it the final edit"*: Trichet, "Vita di Leonardo da Vinci," in *Leonardo da Vinci, Trattato della pittura* (Paris: Langois, 1651), no pagination. A modern English translation of the 1651 Italian printed book is now available in Farago, Bell, and Vecce, *Fabrication*, vol. 2:611–874. Trichet added to his Italian edition of the *Trattato* two seminal essays by Leon Battista Alberti written two centuries earlier. Allegedly, Trichet added Alberti's *On Painting* "for the conformity of the topic" and Alberti's *On Statua* because it was very hard to find. But in reality he did much more than that. Knowing that Leonardo's *Treatise on Painting* was doctored and that sections on linear perspective, shadows, and sculpture were absent, Trichet complemented it with Alberti's essays, thus creating an intellectual genealogy between Alberti and Leonardo. To make sure nobody missed the connection, he had the texts by the two authors printed in the exact same way as if they were sections of the same book. Typesetting, engravings, and page layout made tangibly visible that Alberti and Leonardo's books were one and the same thing.

291 Poussin as the second author: Chambray, "A Monsieur Poussin Premier Peintre du Roy," in *Leonard de Vinci, Traité de la Peinture* (Paris: Langlois, 1651), no pagination.

291 *"the queen of Parnassus"*: Trichet, *"Alla Serenissima e Potentissima Principessa Cristina,"* in *Leonardo da Vinci, Trattato della Pittura* (Paris: Langlois, 1651), no pagination.

291 Trichet's biography of Leonardo: *Leonardo da Vinci, Trattato*, no pagination. See Catherine M. Soussloff, "The Vita of Leonardo da Vinci in the Du Fresne Edition of 1651," in *Re-reading Leonardo*, ed. Farago, 175–96; and Juliana Barone, "The 'Official' Vita of Leonardo: Raphael Trichet Du Fresne's Biography in the Trattato della Pittura," in Frangenberg and Palmer, *The Lives of Leonardo*, 61–83.

292 *"Here is the book"*: Charles Le Brun quoted in André Blum, *Abraham Bosse et la societé française au XVIIe siècle* (Paris: A. Morancé, 1924), 18.

EPILOGUE

295 *"the clumsy landscapes"*: Poussin's letter to Abraham Bosse, first published in Abraham Bosse, *Traité des pratiques geometrales et perspectives, enseignées dans l'Académie Royale de la Peinture et Sculpture* (Paris: Chez l'Auteur, 1665), 128–29; now in *Poussin: Lettres*, 161–62.

295 the reception of Leonardo's *Treatise on Painting*: Martin Kemp, "A Chaos of Intelligence: Leonardo's *Traité* and the Perspective Wars in the Académie Royale," in *Il se rendit en Italie: Études offertes à André Chastel*

(Rome: Edizioni dell'Elefante, 1987), 415–26; Fiorani, "Abraham Bosse e le prime critiche"; Thomas Frangenberg, "Abraham Bosse in Context: French Responses to Leonardo's *Treatise on Painting* in the Seventeenth Century," *Journal of the Warburg and Courtauld Institutes* 75 (2012): 223–60; Judith Field, "Perspective and the Paris Academy," in *Re-reading Leonardo*, ed. Farago, 255–66; Pauline Robison, "Leonardo's Theory of Aerial Perspective in the Writings of André Félibien and the Paintings of Nicolas Poussin," in *Re-reading Leonardo*, ed. Farago, 299–326.

296 Leonardo and André Félibien: Robison, "Leonardo's Theory of Aerial Perspective," discusses how Félibien included Leonardo's theory in his *Discussions concerning the lives and works of the most excellent painters, ancient and modern*, or *Entretiens*, without ever acknowledging the origins of his thoughts on aerial perspective, light, and shadows in Leonardo. In addition, it is worth considering that Félibien could have direct knowledge of—and continuous access to—the shadow drawings the Milanese team had sent to Cassiano (now in Milan, Veneranda Biblioteca Ambrosiana, Codex H227 inf., fols. 1–54), either directly from Cassiano or from Poussin; otherwise he would not have ben able to write in detail about them (*V Entretiens*, 20–52). Félibien's comments on Poussin's interest in optics are in *Poussin: Lettres*, 194–96; and *Entretiens*, preface; 21 (on their close friendship, *une amitié très étroite*); 48 ("M. Poussin did not ignore" the study of optics).

297 only *"part of this treatise was published"*: Guglielmo Manzi, *Trattato della pittura di Lionardo da Vinci tratto da un codice della Biblioteca Vaticana* (Rome: Stamperia De Romanis, 1817), 7.

297 *"truncated and mutilated"*: Ibid., 8.

300 *"ornaments of the world"*: Leonardo da Vinci, Manuscript A, fol. 102v (English translation in Richter, *Literary Works*, no. 23; and Kemp and Walker, *On Painting*, 16).

301 *Paolo Giovio*: Giovio in Vecce, *Leonardo*, 355.

302 *"The first painting was merely"*: Leonardo da Vinci, Manuscript A, fol. 97v (English translation in Kemp and Walker, *On Painting*, 193).

Acknowledgments

///

This book has been a long time in the making, and along the way I accumulated immense debts of gratitude toward the many students, friends, and colleagues who shared their insights, and to the institutions that supported my research.

I was incredibly fortunate that while I was writing this book, a number of Leonardo's works underwent extensive conservation analysis and restoration, and that breathtaking exhibitions organized to celebrate the five hundredth anniversary of the artist's death offered incredible opportunities to see side-by-side works that are usually kept in different museums. These combined events enhanced greatly my knowledge of Leonardo's painting technique, and I am in debt to the museum directors, curators, and conservators who kindly granted me permission to look at Leonardo's works up close, without their protective glass, out of their frames, just like Leonardo had them on the easel when he painted them five centuries ago. Antonio Natali and Erik Schmidt, the former and the current director of the Gallerie degli Uffizi, and Marzia Faietti, the director of the Gabinetto Disegni e Stampe degli Uffizi, facilitated immensely my study of Leonardo's paintings and drawings under their care. Vincent Delieuvin, the chief curator of sixteenth-century Italian painting at the Musée du Louvre, was extremely kind to include me in a study day dedicated to the *Mona Lisa*, and for allowing me to look at other Leonardo paintings during their restoration. Luke Syson, the former curator at the National Gallery, London, and now the director of the Fitzwilliam Museum in Cambridge, U.K., and Larry Keith, Head of Conservation and Keeper at the National Gallery, London, shared their insight on the London *Virgin of the Rocks* before the painting returned to the galleries after an impressive restoration. Elizabeth Cropper, the former dean of the Center for Advanced Study in the Visual Arts, and David A. Brown, the former curator of Italian painting, invited me to view Leonardo's *Ginevra de' Benci* in the restoration lab of the National Gallery of Art, Washington D.C. Martin Clayton, Head of Prints and Drawings for the

Royal Collection Trust at Windsor Castle, was generous with time and expertise about the Leonardo drawings under his care. Antonio Paolucci and Barbara Jatta, the former and the current director of the Vatican Museums, facilitated my study of Leonardo's *Saint Jerome*.

My deepest thanks go to Cecilia Frosinini and Roberto Bellucci, both at the Opificio delle Pietre Dure in Florence, for welcoming me so many times during the restoration of Leonardo's *Adoration of the Magi*; their insights have shaped my thinking deeply and I cannot thank them enough for their generosity in sharing their knowledge and for being such inspiring friends. A sincere thank-you goes also to Cinzia Pasquali, a conservator who restored a number of Leonardo's paintings and who has been an invaluable resource throughout. Elizabeth Walmsley, the painting conservator at the National Gallery of Art, Washington D.C., also generously shared her knowledge of Leonardo's *Ginevra de' Benci*.

I owe an exceptionally big debt to Paul Barolsky, who has always been supportive in more ways that he can imagine; heroically, he read the manuscript as a whole, and as always, his suggestions have been invaluable. I am fortunate to have him as a colleague and friend. I thank also the late Corrado Maltese, who, in myriad Roman conversations, initiated me to the intricacies of art and science and left a lasting mark on the way I look at Renaissance art. The late Carlo Pedretti, who published my first essay on Leonardo when I was a graduate student, was always generous with his expertise, and I wished he could have seen the final result. The scholarship of Martin Kemp has been fundamental to this project, and I keep returning to his inspiring essays on Leonardo's optics and his groundbreaking monograph that forty years ago changed the way we think about Leonardo. David Summers has been a wonderful colleague and guide on the broadest implications of optics in the western tradition, and I cannot thank him enough for sharing his insight with me over the years. With Alessandro Nova, the director of the Kunsthistorisches Institut Florenz, I shared the organization of a symposium and the coauthorship of a scholarly publication, which served as the theoretical basis for this book as it brought together the expertise of historians of art, literature, science, and philosophy as well as conservators and restorers. Carmen Bambach, the curator of Italian and Spanish drawings at the Metropolitan Museum of Art, alerted me to a recently discovered shadow drawing by Leonardo that turned out to be crucial to my book. Paolo Galluzzi, the director of the Museo Galileo, has always been generous with insights. Dominique Raynaud kindly answered my questions on the transmission of Arab optics in the Latin West. Toby Lester read the manuscript at a critical juncture, and I am grateful for his thoughtful and expert feedback.

Conversations with many helped me sharpen my thoughts on the legacy of Leonardo's art theory. I gratefully thank Juliana Barone, Janis Bell, Francesca Borgo, Michael Cole, Francesco Paolo di Teodoro, Lea Dovev, Angie Estes, Claire Farago, Frank Fehrenbach, Emanuela Ferretti, Judith V. Field, Fabio Frosini, Leslie A. Geddes, Paul Hills, Matthew Landrus, Domenico Laurenza, Pietro C. Marani, Pauline Robison, Anna Sconza, Vita Segreto, Monica Tad-

dei, Carlo Vecce, Frank Zöllner, and the late Romano Nanni. To the formidable team of the Institute for Advanced Technology in the Humanities (IATH) at the University of Virginia, I owe the greatest debt. When it became apparent that traditional art historical tools did not provide satisfactory answers to basic questions on the legacy of Leonardo's art theory, the team helped me create a new research tool. I warmly thank Worthy Martin, the director of IATH, and the entire team: Daniel Pitti, Shayne Brandon, Cindy Girard, Sarah Wells, and Bernard Frischer, the former director of IATH.

Equally important have been the conversations on the broadest themes of Renaissance culture with Ingrid Rowland, while many friends informed my thoughts on how to do research today and train the next generation of researchers. Rossella Caruso, Suzanne Moomaw, Nadia Cannata, Tatiana String, Babette Bohn, Maria Careri, Simona Rinaldi, Lynn Isabel, Simona Filippini, Laura Gottwald, and LZ have all contributed to this book more than they know.

Numerous graduate students (several of whom by now have students of their own) have been invaluable collaborators on the book and the digital platform. I warmly thank Tracy Cosgriff, Elizabeth Dwyer, Emily Fenichel, Justin Greenlee, Yoko Hara, Eric Hupe, Elizabeth McMahon, Emily Moerer, and Jessica Stewart. A special thank-you goes to the undergraduate students of my spring 2020 Leonardo class: in the midst of a global pandemic, they were the first who heard this book in its final form as I lectured from it, a chapter each week, first in person and then remotely. Their questions helped me give the final polish to the manuscript.

I thank my colleagues at the University of Virginia. They are a congenial group of scholars, artists, and friends with whom I shared many a conversation on art, the humanities, pedagogy, and much more. The insights from those daily conversations fill every page of this book. I gratefully acknowledge that the book would not have been materially possible without the unfailing support of two successive deans of the College and Graduate School of Arts and Science—Meredith Jung-En Woo and Ian Baucom—and three chairs of the art department—Lawrence O. Goedde, Howard Singerman, and Carmenita Higginbotham; all of them have helped in more ways that they can imagine.

It is a great pleasure to express my gratitude to the institutions that generously contributed to the making of this book: the John Simon Guggenheim Memorial Foundation and the American Council of Learned Societies supported the initial steps of my research, and Villa I Tatti, the Harvard University Center for Italian Renaissance Studies, hosted me for a year. A special thank-you goes to Joseph J. Connors, the former director of Villa I Tatti, who warmly welcomed me in that scholarly paradise. The National Endowment for the Humanities supported a postgraduate summer institute in Florence that proved essential to refine my ideas and form a new group of Leonardo experts. The Samuel H. Kress Foundation generously funded the creation of a digital research tool, and I am grateful to its president, Max Marmor, himself a Leonardo specialist, for his support. The Buckner W. Clay Dean of Arts and Sciences and the Vice President for Research at the University of Virginia supported my work at every step of the way.

In addition, I wish to thank the institutions that granted me access to their collections and permission to reproduce their artifacts: in Florence, the Archivio di Stato, the Biblioteca Nazionale Centrale, the Biblioteca Riccardiana, the Museo Galileo, the Galleria degli Uffizi, the Galleria Palatina at Palazzo Pitti, the Opificio delle Pietre Dure; in Milan, the Archivio dell'Ospedale Maggiore and the Venerabile Biblioteca Ambrosiana; in the United Kingdom, the British Library, the British Museum, the National Gallery, and the Royal Collection Trust at Windsor Castle; in Paris, the Bibliotèque de l'Institut de France, the Bibliothèque Nationale de France, and the Musée du Louvre; in Saint Petersburg, the State Hermitage Museum; at the Vatican, the Biblioteca Apostolica Vaticana and the Vatican Museums; in Rome, the Biblioteca Hertziana and the Biblioteca Nazionale Centrale; in Germany, the Hamburg Kunsthalle and the Alte Pinakothek, Munich; in Poland, the National Museum, Krakow; and in the United States, the Metropolitan Museum of Art, New York, the National Gallery of Art, Washington D.C., and the University of Virginia Library, Charlottesville.

My agent, Susan Rabiner, believed in this book from the very start. Her inquisitive mind is legendary, and thankfully she never stopped asking probing questions. Her encouragement, advice, and friendship have been crucial throughout the process, and I cannot express how deep my gratitude to her is. At Farrar, Straus and Giroux, I was fortunate to enjoy the support of Alexander Star, whose expert advice has been a steady source of inspiration. I was lucky to have the careful and energetic assistance of Ian Van Wye, who expertly supervised the publication process.

Finally, my deepest gratitude goes to my family. My mother, Paola, and my late father, Paolo, were a constant source of personal support. With my siblings Vera, Laura, Brenno, and Lorenzo, I shared laughs, conversations, and great dinners.

This book is dedicated to my sons, Paolo and Davidi, who from a young age traveled with me all over the world to look at art. They lived with this book as they transitioned from adolescence to adulthood and I thank them from the bottom of my heart for their love and forbearance throughout.

Index

235–35, 249, *253*; Leonardo visit to family home of, 241; Leonardo work imitated and studied by, 234–37; life after Leonardo, 241–42; mental discourse importance emphasized by, 261; villa of, 241; reputation as painter, 236–37, 249; romantic relationship with, 229, 233, 240; shadow drawings studied by, 234; travel with, 225, 228; Vasari meeting with, 249, 263–65; Vasari's *Lives* revisions influenced by, 263–65; *Virgin and Child with Saint Anne* duplicated in work of, 236

Melzi, Giovanni Francesco (works): *Portrait of Leonardo da Vinci*, *14*, 14–15, 235–35, 249, *253*; *Vertumnus and Pomona*, 235–36; *see also Book on Painting*

metallurgy: behind Brunelleschi's dome palla, 41–42; of Ghiberti, L., 32, 43; Verrocchio background and talent in, 36–38, 42, 46

Michelangelo, 35, 256; fresco technique used by, 193, 203; funeral ceremony controversy, 262; painting next to *Battle of Anghiari*, 203; relationship with, 203, 226; Vasari on superiority of, 252, 258

Milan: French invasion/occupation of, 161–62, 200, 205; Leonardo's career beginnings in, 146–48; Leonardo's move to, 145–47, 317n61; Melzi villa in, 241

military engineering, 46, 146–47

mirrors, *see* burning mirrors

modern devotion, 81–82, 128–29

Mona Lisa (Leonardo), *206*, 224, 325n114; adjustments and retouches to, 213; Cassiano on seeing, 274; commission for, 207, 211; copy of, apprentices role in, 235, 336n210; drapery techniques for, 216–17; emotional connection approach in, 212, 215; experimental approach to, 207–208, 213–14; flesh tones approach in, 214–16; landscape in, 216; layers in, 214–15; middle ground unfinished in, 218; optical effects in, 216–17; portraiture conventions and experimentation in, 211–13, 336n210; preparatory drawings for, 212, 214; prestige and

influence of, 210–11, 336n210; scholarship on, 336n210; smile, 212, 214; traveling with unfinished, 228–29; as unfinished, factors behind, 6, 13, 205–208, 217–18; Vasari on, 212, 216, 336n210; *Virgin and Child with Saint Anne* relation to, 209

mother (of Leonardo), 20

Murate, Le, 106–107, 111, 122, 321n84

Nanni di Banco, 32

Natural History (Pliny), 21, 26, 30, 72–73, 113

natural philosophy, *see* science and philosophy

natural world and phenomena, 169–70, 218–19, 221, 227–28, 254, 258, 300

Neri di Bicci, 24

Niccolini, Luigi di Bernardo di Lapo, 111–12, 121

Nicolas of Cusa, 45

oil paints, 92–94

On Architecture (Vitruvius), 74, 167

On Divine Proportions (*De divina proportione*) (Pacioli), 90, 334n199

"On Painting" (Alberti, L.), 71, 151, 171

On the Soul (*De anima*) (Aristotle), 55, 59–60

optics, science of: in *Adoration of the Magi*, 136–38, 143, 145, 326n124; Alberti, L., on, 71, 171; Alhacen study and literature on, 11–12, 56–57, 60, *62*, 62–76, 78, 169, 180, 185, 202, 216–17, 245, 317n62; ancients on, 59–60, 63–64; in *Annunciation*, 13, 88–89, 96–99, 321n86; anonymous text describing, *48*, 48–49; in architecture/building techniques, 58; Aristotelian philosophy on, 59–60, 64, 66, 69; artists understanding of, historically, 10–11, 58; astronomers learning, 57–58; backdrops and, 169–70; *Battle of Anghiari* use of, 201–202; biographers omission of, 341n255; in book on painting, 13, 52, 60, 70, *138*, 171–72, 174–75, *182*, 182–84, 187, 190, 201, 220–21, 245–47, 261–65, 276–77, 293, 340n247; *Book on Painting* section on, *138*, 220–21,

reputation (*cont.*)
198–99, 205–206, 214, 252–53,
256–57; Vasari impact on, 259,
265–66, 270; Vasari interviewees
on, 254
Rome: Leonardo's move to and from,
225–28; Poussin in, 287, 346*n280*

Saint George (Donatello), 31–32
Saint Jerome (Leonardo), *139*, 139–41,
328*n139*
Saint Jerome (Verrocchio), 26–27, *27*
Saint John the Baptist (Leonardo), 207,
215, 228
Saint John the Evangelist (Ghiberti, L.),
32
Saint Sebastian, study for (Leonardo),
55, *55*, 316*n56*
Salai, *see* Caprotti, Gian Giacomo
Salvator Mundi (Leonardo), 235
San Donato a Scopeto, 125–26
Santa Maria del Fiore Cathedral, *40*;
Brunelleschi design and dome for,
39–41, *53*, 54–55; Brunelleschi's
castello/lifting machine for, 41, 45,
51, *53*, 53–54, 74; conflict behind
building of, 43–44; history, 39;
official completion and celebration
of, 51–52; *see also* Brunelleschi's
dome palla
Santissima Annunziata, 206–207, 209,
211
Savonarola, Girolamo, 60, 201
science and philosophy: Accademia del
Disegno disregard for, 261–62;
Alhacen as father of experimental,
63; apprenticeship exposure to,
9–10; art education role of, 4, 10, 12,
162; artist separation from, myth
about, 5–6, 8–10, 265, 270, 294;
astronomy and, 44–45, 57–59;
behind *Battle of Anghiari*, 201–202;
book on painting focus on, 13, 52,
60, 70, *138*, 171–72, 175, 187, 190,
201, 220–21, 261; books and
influences for study of, 170–71,
316*n54*; botany studies and, 227;
early life role of and interest in,
8–10, 52–55; folios focus on, 8–9,
12, 51, 188, 300; fossils interest and,
221, 227; hydraulics interest in, 227,
241; imagination and mental
experiments with, 227–28; *Last*

Supper approached with, 193–94,
197; later life shift towards, 5–6, 205;
natural phenomena investigation in,
169–70, 218–19, 221, 227–28, 254,
258, 300; in painting process, 8–9,
13, 191, 227–28; paintings used as
investigation of, 12–14, 191, 228,
300–301; Renaissance artists
influenced by, 10; Vasari's *Lives*
ignoring role of, for Leonardo,
255–59, 264; *see also* geometry; optics,
science of
sculpture, 114, 326*n114*, 347*n289*;
aerial perspective absence in, 187; of
Donatello, 28–29, 31–32, 37;
paragone debates and, 91, 186–87,
193, 261–62; of Verrocchio, 31–35,
32, 37, 46; at Verrocchio's workshop,
23–24, 187
Self-Portrait (Poussin), *287*, 287–88
Ser Piero (Leonardo's father), 4–5,
19–22, 24, 105, 107, 127, 206, 209,
211
set design, 167, 259–60
sfumato technique, 22, 184, 234, 302
shadow: *Adoration of the Magi*
depictions of, 135–39, 326*n124*,
328*n135*; in *Annunciation*, approach
to, 88–89, 91, 95, 98–99; book on
painting on, 174–75, *182*, 182–84,
220–21, 262–63, 276–77, 293, 302;
Book on Painting sections on, *138*,
220–21, 245–47, 262–64, 276–77,
293, 340*n247*; Cassiano inclusion of
folios on, 276–77; color relation to
perception of, 65–66, 68–69, 85–86,
96–98, 100–101, 282–83, 292; depth
illusion created by, 77; *Discourse on
Drawing* on, 266–67, 270, 276;
folios/notebooks on, 56, *56*, 98,
174–75, 180–85, *182*, 220–21,
245–46, 276–77, 302, 340*n247*;
library research on, 61–62;
penumbra definition relation to
light and, 31; Poussin treatment of,
282–83, 287–88; *Saint Jerome* and
universal, 139–40; *Treatise on
Painting* omission of section on, 293,
295–96; universal, 139–41, 180, 185;
Vasari on Leonardo's approach to,
264–65; *see also* optics, science of
shadow drawings: Arconati on
significance of, 277–78; *Book on*

page 2: Leonardo da Vinci, Studies of shadows created by candlelight, ca. 1490–1491, Manuscript C, fol. 22r. Paris, Bibliothèque de l'Institut de France (2174). © RMN–Grand Palais / Art Resource, NY.

page 2: Leonardo da Vinci, Studies of light and shadows on a spherical object, ca. 1490–1491, Manuscript C, fol. 4v. Paris, Bibliothèque de l'Institut de France (2174). © RMN–Grand Palais / Art Resource, NY.

page 14: Francesco Melzi, *Portrait of Leonardo da Vinci*, ca. 1515–1518, red chalk on paper, 27.5 × 19 cm. Royal Collection Trust, Windsor Castle (RCIN 912726). Courtesy of Royal Collection Trust / © Her Majesty Queen Elizabeth II 2020.

page 27: Andrea del Verrocchio and his workshop, *Saint Jerome*, ca. 1460, mixed materials on paper attached to wood, 40.5 × 27 cm. Florence, Galleria Palatina, Palazzo Pitti (inv. 1912 no. 370). © Scala / Art Resource, NY.

page 32: Andrea del Verrocchio, *Christ and Saint Thomas*, ca. 1467–1483, bronze, 230 cm. (91 in.). Florence, Orsanmichele. © Scala / Art Resource, NY.

page 37: Leonardo da Vinci, *Drapery Study for Kneeling Figure*, early 1470s, gray and white tempera, and white wash on gray prepared linen, 16.4 × 16.8 cm. Florence, Gallerie degli Uffizi (Gabinetto Disegni e Stampe, 420E). © Scala / Art Resource, NY.

page 40: Florence, Santa Maria del Fiore, Golden Ball, ca. 1468–1471, designed by Andrea del Verrocchio atop the dome and lantern designed by Filippo Brunelleschi. © Scala / Art Resource, NY.

page 48: Unknown author, Codex Riccardianus 2110, late fifteenth century, fol. 18v. Florence, Biblioteca Riccardiana. © Biblioteca Riccardiana, Florence.

page 49: Leonardo da Vinci, Codex Atlanticus, ca. 1478–1480, fol. 87r. Notes and sketches on burning mirrors, showing (from top to bottom): two polishing machines to smooth glazed surfaces, views of a furnace to melt glass and bake clay cores, and a geometrical diagram. Milan, Veneranda Biblioteca Ambrosiana. © Veneranda

Biblioteca Ambrosiana / Metis e Mida Informatica / Mondadori Portfolio / Bridgeman Images.

page 53: Leonardo da Vinci, Codex Atlanticus, ca. 1478–1480, fol. 847r. View of Brunelleschi's castello, showing the screw (*viticcio di lanterna*) that made it possible to lift the hoist as the lantern went up. Milan, Veneranda Biblioteca Ambrosiana. © Veneranda Biblioteca Ambrosiana / Metis e Mida Informatica / Mondadori Portfolio / Bridgeman Images.

page 55: Leonardo da Vinci, Shadow Drawing, ca. 1478–1480. Back of a study for the figure of *Saint Sebastian*, pen and brown ink, 17.4 × 6.3 cm. Hamburg, Germany. © Hamburger Kunsthalle / Art Resource, NY.

page 56: Leonardo da Vinci, Studies of light and shadows, ca. 1490–1491, Manuscript C, fol. 12r. Paris, Bibliothèque de l'Institut de France (2174). © RMN–Grand Palais / Art Resource, NY.

page 62: Ibn al-Haytham, *De li aspetti*, fourteenth century, Codex Vaticanus Latinus 4595, fol. 30v. Light rays entering room through a pinhole. Vatican City, Biblioteca Apostolica Vaticana. © Biblioteca Apostolica Vaticana.

page 90: Leonardo da Vinci, *The Annunciation*, ca. 1472, oil on wood, 90 × 122 cm. Florence, Gallerie degli Uffizi (1890, no. 1618). © Scala / Ministero per i Beni e le Attività Culturali / Art Resource, NY.

page 97: Francesco Melzi, *Libro di Pittura*, ca. 1540, Codex Urbinas Latinus 1270, fol. 148v. Illustration for Leonardo da Vinci's note "Why in twilight shadows on white objects are blue." Vatican City, Biblioteca Apostolica Vaticana. © Biblioteca Apostolica Vaticana.

page 102: Andrea del Verrocchio and Leonardo da Vinci, *The Baptism of Christ*, ca. 1470–1478, tempera and oil on wood, 177 × 151 cm. Florence, Gallerie degli Uffizi (1890, no. 8358). © Scala / Ministero per i Beni e le Attività Culturali / Art Resource, NY.

page 116: Infrared photography of Leonardo da Vinci, *Ginevra de' Benci*. Washington, D.C., National Gallery of Art.

page 117: Leonardo da Vinci, reverse of *Ginevra de' Benci*, ca. 1475, oil on wood, 42.7 × 37 cm. Washington, D.C., National Gallery of Art (1967.6.1.b).

page 132: Infrared photography of Leonardo da Vinci, *Adoration of the Magi*. Florence, Opificio delle Pietre Dure.

page 134: Leonardo da Vinci, *Figure Studies for the Adoration of the Magi* and *Hydrograph*, ca. 1481–1482, metal point, pen and ink, 27.8 × 20.8 cm. Paris, Musée du Louvre, Département des Arts Graphiques (2258r). © RMN–Grand Palais / Art Resource, NY.

page 138: Francesco Melzi, *Libro di Pittura*, ca. 1540, Codex Urbinas Latinus 1270, fol. 202r. Illustration for Leonardo da Vinci's note "What part of a body will be most illuminated by a light of even quality." Vatican City, Biblioteca Apostolica Vaticana. © Biblioteca Apostolica Vaticana.

page 139: Leonardo da Vinci, *Saint Jerome*, ca. 1482, oil on wood (walnut), 103 × 74 cm. Vatican City, Musei, Monumenti e Gallerie Pontificie, Pinacoteca (40337). © Scala / Art Resource, NY.

page 140: Leonardo da Vinci, *Madonna and Child* (*The Benois Madonna*), ca. 1480–1482, oil on wood (later transferred to canvas), 49.5 × 33 cm. © Saint Petersburg, the State Hermitage Museum (GE 2773). © Scala / Art Resource, NY.

page 151: Leonardo da Vinci, detail from *Virgin of the Rocks*, ca. 1483–1485, oil on wood (later transferred to canvas), 199 × 122 cm. Paris, Musée du Louvre, Département des Peintures (777, 1599). © RMN–Grand Palais / Art Resource, NY.

page 161: Leonardo da Vinci (and others), *Virgin of the Rocks*, ca. 1506–1508, oil on wood, 189.5 × 120 cm. London, National Gallery (1093). © RMN–Grand Palais / Art Resource, NY.

page 168: Leonardo da Vinci, *The Lady with an Ermine* (*Cecilia Gallerani*), ca. 1486–88, oil on wood, 54 × 39 cm. Krakow, National Museum / Princes Czartoryski Museum (MNK-MKCz XII-209). © Laboratory Stock / National Museum, Krakow.

page 169: Leonardo da Vinci, *La Belle Ferronière* (*Lucrezia Crivelli?*), ca. 1495, oil on wood, 63 × 45 cm. Paris, Musée du Louvre, Département des Peintures (778). © RMN–Grand Palais / Art Resource, NY.

page 176: Leonardo da Vinci, *The Skull Sectioned*, ca. 1489, traces of black chalk, pen and ink, 18.8 × 13.4 cm. Royal Collection Trust, Windsor Castle (RCIN 919057r). Courtesy of Royal Collection Trust / © Her Majesty Queen Elizabeth II 2020.

page 177: Leonardo da Vinci, *Vitruvian Man*, ca. 1490, pen and ink, and some wash over metalpoint, 34.3 × 24.5 cm. Venice, Gallerie dell'Accademia (Gabinetto Disegni e Stampe, 228). © Cameraphoto Arte, Venice / Art Resource, NY.

page 178: Leonardo da Vinci, Study of the neck muscles with skin peeled off, ca. 1489–1490, metalpoint (faded), pen and ink, leadpoint, some discolored white heightening, on pale blue-gray prepared paper, 20.2 × 28.7 cm. Royal Collection Trust, Windsor Castle (RCIN 912609r). Courtesy of Royal Collection Trust / © Her Majesty Queen Elizabeth II 2020.

page 179: Leonardo da Vinci, Diagrams of spheres illuminated by the sky, ca. 1490–1492, Manuscript A, fols. 93v–94r. Paris, Bibliothèque de l'Institut de France (2185). © RMN–Grand Palais / Art Resource, NY.

page 182: Leonardo da Vinci, Diagrams of spheres illuminated by round light sources, ca. 1490, Manuscript C, fols. 18v–19r. Paris, Bibliothèque de l'Institut de France (2174). © RMN–Grand Palais / Art Resource, NY.

page 189: Unknown artist, *Academia Leonardi Vinci*, ca. 1490, engraving, 29 × 21 cm. London, British Museum (1877, 0113.364). © Trustees of the British Museum.

page 191: Leonardo da Vinci, *The Last Supper*, ca. 1495–1498, mural painting, 460 × 880 cm. Milan, Refectory of Santa Maria delle Grazie. © Alinari / Art Resource, NY.

page 206: Leonardo da Vinci, *Mona Lisa* (*Lisa Gherardini wife of Francesco del Giocondo*), ca. 1503–1517, oil on wood, 77 × 53 cm. Paris, Musée du Louvre, Département des Peintures (779). © RMN–Grand Palais / Art Resource, NY.

pages 222 and 223: Leonardo da Vinci, The Muscles of the Shoulder, Arm and Neck, ca. 1510–1511, black chalk, pen and ink, wash, 28.2 × 20.2 cm. Royal Collection Trust,

Windsor Castle (RCIN 919005v and 919008v). Courtesy of Royal Collection Trust / © Her Majesty Queen Elizabeth II 2020.

page 243: Francesco Melzi, *Libro di pittura*, ca. 1540, Codex Urbinas Latinus 1270, fol. 1. Vatican City, Biblioteca Apostolica Vaticana. © Biblioteca Apostolica Vaticana.

page 244: Francesco Melzi, *Libro di pittura*, c. 1540, Codex Urbinas Latinus 1270, 218v–219r. Vatican City, Biblioteca Apostolica Vaticana. © Biblioteca Apostolica Vaticana.

page 253: Portrait of Leonardo da Vinci, from Giorgio Vasari, *Le vite de' più eccellenti pittori scultori e architettori* (Florence: Giunti, 1568). Based on Francesco Melzi's *Portrait of Leonardo*, ca. 1513–1518.

page 265: *Disccorso sopra il disegno di Lionardo Vinci. Parte seconda*, after 1568, Codex Riccardianus 3208, frontispiece. Florence Biblioteca Riccardiana. © Biblioteca Riccardiana, Florence.

page 277: Unknown artist, Codex H227 inf., fol. 61r: shadow drawings copied from Leonardo's Manuscript C. Milan, Veneranda Biblioteca Ambrosiana. © Veneranda Biblioteca Ambrosiana / Metis e Mida Informatica / Mondadori Portfolio / Bridgeman Images.

page 281: Nicolas Poussin (after), drawing for Leonardo da Vinci's chapter "On the Mighty Motions of a Man's Limbs," before 1640, pen and ink, and wash, Codex OR-11706, leaf insert between fol. 43v and fol. 44r. Saint-Petersburg, the Hermitage State Museum, Prints and Drawings Collection. © The Hermitage State Museum, Saint Petersburg.

page 287: Nicolas Poussin, *Self-Portrait*, 1650, oil on canvas, 98 × 74 cm. Paris, Musée du Louvre, Département des Peintures (7302). © RMN–Grand Palais / Art Resource, NY.

page 290: Leonardo da Vinci, *Trattato della Pittura* (Paris, Langlois, 1651), frontispiece.